THE AZTEC WORLD

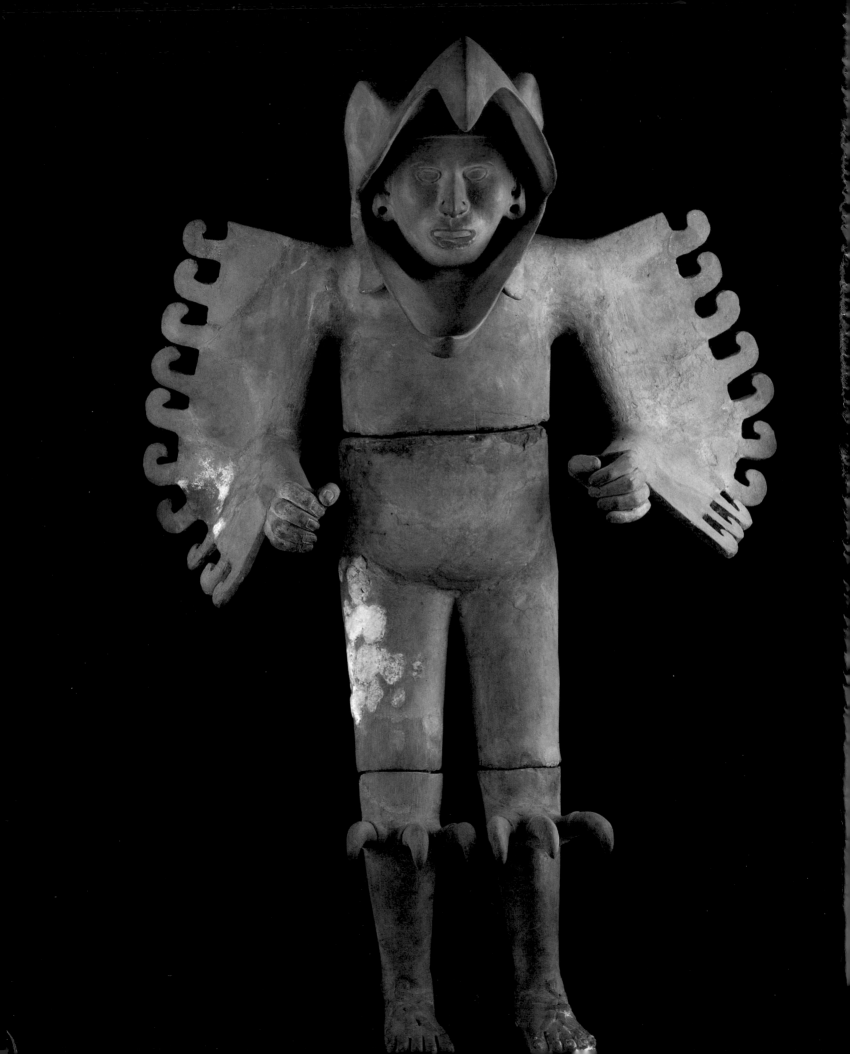

EDITED BY ELIZABETH M. BRUMFIEL AND GARY M. FEINMAN

THE AZTEC WORLD

ABRAMS, NEW YORK

in association with The Field Museum, Chicago

Instituto Nacional
de Antropología
e Historia

Consejo Nacional
para la
Cultura y las Artes

Project Manager: Ariel Orlov
Editor: Esther de Hollander
Designer: Kris Tobiassen
Production Manager: Jules Thomson

Library of Congress Cataloging-in-Publication Data:

Brumfiel, Elizabeth M.
 The Aztec world / by Elizabeth M. Brumfiel and Gary M. Feinman.
 p. cm.
 Catalog of an exhibition to be held at The Field Museum, Chicago, from October 31, 2008 to April 19, 2009.
 ISBN 978-0-8109-7278-0 (hardcover) ISBN 978-0-8109-8309-0 (paperback)
 1. Aztecs—Antiquities—Exhibitions. 2. Aztecs—History—Exhibitions. 3. Mexico—Antiquities—Exhibitions.
I. Feinman, Gary M. II. Field Museum of Natural History. III. Title.

F1219.73.B78 2008

972'.01—dc22
 2007048998

Printed and bound in China

10 9 8 7 6 5 4 3 2 1

Abrams books are available at special discounts when purchased in quantity for premiums and promotions as well as fundraising or educational use. Special editions can also be created to specification. For details, contact specialmarkets@hnabooks.com or the address below.

HNA
harry n. abrams, inc.
a subsidiary of La Martinière Groupe

115 West 18th Street
New York, NY 10011
www.abramsbooks.com

Exelon Corporation is proud to sponsor *The Aztec World* exhibition at The Field Museum. I hope that you have the opportunity to visit the exhibition, to view the rare artifacts, and learn more about one of the world's great civilizations. Exelon is always proud to partner with The Field Museum to make Chicago a great living classroom.

JOHN W. ROWE
Chairman and CEO,
Exelon Corporation

Major Sponsor

CONTENTS

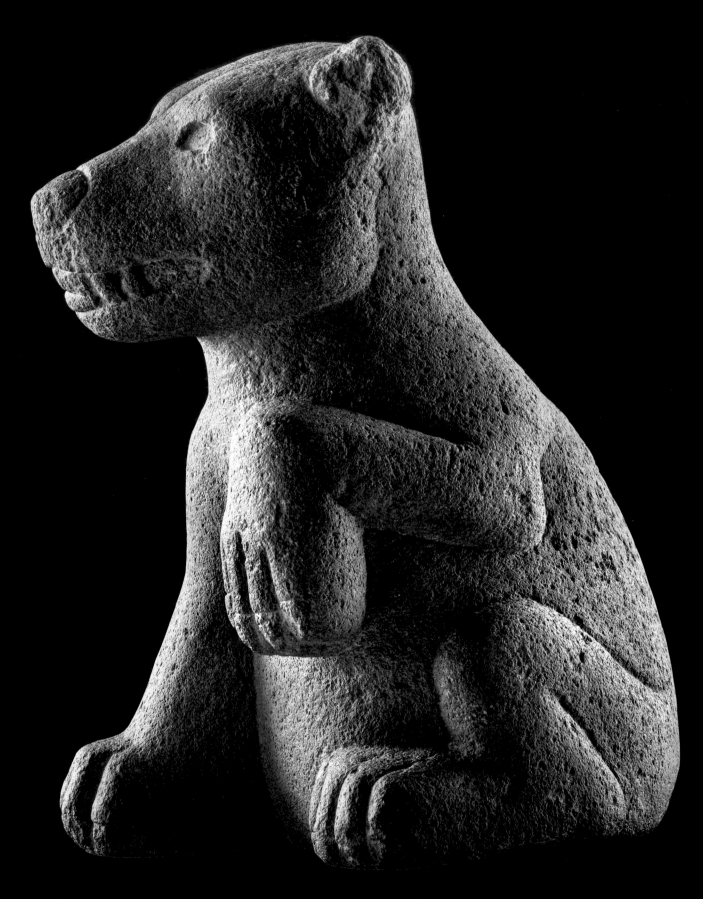

Figure 1. Stone sculpture from the collection of The Field Museum. This poignant representation of a dog was found in the Toluca Valley outside Mexico City.

FOREWORD

JOHN W. McCARTER, JR.
PRESIDENT AND CEO,
THE FIELD MUSEUM, CHICAGO

The Field Museum is pleased to present *The Aztec World*, an original exhibition and companion volume that present new perspectives on one of the most spectacular civilizations in human history. Arriving in what is now Mexico City in 1325, the Aztecs soon built one of the most powerful empires on earth. Within the space of two hundred years, the Aztecs used art, religion, commerce, military might, and technology to forge a rich and powerful empire that continues to fascinate us with its beauty and sophistication.

Bringing to life the farmers, artists, noble families, women, and warriors—a broad spectrum of Aztec society at the height of its power—*The Aztec World* merges art history and anthropology to present extraordinary works of Aztec art in social, political, and religious context in order to provide a deeper understanding of this complex culture. The exhibition explores the city of Tenochtitlán, beginning at the shores of Lake Texcoco where farmers, the backbone of Aztec society, worked to support the needs of a sprawling empire. It reveals how Aztec ingenuity turned swampland into rich, productive soil. Beautiful artifacts made from precious metals, ceramic, obsidian, wood, and shell reveal the unsurpassed skill of the artisans and the variety of goods found in the famous Aztec market of Tlatelolco. These artifacts reveal both the differences and similarities between the religious life of ordinary citizens and that of the elite. *The Aztec World* unfolds the pantheon of Aztec gods and delves into the lives of women, everyday people, warriors, priests, and the emperor and ruling classes. Our story concludes by examining the legacy of the Aztecs, from the moment of Spanish conquest in 1521, when the two cultures began to merge and form today's Mexico.

As a preeminent research institution in Mesoamerican anthropology, with related collections of more than 27,000 objects and an established track record of producing richly interpreted and contextualized exhibitions, The Field Museum is well-positioned to collaborate with Mexico's leading cultural institutions—and with leading scholars in the United States—to present this highly innovative exhibition to the public.

An additional unique, and most significant, aspect of this exhibition is the bi-national nature of the curatorial team. We owe a profound debt of gratitude to our esteemed Mexican colleagues, who gave unsparingly of their time and expertise, and who granted us access to the world's most

important, prestigious collections of Aztec art. Among them are Dr. Felipe Solís Olguín, Director, Museo Nacional de Antropología; Dr. Juan Alberto Román, former director, Museo del Templo Mayor; Dr. Leonardo López Luján, Director, Proyecto Templo Mayor; and Dr. Carlos Javier González González, Director, Museo del Templo Mayor. We also wish to our partners at Mexicio's Instituto Nacional de Antropología e Historia (INAH): Dr. Alfonso de Maria y Campos, Director General, Sr. José Enrique Ortiz Lanz, National Coordinator of Museums and Exhibitions, Sr. Juan Manuel Santín del Río, Director of Exhibitions, and Sra. Jacqueline Correa Lau, Project Coordinator, INAH. And, of course, we are grateful for the extraordinary depth and breadth of talent of The Field Museum's own project team. *The Aztec World* represents a remarkable achievement that we believe will have a lasting impact on our understanding of one of the world's most extraordinary civilizations.

We are most grateful to Exelon Corporation, the Chicago sponsor of *The Aztec World*.

ACKNOWLEDGMENTS

THE FIELD MUSEUM, CHICAGO

Álvaro Amat, Exhibition Design Director
Gordon Ambrosino, Collections Manager for Anthropology
Elizabeth Beckman, Exhibition Designer
Susan Blecher, Exhibition Registrar
Daniela Bono, Collections Assistant for Anthropology
Daniel Breems, Exhibition Production Supervisor
Elizabeth M. Brumfiel, Professor of Anthropology,
 Northwestern University Adjunct Curator, Anthropology
Jean Cattell, Graphic Design Director
Gary Feinman, Curator, Mesoamerican Anthropology
Nel Fetherling, Exhibition Shop Supervisor
David Foster, Temporary Exhibitions Director
Sarah Franken, Graphic Designer
Pamela Gaible, Exhibition Shop Supervisor
Robin Groesbeck, Director of Exhibitions
Hilary Hansen, Project Manager for Exhibitions
Jaap Hoogstraten, Exhibition Operations and Media Director
Neil Keliher, Exhibition Maintenance Manager
Marianne Klaus, Assistant Conservator for Anthropology
Ray Leo, Exhibition Production and Maintenance Director
Matthew Matcuk, Exhibition Development Director
Franck Mercurio, Exhibition Developer
Ariel Orlov, Publication Manager
Christopher Philipp, Collections Manager for Anthropology
Rachel Post, Exhibition Project Assistant
Laura Sadler, Senior Vice President, Museum Enterprises
Jill Seagard, Scientific Illustrator, Anthropology
Tony Stepovy, Media Services Manager
Christine Taylor, Collections Manager for Anthropology
Deborah Van Kirk, Image Rights and Research
Thatcher Waller, Lighting Design Supervisor
Lori Walsh, Graphic Designer
John Weinstein, Head Photographer

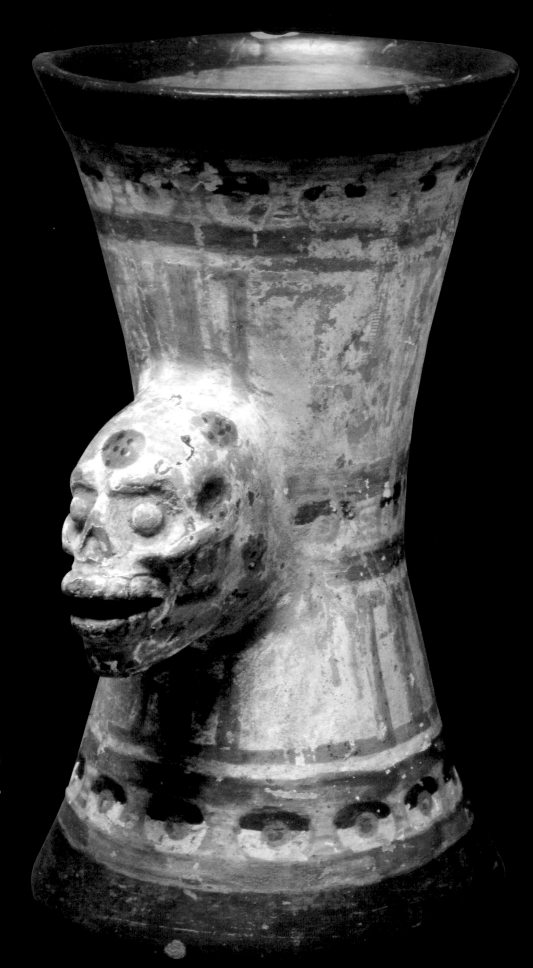

Figure 2. Ceramic drinking vessel with skull from the collection of The Field Museum. Though found in Mexico City, this drinking vessel was probably imported from Puebla.

FOREWORD

AMB. ALFONSO DE MARIA Y CAMPOS, GENERAL DIRECTOR,
INSTITUTO NACIONAL DE ANTROPOLOGÍA E HISTORIA,
MEXICO

The history of the Mexicas, or Aztecs as they are commonly known, is resplendent. In less than two centuries they built what was the most powerful empire in Mesoamerica. But this rapid ascent toward the domination of their neighbors, driven by the conviction of their military superiority and their status as a divinely chosen people, was accompanied by the troubling certainty, sung by their poets and asserted by their priests, of their inevitable fall and the inevitable destruction of their world.

Perhaps this unique configuration of the Mexica mindset, which combined eschatology (an ideological concern with death and the end of the world) with the certainty of being their god's chosen people, provides an explanation for a large part of the paradoxical beauty of their art. We can perceive a certain urge to leave an indelible mark on human memory: The emphatic style in which they carved their imposing works in stone and built their cities evokes their seemingly inexhaustible surge of conquests.

But the message these majestic objects—from the collections of the National Museum of Anthropology and the Museum of the Great Temple of Mexico City—transmit to us is a far cry from the imperial vanity of other civilizations, which built with the idea that they were the alpha and omega of all time. Though these masterpieces were made so that their voice might be heard for centuries, they speak to us of the fleeting nature of life, the uncertainty that stalks the individual at every turn, the assertion—as heart-rending and stony as the sculptures themselves—that the only sure thing in our lives is the inevitability of death.

Today, when the world seems obligated to choose between fundamentalisms of one kind or another that tolerate no differences, *The Aztec World* offers a refreshing new look by showing us a culture that, though it saw itself as the indisputable power of an entire era, never lost sight of the fact that it was a mere heartbeat in the infinite history of humankind.

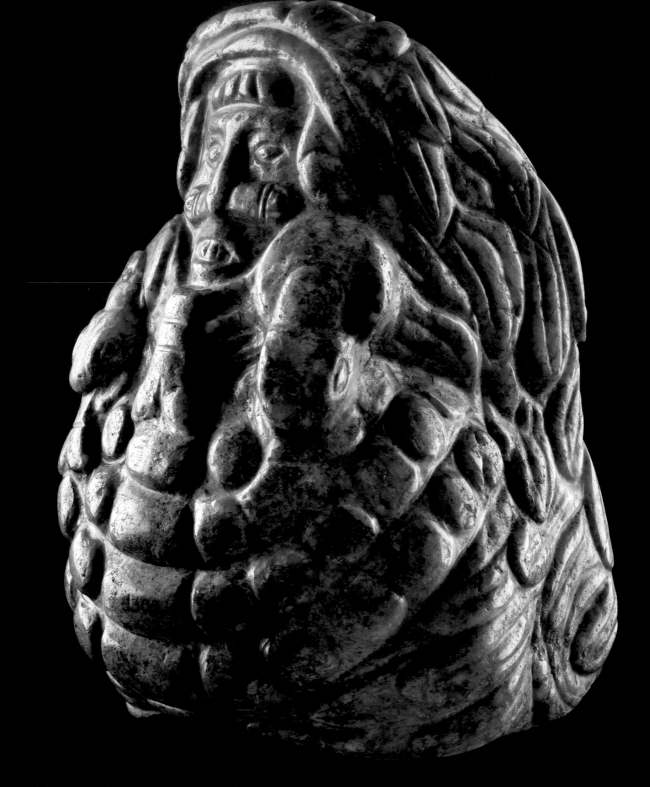

Figure 3. Greenstone figurine of Quetzalcoatl, the
Feathered Serpent, from the collection of The Field
Museum. Quetzalcoatl was the patron deity of artisans,
appropriate for this finely crafted figurine.

ACKNOWLEDGMENTS

INSTITUTO NACIONAL DE ANTROPOLOGÍA E HISTORIA, MEXICO

CONSEJO NACIONAL PARA LA CULTURA Y LAS ARTES

Sergio Vela, *President*

INSTITUTO NACIONAL DE ANTROPOLOGÍA E HISTORIA

Alfonso de Maria y Campos, *General Director*
Rafael Pérez Miranda, *Technical Secretary*
Luis Ignacio Saínz Chávez, *Administrative Secretary*

José Enrique Ortiz Lanz, *National Coordinator of Museums and Exhibitions*
María del Perpetuo Socorro Villarreal Escárrega, *National Coordinator of Legal Affairs*
Benito Taibo Mahojo, *National Coordinator of Outreach*
Felipe Solís Olguín, *Director of the Museo Nacional de Antropología*
Carlos González, *Director of the Museo del Templo Mayor*
Juan Manuel Santín, *Director of Exhibitions*
Gabriela Eugenia López, *Director of Museums*
Patricia Real, *Director of Design and Installation*
Enrique Álvarez, *Director of Legal Affairs and Consultations*
Héctor Toledano, *Director of Publications*
Juan Contreras de Oteyza, *Deputy Director for International Exhibitions*
Jorge Juárez, *Deputy Director for Real State Affairs*

EXHIBITION

CURATORS

Leonardo López Luján
Juan Alberto Román Berrelleza
Felipe Solís Olguín

PROJECT COORDINATOR

Jacqueline Correa Lau

LENDING INSTITUTIONS, INAH

Museo del Templo Mayor
Museo Nacional de Antropología
Zona Arqueológica de Tlatelolco
Dirección de Salvamento Arqueológico
Museo de las Culturas de Oaxaca
Museo Nacional del Virreinato
Museo Regional de Puebla
Museo Nacional de Historia
Museo de las Esculturas Mexicas "Eusebio Dávalos"
Museo Baluarte de Santiago

OTHER LENDING INSTITUTIONS

Museo Arqueológico del Estado "Dr. Román Piña Chan"
Museo de Antropología e Historia del Estado de México
Centro Regional Cultural Apaxco
Fundación Televisa
Patrimonio Artistico Banamex
Museo Universitario de Ciencias y Arte, UNAM

ADDITIONAL ASSISTANCE

Ramiro Acevedo, Martín Antonio, Alejandra Barajas, María del Refugio Cárdenas, Fernando Carrizosa, René Castellanos, Bertha Cea, Ximena Chávez, Delia Domínguez, Trinidad Durán, Enrique Fernández, María Teresa García, Agustín Gasca, Cecilia Genel, Erika Gómez, Claudio X. González, Salvador Guilliem, Mauricio Maillé, Alejandra Morales, David Morales, Víctor Ángel Osorio, Ileana Peña, Fernando Pérez, Virginia Pimentel, Ernesto Rodríguez, José Luis Rojas, Salvador Rueda, Diego Sapién, Graciela de la Torre, Roberto Velasco.

FOREWORD

DR. CARLOS JAVIER GONZÁLEZ GONZÁLEZ,
DIRECTOR, MUSEO DEL TEMPLO MAYOR,
MEXICO

The Aztecs were responsible for the last great Mesoamerican social expression. Despite their grandeur and the enormous fear they inspired in other indigenous societies of that great territory, on August 13, 1521, they succumbed to a handful of Spanish conquerors led by Hernán Cortés, who took advantage of the prevailing climate of hostility toward them, in particular among the Tlaxcaltecs, their bitter enemies. In this regard, it is paradoxical that their very strength and power became the engine of their downfall.

Precisely for having been that last major expression, the Aztecs in a sense synthesized the complexity and magnificence achieved by the extraordinary human communities that had preceded them in Mesoamerica. But not—as had been thought in the past—because they acquired that complexity through their military conquests; rather, simply because they were the last link in an ancient chain of common experience and learning. They were well aware of that historical inheritance, as is shown by their veneration of Teotihuacan, without a doubt the most important pre-Columbian city in the America. They imagined Teotihuacan as the crucible in which the gods created the Fifth Sun (the current era), for whose life and preservation they felt responsible. But Teotihuacan's splendor had faded six hundred years before the Aztecs founded their capital of Tenochtitlan.

The complexity of Aztec society can be appreciated in their division of labor and multiplicity of specialized activities. However, one of its most conspicuous features, and the one that most fascinates contemporary specialists, is the clear unity that prevailed between daily life and religious thought. Every aspect and every moment of life, as well as every phenomenon or being of nature and the cosmos, had a raison d'être or an explanation in the framework of their religion, and in the same way, Aztec men and women sought to influence the course of events and modify their destiny by engaging in communication with the divine sphere. Only in that light can it be understood how they conceived war as a life-regenerating activity, because through it they fed the Sun and the Earth, respectively the male and female aspects of the cosmos, with blood. That is also the sense in which human sacrifice should be understood, though two additional and equally important aspects can be added: Offering a human life was the supreme rite of passage by which humans entered into contact with the sacred, as well as a compensation for the original sacrifice of the gods who created the world according to Aztec mythology.

Organizing an exhibition to present a complete overview of the Aztecs may be a pleasant task, but it is by no means an easy one. The Field Museum of Chicago (Chicago has been the sister city of Mexico City—which is to say, the ancient Tenochtitlan—since 1987) has taken up that task, and we naturally wish it all great success. Since Chicago is a city located in the Midwest of the United States, and in keeping with this important museum's educational mission, one of the crucial goals is for the exhibition to be visited by a public not very familiar with the Aztec world, so that they can achieve an adequate introduction to that culture through the exhibit. It is also very gratifying that the organizers' intention is to present the subject of sacrifice in its proper setting, as a phenomenon involving everyone, which should therefore be neither magnified nor minimized. Finally, Aztec society is just one of the many expressions of the human phenomenon. I wish to express my hope that the visitors to this remarkable exhibition and the readers of this companion publication will appreciate the cultural wealth of that society, which though emblematic of Mexico, now belongs to all of humankind.

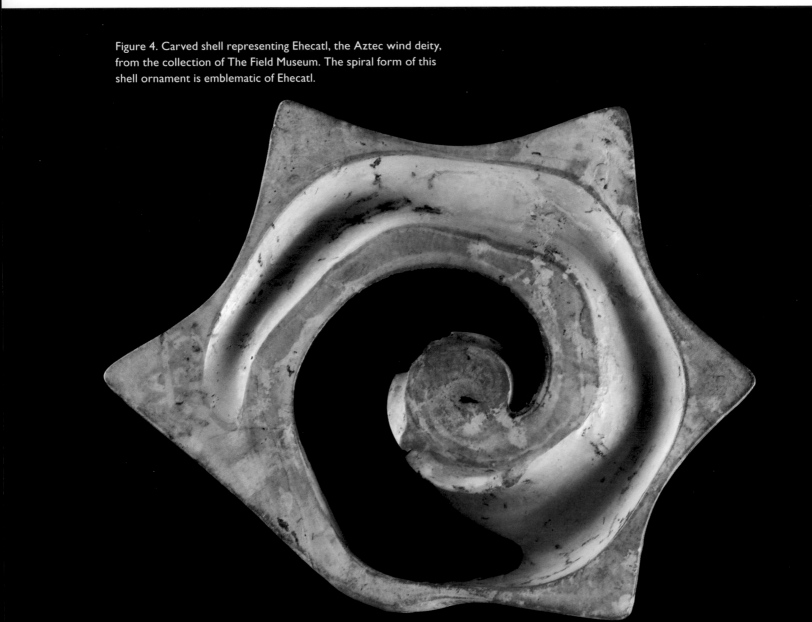

Figure 4. Carved shell representing Ehecatl, the Aztec wind deity, from the collection of The Field Museum. The spiral form of this shell ornament is emblematic of Ehecatl.

FOREWORD

DR. FELIPE SOLÍS OLGUÍN, DIRECTOR,
MUSEO NACIONAL DE ANTROPOLOGÍA,
MEXICO

Aztec culture and art have had a place in the world's imagination as a result of sensational archaeological finds that revealed fascinating testimonials to this civilization that was destroyed at the turn of the sixteenth century.

The discovery of the goddess Coyolxauhqui, carved in relief, led to excavations and a rediscovery of the remains of the legendary Templo Mayor (Great Pyramid), the center of religious activity in Mexico-Tenochtitlan.

From 1978 to the present, the discoveries and studies that have been carried out have strongly reinforced the academic quality of our knowledge of Aztec archaeology and history. At the present time, we can understand the Aztec people's different cultural expressions through a very wide range of approaches: from the anthropological standpoint to the most precise scientific analyses offered by chemistry and biology.

However, the most fascinating way to approach and contemplate the Aztecs is through the exhibitions that, for a short time in a fortunate place, bring together the most outstanding examples of the Aztecs' artistic production. One such opportunity is the show that has been organized by the Field Museum of Chicago, which furthers the interest that originated in 1790 with the discovery of the Coatlicue and the Sun Stone monuments, with which the Mexican museum tradition was inaugurated in a way that fascinated William Bullock. Bullock organized the first exhibition to show this people's archaeological treasures in London in 1824; that was the milestone for all later presentations of Aztec art and culture.

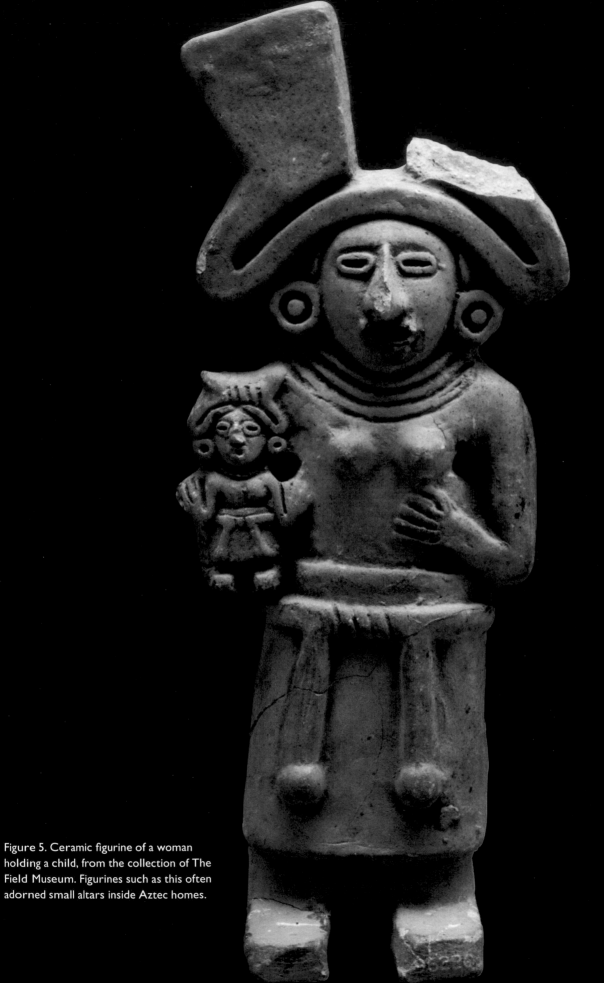

Figure 5. Ceramic figurine of a woman holding a child, from the collection of The Field Museum. Figurines such as this often adorned small altars inside Aztec homes.

INTRODUCTION
THE AZTEC WORLD IN HISTORICAL CONTEXT

ELIZABETH M. BRUMFIEL,
NORTHWESTERN UNIVERSITY, AND
GARY M. FEINMAN, THE FIELD MUSEUM

In 1895, William H. Holmes, the first curator in the Department of Anthropology at Chicago's Field Columbian Museum (now The Field Museum), published *Archaeological Studies among the Ancient Cities of Mexico*, the initial volume in the museum's anthropological monograph series. To begin the volume, Holmes (1895:15) wrote: "The present paper does not assume to be more than a sketch of limited portions of a great subject. It aims only to present the various ruined cities and archaeological sites visited as seen at a passing glance—a glance by far too brief for complete or satisfactory observation, but which, nevertheless, has given vivid and valuable impressions. The studies which shall cover this ground adequately and finally are yet to be made. Years of patient study, excavation, comparison and literary research are necessary."

Now, more than 110 years later, Holmes's observations have proven prescient. And, while nineteenth-century expeditions and observations (such as his) laid an important foundation for later research, the practices and procedures through which we study the past have undergone great transformations since Holmes's era. Most important, the interpretations presented in this book as well as in the associated exhibition are more often than not the direct outgrowth of detailed, painstaking research in which archaeological pieces were discovered and recorded in context, in a manner that was not routinely practiced at the close of the nineteenth century. Especially over the past quarter century, research findings, such as those made by the archaeological team that conducted excavations of the Templo Mayor of Tenochtitlan (beneath downtown Mexico City), have yielded new more complete understandings of Aztec life, craftsmanship, politics, and religion. Within this finer context, we can look at the masterworks of the Aztecs not just as works of art, but also as part of a material record that informs us about the cultural practices and beliefs of the Aztec peoples.

In this exhibition, we build on more than a century of archaeological and documentary research to present a contextualized and multifaceted perspective on *The Aztec World*. We illustrate and explore that world through different lenses, ranging from that of the household to the expansive empire, looking holistically at the roles of women and men, soldiers and citizens, and farmers and rulers. We explore the history, economy, politics, religion, and art, as well as the contemporary legacy left by the customs and achievements of the Aztecs. Our collective aim is to draw connections between the different aspects of Aztec life, culture, and history in an effort to present this important late pre-Columbian society in its geographic and social context. The world of the Aztecs was shaped both by the Mesoamerican traditions and history that preceded it, and the larger physical environment and political setting of Aztec life.

Over the past few decades, visually spectacular exhibitions have featured the Aztecs with a focus on the aesthetic achievements of this empire. These rich displays have appeared in capitals across the globe. None of these prior exhibitions has come to Chicago, even though many of the city's denizens have Mexican roots. At The Field Museum, despite the early efforts by Holmes and others to study the Mexican past, a major exhibition featuring significant pieces from pre-hispanic Mexico has not been mounted since 1952. For these reasons, it is our great honor and a distinct pleasure to cocurate this exhibition of incredible pieces in concert with an outstanding binational group of scholars: Felipe Solís Olguín, Juan Alberto Román, and Leonardo López

Luján. We are pleased that a significant number of pieces from the Field's own collection are included in this display. All of these pieces came to Chicago during the first six decades of the twentieth century and have only rarely been displayed since. (Figures 1–6)

The central thrust of *The Aztec World* is to provide a context for understanding the people who in their native language, Nahuatl, were known as Aztecs, Mexica, or Tenochcas. The first, and most familiar name, links them to the place (Aztlan) that, according to their myths, the Aztecs left in the twelfth century when they began their long migration south to central Mexico. Guided by their patron deity, Huitzilopochtli, they found their way to the largest expanse of flat-land in Mexico's highlands, the Basin of Mexico. The origin of Mexica is somewhat obscure, but its derivation is thought to have come from a secret name, Mexi, used for Huitzilopochtli, who, according to myth, instructed his people to use this name rather than "Aztecs." Tenochcas stems from Tenochtitlan, "Place of the Prickly Pear," the Aztec capital city where an eagle perched on top of a prickly pear signaled that the Mexica had found their chosen home.

When they arrived in the Basin of Mexico, the Aztecs settled in a region that had long been densely populated and that had been the home of earlier cities, including the great metropolis of Teotihuacan. By the fourteenth century, the Basin had become politically fragmented with numerous competing small polities and a multiplicity of ethnic groups that were interconnected through trade, diplomacy, warfare, and intermarriages between ruling families. In this regard, it is not surprising that the Aztecs both owed much to the traditions and accomplishments of their Mesoamerican predecessors and that their pathway to empire was far from easy or direct. The competitive political milieu that they encountered was a factor that influenced the selection of the marshy lakeside setting that eventually became the great capital, Tenochtitlan, and fostered some of the specific proclivities and strategies adopted by the Aztec rulers and their followers during the empire's eventual rise to political dominance.

In this exhibition, we explicitly emphasize elements of context, such as those outlined above, in order to move beyond persistent and one-dimensional stereotypes of the Aztec world and explore its diverse peoples. Like all known historical empires, the military conquest of neighboring peoples was part of the Aztec rise to power. Like all Mesoamerican peoples, sacrifice was a central element of Aztec cosmology and belief, a key compact between the supernatural and the world in which humans lived. As curators, we neither ignore nor whitewash these key aspects of Aztec life and culture, nor do we wish to exploit or overemphasize them. Rather, we probe these facets of the Aztec world in a broader historical and cultural context that emphasizes and brings to light the incredible achievements and aesthetic accomplishments of these Mesoamerican peoples, and the heritage that they left for those who followed.

REFERENCE

Holmes, William H., 1895. *Archaeological Studies among the Ancient Cities of Mexico.* Field Columbian Museum, Anthropological Series 1. Chicago.

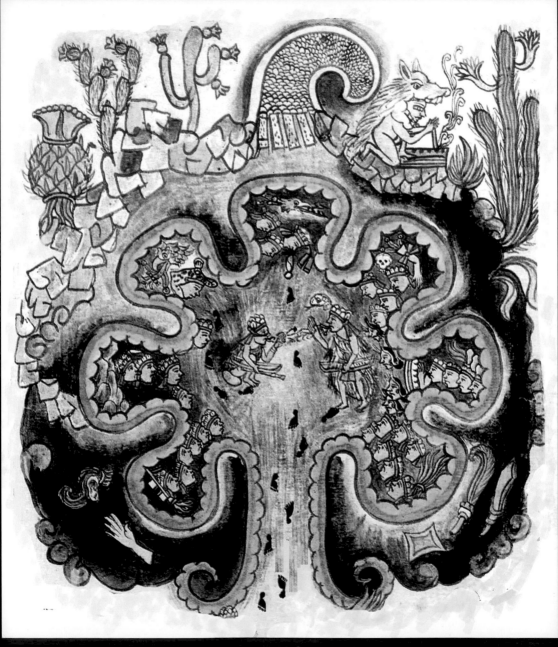

Figure 1. Chicomoztoc, the Seven Caves, as seen in the *Historia Tolteca-Chichimeca.*

ONE
MEXICA POLITICAL HISTORY

FREDERIC HICKS,
UNIVERSITY OF LOUISVILLE

The Mexica were one of the Nahuatl-speaking peoples of central Mexico who were generally known as "Aztecs," after their mythical homeland of Aztlan, but by the time the Spanish arrived in the early sixteenth century they had become the dominant people of the area (see Smith 1996 for a detailed account). Their capital city was Tenochtitlan, now Mexico City, which at that time was an island in Lake Texcoco. From there they controlled an empire that included most of what is now central, eastern, and southern Mexico. How did they manage, in less than a century, to grow from a small, dependent city-state to the capital of one of the largest empires native America had ever seen?

A lot can be learned from native historical accounts. The Aztecs, like most Mesoamerican peoples, were very conscious of history, and concerned that it be preserved. In pre-Spanish times these histories were recorded in picture-writing, but they were also recited in chants and songs and acted out in ritual performances (Calnek 1978). When the Spanish conquered the region in 1519–21, they introduced the European alphabetic system, which was adapted for writing the native languages as well as Spanish, and a number of literate people recorded their histories in prose form, in either Spanish or Nahuatl. Some Spaniards also wrote histories of the Aztec. Many of these histories are centered on Tenochtitlan and present the perspective of the dominant empire (e.g., Alvarado Tezozomoc 1975), but some are centered on other cities, so we can see the empire's rise from a broader perspective (e.g., Alva Ixtlilxóchitl 1975–77; Schroeder 1991).

When they deal with the earliest periods, these histories have a strong mythological element, but as they get closer to the sixteenth century—the time when the surviving documents were written down—they become more realistic. As with the histories of many peoples, the account of the early, semi-mythical period serves primarily to provide a unifying ideology and to justify their way of life and place in history. Aztec histories have one noteworthy feature: While the historical accounts of most Mesoamerican peoples stress that they have always lived in their present homeland, those of the Aztec always claim that they came from somewhere else. They undertook

5

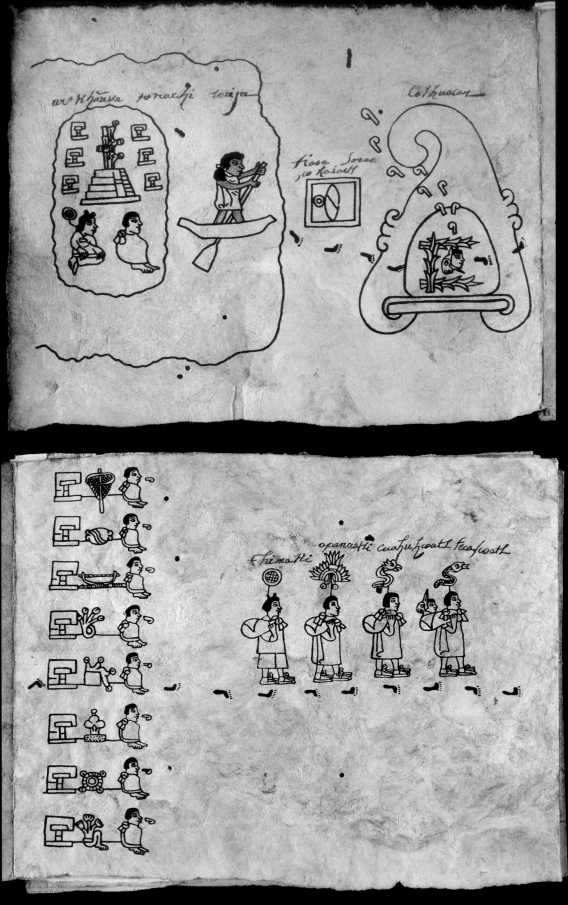

Figure 2. The Aztecs leave Aztlan, encounter Huitzilopochtli in Teoculhuacan, and proceed on their peregrination. The lead man carries Huitzilopochtli on his back. These pages come from *Codex Boturini*

a migration, often guided by their god, and underwent many trials and tribulations, until finally they arrived at their present location (Boone 2000).

MIGRATION PERIOD

In most historical accounts, the starting point of the Mexica migration was either Aztlan, a mythical place represented as an island in a lake, or Chicomoztoc, literally "seven caves," said to have been near Aztlan (Figure 1). The Mexica were one of seven or eight different groups who, after long migrations, settled in Central Mexico. From Aztlan these groups, represented by their leaders, paddled in a canoe from the island to the shore (Figure 2), or in other versions the groups or their leaders left from the seven caves. All were Nahuatl-speaking people who became prominent in later Aztec history: Xochimilca, Tepaneca, Acolhua, Tlalhuica, Tlaxcalteca, and the Matlatzinca.

Some sources refer to these groups as "Chichimecs." This name was applied to tribes or bands who were nomadic or migrating, without access to agriculture or the arts of civilization, and suffering hardships. In pictorial documents they are shown dressed in skins, like a primitive ethnic group (Figure 3). This description cannot be taken literally, however. The Valley of Mexico has been well explored archaeologically, and it is clear that only agricultural people lived in the area for many millennia, so this description may represent the hardships of the people during their migrations.

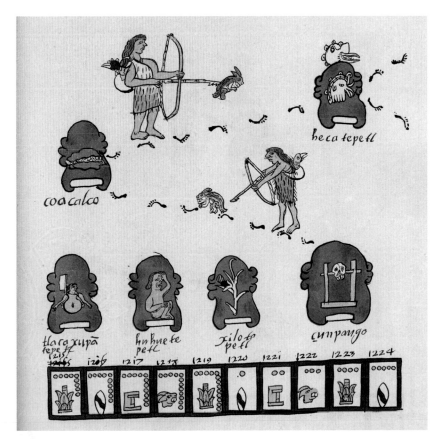

Figure 3.
Chichimec hunters
from *Codex
Tellerian-Remensis*.

Although these migration stories include many fantastic and magical adventures, major movements of people may actually have occurred. The Aztec language was Nahuatl, a language of the Uto-Aztecan family. Other languages of this family were spoken by the natives of northern Mexico and the western United States—peoples such as the Tarahumara, Pima, Ute, Hopi, and Shoshone. Linguistic evidence indicates that they were indeed relatively recent arrivals in central Mexico. Other peoples of Mexico spoke different, unrelated languages such as Tarascan (Purépecha), Mixtec, Zapotec, and Maya. Furthermore, there is archaeological evidence that complex farming cultures once extended well to the north, in the states of Zacatecas and Durango, but vanished around the thirteenth century. It is possible that these were the ancestors of the Nahuatl-speakers, and that climatic deterioration led them to withdraw southward seeking better lands. In the process, they would have had to abandon some of the frills of complex civilization, so might be represented in the pictorial documents in a way that we might interpret as "primitive."

The Mexica were the last to leave Aztlan/Chicomoztoc and among the last to arrive in the Valley of Mexico (Smith 1984). The Mexica migration included many trials and tribulations. Sometimes the Mexica were joined by other groups, and sometimes one or another of the "tribes" broke away to continue their migration separately, but always they were urged on by their god Huitzilopochtli ("Hummingbird of the Left"), borne on the back of a *teomama*, or "god carrier." Sometimes the Mexica stopped and wanted to remain, but Huitzilopochtli urged them on. Eventually they reached Coatepec, "Hill of the Snake," where they stayed for twenty-eight years. In some versions, this is where the god Huizilopochtli had been born during an epic battle with his half-sister Coyolxauhqui and the four hundred Huitznahuas (Gillespie 1989).

Eventually, the Mexica moved on. They settled again at Tula, where they dammed a river to create a lake, and an island in the lake. Many wanted to stay, for the land was fertile and productive, but the god Huitzilopochtli said they had to dismantle the dam and move on. They would know they had reached their destined place, he told them, when they saw an eagle, holding a snake, perched on a nopal cactus growing out of a rock. But, he added, they would have to take the place in war, so the world would know their valor.

Arriving in central Mexico, the migrating groups, such as the Mexica, encountered scattered Toltec settlements. The Toltecs had inhabited Tula (Tollan), a major city in central Mexico that flourished in the tenth to the twelfth centuries. Tula was regarded by later peoples as a font of civilization. Its impressive ruins, on a hill overlooking the present city of Tula, Hidalgo, just north of the Valley of Mexico, have been extensively excavated and studied (Healan 1989), (Figure 4). It was essentially abandoned by 1150, and for several centuries thereafter, no city in the Valley of Mexico exercised power over the entire region. This power vacuum is probably what made it possible for different migrating groups, each under its leader, to establish separate city-states that dominated different regions. Although Tula lay abandoned, Toltec ancestry was regarded as true nobility, and if a local warlord could establish a connection through marriage with a noble Toltec lineage, the nobility of his own offspring would be unquestioned, and they could interact as equals with any established ruling family. In the southern Valley of Mexico, the ruling lineage of Culhuacan was generally acknowledged to have been of noble Toltec descent.

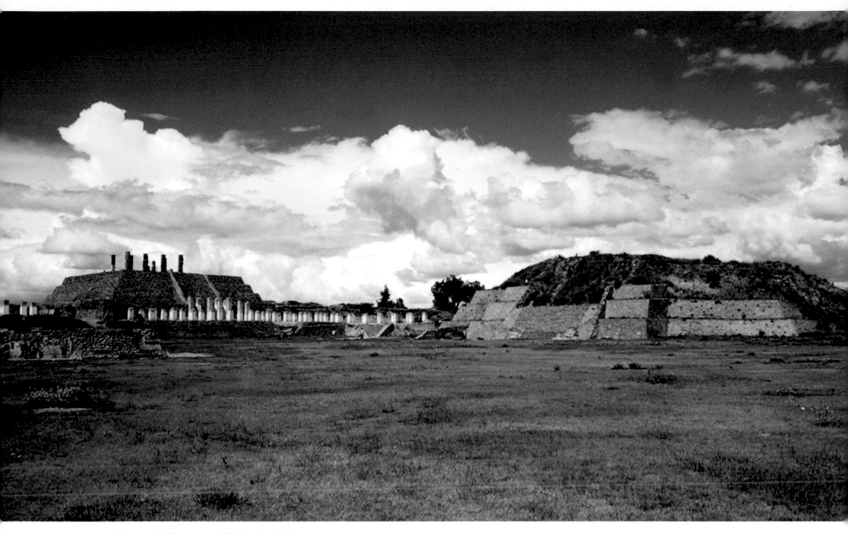

Figure 4. The ruins of Tula, the Toltec center.

THE DEVELOPMENT OF LOCAL CITY-STATES

After Tula, the basic political unit in Aztec Mexico was a local state (*altepetl*), a "city-state." This was made up of the ruling center and its outlying towns or villages. The ruling center was focused on the palace of the king, or *tlahtoani*, and contained the various institutions through which the state was governed. These included meeting halls where the important people could gather; temples set atop high pyramids, around which ceremonies for the many gods were held; the palaces of other important nobles; an armory; priestly residences; one or more youths' houses, where boys were trained in war and ritual; perhaps workshops for artisans who fashioned luxury goods; and possibly a market and a ball court. This center, however, should not be imagined as a tightly nucleated, compact city. In most cases, houses, including noble palaces, were scattered throughout the local territory. It is doubtful that the Aztecs recognized a difference between "urban" and "rural" settlements (Hicks 1982; Hirth 2003; Hodge 1984).

The king ruled with the aid of a nobility. Below the city-state, the basic unit was the noble house or lineage (Carrasco 1976). The head of such a house was a noble with the rank of *teuctli*, or lord (Figure 5). Each house included the lord's kin, either his sons or daughters, his siblings, or descendants of earlier lords of the house. Sometimes these junior nobles headed houses of their own, dependent on the lord's house. The king was also the head of a noble house, in this case the royal house. New houses were created when a king gave a portion of his domain to a son or other heir to govern, or divided his domain among several heirs, or gave a portion to an incoming warlord with a large following. There were many noble houses headed by teuctlis within each

Figure 5. Eight high lords of Tenochtitlan, from *Codex Mendoza*.

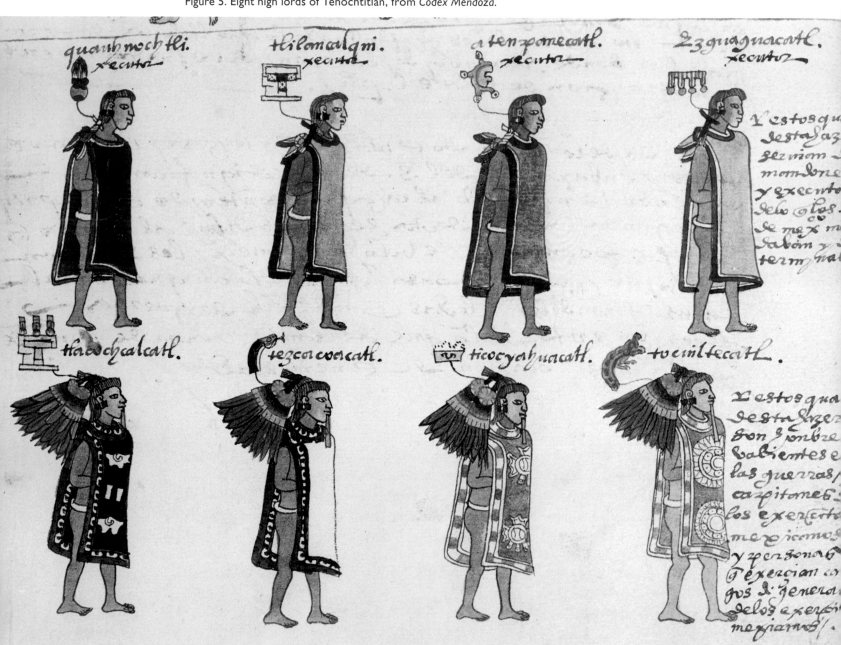

altepetl and subject to its tlahtoani. This can probably best be understood as a way to delegate authority, so that a ruler did not have to micromanage everything in his realm, and to minimize dissent, keeping potential rivals satisfied.

A noble house possessed land, which was worked by commoners (*macehualli*) who lived on the land. Land was the fundamental resource in Aztec Mexico. It was valued partly for what could be grown on it, but more importantly, for the manpower it would support. This manpower, the *macehuallis*, served the nobles of the house by providing food from the land they worked, cloth that they wove, and domestic services. Commoner men were expected to serve as soldiers in time of war. The more manpower a noble could command, the more wealth and power he had. The noble houses and all their resources were also at the service of the king, so in addition to the junior nobles and macehuallis of his own house, the king could call on those of his dependent nobles. The desire for more land and macehuallis was a motive for expansion, usually through conquest, and such expansion predates the Aztec period.

THE FOUNDING OF TENOCHTITLAN

As one of the last groups to enter the Valley, the Mexica found many of the desirable localities already occupied by others. These included the Acolhua, a group of small city-states in the northeastern Valley of Mexico that were dominated by the king of Texcoco, and the Tepanec, a powerful confederation of city-states in the southern and western part of the Valley, dominated by the king of Azcapotzalco (Figure 6).

The Mexica reached Chapultepec, on the shore of Lake Texcoco, and here their story begins to take on a less mythical and more historical quality. Chapultepec was in the territory dominated by the Tepanec, but the Mexica settled there without recognizing Tepanec authority. They lived at Chapultepec for some time, but eventually their neighbors attacked them and drove them from their homes. Their god Huitzilopochtli then led them to Culhuacan, whose king allowed them to settle in the region called Tizaapan, in the marshes. Here they planted fields, caught and ate snakes and lizards, served the Culhua king as mercenaries, and built a temple.

The ruling dynasty of Culhuacan was of Toltec origin, thus the legitimacy of its nobility was unquestioned. The Mexica leaders proposed to the king of Culhuacan that they become kin, and asked for his daughter to come and rule them as their queen and wife of their god Huitzilopochtli. This would give the Mexica a link to the Toltec nobility of Culhuacan. The king agreed, and the future looked bright, but according to one story the god Huitzilopochtli had other plans. The young princess was to be a "woman of discord." She was brought to Tizaapan with much honor, but then she was sacrificed to Huitzilopochtli, flayed, and her skin worn by one of the priests of the temple. The king of Culhuacan, her father, was invited to visit his daughter, but when he saw a priest dressed in his beloved daughter's skin, he was furious. He ordered the Mexica to be destroyed. They were driven into the swamps of Lake Texcoco, but here, finally, they saw the eagle, on a nopal growing out of a rock, with a snake in its mouth, just as Huitzilopochtli had

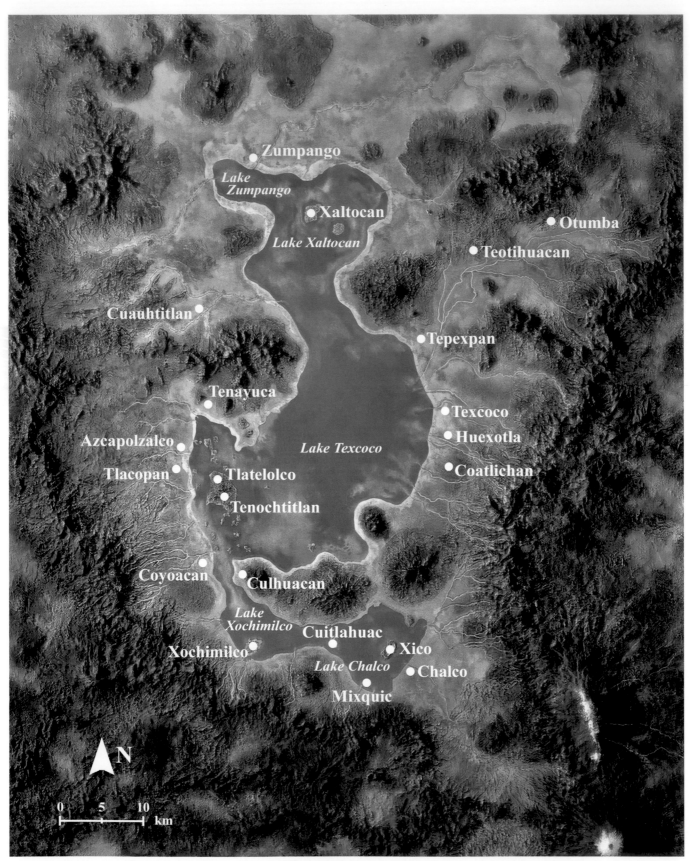

Figure 6. The Valley of Mexico, showing the lakes and the principal Aztec centers.

foretold, and it was on an island in a lake, just like the ancestral Aztlan. Here, as they fought off the Culhuas, they founded the city of Tenochtitlan (Figure 7).

The area proved to be very fertile, but it was again within the territory of the Tepanec ruler. This time, the Mexica became his subjects. They traded lake products to the surrounding communities and built *chinampas,* very productive tracts of land reclaimed from the lake, their fertility regularly replenished with mud dredged from the canals that separated the chinampas from each other. The Mexica paid tribute to Azcapotzalco and gave military service. From the mid-fourteenth century to 1428, the Mexica fought for the Tepanec ruler and helped build his empire. As a reward for their service, they were assigned tribute-payers of their own.

In 1375, the Mexica sought their own tlahtoani, or king, to provide leadership and legitimacy. Again they looked toward Culhuacan, because of the prestige of its royal Toltec dynasty, and despite the earlier unpleasantness, a king of Culhuacan gave his daughter in marriage to a high-ranking Mexica, and their son, Acamapichtli, became the first Mexica king. He ruled Tenochtitlan for nineteen years and was succeeded by his son Huitzilihuitl, whose mother was also a princess of Culhuacan. Meanwhile, a group of Mexica separated and established its own center, Tlatelolco, adjacent to Tenochtitlan. Tlatelolco soon became the site of the largest Aztec market. The people of Tlatelolco also sought a king, and the Tepanec ruler Tezozomoc gave them one of his sons.

Under its renowned ruler Tezozomoc, installed in office in 1371, Azcapotzalco conquered many neighboring city-states in the Valley of Mexico, with Tenochtitlan and Tlatelolco as its loyal allies. King Huitzilihuitl of Tenochtitlan married a daughter of Tezozomoc, and their son Chimalpopoca became the third Mexica king in 1396. This gave Tenochtitlan a special place among

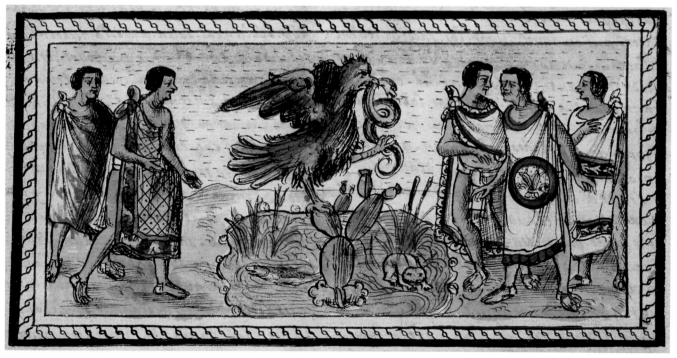

Figure 7. The Aztecs arrive at the site of Tenochtitlan, from *Codex Durán*.

Tezozomoc's vassals. Fighting in the service of Azcapotzalco, the Mexica gained fame for their military prowess. By the time of Tezozomoc's death in 1427, Azcapotzalco had subjected sixteen city-states, distributed throughout the Valley of Mexico, Morelos, and Puebla (Carrasco 1984). The most important of these was Texcoco. Tezozomoc's armies sacked Texcoco and killed its ruler, but the ruler's son and designated heir, fourteen-year-old Nezahualcoyotl, escaped. The Tepanec were aided in this victory by the Mexica, but the king of Texcoco had married a half-sister of King Chimalpopoca of Tenochtitlan, so Nezahualcoyotl was a nephew of Tenochtitlan's ruler.

Tezozomoc did not directly administer each of these colonies. Rather, he installed his sons as rulers in many of them, but he gave Texcoco and its realm to Tenochtitlan, as a reward for its military assistance. Most of these subject city-states gave the Tepanec ruler a tribute in labor and goods, but some, including Tenochtitlan and Tlatelolco, gave only military service, which was not quite the same thing. War was an honorable activity, the ideal profession of all men, both nobles and commoners, including those of the dominant polity. It provided an opportunity to acquire loot and was a path to upward mobility.

King Tezozomoc of Azcapotzalco died in 1426. His chosen successor was his son Tayauh, but another son, Maxtla, usurped the throne. Chimalpopoca, the Mexica king, supported Tayauh, but for this he was assassinated (Figure 8), and Maxtla raised the tribute demanded of Tenochtitlan.

After the assassination of Chimalpopoca, the Mexica named his brother Itzcoatl as their new king. Nezahualcoyotl, the deposed heir of Texcoco, was living in Tenochtitlan with his uncle

Figure 8. King Chimalpopoca ("smoking shield"), shown wrapped for burial, was killed in the year 12 Rabbit (1426) by Maxtla, assisted by a warrior from Tlatelolco. Itzcoatl ("obsidian snake") succeeds him as king. This page comes from *Codex Tellerian-Remensis*.

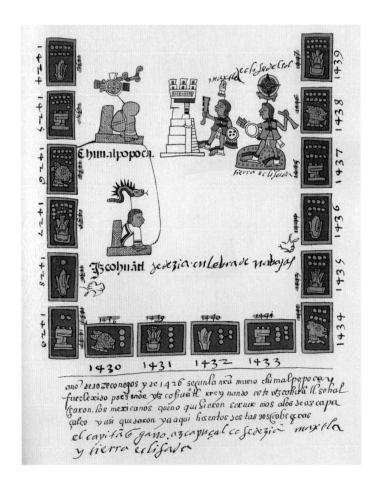

Itzcoatl. Itzcoatl, with his advisor Tlacaelel and his military commander Moteuczoma, planned a rebellion against the Tepanec. Not all of the Mexica supported him in this; many were fearful of the revenge that the Tepanec would extract if the rebellion failed. But the story goes that Itzcoatl made a deal with the dissident faction: We'll go to war, and if we win, you will be our servants, and if we lose, we will be yours. Itzcoatl won the support of the dissident Tepanec town of Tlacopan (Tacuba) and the kingdom of Huexotzinco in the Valley of Puebla, and with this, plus whatever forces of Texcoco that Nezahualcoyotl could mobilize, the three allied kings (Itzcoatl of Tenochtitlan, Nezahualcoyotl of Texcoco, and Totoquihuatzin of Tlacopan) defeated Maxtla, the Tepanec king. The kingship of Azcapotzalco was abolished, and a new Tepanec dynasty was established in Tacuba. The young prince Nezahualcoyotl was officially installed as king of Texcoco.

THE EMPIRE OF THE TRIPLE ALLIANCE

The three supreme rulers agreed on a division between them of the territory that had been conquered by Azcapotzalco, and set out to bring it under their control. It took a mixture of diplomacy and force to consolidate this territory. Over the initial objection of Itzcoatl, Nezahualcoyotl restored the fourteen dependent city-states of Texcoco to their previous rulers, or to their sons if the old rulers had died during the Tepanec period. They were members of Nezahualcoyotl's own royal lineage and for that reason alone had to be treated with honor. Their exclusion would have weakened the cohesion and legitimacy of the royal lineage, and they would be a source of trouble. In some cases the heirs had to be convinced that they would not be punished if they returned from exile, or had cooperated with the Tepanec. With Tlacopan, Tepanec rule was transferred from one lordly Tepanec lineage to another, but significantly, Tepanec royalty was not abolished. Like their Acolhua counterparts, they were made full allies, so had no reason to revolt. This was in contrast to the practice of the Tepanec king Maxtla, who killed or banished the kings he conquered, which led to the massive revolt that contributed to his defeat.

The three allied kings now began a series of conquests that resulted in the Aztec Empire, often called the Empire of the Triple Alliance, or sometimes the Tenochca Empire (Carrasco 1999). From the start, the king of Tenochtitlan was dominant. The young king Nezahualcoyotl of Texcoco was in effect his pupil, and the king of Tlacopan owed his position to the king of Tenochtitlan. While Nezahualcoyotl was consolidating his realm, the Tenochca king, Itzcoatl, set out to conquer, or reconquer, the towns in his part of the Valley. The first was Coyoacan, a Tepanec city to which Maxtla had retreated after the fall of Azcapotzalco. With this conquest, the Triple Alliance established the practice of leaving the defeated king in power, but taking lands in the conquered territory and assigning them to high dignitaries in Tenochtitlan and allied towns. The largest and best units of land went to the tlahtoani and the highest Tenochca officials, but lower-ranking nobles, if they performed well, could expect to receive some. These lands were worked by commoners of the defeated states, who produced food and supplied manpower for imperial rulers or their subordinate nobles. This pattern was repeated with the conquests of Xochimilco and Cuitlahuac, and in the long war against Chalco, in the southeastern Valley of Mexico.

Thus the high nobles gained many lands and subjects, but they were not all within the boundaries of their home states. We know that some nobles of the royal house of Tepetlaoztoc, in Acolhuacan north of Texcoco, had lands in Chalco thirty miles to the south (Figure 9), and the domains of Tepechpan and Acolman, two city-states in the Teotihuacan Valley, were much intermixed. This was a common pattern, and the result was that it was not always possible to draw clear boundaries between one state and another. Another result, as Brumfiel (1983) has noted, was that it was difficult for a dissident dependent ruler to mobilize his macehuallis as a rebellious fighting force, since they would be so widely scattered. Indeed, it was the imperial domination of the whole area that gave these nobles access to their widely scattered lands and subjects.

Itzcoatl died in 1440 and was succeeded by Moteuczoma Ilhuicamina, the first Moteuczoma, grandfather of the ruler by the same name that Cortés defeated. Under Moteuczoma I, the Triple Alliance began making conquests beyond the Valley of Mexico. It was impractical to levy a tribute in food and domestic service from such distant areas. Transport was on the backs of men, who had to eat while traveling, and a journey of many days would require them to consume too much food tribute. Instead, the tribute demanded from more distant provinces consisted of light-weight luxury goods, both local raw materials and manufactured goods (Figure 10). In addition,

Figure 9. Four nobles of the royal house of Tepetlaoztoc, their lands, their macehuallis, and their tribute. Each lord has from three to seven named places, with from five to twenty macehuallis working each place. This page comes from *Codex Tepetlaoztoc*.

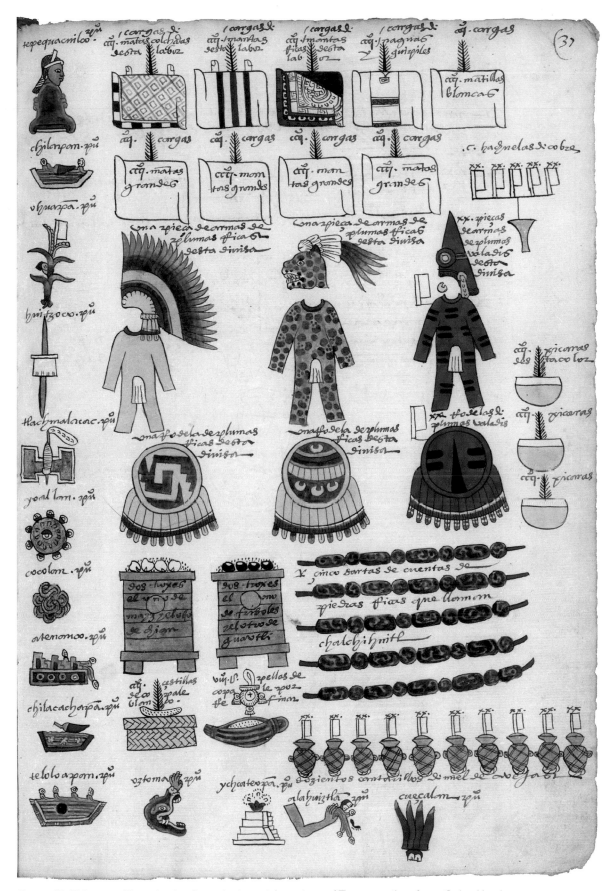

Figure 10. Tribute to Tenochtitlan from the imperial province of Tepecuacuilco, from *Codex Mendoza*.

conquered states were required to provide military assistance when needed, to furnish draft labor for occasional special projects, and to attend periodic rituals in the imperial capitals. The luxury goods paid as tribute or the raw materials from which such goods could be made by artisans in the imperial capitals served a political function. They were used for display, to add awe-inspiring splendor to the imperial capitals and their ruling officials, to reward loyal service to the state, and as gifts, including gifts to defeated or subject dignitaries, who were thus morally indebted to the imperial sovereign.

Marital alliances were a common way for the kings of two states to form a close relationship. One king might offer a daughter in marriage to a subordinate king, with the stipulation that the son of this marriage would rule in the subordinate's place. Polygyny was common among high-ranking nobles, which ensured that a king usually had a supply of daughters to give in marriage. In general, the formation of marital or other kin relations between the nobility of two states created a bond between those states and made it harder to refuse when one asked the other for military assistance.

Periodic festivities brought elites from many parts of the empire together. They involved feasting, dramatic performances, lavish displays of wealth, and gift-giving. These festivities, sometimes termed "consumption rituals," were an important part of the political system. They provided a way for the ruling elites, in conquered areas as well as the imperial heartland, to become acquainted, and to give the higher nobility of all parts of the empire a sense of common interest and unity. On some occasions, even enemy kings were invited. As the royal advisor Tlacaelel said, "Even though we are enemies in the wars that we wage, in our festivities we should rejoice together" (Durán 1967, II: 336–37).

The empire expanded into southern and eastern Mexico, gaining access to the resources of many different ecological zones (Figure 11). When the Mexica undertook a war of conquest, they preferred a negotiated settlement to unconditional surrender. As the war proceeded, the Mexica stated their demands, and as defeat seemed inevitable, the target state made a counter-offer, and the war came to a close. The defeated ruler was left in office unless he was stubbornly uncooperative. An uncooperative ruler was replaced by a different and more cooperative noble of the same royal house, or sometimes by a Mexica governor. Lands were set aside for the support of the commoners who would produce the tribute to the empire, and a Mexica tribute-collector (*calpixqui*) would be sent to see that it was collected and sent back to Tenochtitlan. The defeated ruler would remain in power and in control of his people and would retain most of his lands and macehuallis, and thus also his military capacity. So long as he did this, he was treated as an ally and invited to participate in the lavish festivals of the imperial capital. There were occasional rebellions, however, and they were punished brutally.

In summary, the Mexica and their allies developed a political and imperial system that appears to have been more successful than its immediate predecessor. All empires are ephemeral, and we will never know how long the Aztec Empire would have lasted if the Spanish had not arrived in 1519. But several processes seem noteworthy.

Cooptation was a common process. Local nobles were given a stake in the system, They could receive grants of land and macehuallis in conquered regions, but depended on the empire for access to them. To the extent possible, defeated enemy kings were not stripped completely of power, but were welcomed as allies, left in office, retained their lands and subjects, participated

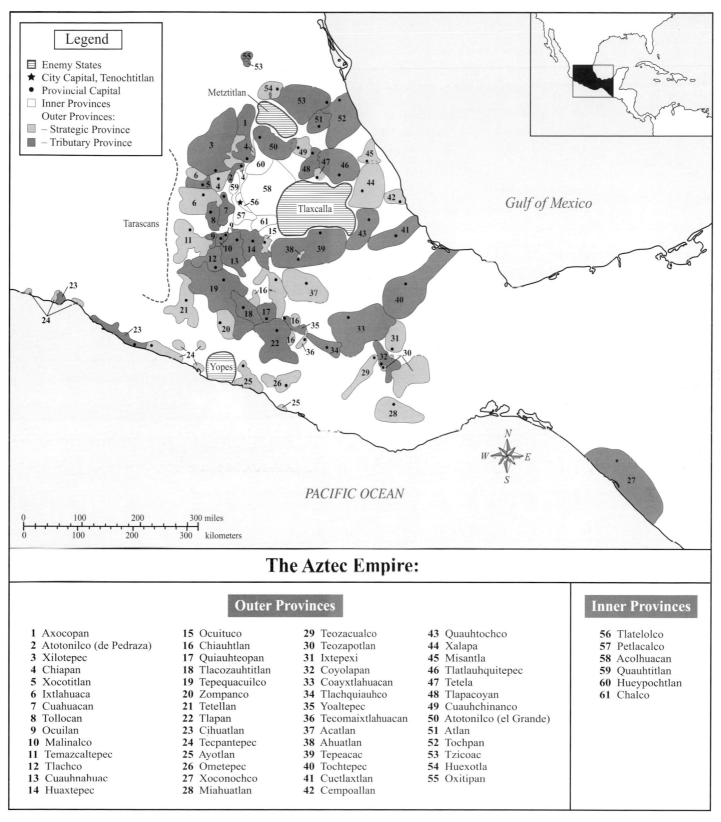

Legend

- ⊞ Enemy States
- ★ City Capital, Tenochtitlan
- • Provincial Capital
- ▢ Inner Provinces
- Outer Provinces:
- ▢ – Strategic Province
- ▓ – Tributary Province

Metztitlan

Tlaxcalla

Tarascans

Yopes

Gulf of Mexico

PACIFIC OCEAN

N
W E
S

| 0 | 100 | 200 | 300 miles |
| 0 | 100 | 200 | 300 kilometers |

The Aztec Empire:

Outer Provinces

1 Axocopan	15 Ocuituco	29 Teozacualco	43 Quauhtochco
2 Atotonilco (de Pedraza)	16 Chiauhtlan	30 Teozapotlan	44 Xalapa
3 Xilotepec	17 Quiauhteopan	31 Ixtepexi	45 Misantla
4 Chiapan	18 Tlacozauhtitlan	32 Coyolapan	46 Tlatlauhquitepec
5 Xocotitlan	19 Tepequacuilco	33 Coayxtlahuacan	47 Tetela
6 Ixtlahuaca	20 Zompanco	34 Tlachquiauhco	48 Tlapacoyan
7 Cuahuacan	21 Tetellan	35 Yoaltepec	49 Cuauhchinanco
8 Tollocan	22 Tlapan	36 Tecomaixtlahuacan	50 Atotonilco (el Grande)
9 Ocuilan	23 Cihuatlan	37 Acatlan	51 Atlan
10 Malinalco	24 Tecpantepec	38 Ahuatlan	52 Tochpan
11 Temazcaltepec	25 Ayotlan	39 Tepeacac	53 Tzicoac
12 Tlachco	26 Ometepec	40 Tochtepec	54 Huexotla
13 Cuauhnahuac	27 Xoconochco	41 Cuctlaxtlan	55 Oxitipan
14 Huaxtepec	28 Miahuatlan	42 Cempoallan	

Inner Provinces

- 56 Tlatelolco
- 57 Petlacalco
- 58 Acolhuacan
- 59 Quauhtitlan
- 60 Hueypochtlan
- 61 Chalco

Figure II. The extent of the Aztec Empire.

with the imperial rulers in royal feasts, and were sent back home with lavish gifts. Sometimes they were given the opportunity to participate in war alongside the imperial forces, and under those conditions were usually victorious and could enjoy the spoils of war. Thus the empire was governed with the aid of local kings or lords who knew the region and its people. Meritorious service was rewarded. Always the highest rewards went to the highest-ranking nobles, who got lands and subjects, but war could be a channel of upward mobility for commoners as well, who could be ennobled as a reward for their feats.

The empire also generated resistance. Tribute was sometimes excessive, and the imperial calpixqui, sent to the area to supervise tribute collection and incidentally to keep tabs on local affairs, could be offensively arrogant. The ambitions of dependent rulers sometimes exceeded what the imperial rulers permitted, so rebellions were not uncommon, and some states had to be conquered more than once. Such cases could result in mass banishment and slaughter. We do not have good data on how all this was viewed by the ordinary peasant who worked the fields and responded to calls to draft labor and war. But when the Spanish, who landed in Veracruz in 1519, gave people reason to believe that they might be able to defeat the Aztec Empire, they gained a great many followers among local rulers and their people. The final conquest of Tenochtitlan, in 1521, was the work of some five hundred Spaniards plus tens of thousands of Indians, former subjects of the Aztec Empire.

REFERENCES

Alva Ixtlilxóchitl, Fernando. 1975–77. *Obras Históricas*. Ed. Edmundo O´Gorman. 2 vols. México: Universidad Nacional Autónoma de México, Instituto de Investigaciones Históricas.

Alvarado Tezozomoc, Francisco. 1975. *Crónica mexicana*. México: Editorial Porrúa S.A.

Boone, Elizabeth Hill. 2000. *Stories in Red and Black: Pictorial Histories of the Aztecs and Mixtecs*. Austin: University of Texas Press.

Brumfiel, Elizabeth M. 1983. Aztec State Making: Ecology, Structure, and the Origin of the State. *American Anthropologist* 85: 261–84.

Calnek, Edward E. 1978. The Analysis of Central Mexican Historical Texts. *Estudios de Cultura Náhuatl* 13: 239–66.

Carrasco, Pedro. 1976. Los linajes nobles del México antiguo, in *Estratificación social en la Mesoamérica prehispánica*. Ed. Pedro Carrasco and Johanna Broda, pp. 19–36. México: SEP-INAH.

———. 1984. The Extent of the Tepanec Empire. In *The Native Sources and the History of the Valley of Mexico*. Ed. J. de Durand-Forest, pp. 73–92. Oxford: Proceedings of the 44th International Congress of Americanists, BAR International Series 204.

———. 1999. *The Tenochca Empire of Ancient Mexico*. Norman: University of Oklahoma Press.

Durán, Fr. Diego. 1967. *Historia de las Indias de Nueva España e Islas de la Tierra Firme*. 2 vols. México: Editorial Porrúa.

Gillespie, Susan D. 1989. *The Aztec Kings: The Construction of Rulership in Mexica History*. Tucson: University of Arizona Press.

Healan, Dan M., ed. 1989. *Tula of the Toltecs: Excavations and Survey*. Iowa City: University of Iowa Press.

Hicks, Frederic. 1982. Texcoco in the Early Sixteenth Century: The State, the City, and the Calpolli. *American Ethnologist* 9: 230–249.

———. 1986. Prehispanic Background of Colonial Political and Economic Organization on Central Mexico. In *Supplement to the Handbook of Middle American Indians*. Victoria Bricker, gen. ed., vol. 4, *Ethnohistory* (Ronald Spores, vol. ed.), pp. 35–54. Austin: University of Texas Press.

————. 1996. Class and State in Aztec Official Ideology, in *Ideology and the Formation of Early States*. Ed. Henri J. M. Claessen and Jarich G. Oosten, pp. 256–77. Leiden: E. J. Brill.

Hirth, Kenneth G. 2003. The Altepetl and Urban Structure in Prehispanic Mesoamerica/El Altepetl y la estructura urbana en la Meoamérica prehispánica, in *El urbanismo en Mesoamérica/Urbanism in Mesoamerica* (William T. Sanders, Alba Guadalupe Mastache and Robert H. Cobean, eds.), pp. 58–84. Mexico and University Park: Instituto Nacional de Antropología e Historia and Pennsylvania State University.

Hodge, Mary G. 1984. *Aztec City-States*. Ann Arbor: Memoirs of the Museum of Anthropology, University of Michigan, No. 18.

Schroeder, Susan. 1991. *Chimalpahin and the Kingdoms of Chalco*. Tucson: University of Arizona Press.

Smith, Michael E. 1984. The Aztlan Migrations of the Nahuatl Chronicles: Myth or History. *Ethnohistory* 31: 153–86.

————. 1986. The Role of Social Stratification in the Aztec Empire: A View from the Provinces. *American Anthropologist* 88: 70–91.

————. 1996. *The Aztecs*. Oxford and Cambridge: Blackwell.

Figure 1. The Valley of Mexico, showing lakes and principal Aztec centers.

TWO
ENVIRONMENT AND RURAL ECONOMY

JEFFREY R. PARSONS,
THE UNIVERSITY OF MICHIGAN

The Aztec heartland was the Valley of Mexico, or *Anahuac* as it was known to the Aztecs themselves. In Aztec times Anahuac was the breadbasket that fed well over a million people with cultivated crops and harvested "wild" wetland foods and that also provided many other essential raw materials—such as clay for making pottery; obsidian for making stone tools; wood for tools, furniture, poles and beams; salt for seasoning and preserving foods; reeds for making mats, baskets, and seats; and fiber for cloth and cords. Anahuac's diverse environment included snow-capped mountains, rugged hill ranges, fertile piedmonts, broad plains, marshes, and lakes—all of which played important and complementary roles in the rural economy. This economy was so productive that the population of Anahuac at the time of initial European contact in 1519 (ca. 1.2 million) was not exceeded until after the late nineteenth century. Many of the sixteenth-century techniques are so productive that they continued to be used during the Colonial period and into the twentieth century.

Our understanding of Aztec rural lifeways comes from three different kinds of sources: the ancient material remains studied by archaeologists through excavations and regional surface surveys; the written documents compiled by soldiers, priests, administrators, and travelers from the sixteenth through the nineteenth centuries; and modern ethnographic studies of the Aztecs' living descendants who have maintained some of their traditional lifeways, deeply rooted in the pre-Columbian past. Because we know a great deal about Aztec agriculture and their exploitation of wetland resources, I will emphasize these components of the rural economy, leaving aside several other important activities about which we know much less: the manufacture of domestic pottery; the quarrying of obsidian, lime, and basalt; and the harvesting of timber.

THE GEOGRAPHIC SETTING

The Valley of Mexico forms a great natural saucer approximately 7,500 square kilometers (2,850 square miles) in area and rimmed on all sides by higher ground that surrounds a central depression (Figure 1). It is one of several internal-drainage basins within the broad volcanic belt that extends across the width of central Mexico, where intensive volcanism during Pleistocene times produced a series of large valleys and enclosed basins, each defined by bordering mountains and hill ranges. For the Valley of Mexico the bordering peaks attain elevations up to 4,000 to 5,000 meters above sea level (13,200–16,500 feet), while the lowest points in the central depression are about 2,235 meters (7,400 feet).

Because the Valley of Mexico lacked natural external drainage, the lowest elevations were formerly covered by an interconnected series of shallow lakes and marshes over an area of about 1,000 square kilometers (400 square miles). Lake Texcoco, at the bottom of the drainage gradient, was saline, while the other lakes ranged from fresh (Lakes Chalco and Xochimilco) to brackish (Lakes Xaltocan and Zumpango). Artificial drainage begun in the early seventeenth century gradually reduced the size of the wetlands, and today virtually none remains. José Velasco's realistic 1894 painting (Figure 2) evokes something of Anahuac's physical appearance in earlier centuries.

Figure 2. Facing southeast across the central Valley of Mexico in 1894. Mexico City is in the central middle distance, and Lake Texcoco is just beyond.

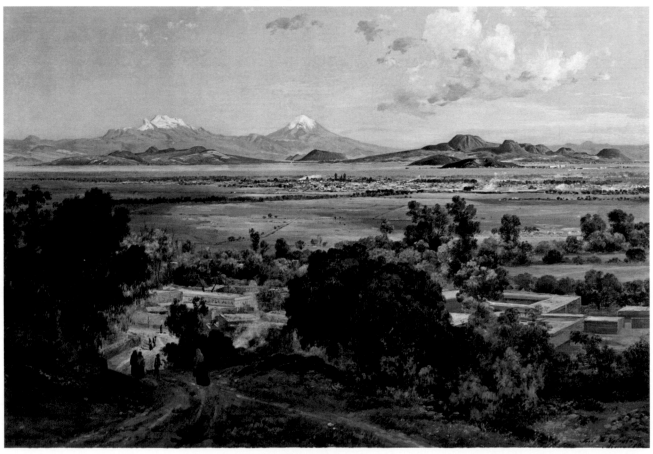

The lakes also served as arteries of transportation and communication—in a setting where overland transport was confined to human carriers, only with boats was it possible to efficiently move bulk commodities over any distance. Such effective transportation and communication meant that people and products could move efficiently between scattered rural producers and nucleated urban consumers.

Moving inland away from the lakeshore one crosses a broad, nearly level lakeshore plain with deep, alluvial soil. Today most of this lakeshore zone is well drained and intensively cultivated or occupied by modern settlements, but in pre-Hispanic times much of it would have been seasonally swampy, and of marginal agricultural utility without the extensive artificial drainage that was undertaken by Aztec engineers in the southern lakes and marshes to create the highly productive *chinampas*, or raised agricultural beds.

Moving farther inland, at approximately 2,270 meters (7,447 feet) elevation, the terrain begins to steepen slightly, and from there up to about 2,500 meters (8,202 feet) one moves across a well-drained lower piedmont traversed by numerous small streams, many of which provided irrigation water for agricultural fields. Above 2,500 meters (8,202 feet) elevation the land surface steepens notably as it ascends through a more thin-soiled upper piedmont up to the base of the thickly forested sierra at about 2,750 meters (9,022 feet). In the sixteenth century much of the upper piedmont and all the sierra would have been forested and home to deer, rabbit, and other animal species. Average annual rainfall for the region as a whole is 600–700 mm (23–27 inches), most of which falls in the rainy season from June to September.

Also notable were exceptionally large outcrops of obsidian, a natural volcanic glass, near Pachuca and Otumba in the northeast. For a society lacking metal tools, these quarries provided raw material for knives, scrapers, blades, and projectile points.

URBAN-RURAL INTERACTION

More than half of the 1.2 million people living in Anahuac during the early sixteenth century inhabited urban centers that ranged in population from a few thousand to more than 150,000 people. Most urban people did not produce their own food or other raw materials—they were administrators, bureaucrats, messengers, laborers, servants, priests, merchants, traders, transients, and many different kinds of skilled artisans. Most foodstuffs and raw materials came from the rural sectors. The rural and urban economies were integrated through periodic markets that redistributed the complementary products of both sectors.

Writing in the mid-sixteenth century just a few decades after the Spanish conquest in 1519, Bernardino de Sahagún described the great quantity and variety of foodstuffs and raw materials produced in Anahuac that were available in the main urban marketplace of the former Aztec capital:

> dried grains of maize, white, black, red; and yellow; yellow beans, white ones, black, red; pinto
> beans; large beans; gray amaranth seed, red amaranth seed, and fish amaranth; white chía, and the
> wrinkled variety; salt; fowl; turkey cocks and hens; quail; rabbits, hares, and deer; ducks and other
> water birds, gulls, and wild geese; maguey syrup and honey; hot chilis, chili from Atzitzuiuacan,

small chilis, chili powder, yellow chili, chili from the Couixca, sharp-pointed red chilis, long chilis, smoked chilis; small, wild tomatoes, and ordinary tomatoes.

And separately were sold every kind of fruit: the American cherry, . . . *tejocotes*, *cimate* roots, squash cut in pieces, chayote, squash seeds, *Cassia* seeds; and white fish, frogs, and water dogs; water fly eggs, water flies, lake scum, and red shellfish; . . . and lime, and obsidian; and firewood, and pointed oaken poles, . . . paddles, staves; maguey roots, maguey fiber . . . and all manner of edible herbs—onions, water plant leaves, thistles, amaranth greens and heads, purslane, mixed greens, varieties of sorrel; tuna cactus fruits, sweet and acid; squash greens, tender young squash, squash blossoms; bean greens and green beans; green maize, tender maize, tender maize stalks; tamales of maize blossoms, tortillas of green maize, and all edible things—tortillas, tamales and tortillas with honey, large tortillas, and rolled tortillas. (Sahagún 1979:67–69)

THE DISTRIBUTION OF RURAL SETTLEMENT

Figure 3 shows the distribution of early sixteenth-century rural settlements (those sites with estimated populations of fewer than 1,000 people), while Figure 4 shows Aztec urban centers (with estimated populations of more than 1,000 people) that archaeologists have identified during their systematic regional surveys (Table 1). These maps do not show unsurveyed sites, including several major urban centers and the Aztec capital, Tenochtitlan, which once existed and now lie under the urban sprawl of modern Mexico City in the southwestern Valley of Mexico. Archaeologists identify these ancient settlements by the presence on the ground surface of a distinctive ceramic assemblage whose most diagnostic types include decorated Black-on-Orange and Black-on-Red pottery (Figure 5). Populations are estimated by the surface areas over which ancient house mounds and surface pottery extend and by the relative density of these archaeological remains.

TABLE 1.

Urban and rural Aztec population in surveyed parts of the Valley of Mexico

	URBAN (sites of >1000 people)	RURAL (sites of <1000 people)
Number of sites	47	1,513
Estimated total population	209,028	110,012

Figure 3 shows extensive rural settlement from the lakebed into the foothills of the bordering sierra. This widely distributed rural population suggests that many different resources were procured and processed: accessing wood and other forest products in the upper piedmont and nearby lower sierra; cultivating irrigated and nonirrigated fields along permanent and seasonal streams in the lower piedmont; intensive chinampa cultivation in the drained marshes of the southern freshwater lakes; saltmaking around the shores of saline Lake Texcoco; quarrying and manufacturing lime in the calcareous northwestern corner of the basin; and harvesting numerous "wild" aquatic plants and animals in the marshes and lakes at the bottom of the drainage gradient.

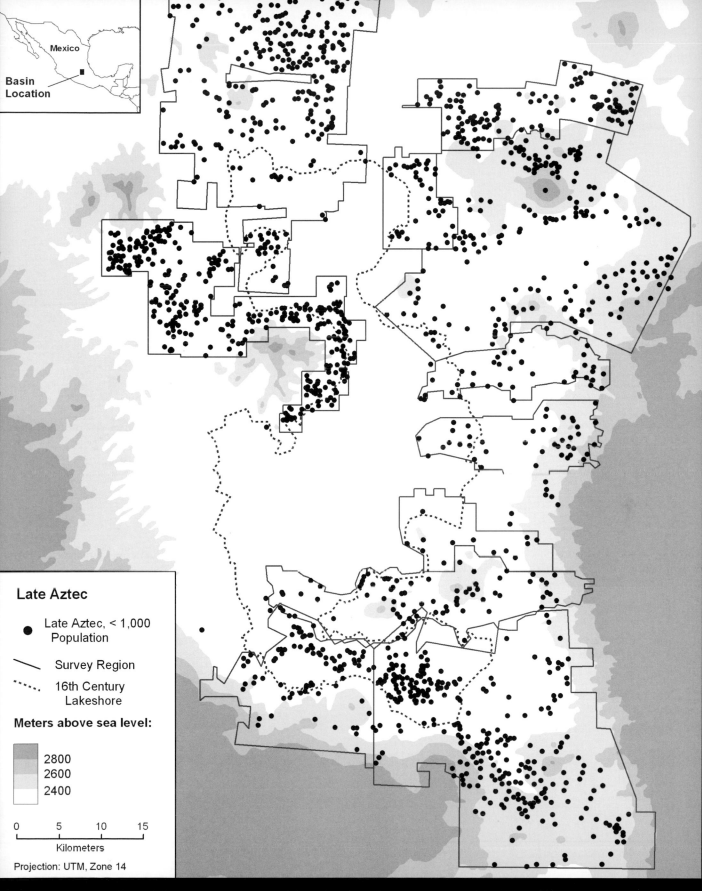

Figure 3. Aztec rural settlement in the archaeologically surveyed parts of the Valley of Mexico.

Late Aztec

● Late Aztec, < 1,000 Population

— Survey Region

···· 16th Century Lakeshore

Meters above sea level:

2800
2600
2400

0 5 10 15
Kilometers

Projection: UTM, Zone 14

Mexico

Basin Location

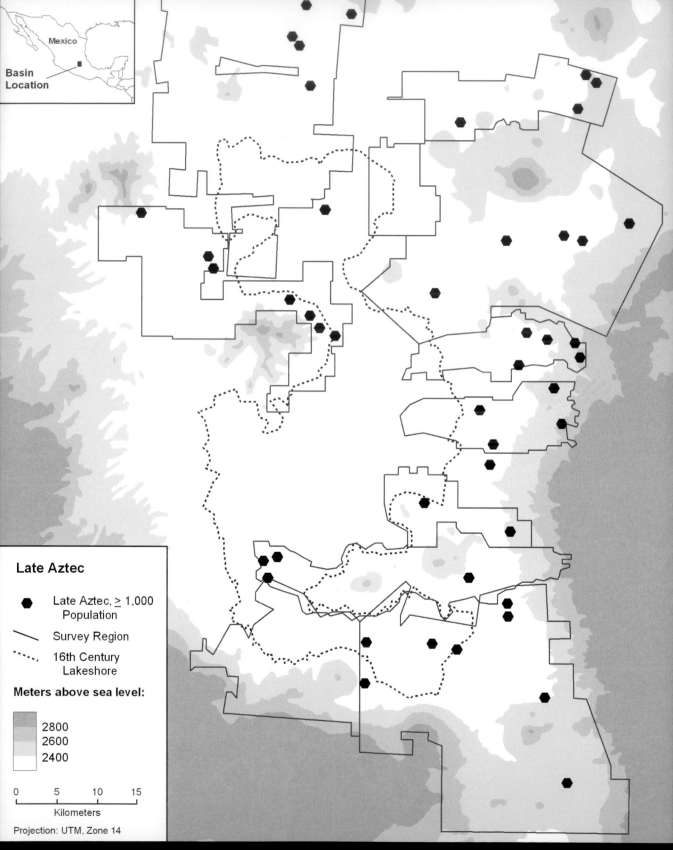

Basin Location

Mexico

Figure 4. Aztec urban centers in the archaeologically surveyed parts of the Valley of Mexico.

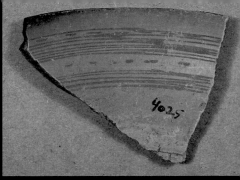

(A) Black-on-Orange bowl.

(B) Black-on-Orange molcajete (grinding dish).

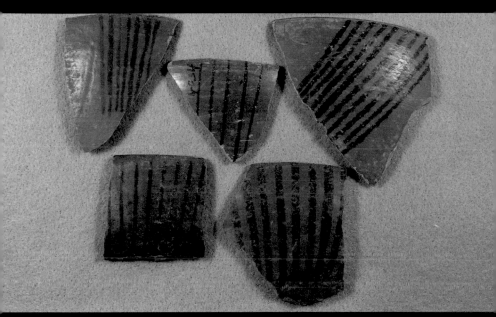

(C) Black-on-Red bowls.

(D) Black-and-White-on-Red bowls.

Figure 5. Examples of decorated pottery from rural Aztec sites in the Valley of Mexico.

AGRICULTURE

Aztec farmers cultivated many different plants, but possessed few domesticated animals (dogs and turkeys). Seed-based crops planted annually included two cereals (maize and amaranth), the common bean, squashes, and many different chiles. Two domesticated types of cactus were also important as food: maguey *(Agave americana)* and nopal *(Opuntia streptacantha)*. Maguey—a source of fiber, fuel, and edible sap and flesh—complemented seed-based agriculture because it attains maturity over seven- to twenty-year cycles and is largely impervious to the cold, hail, and drought that so often made seed-based agriculture uncertain, and it reproduces vegetatively rather than through seeds that needed to be harvested, selected, and stored from one year to the next. Lacking draft animals and plows, Aztec farmers worked the land with digging sticks and other hand implements.

Sahagún described the sixteenth-century farmer's work (Figure 6):

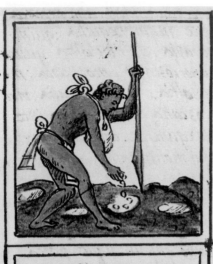

Figure 6. Aztec farmers planting and cultivating maize. (Top) Planting maize kernels using digging stick. (Bottom) Cultivating maize with digging stick.

The good farmer . . . works the soil, stirs the soil anew, prepares the soil; he weeds, breaks up the clods, hoes, levels the soil, makes furrows, makes separate furrows, breaks up the soil. He sets the landmarks, the separate landmarks . . . he stirs the soil anew during the summer . . . he takes up the stones; he digs furrows; he makes holes; he plants, hills, waters, sprinkles; he broadcasts seed; he sows beans, provides labor for them—punches holes for them, fills in the holes; he hills [the maize plants], removes the underdeveloped maize ears, discards the withered ears, breaks off the green maize stalks, thins out the green maize stalks, breaks off the underdeveloped maize ears, breaks off the nubbins, harvests the maize stalks, gathers the stubble; he removes the tassels, gathers the green maize ears, binds the ears [by their shucks], forms clusters of maize ears, makes necklaces of maize ears. He hauls away [the maize ears]; he fills the maize bins; he scatters [the maize ears]; he spreads them; he places them where they can be reached. He cuts them, he dismembers them. He shells them, treads on them, cleans them, winnows them, throws them against the wind. (Sahagún 1961:41-42)

THE IMPORTANCE OF IRRIGATION AND MARSH DRAINAGE

The onset of summer rains (normally in mid-May, but sometimes delayed until mid-June) is uncertain and unpredictable, and the quantity of rainfall can vary unpredictably over time and space. Similarly, the first severe fall frosts often occur as early as mid October, and they can continue into March. Thus, the productivity of seed-crop agriculture based on rainfall has always been risky and uncertain in Anahuac. Artificial water control was the only secure way to ensure that crops could

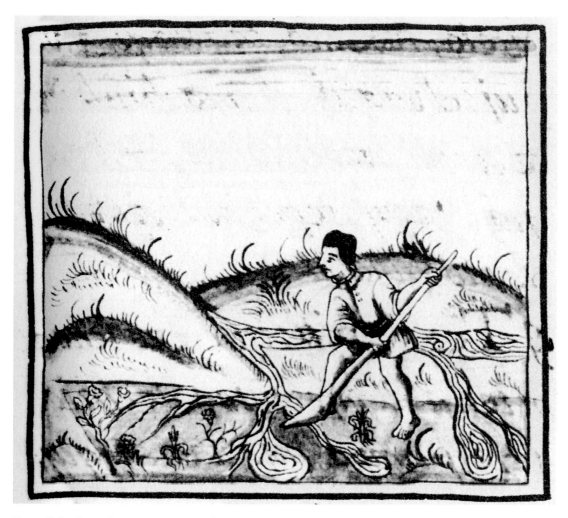

Figure 7. An Aztec farmer irrigating his fields.

be planted early enough in the spring so that they would attain maturity before the onset of killing autumn frosts. Consequently, canal irrigation (Figure 7), swamp drainage, and maguey-nopal cultivation on nonirrigated lands were all essential components of Aztec agriculture.

CHINAMPA CULTIVATION—GARDENS IN THE MARSHES

Remnants of chinampa agriculture have survived until the present in Lake Xochimilco (Figure 8), and during the sixteenth century, chinampa gardens extended over most of the entire surface of Lake Chalco-Xochimilco and in smaller areas in Lake Xaltocan. Chinampa farmers probably supplied close to half of the foodstuffs consumed annually at the Aztec capital and in other large urban centers. These foodstuffs moved easily from field to city in boats along an extensive system of canals—some of which survived until about 1930 (Figure 9). Craft goods and other products of urban workshops, as well as tons of human waste collected systematically in the cities for use as agricultural fertilizer, came to chinampa farmers along the same waterways.

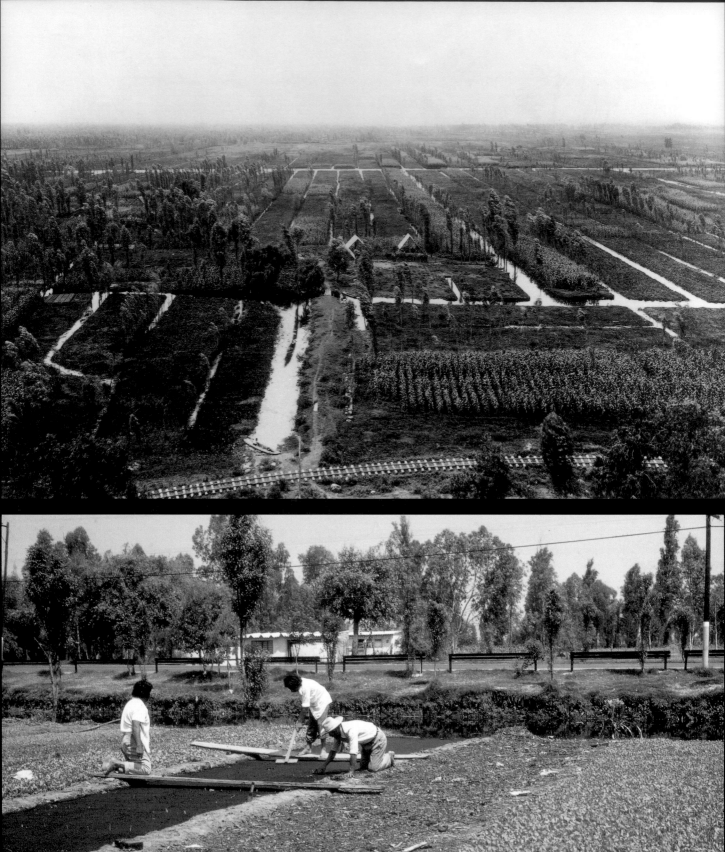

Figure 8. Twentieth-century chinampa agriculture. (Top) Overlooking chinampa zone ca. 1900. (Bottom) Preparing a chinampa seed bed using manure and mud from adjacent canal.

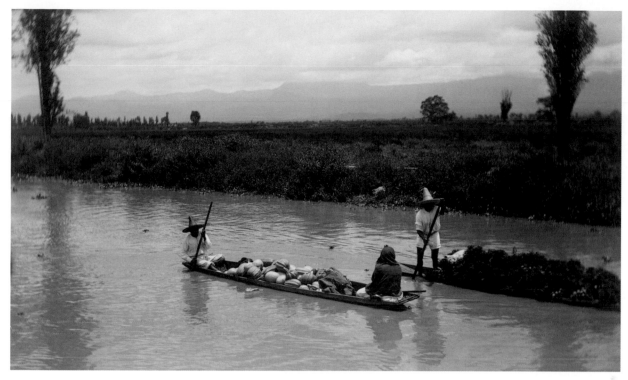

Figure 9. Boats laden with chinampa produce en route to the market in Mexico City ca. 1915.

In pre-Aztec times most of Lake Chalco-Xochimilco consisted of marshland and open water. During the fourteenth and fifteenth centuries these thousands of hectares of poorly drained land were transformed into highly productive gardens by means of large-scale drainage and flood-control projects. The chinampa planting surfaces were laboriously created by lifting masses of soil and aquatic vegetation and consolidating them at a level far enough above the water table so that seed germination and plant growth could occur. As seen in Figure 8, the sides of many chinampa fields were stabilized by rows of small trees.

A chinampa's fertility could be continuously renewed by means of scooping up onto the field surfaces the fine mud sediments and aquatic vegetation that accumulated naturally in the waterways surrounding each field. This natural fertilizer could be supplemented by local household refuse and boatloads of human waste from urban communities. Long-term productivity was achieved through multiple cropping and crop rotation, whereby soil nutrients depleted by one cultigen are partially resupplied by another. With a centrally administered network of drainage canals, dikes, and sluice gates, the water table could be maintained at a fairly constant level over large areas, despite marked seasonal variation in rainfall.

MAGUEY: A COMPLEMENT TO SEED-BASED AGRICULTURE

Maguey can withstand extended drought, cold temperatures, and hailstorms, and is capable of thriving on impoverished soils—all common problems for agriculturalists in Anahuac, particularly before the introduction of European domestic grazing animals (sheep, goat, and cattle) made

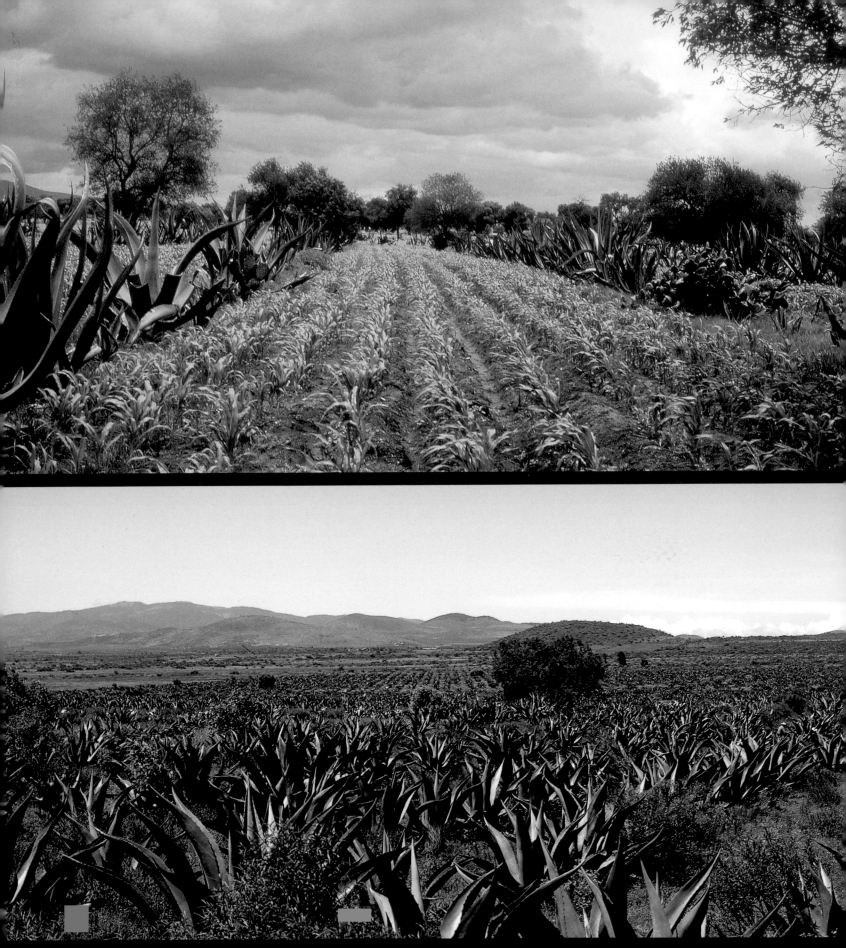

Figure 10. Different ways of cultivating maguey today. (Top) Interplanted maize and maguey. (Bottom) Monocrop maguey.

other crops (Figure 10, top) also reduces sheet wash and conserves the land through the holding and stabilizing action of the massive maguey plant and its extensive root system. In some drier and thin-soiled areas maguey is often planted alone (Figure 10, bottom).

The most important maguey product in historic times has been pulque, a mildly alcoholic beverage formed by the natural fermentation of the plant's sugary sap (*aguamiel*). Other uses of the plant include non-alcoholic sap products (fresh sap, syrup, and sugar), fiber (*ixtle*) for textiles, cooked edible root, and using the plant's thick central stalk (*quiote*), trunk, and leaves as construction materials, household utensils, domestic fuel, and even beehives.

Besides the digging sticks illustrated in Figures 6, 7, and 11, the tools used by the Aztecs for extracting, fermenting, and storing maguey sap included large, jagged-edged knives (made of either obsidian or flint) suitable for cutting out the heart of the mature plant so that its sap could be appropriated by people; circular scrapers for the daily scraping of the interior cavity surface to facilitate daily sap flow (Figure 12); and a variety of ceramic vessels for transporting and fermenting the collected liquid.

Figure 11. Maguey cultivation.

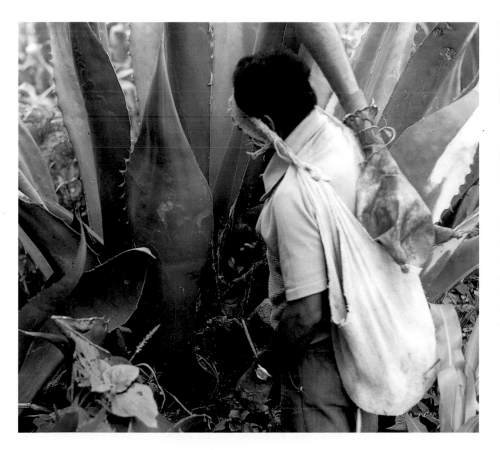

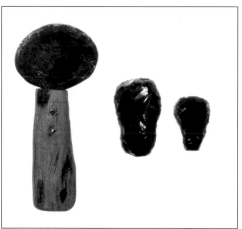

Figure 12. (Left) Modern farmer scraping maguey cavity with iron tool. (Above) Modern iron scraper, left, and two Aztec obsidian scrapers.

Figure 13. (Right) A modern woman scraping maguey fiber with an Aztec stone scraper. (Below) Examples of Aztec ground stone scrapers.

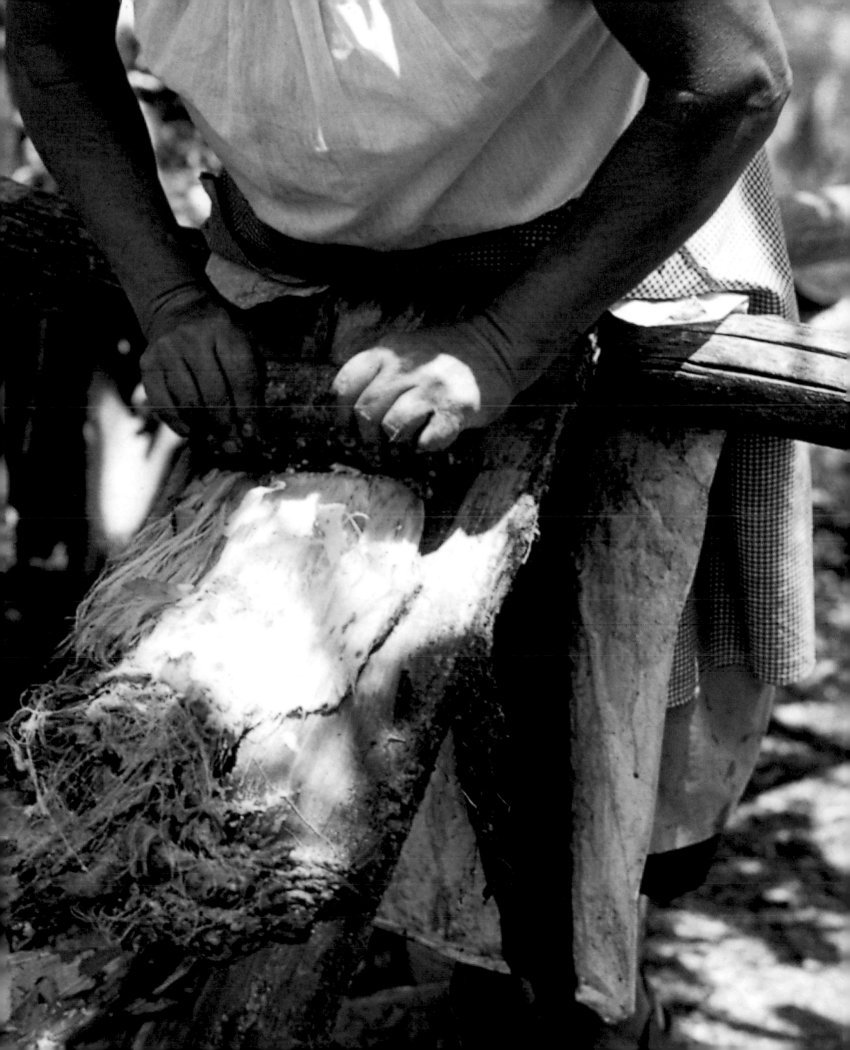

EXTRACTING THE MAGUEY FIBER

Each maguey leaf contains abundant fiber (*ixtle*), the principal fiber for making ordinary Aztec clothing. In order to be made into thread, the fiber must be removed from the encasing flesh of the massive maguey leaf. Today this is done with a metal scraper; in Aztec times this was performed with a smooth-edged stone scraper that was pressed firmly against the maguey leaf with strong, downward movements along a backing board (Figure 13).

SPINNING THE MAGUEY FIBER

Once the removed fiber has been dried, cleaned, and carded (usually with a thick maguey thorn), it is then spun into thread of varying thickness. This is accomplished by drop spinning, using a wooden spindle weighted at one end with a ceramic spindle whorl for better control over thread quality (Figure 15).

An experienced spinner employs whorls of different weights to make thread of different thicknesses: smaller whorls, typically weighing 11 (0.4 oz) to 25 (0.9 oz) grams, for making fine thread, and progressively heavier whorls, weighing 35 (1.2 oz) to 75 (2.6 oz) grams, or more, for progressively thicker thread (Figure 14). Women in most rural Aztec settlements also spun imported cotton thread, judging from the abundance in these sites of small whorls that would not have been suitable for spinning the thicker maguey thread. Figure 15 (right) shows an Aztec woman who is probably spinning cotton thread, using a small bowl to support the weight of the spindle and spindle whorl.

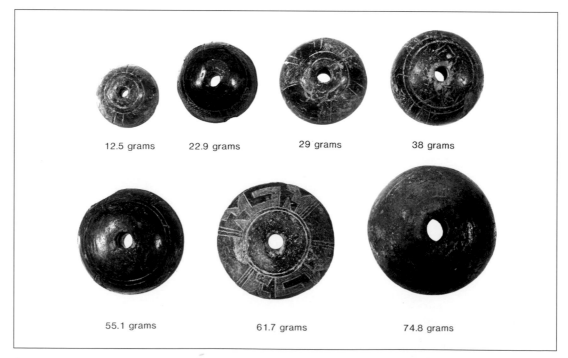

12.5 grams 22.9 grams 29 grams 38 grams

55.1 grams 61.7 grams 74.8 grams

Figure 14. Aztec spindle whorls used to make maguey-fiber threads of different thicknesses.

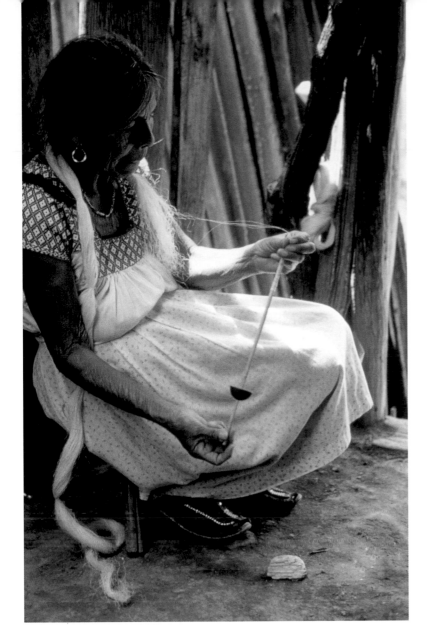

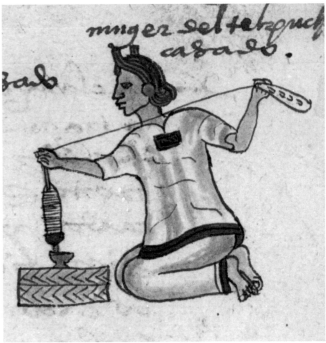

Figure 15. Spinning in modern and Aztec times. (Left) Modern woman spinning maguey fiber, using an Aztec spindle whorl. (Above) Aztec woman spinning cotton thread.

Once the thread has been spun, it is woven on a simple, backstrap loom (Figure 16) into large, square carrying cloths (*ayates*) that are employed today for back-packing burdens ranging from babies to firewood. In Aztec times, maguey-fiber textiles were used for making a wide variety of clothing.

HARVESTING WETLAND RESOURCES

In pre-Columbian times the lakes and marshlands were sources of abundant aquatic plant and animal life, including reeds, tuberous plants, algae, insects and insect eggs, frogs, salamanders, turtles, several species of fish and their eggs, several species of small crustaceans, and vast numbers of waterfowl and their eggs. The saline soils bordering Lake Texcoco provided an abundance of raw material for making salt.

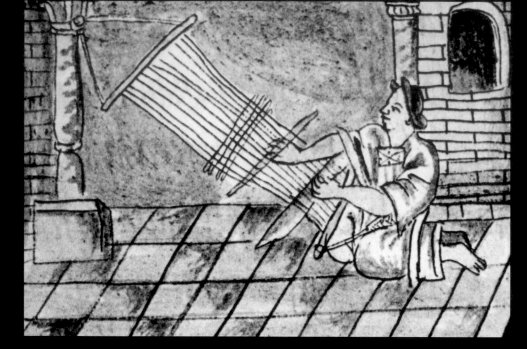

Figure 16. Backstrap weaving of maguey fiber cloth. (Right) Aztec woman using a backstrap loom. (Below) Modern woman weaving ixtle thread on a backstrap loom.

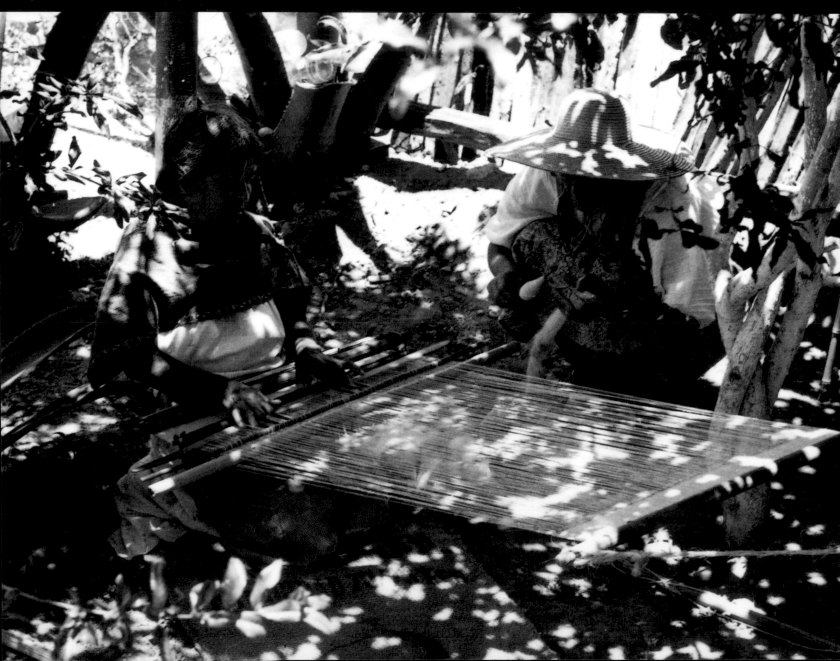

Until the mid-twentieth century the open waters and marshlands of Lake Texcoco continued to provide very substantial quantities of the same foods and raw materials that had been significant in Aztec times. Until the 1940s these resources continued to be collected, hunted, or harvested with much the same techniques and organization as those described in the sixteenth-century sources (e.g., netting, spearing, snaring, following and trapping waterfowl, netting fish, preparing insect-egg nurseries, individual or community ownership of fishing and collecting territories, market exchange between lake fishers and inland agriculturalists).

Throughout the historic period many hundreds of thousands of waterfowl annually made their way into the urban marketplaces. Annual harvests of edible insect products might have amounted to thousands of metric tons. The potential annual harvests of fish, larval salamanders, frogs, turtles, crustaceans, mollusks, algae and other aquatic plants would have been very considerable, probably amounting to at least many hundreds of metric tons annually. As in the sixteenth-century sources, marsh reeds and rushes are often noted as raw material for mats and housing and food.

A mid-sixteenth century map of Lake Texcoco and the adjacent lakeshore plain (Figure 17) shows individuals engaged in several different activities: (1) spearing (fish? salamanders?) from a canoe; (2) a man fishing (?) with a pole and line; (3) a man capturing waterfowl in large, upright nets suspended from poles; (4) a man walking with a push-net over his shoulder; (5) a man pushing a net through the water (to capture insects?); (6) two men engaged in uncertain activity (building or repairing the reed barrier?).

Figure 17. Section of 1550 map showing Lake Texcoco and adjacent lakeshore plain. North is to the right.

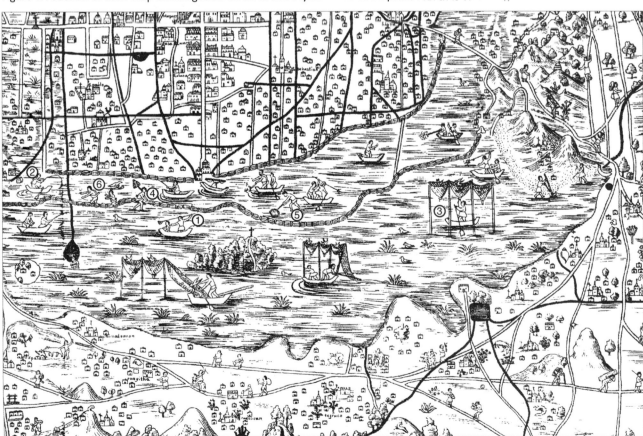

Figure 17 shows that a reed barrier of some sort separated two distinct sectors of the lakebed: an outer section (apparently shallower water), in which clusters of reeds or rushes occur, and within which waterfowl are being netted, along with some other activities being carried out by men in boats; and an inner section (presumably deeper water), in which aquatic plants are absent, and where activities other than waterfowl netting are under way. This barrier apparently functioned to separate deeper and shallower bodies of lake water, each of which was probably appropriate for different types of harvesting activities—graphic evidence of a managed wetland landscape.

(A) Chert "saw"

(B) Obsidian point

(C) Obsidian blade

(D) Obsidian knife

Figure 18. Examples of stone and ceramic artifacts from the lakebed survey.

(E) Notched potsherd, probably a net sinker

Figure 19. Example of a small lakebed archaeological site.

THE LAKEBED SURVEY IN 2003

In 2003 I directed an intensive surface survey over approximately 22 square kilometers (8.5 square miles) on the dried-up bed of central Lake Texcoco (Figure 1). During the survey we found pre-Columbian artifacts at more than 1,100 locations. The contents of these locations ranged from single ceramic vessels or single stone tools to clusters of lithic and ceramic artifacts diffusely scattered over areas of five to fifty meters in diameter (Figures 18, 19). Most of the identifiable pottery found at these locations in the 2003 survey dates to the fourteenth through the early sixteenth centuries (like those sherds shown in Figure 5).

Although we do not yet understand the functions of the activities represented by these archaeological remains, they suggest that people ranged widely over central Lake Texcoco in the course of activities devoted to procuring and processing aquatic resources. Documentary sources suggest that we are potentially dealing with the remains of insect netters, salamander spearers, duck hunters, reed cutters, fishers, and collectors of algae, birds' eggs, and turtles (Figures 20, 21).

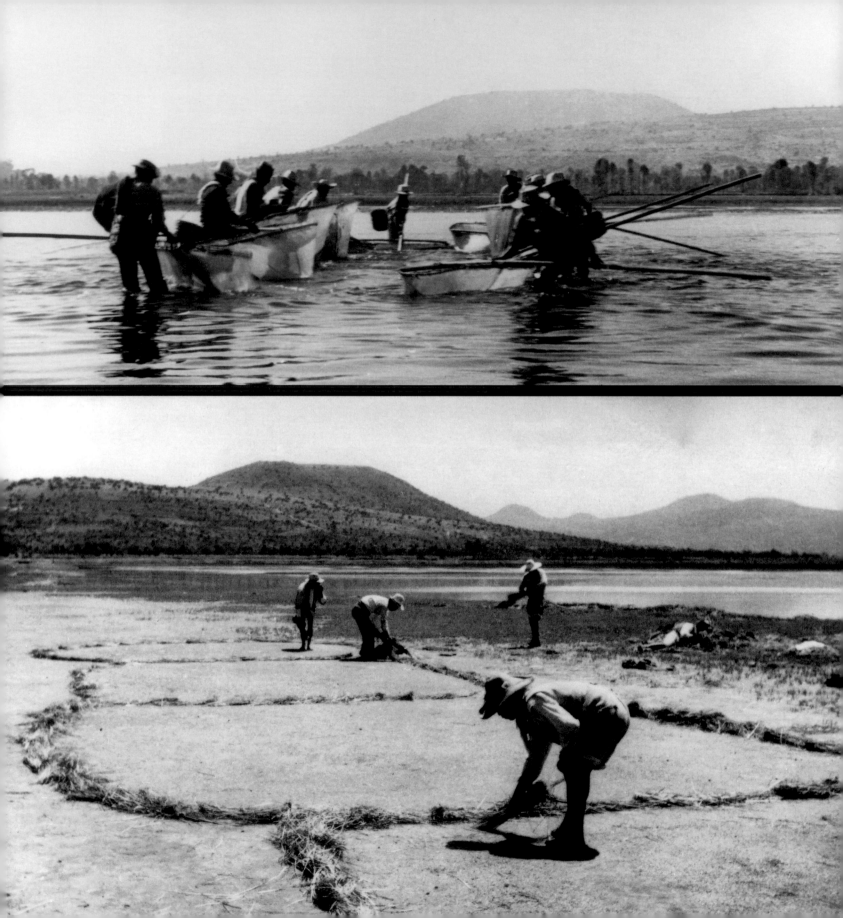

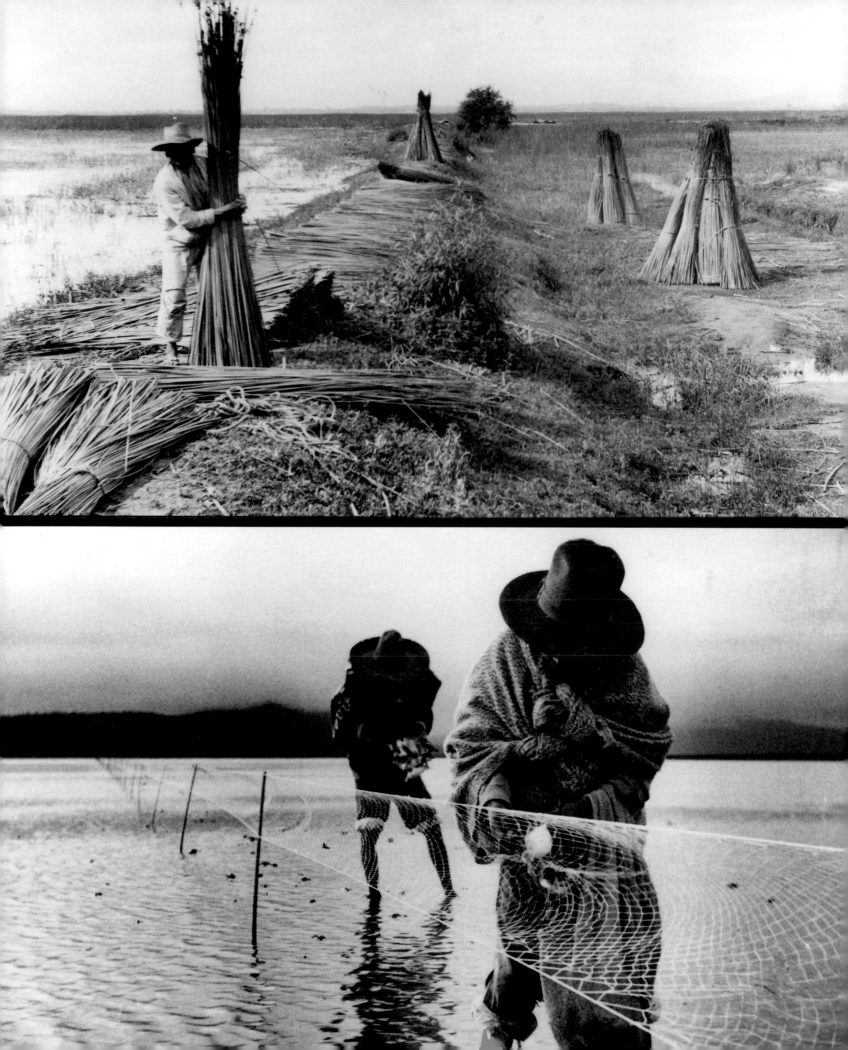

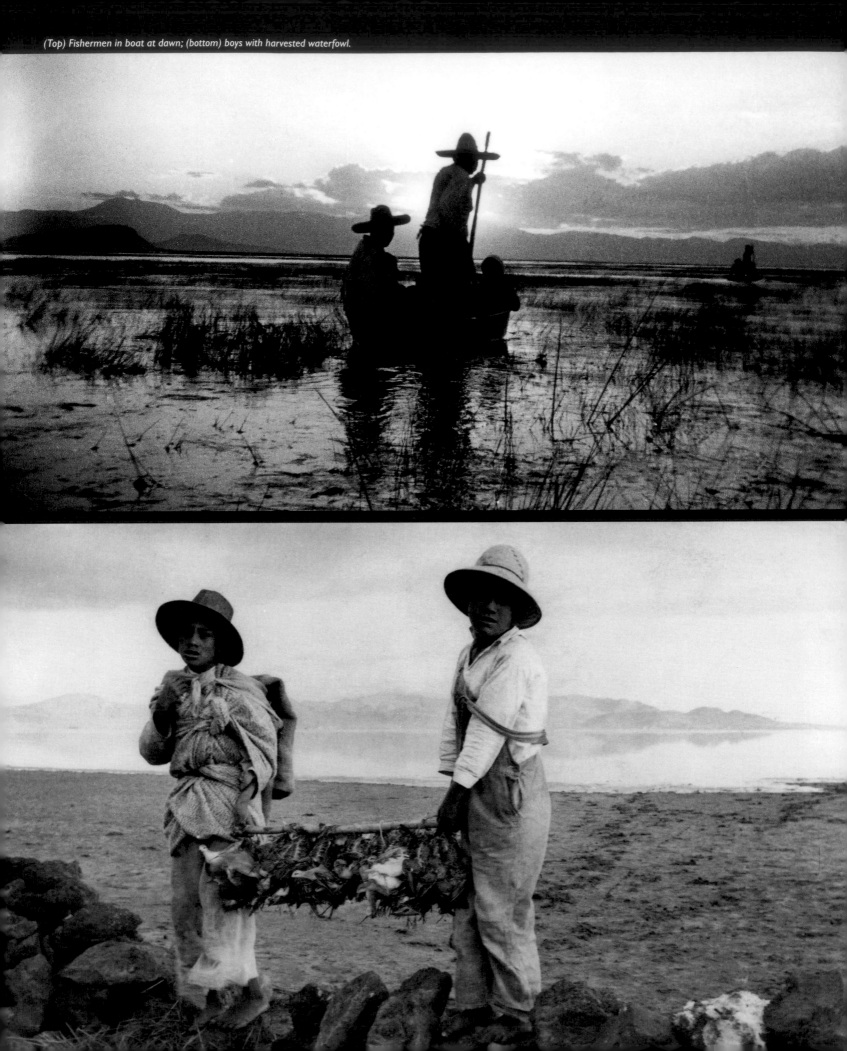

(Top) Fishermen in boat at dawn; (bottom) boys with harvested waterfowl.

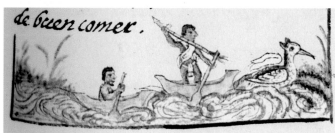

de buen comer.

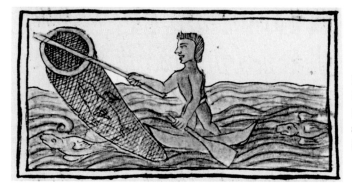

Figure 21. Harvesting waterfowl and fish in Lake Texcoco in the sixteenth century. (Top) Netting waterfowl; (Middle) spearing waterfowl from canoes; (Bottom) fishing with net from canoe.

SALTMAKING

In historic times, traditional saltmaking around the shores of saline Lake Texcoco has involved leaching the salt content of saline lakeshore soils and boiling the resulting brine to produce crystalline salt. There are six basic sequential steps (Figure 22): (1) collecting the lakeshore soils and transporting them to the workshop; (2) mixing the soils; (3) filtering water through the soil mixture in order to leach out the salts and concentrate them in a brine solution; (4) boiling the brine to obtain crystalline salt; (5) drying the crystalline salt; and (6) selling the dried salt.

Figure 22. Modern saltmaking at Nexquipayac, shore of Lake Texcoco.

(A) Skimming saline soil on lakeshore.

(B) Mixing different kinds of soil at workshop.

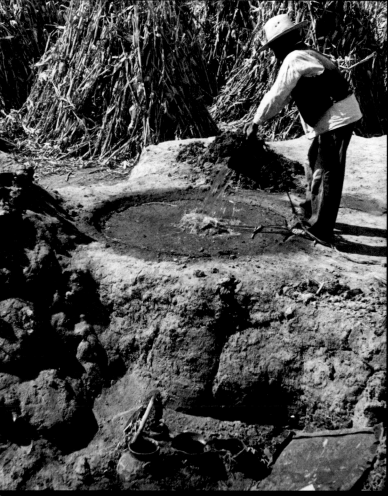

(C) Pouring water into leaching pit, 1938. Note tube leading into jar at base.

(D) Boiling brine to produce crystalline salt.

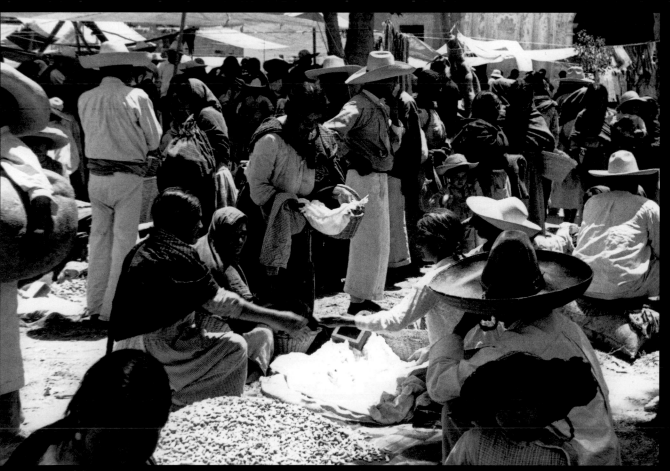

(E) Selling salt at local market, 1938.

Sixteenth-century sources suggest that Aztec saltmakers followed these same procedures, and there are numerous small archaeological sites around the borders of Lake Texcoco (Figure 3) that probably represent places where these saltmakers lived and worked. All these lakeshore sites include high percentages of a distinctive fabric-impressed pottery (Figure 23) that was probably used as a disposable container for packaging salt intended for market sale.

Figure 23. Texcoco fabric-marked pottery. (Top) Fragments of Texcoco fabric-marked pottery. (Bottom) Texcoco fabric-impressed vessel, ca. 20 cms. in diameter.

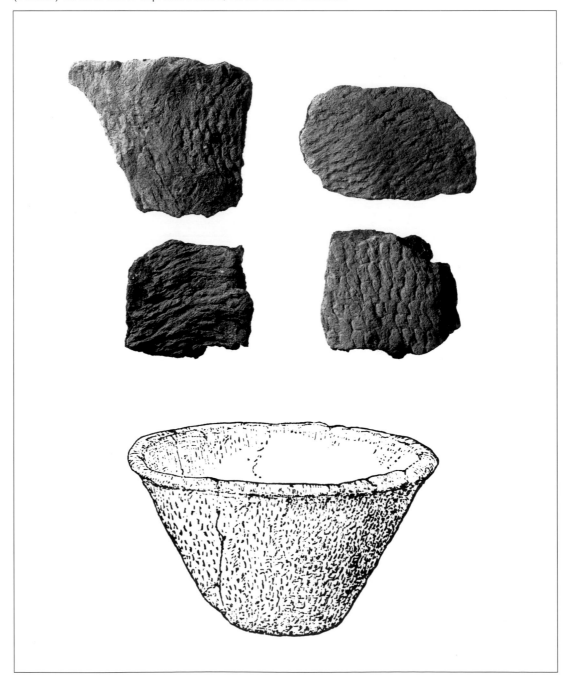

OVERALL SUMMARY AND CONCLUSIONS

Rural production of food and raw materials in Anahuac supplied the basic staples that underwrote Aztec civilization in its heartland. Using archaeological, historical, and ethnographic information, this chapter has emphasized agriculture and the harvesting of a variety of managed wetland resources; forestry and quarrying have not been discussed in detail owing to scarcity of information.

Aztec farmers used simple hand tools to cultivate both annual seed crops (primarily maize, amaranth, beans, and squash) and perennial cactus (maguey). Because of its non-seasonality, its resistance to drought, and its deterrence of soil erosion, maguey complemented seed-based agriculture and greatly extended the productive landscape for a society lacking pastoralism. Three different agricultural systems were practiced: rainfall-based cultivation of seed crops and maguey in areas of thinner soils where irrigation was not feasible; irrigation-based cultivation of seed crops in deeper-soil areas where canal irrigation could be practiced; and intensive chinampa cultivation in drained marshland. The marshlands and lakes furnished abundant salt, waterfowl, fish and fish eggs, edible insects and insect eggs, frogs, salamanders, turtles, small crustaceans and mollusks, algae, reeds, and other aquatic plants. These "wild" aquatic resources were carefully managed and intensively harvested. Like maguey, they complemented seed-based agriculture and helped compensate for the absence of pastoralism.

Overall integration between rural and urban economies was accomplished through marketplaces in urban communities throughout Anahuac. Here rural farmers and wetland harvesters exchanged their foodstuffs and raw materials for craft products and services supplied by urban artisans.

REFERENCES

Archaeological and Historical Studies

Apenes, O. 1947. "Mapas Antiguas del Valle de México." Publication No. 4. Mexico City: Instituto de História, Universidad Nacional Autónoma de México.

Armillas, P. 1971. "Gardens on Swamps." *Science* 170:4010:653–661.

Brumfiel, E. (editor). 2005. "Production and Power at Postclassic Xaltocan." Mexico City and Pittsburgh: Instituto Nacional de Antropología e História, and University of Pittsburgh.

Charlton, T., D. Nichols, and C. Otis Charlton. 2000. "Otumba and its Neighbors: Ex Oriente Lux." *Ancient Mesoamerica* 2:2:247–267.

Evans, S. 1988. "Excavations at Cihuatecpan: An Aztec Village in the Teotihuacan Valley." Publications in Anthropology, No. 36. Nashville, Tenn.: Vanderbilt University.

Gibson, C. 1964. *The Aztecs under Spanish Rule.* Stanford, Calif.: Stanford University Press.

Harvey, H. (editor). 1991. *Land and Politics in the Valley of Mexico: A Two Thousand Year Perspective.* Albuquerque: University of New Mexico Press.

Hodge, M. 1998. "Archaeological Views of Aztec Culture." *Journal of Archaeological Research* 6 (no. 3):197–238.

Hodge, M., and M. Smith. 1994. "Economies and Polities in the Aztec Realm." Institute for Mesoamerican Studies, State University of New York at Albany. Austin: University of Texas Press.

Melville, E. 1994. *A Plague of Sheep: Environmental Consequences of the Conquest of Mexico.* Cambridge: Cambridge University Press.

Nichols, D., E. Brumfiel, H. Neff, M. Hodge, T. Charlton, and M. Glascock. 2002. "Neutrons, Markets, Cities, and Empires: A 1000-Year Perspective on Ceramic Production and Distribution in the Postclassic Basin of Mexico." *Journal of Anthropological Archaeology* 21:25–82.

Parsons, J. 2001. "The Last Saltmakers of Nexquipayac, Mexico: An Archaeological Ethnography." Anthropological Paper No. 92, Museum of Anthropology, University of Michigan, Ann Arbor.

———. 2006. "The Last Pescadores of Chimalhuacan, Mexico: An Archaeological Ethnography." Anthropological Paper No. 96, Museum of Anthropology, University of Michigan, Ann Arbor.

Parsons, J. & M. Parsons. 1990. "Maguey Utilization in Highland Central Mexico: An Archaeological Ethnography." Anthropological Paper No. 82, Museum of Anthropology. University of Michigan, Ann Arbor.

Sanders, W., J. Parsons, & R. Santley. 1979. *The Basin of Mexico: Ecological Processes in the Evolution of a Civilization.* Academic Press, New York.

Sixteenth-Century Documentary Sources

Codex Mendoza. 1978. *Codex Mendoza: Aztec Manuscript.* Miller Graphics, Fribourg,: Productions Liber.

Sahagún, B. 1961. *Florentine Codex: General History of the Things of New Spain. Book 10: The People.* Translated and edited by C. E. Dibble and A. J. Anderson. Monographs of the School of American Research and the Museum of New Mexico, Santa Fe. Salt Lake City: University of Utah Press.

———. 1963. *Florentine Codex: General History of the Things of New Spain. Book 11: Earthly Things.* Translated and edited by C. E. Dibble and A. J. Anderson. Monographs of the School of American Research and the Museum of New Mexico, Santa Fe. Salt Lake City: University of Utah Press.

———. 1979. *Florentine Codex: General History of the Things of New Spain. Book 8: Kings and Lords.* Translated and edited by C. E. Dibble and A. J. Anderson. Monographs of the School of American Research and the Museum of New Mexico, Santa Fe. Salt Lake City: University of Utah Press.

———. 1981 *Florentine Codex: General History of the Things of New Spain. Book 2: The Ceremonies.* Translated and edited by C. E. Dibble and A. J. Anderson. Monographs of the School of American Research and the Museum of New Mexico, Santa Fe. Salt Lake City: University of Utah Press.

Miscellaneous

Holmes, W. 1885. Evidence of the antiquity of man on the site of the City of Mexico. *Transactions of the Anthropological Society of Washington* 3:68–81. Washington, D.C.

Pellicer, C. (editor). 1970. *José María Velasco: Pinturas Dibujos Acuarelas.* Fondo Editorial de la Plástica Mexicana, México, D.F.

THREE
HEALTH AND DISEASE AMONG THE AZTECS

JUAN ALBERTO ROMÁN BERRELLEZA,
INSTITUTO NACIONAL DE ANTROPOLOGÍA E HISTORIA

Regardless of their origin and geographic location, the societies of ancient Mesoamerica suc cessfully built up a medical canon, transmitted medical knowledge from one generation to the next, and discovered and tested therapeutic techniques that allowed them to create what can generally be considered a health system. The Aztec society, in its brief lifetime, brought together traits, beliefs, practices, and material and symbolic resources drawn from much older cultures.

The knowledge achieved by the Mexica physicians was so broad and relatively profound, and the therapeutic treatments they applied to sick people were so successful, that the Spanish conquerors were amazed by the effectiveness of pre-Hispanic medicine. In one of his letters, Hernán Cortés asked Emperor Charles V not to send doctors to New Spain because the original inhabitants of those lands cured diseases well and quickly, in addition to having extensive professional experience and enormous expertise regarding medicinal plants and ways of preparing a variety of remedies from them.

After the Spanish military conquest was completed, the Catholic friars and missionaries wanted to collect as much information as possible about the conquered peoples as part of a strategy to dominate them in every sense, but especially in their spiritual lives. This is how information embracing many aspects of Aztec society has come down to us today. Among the many and varied subjects that the friars studied and recorded are those diseases that afflicted the ancient inhabitants of Mexico City–Tenochtitlan and their surroundings, as well as the treatments for those diseases. But despite the enormous importance of the texts left to us by Friar Bernardino de Sahagún, Juan Martín de la Cruz, and Francisco Hernández, today we have only a superficial and incomplete image of what Nahuatl medicine was like. This is so not only because the information is very scant in some cases, but also due to its conceptual structure, which has prevented

specialists from understanding it in all its dimensions and scope. Nevertheless, in the following pages we try to provide a general overview of health and disease as they were enjoyed and suffered by the Mexicas in the pre-Hispanic era.

THE PRE-HISPANIC WORLDVIEW IN THE PROCESSES OF HEALTH AND DISEASE

To better understand pre-Hispanic medical practice, it is necessary to penetrate Nahua thought concerning their vision of the universe and the place that humans occupy in the cosmos. This will permit us to gain access to Nahua concepts of health and disease and how they addressed the causes of suffering. López Austin (1988:55–98) explains that these ideas, beliefs, and concepts are encompassed in the Aztec worldview. The pre-Hispanic worldview integrated different ideological systems into a coherent whole so that the ideas, beliefs, and traditions about the world and about the role and place of humans within it provided an explanation consistent with reality. As a result, the worldview served as an umbrella that encompassed the many aspects of life, including religion, war, morality, education, and medicine.

In general terms, the Mexicas believed that the world was split into two great parts, which were at the same time in opposition to one another and complementary. This dichotomy included mother and father, cold and hot, night and day, death and life, and so on, in a segmentation of opposing pairs. In addition to this primary division, the ancient Nahuas divided the universe vertically into thirteen heavenly levels and nine levels of descent into the underworld. Each of those upper and lower levels was inhabited by specific gods and lesser supernatural beings. Another division existed in the horizontal dimension, where the earth's surface was segmented into four parts. A cardinal direction was assigned to each of these parts, as well as a color, a symbol, and its opposite pole: north-black-flint-death, south-blue-rabbit-life, east-red-cane-male, and west-white-house-female. Meanwhile, the joining of these four parts, the center point or navel, was represented by the color green, a symbol of order and balance. On the edges on the horizontal plane, four supports were thought to hold up the sky. They were imagined as four cosmic trees, through which the gods and their forces were transmitted to the surface of the earth (López Austin 1988:58–68) (Figure 1).

This universe so defined was extremely dynamic. The interaction between the vertical and horizontal dimensions was channeled through the cosmic trees, which were passageways through which the forces of heaven and the underworld circulated. These forces generated time, that is, sequential time periods that gave rise to the calendars. The first of these was the *tonalpohualli*, or the divinatory calendar, which consisted of a cycle of 260 days, each with its own sign. This was a kind of horoscope through which an individual's destiny was foreseen according to the date

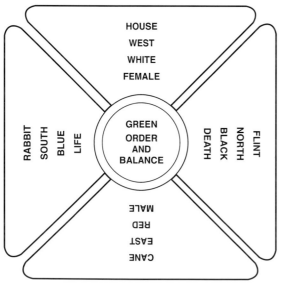

Figure 1. Division of the world in the horizontal dimension.

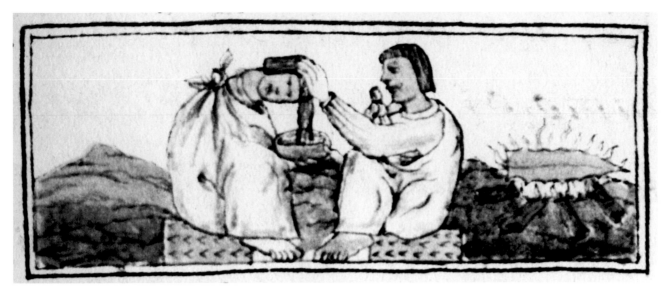

Figure 2. Aztec healer treating a patient with a head wound.

and sign of his birth. The other calendar was the *xiuhpohualli*, a solar and ritual calendar; it had an annual cycle of 360 days plus five days at the end of the year, for a total of 365 days. The most important conceptions about the world and the universe were encompassed in these great divisions of space and time; they also related to health and disease, as we shall see below.

CONCEPTS OF HEALTH AND DISEASE

Within the pre-Hispanic vision of complementary opposition mentioned above is the health-disease dichotomy. Preserving health and avoiding disease required the maintenance of an equilibrium: finding a middle ground based on moderation, respect, and faithful performance of one's obligations to the gods, to society, and to one's own body. Failing to perform one or more of those obligations could rupture that balance and cause multiple diseases, which could only be cured with remedies that included the gods, magic, medicinal plants, and healers (Figure 2).

For example, the dual division of the universe was expressed in human bodily integrity because disease, food, and medicines were regulated by the division of hot and cold. Humans were thought to comprise both hot and cold principles, harmonized in a state of equilibrium. This balance could be lost due to external or internal forces, and by the same token, external factors and the sick person's own actions could restore the lost balance (López Austin 1988:60). Accordingly, the disease acquired specific characteristics depending on its cause, its victim, the intensity and severity of its clinical expressions, the affected organ or part of the body, and the patient's physical condition at the time of falling ill (Viesca Treviño 2005:76).

An important point related to health and disease was the Aztec belief in the existence of three forces or spiritual entities in the human body, equivalent to what we know as the "soul." Each of them performed specific functions in the body throughout a person's life and even after his death. The first of these entities was called *tonalli* and was associated with the sun's heat, the day, and an individual's destiny as determined by the day on which he or she was born. It had its seat in the head and was believed to be capable of producing the growth of children, whetting the

appetite, and causing wakefulness; it was also responsible for the force transmitted through sight and played a role in the ability to think, along with the following entity. The *teyolía*, the second entity, was located in the heart. Among the characteristics attributed to it were the ability to reason and to engage in organized and logical thought, as well as to acquire knowledge and regulate the memory. The third spiritual entity was located in the liver; it was called *ihíyotl*. It was related to human vigor, and its corresponding passions and feelings, such as joy, pleasure, envy, desire, and anger. Endowed with these three "souls," an individual could perform adequately in the social, natural, and family world, but an individual's health depended on maintaining a perfect balance among them (Ortiz de Montellano 1990:55–67; Viesca Treviño 2005:64–69) (Figure 3).

THE CAUSES OF THE DISEASES

There was a fair degree of agreement among the specialists that diseases could be divided into three major categories: those caused by supernatural forces, those caused by human magic, and those caused by natural forces. With regard to the first, in pre-Hispanic times the gods were viewed as one of the causes of suffering and disease (Ortiz de Montellano 1993:158–95). This explanation of disease had certain variants. One of them related to the violation of divine rules by humans. As a result of a violation, the god in question might send a certain form of punishment, which could take the form of some kind of disease.

Figure 3. Schematic representation of the three main spirit entities and their location in the body, according to Aztec thought.

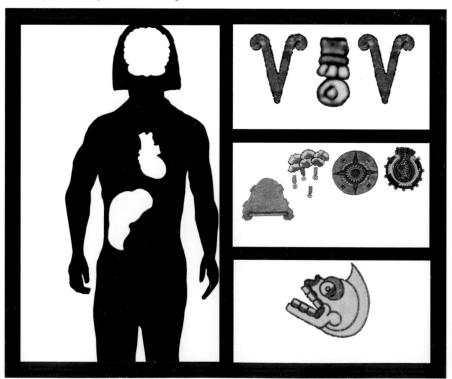

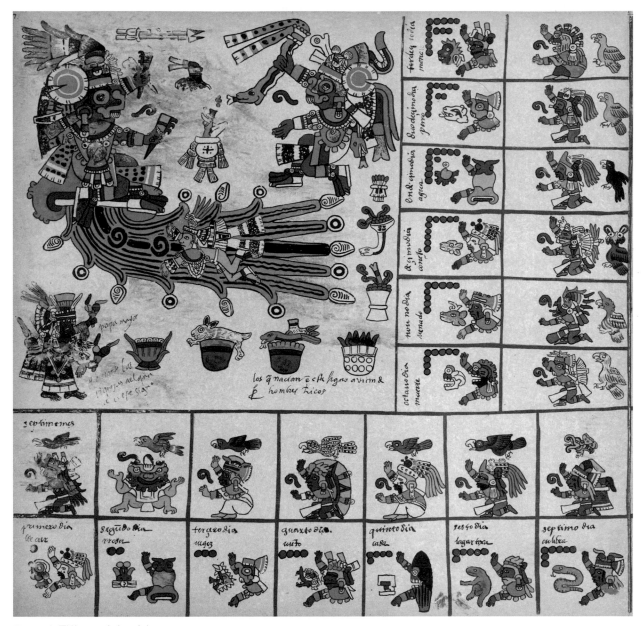

Figure 4. Tláloc and the tlalocs were considered the lords and masters of the rain, but also the sources of a variety of diseases attributed to cold and water, such as gout and dropsy.

If this was the cause of disease, it could only be cured through petition, prayer, penitence, and sacrifices to the deity that had imposed the suffering, because it was the god who conferred both health and disease, at his discretion (Pérez Tamayo 1988:35–36). In pre-Hispanic belief systems, certain deities were the causes of specific diseases. Hence, misbehavior or even the envy of a deity provoked the reaction of gods such as Tlaloc and his helpers, Xipe-Totec, Xochiquetzal, Chalchiuhtlicue, Chicomecoatl, Tezcatlipoca, and Quetzalcoatl, among others, who could harm the violator in a variety of ways, causing him to fall ill with gout, dropsy, tendinitis, leprosy, scabies, or facial paralysis (López Austin 1975:32; Sahagún 1987:49–51; Seler 1988, I:150–51). Sahagún mentions that those deities also acted as the patrons of the diseases in question (Figure 4).

Other behaviors could also attract the attention of the gods. Tlaloc and Chalchiuhtlicue chose their servants by striking them with lightning bolts, drowning them in rivers and lakes, or causing their death by leprosy or venereal disease. Any kind of dysfunction that could be related to water was also included in this category. These types of disease were sent in recognition of the victim's virtuous life, which attracted the gods' attention. A different cause of disease likewise attributed to the gods was determined by a person's date of birth. The time regulated by the tonalpohualli, the 260-day divinatory calendar, determined the possibility of falling prey to certain conditions (López Austin 1975:32) (Figure 5).

Figure 5. Chalchiuhtlicue, goddess of rivers, lakes, and ponds, who could afflict those who failed to practice the rites in her honor and make offerings to her, or who disobeyed certain rules of conduct, with venereal disease and leprosy.

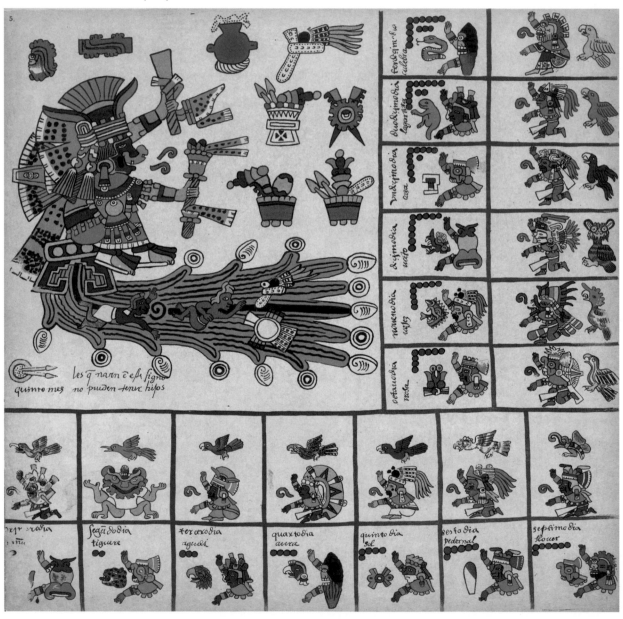

The second category of disease involves those caused by individuals such as magicians, sorcerers, and herb doctors, who were endowed with a special force or energy with which they hurt others, either intentionally or involuntarily. For example, the sudden appearance of a ghost produced by a magic spell provoked such fright that a person's health could be undermined in a variety of ways, depending on his physical and mental conditions, though in most cases the worst harm was suffered by the tonalli, either by loss or by weakening. The targeted person could go crazy if his heart did not recover from the shock it had suffered, and he could even die if the tonalli did not return to his body. Other diseases of magical origin were provoked by the *tlacatecólotl*, a generic name for sorcerers of all kinds. Chief among them were the *teyollocuani* and the *tecotzcuani*. The first could cause people to go crazy by symbolically eating their hearts and thereby damaging the teyolía, while the second could cause certain kinds of muscular disorders by magically eating the victims' calves. These sorcerers could also cause other diseases, but most commonly, the bewitched people deteriorated until they died. In these cases, only another sorcerer could remove the harmful effects of these spells, through complicated procedures of divination and incantations using a complex and esoteric language full of metaphors to break the spell and bring about the victim's recovery (Ortiz de Montellano 1993:172--77).

The last category of disease is that of natural origin where the cause and the effect are obvious, such as harm caused by accidents, battle wounds, excesses, exposure to sudden temperature changes, among others. Finally, there are diseases of mixed causes in which at least two of the categories discussed above come together (Ortiz de Montellano 1990:129–61).

AZTEC MEDICAL TREATMENTS

Aside from the religious and magical treatments and cures used to restore the lost health of individuals, the Aztecs had a vast and thorough empirical knowledge of therapeutic plants whose application complemented other curative processes. Aztec physicians built up a store of knowledge over the centuries, not only about the different forms of disease that they observed in their professional practice, but also knowledge of plants and other medicinal resources, necessary rituals, and surgical operations.

The Aztecs, as close observers of nature, knew how to take advantage of a broad repertory of plant-based therapeutic agents. Studies using modern research methods have recently been made of 118 out of the slightly more than 200 medicinal plants mentioned in the sixteenth-century sources, to determine their effectiveness. The result is that nearly 85 percent of the plant-based remedies contain biochemical substances that yield the desired curative effect. This corroborates the fact that Aztec medicine had a rational empirical-scientific foundation, whose effectiveness went beyond the limits of superstition, magic, and supernatural belief (Bye and Linares 1999; Ortiz de Montellano 1990).

Different sources provide details on therapeutic treatments involving the roots, stems, leaves, flowers, fruits, sap, and even seeds of many plants. For example, the leaves of the maguey plant (*Agave* spp.) were used with special skill to treat wounds caused by blows, as well as muscle pain, gastritis, and gall bladder/bile problems. Squash seeds (*Cucúrbita* spp.), now known as "pepitas,"

were used to eliminate intestinal parasites and relieve gingivitis. The combination of epazote (*Teloxys ambrosioides*) seeds and leaves was used to treat fright, stomach inflammation, and menstrual problems. Prickly pear (*Opuntia* spp.) fruit, most notably "tunas" and "xoconostles," was used to relieve stomach, digestive, and kidney problems, as well as lung conditions, and served as an aid during childbirth. Aside from its use as food, prickly pear is mentioned as a highly effective treatment for skin conditions (blows, bruises, and burns), as well as being an anti–inflammatory agent. It has now been proven that it reduces cholesterol and triglycerides, and induces weight loss. These few examples should suffice to briefly illustrate how the Aztec physicians had remedies with which to cure a wide range of health conditions, based on rational knowledge of their effectiveness in curing the sick (Figures 6, 7, 8).

Figure 6. The *Tlatlancuaye* was a plant that was often used to treat and cure certain kinds of inflammatory diseases and those provoked by cold, such as rheumatism and gout.

Figure 7. The *Yolloxóchitl* was the flower of an Aztec medicinal plant with a heart-toning effect; it was used by the Mexica physicians to strengthen the heart, and it also had diuretic properties.

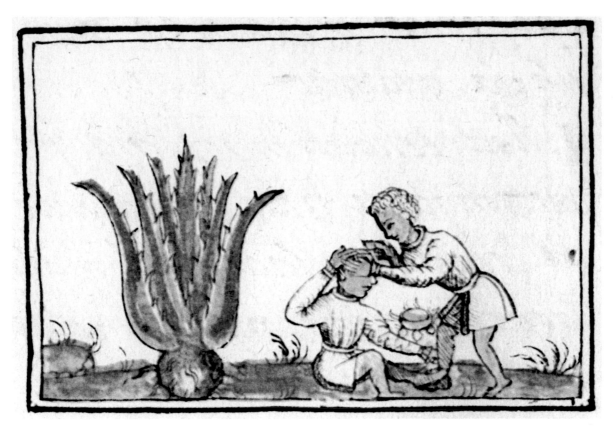

Figure 8. An Aztec physician subjecting a patient to treatment using an agave plant.

OSTEOLOGICAL ANALYSIS: RECENT FINDINGS

It is important to point out that human skeletal remains are the most accessible source of knowledge about ancient populations. But for the diseases that afflicted pre-Hispanic people, we must limit our inquiry to those diseases that left their mark on the bones. At present, the analysis of bone remains has yielded valuable information on the conditions of health and disease that prevailed within this population in the pre-Hispanic era. Remarkably, it was thought that there might be differences between the diseases of sacrifice victims from outlying regions and the individuals from residential areas of Tenochtitlan. But recent research has shown that both groups got sick just as often and their health problems were very similar (Murillo 2006; Hernández 2006). Different lines of research have been pursued, some of them in cooperation with specialists from other areas, and have corroborated many aspects of the historical sources while revealing information that was not provided by the original chroniclers.

For example, dental anthropology has yielded very important data (Román and Rodríguez 1997). Babies have been found to have suffered from hypoplasia of the enamel, a pathological dental condition defined as a set of anomalies in the development of the tooth enamel structure whose causes may be hereditary factors, localized trauma, or systemic metabolic stress stemming from malnutrition and infection. Infection is the most likely cause among the pre-Hispanic

populations (Goodman et al. 1984; Skinner and Goodman 1992). Among the different forms of enamel hypoplasia found in pre-Hispanic populations are those that modify the size, shape, or color of the teeth, and those showing linear patterns on the surface of the affected teeth. More than 60 percent of children have been found to have had this condition (Román and Rodríguez, 1997:225) (Figure 9).

In second place are the lesions found in dental tissue commonly known as cavities. These lesions are caused by the destruction of dental tissue due to a variety of factors. The lesion starts by eating through the enamel, causing no discomfort. As it progresses, it affects the dentin and pulp, and eventually damages the tooth's nerve. At that point there is acute or chronic pain and infection sets in, which in turn provokes a purulent abscess in the area that may dissolve the bone in the gums (Newman and Goodman 1989; Román and Rodríguez 1997:217) (Figure 10). Abscesses have been found in up to 48 percent of affected children. The end result of both acute and chronic cavities is the loss of the affected teeth.

Another condition reported in very young children is gingivitis, which is defined as an inflammation of the bony gum caused by poor oral hygiene and an accumulation of calcified bacterial plaque, commonly known as tartar.

A relatively high presence of tartar has been found. There are deposits with a crust-like appearance that surround the tooth, as a consequence of near nonexistent hygiene of the mouth. Tartar also contributes to halitosis, that is, bad breath (Figure 11).

Alone or together, all these conditions reflect a set of risks to the health of the individual who suffers them, because these kinds of clinical and pathological states are the sources of systemic infection, that is, infections that can eventually affect other organs and organic systems. Among

Figure 9. A child showing hypoplasia of the enamel, reflected in the blue coloring of the baby teeth.

Figure 10. A child showing tooth decay which affected the enamel, dentin, and pulp cavity of the lower right third molar. The lesion provoked inflammation, infection, and chronic severe pain.

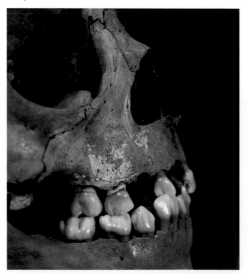

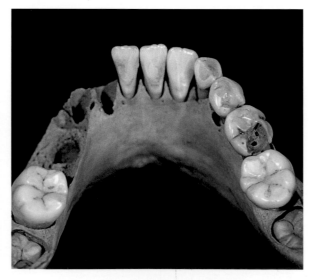

the most important consequences of having a dental disease are infections of the respiratory tract such as runny nose and colds (rhinopharyngitis), infections of the throat, and even some types of lung infections and ear infections (otitis). Dental diseases can also affect the digestive system, causing a variety of conditions ranging from gastritis and ulcers to diarrhea. In severe cases, infections of the brain and the bones (osteomyelitis) may occur, or a variety of joint conditions such as rheumatoid arthritis (Román and Rodríguez 1997:239).

Another kind of pathology found to be widespread was porotic hyperostosis. This term encompasses lesions that mainly affect the bones of the skull and the eye sockets (cribra orbitalia). The affected bone develops a porous quality that has a sieve-like or coral appearance. This is related to iron-deficiency anemia, which can result from nutritional deficiencies due to frequent diarrhea, diets with little iron, or the action of several species of intestinal parasites, among other factors (Román 1990:84–94) (Figure 12). This pattern is found in many pre-industrial urban populations, and would have been present in Cortés's sixteenth-century Spain.

DISEASES OF ADULTS

In addition to suffering nearly the same dental diseases as children, adults were also subject to health problems associated with age. In first place come bone-joint diseases, which became chronic or inflammatory conditions due to a variety of causes. These diseases are expressed in pain and alterations in the function of certain bones, muscles, and joints. These conditions can progressively destroy the connective structures of the joints (mainly the cartilage) and cause de-

Figure 11. An adult showing an extreme buildup of tartar on all his teeth, which produced strong halitosis in the individual, in addition to being a source of permanent infection.

Figure 12. A fragment of a child's skull in which there appears a lesion characteristic of iron deficiency anemia known as porous hyperostosis.

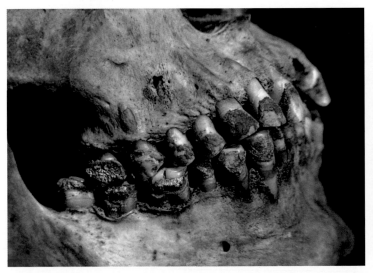

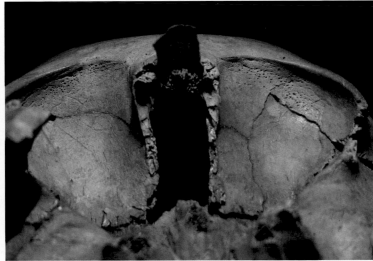

formities; they may even cause varying degrees of disability. Most individuals between 30 and 35 years of age had one or another of these conditions, mainly in the spinal column and the shoulder, elbow, hip, and knee joints. Among the most common of these are arthritis and ankylosing spondylitis (Figure 13).

Other bone pathologies in the pre-Hispanic population were due to infectious diseases. Among the most common were tuberculosis, leprosy, and syphilis (Figure 14).

Since this was a warrior people, another major group of bone lesions and their collateral consequences consisted of bone trauma, led by a large number and many types of fractures, dislocations, and infected wounds. In general, these lesions are found in male individuals, and disproportionately affect the long bones of the limbs, as well as the skull (Figure 15).

In conclusion, it is important to clarify that we do not know the real frequency of these and other diseases and health conditions within the pre-Hispanic population, or the treatments and medicines that were prescribed to cure the sick in all cases. The reasons for this are, first, that the sources do not describe or classify the types of diseases precisely enough, and they do not clearly explain their symptoms and evolution, which makes it difficult to reliably identify them—except when a clear diagnosis is provided with the characteristics that are well defined in the texts and descriptions of the treatments involved.

Second, it needs to be recognized that there are no representative samples of the population grouped by age and sex, which would allow us to make paleoepidemiological studies, that is, to determine which were the most common diseases among children, adolescents, and adults or the elderly, or what sickened men and women of different ages, for example.

A third problem is that since the individuals belonged to the different social strata of Aztec society, we can only speak of the existence of this or that disease but we cannot describe its prevalence within a specific social or occupational group, or in rural areas as opposed to the city. The

Figure 13. An example of degenerative disease appears in the lumbar vertebrae of an adult from Tlatelolco; they show the bony outgrowths known as osteophytes caused by osteoarthritis, a disease that affected the elderly.

Figure 14. An extreme case of a probable bone tuberculosis which affected the iliac bones of an individual of advanced age.

Figure 15. Traumatism and process of infection located on the forward side of an adult's tibia, caused by the incrustation of an arrowhead. The wound must have been extremely painful, in addition to showing inflammation and continual suppuration.

differing economic, political, and social statuses among the population offered different consumer goods and different living standards and lifestyles, which would have strongly influenced their different states of health and disease. All this poses an extremely complex problem, which speaks to us of a highly developed society about which we know only small fragments in regard to medicine.

REFERENCES

Bye, Robert and Edelmira Linares. 1999. "Plantas medicinales del México prehispánico" ["Medicinal Plants of Pre-Hispanic Mexico"] In *Arqueología Mexicana*. Vol. VII, no. 39, Mexico City, pp. 4–11.

Furst, J. 1995. *The Natural History of the Soul in Ancient México*. New Haven: Yale University Press.

Goodman, Alan, et al. 1985. "Health Changes at Dickinson Mounds, Illinois" in *Paleopathology at the Origins of Agriculture*, Mark N. Cohen and George Armelagos, eds. Orlando, Fla.: Academic Press, 271–305.

Hernández Espinosa, Patricia O. 2006. "Entre flores y chinampas: La salud de los antiguos habitantes de Xochimilco ["Between Flowers and *Chinampas*: Health of the Old Inhabitants of Xochimilco"]. In Lourdes Márquez Morfín and Patricia Hernández Espinosa, coordinators, *Salud y Sociedad en el México Prehispánico y Colonial* [*Health and Society in Pre-Hispanic and Colonial Mexico*]. Mexico City: ENAH, 327–66.

López Austin, Alfredo. 1975. *Textos de medicina náhuatl* [*Náhuatl Medicinal Texts*]. Mexico City: UNAM.

———. 1988. *Cuerpo humano e ideología* [The Human Body and Ideology]. Vol. 1. Mexico City: UNAM-IIH

Murillo Rodríguez, Silvia. 2006. "Sociedad y salud en la isla de Xico" ["Society and Health on the Island of Xico"]. In Lourdes Márquez Morfín and Patricia Hernández Espinosa, coordinators, *Salud y Sociedad en el México Prehispánico y Colonial*, Mexico City: ENAH, pp. 129–50.

Newman, Michael and Goodman, Anthony. 1989. "Oral and Dental Infections" in Sydney Finegold and Lance George, eds., *Anaerobic Infections in Humans*. SanDiego, Calif.: Academic Press.

Ortiz de Montellano, Bernard R. 1990. *Aztec Medicine, Health, and Nutrition*. New Brunswick and London: Rutgers University Press.

———. 1993. *Medicina, salud y nutrición aztecas* [Aztec Medicine, Health, and Nutrition]. Mexico City: Siglo XXI Editores.

Pérez Tamayo, Ruy. 1988. *El concepto de enfermedad* [*The Concept of Disease*], UNAM Facultad de Medicina, CONACYT-FCE, Mexico City.

Román Berrelleza, Juan Alberto. 1990. *El sacrificio de niños en el Templo Mayor* [Child Sacrifice at the Great Pyramid], INAH/GV Editores, Asociación de Amigos del Templo Mayor, Mexico City.

———. 1997. "Las patologías dentales en individuos localizados en ofrendas a los dioses de la lluvia" ["Dental Pathologies in Individuals Sacrificed to the Gods of Rain"] In *El cuerpo humano y su tratamiento mortuorio* [*The Human Body and its Funeral Treatment*]. Elsa Malvido, Gregory Pereira, and Vera Tieslerz, coordinators, Mexico City: INAH, pp. 213–40.

Sahagún, Fray Bernardino. 1997. *Historia General de las Cosas de la Nueva España* [*General History of Things in New Spain*], Editorial Porrúa No. 300, Mexico City.

Skinner, Mark and Goodman, Alan. 1992. "Anthropological Uses of Developmental Defects of Enamel," in *Skeletal Biology of Past Peoples: Research Methods*. New York: Wiley-Liss, 153–74.

Viesca Treviño, Carlos. 2005. *Medicina prehispánica de México* [*Pre-Hispanic Medicine in Mexico*]. Mexico City: Panorama Editorial.

Zolla, Carlos. 2005. "La medicina tradicional indígena en el México actual" ["Traditional Indigenous Medicine in Mexico Today"]. In *Arqueología Mexicana*. Vol. XIII, no. 74. Mexico City, pp. 62–65.

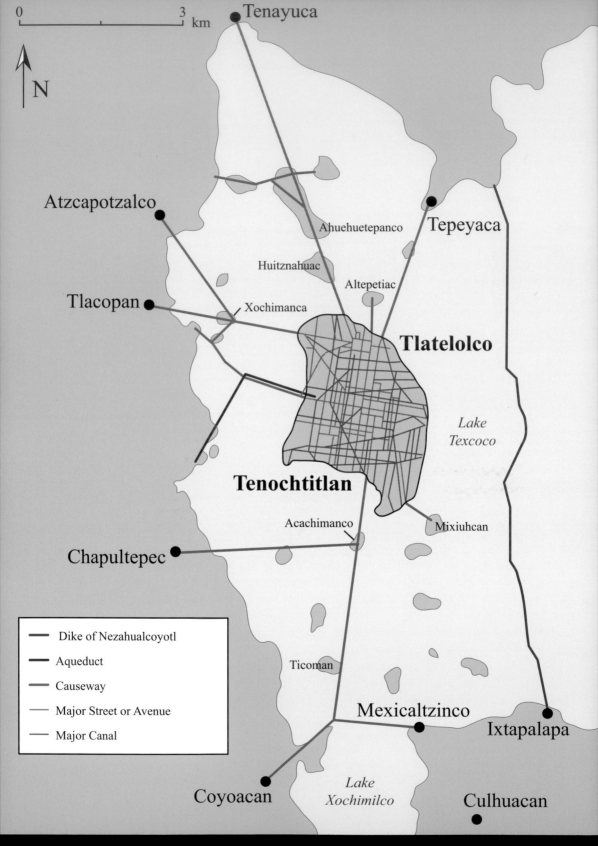

Figure 1. The Metropolitan Region of Tenochtitlan.

TENOCHTITLAN IN 1519: A PRE-INDUSTRIAL MEGALOPOLIS

WILLIAM T. SANDERS, PENNSYLVANIA STATE UNIVERSITY

Montezuma then took him by the hand and pointed out to him the different parts of the city, and its vicinity, all of which were commanded from that place. Here we had a clear prospect of the three causeways by which Mexico communicated with the land, and of the aqueduct of Chapultepeque, which supplied the city with the finest water. We were struck with the numbers of canoes, passing to and from the main land, loaded with provisions and merchandise, and we could now perceive, that in this great city, and all the others of that neighborhood which were built in the water, the houses stood separate from each other, communicating only by small drawbridges, and by boats, and that they were built with terraced tops. We observed also the temples and oratories of the adjacent cities, built in the form of towers and fortresses, and others on the causeway, all whitewashed, and wonderfully brilliant. The noise and bustle of the market-place below us could be heard almost a league off, and those who had been at Rome and at Constantinople said, that for convenience, regularity, and population they had never seen the like. (Díaz del Castillo 1927:178)

These are the words of Bernal Díaz del Castillo, a Spanish soldier who accompanied Hernán Cortés in the conquest of Mexico. As soon as Cortés reached the coast of what is today Mexico, he heard stories of a king who lived in a great city situated within a lake, who had conquered most of the surrounding area and gathered great wealth from conquered kingdoms. After an arduous trek, Cortés and his army reached the capital city, called Mexico or Tenochtitlan. As Díaz's description demonstrates, the Spaniards were stunned by what they saw.

The city had a population of well over 100,000, possibly as high as 200,000, concentrated in an area of only 4.6 square miles. It was located within a shallow lake, connected to the lake shore to the north, west, and south by broad causeways (Figure 1). Nine smaller urban communities, Tenayuca, Azcaputzalco, Tlacopan, Coyoacan, Huitzilopochco, Mexicalcingo, Culhuacan, Ixtapalapa and Xochimilco, were located either within the lake or on the shore. Including these outlying communities, the total population of this megalopolis in 1519 was 200,000 or 300,000 people, making it one of the ten largest cities in the sixteenth-century world.

A major factor in the emergence of this conurbation was the presence of the lake as an artery for the movement of goods and people by canoe and as a source of the food that sustained these urban communities. The abundance and the close spacing of transport canals facilitated the movement of canoe traffic even to the houses of private residents (Figure 2). Canoe transport was critical even in supplying drinking water to the residents of the city.

The lake waters were fresh enough to support agricultural activity and to use for some household tasks, such as bathing and washing clothes, but they were too saline to drink or use in food preparation. The city relied upon water from the springs in what is today Chapultepec Park. A great aqueduct brought spring water to the center of the city, and secondary channels carried water from the aqueduct directly to high status residences. The rest of the population relied upon water supplied by professional water carriers. Water carriers paddled their canoes to specific locations along the aqueduct where government inspectors opened a conduit and permitted them to fill their water jugs. The boatmen paid a fee for the water, and this fee was presumably added to the price for which the water was sold.

A second factor in the emergence of this great city was imperial expan-

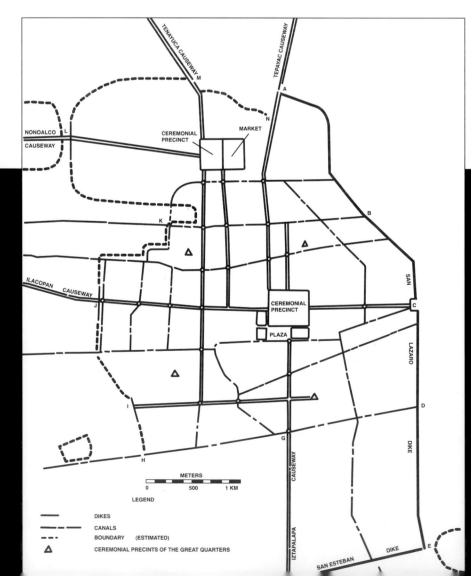

Figure 2. The City of Tenochtitlan/ Tlatelolco showing the major navigation canals in the mid-sixteenth century.

sion. The Aztec Triple Alliance dominated more than four hundred once independent polities, with a total population of five to six million people spread over an area of 77,220 square miles (see Chapter 1, Figure 12). Conquered polities within the Basin of Mexico supplied labor for the construction of public buildings and urban infrastructure, and they were taxed in basic commodities for the support of the government. A large territory adjacent to the Basin of Mexico (in the present-day states of Hidalgo, Puebla, and Morelos and the state of Mexico) provided staple grains and other bulky products such as lumber and lime for construction. The rest of the empire, which consisted of polities at lower altitudes, paid a tribute in tropical products including fine cotton textiles, cacao beans, copper tools (primarily axes), tropical fruits, tropical bird feathers, fine textured stone, shell, and gold for the manufacture of jewelry, all products used by the upper and middle classes.

The collection and distribution of tribute from this huge support area stimulated the economy of the city and gave professional merchants greater scope for their mercantile activity.

THE AREA OCCUPIED BY THE CITY

Tenochtitlan was a dense urban settlement, covering approximately 4.6 square miles (Figure 3). The map actually includes two adjacent cities, Tenochtitlan and Tlatelolco, founded separately and each governed by its own hereditary ruler until 1473 when Tenochtitlan conquered Tlatelolco and replaced its ruler with an appointed governor. Ahuitzotl's Dike marked the eastern edge of the city. Tenochtitlan appears to have occupied an area of about 3.5 or 3.8 square miles, and Tlatelolco, about 1 square mile.

Figure 3. Tenochtitlan and its five great barrios (including Tlatelolco) in 1519.

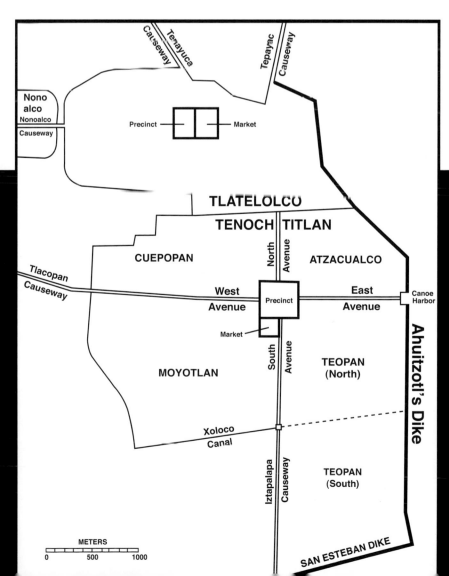

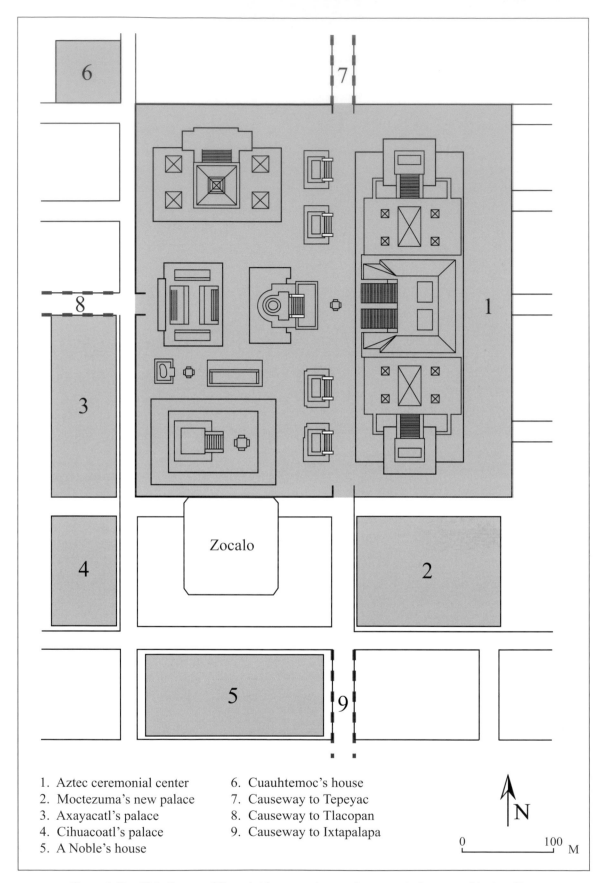

Zocalo

1. Aztec ceremonial center
2. Moctezuma's new palace
3. Axayacatl's palace
4. Cihuacoatl's palace
5. A Noble's house
6. Cuauhtemoc's house
7. Causeway to Tepeyac
8. Causeway to Tlacopan
9. Causeway to Ixtapalapa

N

0 100 M

Figure 4. The Civic Center of Tenochtitlan, superimposed on twentieth-century Mexico City.

The core of Tenochtitlan was an area approximately 2,624 square feet with several important features (Figure 4). A large open plaza, today called the Zocalo, served as central marketplace, primarily for the sale of food. To the north was a great rectangular enclosure, 1,312 feet east-west by 1,230 feet north-south, which was the religious center of the city. To the south and west of the market were the residences of high-ranking nobles and former Aztec rulers. Among them was the palace of Axayacatl, the sixth ruler of Tenochtitlan, used to lodge the Spanish army during the conquest. Moctezuma II's palace, east of the central plaza, probably measured 1,640 feet north-south by 1,148–1,312 feet east-west.

THE ROYAL PALACE AND COURT

In ancient states, the palace of the ruler is an administrative center as well as a residence. Spanish and Mestizo writers describe the Aztec ruler's palace in some detail, giving us information on the institutional structure of the Aztec state (Table 1).

TABLE 1

Use of Space in the Palace of Moctezuma II

Name in Nahuatl of Facility	Function	Personnel
Totocalli	Craft workshop	Tolteca (goldsmiths, lapidarians, feather workers)
Coacalli	Lodgings for visitors of high rank	Servants attending these lords
Cuicacalli	House of song and council complex for telpochcalli school teachers	Ward school teachers, tiachcahuacan, telpochtlatoque
Petlacalco	Storage facilities for royal tax and tribute and administrative facilities	Tax administrators (calpixque), accountants (tecuiloque)
Tlacxitlan	Highest judicial court for nobles and commoners for final sentence	Judges (of noble descent)
Tecalli	Lower court for civil cases involving commoners' appeals	Judges (tecuhtlatoue or tepantlatoque), lawyers and police (achcacauhtin)
Malcalli	Prison	Guards, prisoners
Tecpilcalli	Warrior councils	Noble warriors of high rank
Tequihuacalli or Cuauhcalli	House of Eagles, council of war	Highest-ranking warriors of commoner descent

Table 1 makes clear that the palace served as a center of government and that the government was staffed by a great number of specialized officials, some of whom resided within the palace. A notable feature of the political system was the presence of judicial courts to resolve disputes and punish transgressors—the hallmark of a state-level political society.

The palace was built on a rectangular platform with twenty entrances on four sides. Within it were three great patios surrounded by ample hallways, 29.5 feet in width. One of the patios had a fountain in the center, which supplied water to the palace. Within the palace were one hundred apartments, each measuring 26 by 33 feet and provided with a bath.

The northern two thirds of the palace included the royal residence, the council chambers, and two open courtyards that were meeting places for large numbers of high-status people. Archaeological excavations suggest that the third patio was the major area for food preparation in the palace. Areas to the southeast and east were probably occupied by botanical and zoological gardens, storage facilities for the royal tribute, and craft workshops where the royal tribute was processed into elite goods. Portions of this area, particularly the botanical gardens, must have resembled the chinampa periphery of the city (see bottom of map).

An important aspect of royal life was the daily gathering of hundreds, or thousands, of people to attend the ruler and to pay him respect. Partly, this was simple display: It emphasized the high status of the ruler of Tenochtitlan. Conquered lords were required to reside at Tenochtitlan part of the year, and their heirs resided permanently in the city until they reached adulthood. Both were required to visit the palace daily and pay their respects to the ruler. Representatives from the city wards came to receive instructions regarding the maintenance of the street and canal system and the daily cleaning of the city. All of these visitors were fed at the palace, a conclusion based on archaeological evidence.

In the 1930s, Eduardo Noguera conducted excavations on the site of the old Volador marketplace prior to the construction of a new Palacio de Justicia (Figure 4). He uncovered a small altarlike platform in the center of a large plaza. The altar was only a meter tall with an area of approximately 753 square feet. When Noguera excavated the small platform, he found an extraordinary deposit of nearly two thousand complete, but broken, ceramic vessels! Vessel types

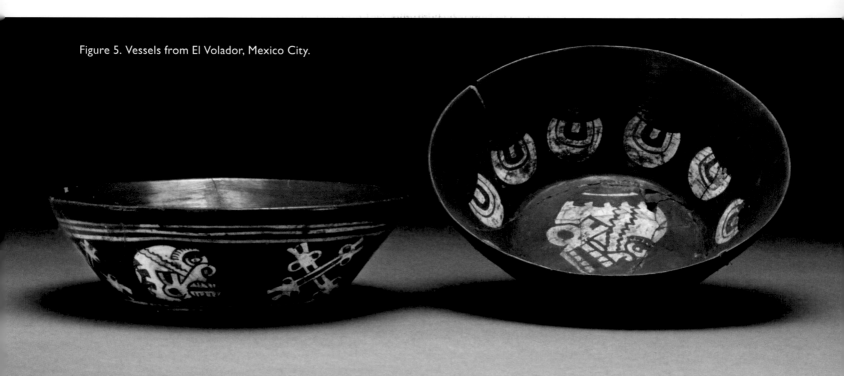

Figure 5. Vessels from El Volador, Mexico City.

included: chile grinders (15), "cafeteria trays" (153), small bowls (132), "copas" (249), and miscellaneous (112) (Solis and Morales 1991).

"Cafeteria trays" are shallow platelike Black-on-Orange vessels, divided into compartments like those in a cafeteria tray, clearly used to serve solid food. The bowls were used for liquid foods (Figure 5), and copas are stemmed goblets, for drinking pulque (an alcoholic beverage extracted from the maguey plant) and chocolate. Very notable in this assemblage is the emphasis on vessels for serving food and drinks.

Why were the vessels intentionally broken? The answer is undoubtedly related to the famous New Fire Ceremony. In Aztec cosmogony, time was divided into fifty-two-year cycles, and the current world was destined to be destroyed at the end of one of these cycles. The day before the completion of a cycle, therefore, all household utensils were destroyed and people waited anxiously for the sun to rise on the first day of the next fifty-two-year cycle. That day, new vessels were purchased by the population, and they began a new fifty-two-year period of guaranteed existence.

The last cycle ended in the year 1507, four years after Moctezuma II ascended the throne. The burial of the vessels at Volador almost certainly coincides with one of these fifty-two-year cycles, presumably the last one. Because of the great number of these vessels and the Spanish accounts of the great number of people who were fed at the palace, we conclude that these vessels were used for serving the visitors, and that the Volador patio was the reception area for these daily visitors.

THE GREAT TEMPLE (TEMPLO MAYOR) AND ITS CEREMONIAL PRECINCT

The religious center of Tenochtitlan was a walled ceremonial precinct that contained many important temples. Civic life in Tenochtitlan was almost continuously shaped and colored by highly theatrical ritual performances focused on one or another of the temples within this precinct. The precinct was dominated by the Great Temple, a towering pyramid topped by two sanctuaries (Figure 6). The southern sanctuary belonged to Huitzilopochtli, the tutelary god of the Mexica; the northern sanctuary was occupied by Tlaloc, the God of Rain.

Sahagún provides a list of seventy-eight temples and religious facilities located within the ceremonial precinct, and he provides useful information about the deities honored and rituals performed. Of these seventy-eight structures, only twenty-six are identified as temples. Most of the other structures were probably associated with the temples. Yopico temple, for example, would have been closely linked with a *calmecac* (religious school) and a skull rack (*tzompantli*). The temple of Huitzilopochtli was probably linked to eight other structures, including two *calmecacs* (schools), a *cuauhxicalco* (the eagle house), a *tlachtli* (ball court), a tzompantli, and two "houses" named Tilocan and Itepeyoc.

The number of structures on Sahagún's list has given rise to a prolonged controversy. Some scholars believed that the precinct would have been "too crowded," and suggested that Sahagún referred to religious structures scattered throughout the city. Spanish sources state that each of the city's great quarters and barrios had its own temple (Cortés 1963). There is, presently, archaeological evidence for approximately forty structures within the precinct. These religious structures

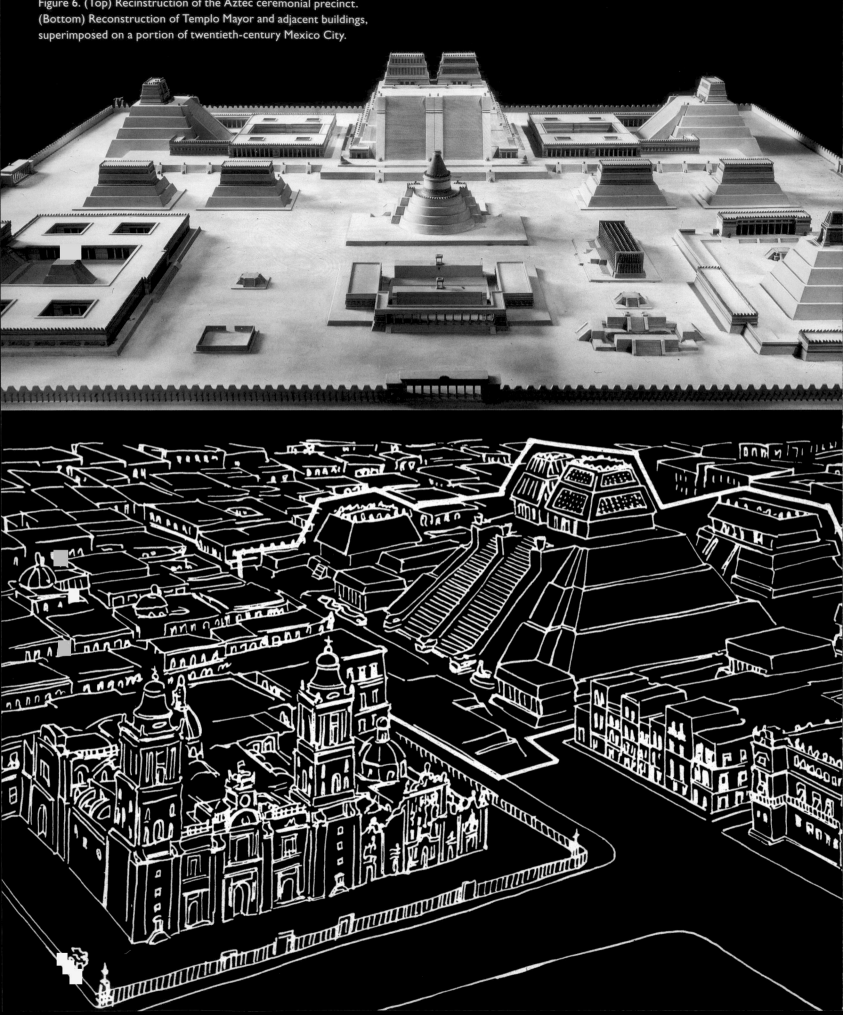

Figure 6. (Top) Reconstruction of the Aztec ceremonial precinct. (Bottom) Reconstruction of Templo Mayor and adjacent buildings, superimposed on a portion of twentieth-century Mexico City.

are closely juxtapositioned, so that the available space would have easily accommodated several dozen additional structures. Thus, the archaeological evidence confirms Sahagún's description.

The archaeological and historical data lead us to interesting conclusions about the uses and functions of space within the precinct. First, the dense clustering and the congested nature of buildings within the enclosure mean that great numbers of people could not have participated in or observed Aztec religious ceremonies. Access must have been restricted to actual participants and a few elite spectators, probably no more than a few hundred or a few thousand people at any given time. Second, the residential spaces occupied by priests, novices, and students were not extensive, probably accommodating no more than a few hundred or a few thousand ecclesiastics.

Excavations of the Great Temple directed by Eduardo Matos (1984) have revealed that it was built and completely rebuilt at least five times (Stages II–VI); in addition, a half dozen or more new facades were built over the old (Figure 7). These rebuildings were conducted by rulers to commemorate their success in war, and they are a striking example of the integration of state and church.

The construction of pyramids and other massive structures over porous marshy terrain presented difficult engineering problems. Differential rates of sinkage constantly threatened the stability of these buildings. Countermeasures included the use of hundreds or even thousands of fence-post-sized supporting piles, and the construction of a huge earthen platform measuring at least 1,312 by 1,312 by 37.7 feet and containing almost 65 million cubic feet of earth and rubble

Figure 7. The Great Temple of Hutzilopochtli and Tlaloc showing successive stages of rebuilding.

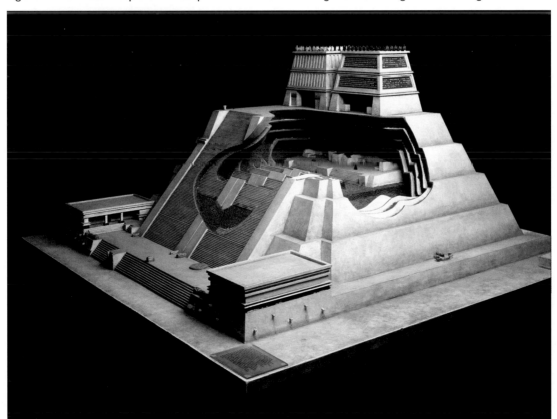

fill (López Luján 1994) (Figure 8). This platform is perhaps the largest public construction in Mesoamerican history. Additional platforms of this size may underlie the entire civic center of Tenochtitlan, an enormous input of labor for a civic construction.

A major archaeological discovery was the great number of offerings associated with the Great Temple. An important study of offerings at Tenochtitlan's Great Temple by López Luján (1994) indicates that many were probably set in place as part of ceremonies dedicated to Tlaloc and Huitzilopochtli, the two gods residing in side-by-side shrines at the top of the pyramid. These offerings likely marked the dedication of a newly rebuilt temple, or the coincidence of new conquests or other major political events with one or another of the regular religious ceremonies.

Figure 8. Excavations in the Cathedral and El Sagrario.

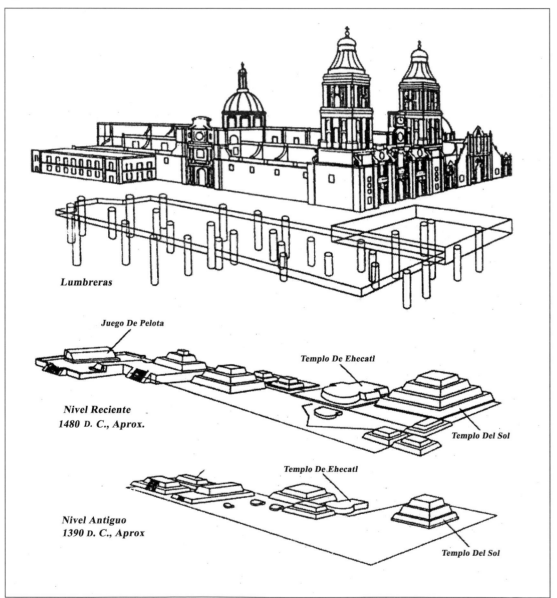

The close link between politics and religion is abundantly clear in the content of the offerings. The offerings included goods that were delivered as "gifts" or "tribute" from allied and conquered states alike, ranging from live animals to jade, gold, textiles, and tropical plumage. Clearly, *the spoils of empire* were emphasized (Figure 9).

Offering 48 is one of the most intriguing in terms of its historical significance. It included the skeletal remains of forty-two children. No cut marks were found on the bones, leading investigators to conclude that the children's throats had been slit, in agreement with historical descriptions of sacrifices dedicated to Tlaloc. These sacrificial offerings were associated with Tlaloc's half of the Phase IVa Templo Mayor, and evidently date to the mid- or late 1450s.

Figure 9. Offering 106 from the Templo Mayor.

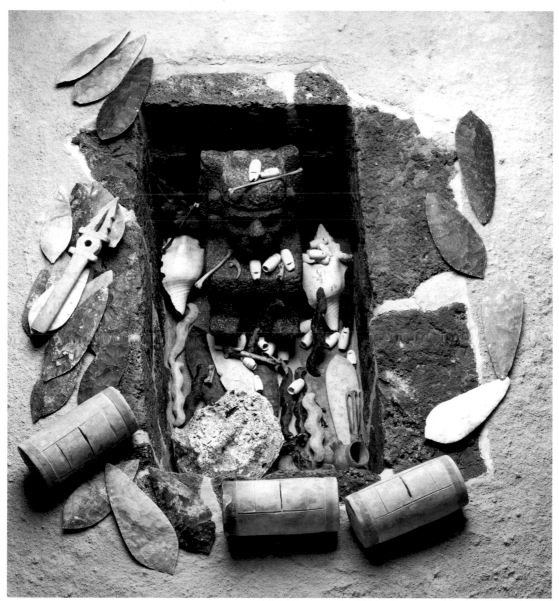

This was, according to Mexica historical accounts, a period of severe drought, early frosts, and consequently, severe famine. The situation became so desperate that the ruler, Moctezuma I (1440–67), first emptied his grain storehouses as "famine relief," and once this source was exhausted, decreed that his people might save themselves by any available means. Many poor people sold themselves as slaves to people from the Gulf Coast, which had not been afflicted with drought (Durán 1967).

Figure 10. The barrios of Tenochtitlan/Tlatelolco based on the 1789 barrio map by José de Alzate.

Barrios

1	Tzapotlan	35	Ciaijcpmtzomcp
2	Chichimecapan	36	Toxcminca
3	Huehuecalco	37	T?
4	Tecpancaltltlan	38	Caozloa
5	Teocaltitan	39	Zaoitlan
6	Tequicaltitlan	40	Tzahualtonco
7	Atuampa	41	Mecamalinco
8	Astacalco	42	Atenantitech
9	Tlalcocomolco	43	Atenantitlan
10	Amanalco	44	Telpochcaltitlan
11	Cihuattocatltilan	45	Apohcacan
12	Yopico	46	Atecocolecan
13	Tepetitlan	47	Atezcapan
14	Atizapan	48	Tlatelolco
15	Xihuitonco	49	Hueipan
16	Tlatilco	50	Tepitom
17	Tequixquipan	51	Capoltitlan
18	Necatitlan	52	Coatlan
19	Xoloco (Tlachcoat)	53	Xolalpa
20	Cuezcontitlan	54	Acozac
21	Acatlan	55	Tlaxoxiuhco
22	Toltenco	56	Tolquechiuhcan
23	Otlica	57	Iztatlan
24	Ateponazco	58	Nonoalco
25	Tlachcuititlan	59	Colhuacatzonco
26	Macultlapllon	60	Tezcatzonco
27	Misiue	61	Analpa
28	Zacatlan	62	Teocaltitlan
29	Tzoquipan	63	Atlampa
30	Huitznahuatonco	64	Tlaxilpa
31	Temazcaltitlan	65	Toltenco
32	Ocelotzontecontitlan	66	Copolco
33	Ometochtitlan	67	Cuepopan
34	Atlixco	68	Tecoaltitlan

Legend

△ Ceremonial Precints of the Great Quarters
▢ Ceremonial Precint
▢ Market
Tenochtitlan City Division Quarters:
▢ Cuepopan
▢ Atzacualco
▢ Moyotlan
▢ Teopan (North)
▢ Teopan (South)

THE WARDS OF TENOCHTITLAN/TLATELOLCO[1]

Avenues radiating from the ceremonial precinct of Tenochtitlan divided the city into four Great Quarters: Atzacualco, Cuepopan, Moyotlan, and Teopan (Figure 10). Each of the four quarters was divided into smaller wards or districts, "barrios grandes." These were further subdivided into smaller spatial divisions, "barrios menores." The latter, in some cases at least, were no more than a short line of houses on one side of a single street.

The smaller barrios played a crucial role in virtually all aspects of economic, civic, and religious life. For many high-status professions and crafts, the barrios functioned as hereditary guild-like organizations. Goldsmiths, feather workers, lapidaries, and the *pochteca,* the long-distance merchants who procured the raw materials for these crafts (along with the finished products by foreign craftsmen) occupied specific barrios, each with a temple complex where the patron deity of that craft group was worshipped.

Many other barrios must have contained people with diverse, less prestigious occupations. Did the producers of more mundane goods live in barriolike concentrations similar to elite craftsmen? There is some evidence to suggest that they did. Monzón collected references to associations between craft specializations, barrio residence, and patron deities, summarized by Sonia Lombardo de Ruíz (1973) in Table 2.

TABLE 2

Barrios, Occupations, and Deities

Barrio Name	Principal Occupation	Principal Deities
Acxotlan (Tlat)	Merchants	Yiacatechutli
Ahuachtlan (Tlat)	Merchants	Yiacatecuhtli
Amantlan (Ten/Tlat)	Feather workers	Coyotlinahual
Atempan (Ten/Tlat)		Toci
Atlaucho (Ten?/Tlat)	Merchants	Yiacatechutli
Huitznahuac (Ten)		Huitzilopochtli, Tezcatlipoca, Centzon-huitznahua
[Nappanteuctlan]	Matmakers	Nappatecuhtli
Pochtlan (Ten/Tlat)	Merchants	Yiacatecuhtli
Tlamatzinco (Ten)	Pulque makers/venders	Tlamatzincatl, [Yiacatecuhtli?]
Tzapotlan (Ten)	Sellers of turpentine unguent	Tzapotlatonan
Tzonmolco (Ten)	Merchants	Xiuhtecuhtli, Huehueteotl, Ixcozauh-qui, [Yiacatecuhtli]
Yaotlican (Ten)	[Merchants?]	[Yiacatecuhtli?]
Yopico (Ten)	Gold and silversmiths	Xipe Totec
	Fishermen	Opochtli
	Lapidaries	Chicnahuizcuintli, Nahualpilli, MaculCalli, Cinteotl

[1] Most of the information presented here and in Residences at Tenochtitlan/Tlatelolco is abstracted from a paper by Calnek (2006).

Barrio elders, called *tlaxilacalleque*, maintained property registers, recorded births, marriages, and deaths, and adjudicated minor disputes involving barrio members. Barrios occupied by commoners (*macehualtin*) provided labor services to the ruler when required and were responsible for supplying well-trained contingents for military campaigns.

The only extant map of the urban barrios was prepared by Don Jose de Alzate in 1789, more than two and a half centuries after the Spanish conquest. His map was superimposed on an earlier street plan by Manuel Villavicencio, as revised by Ildefonso Iniesta Vejarano. Figure 10 is a drawing of this map with modern street names added when they coincide with streets shown on the original plan. After Conquest, an area of 1 square mile in the center of Tenochtitlan was co-opted by the Colonial administration to provide a residential area for the Spanish settlers. The native population was forcibly removed and resettled elsewhere. As a result, the pre-Hispanic barrios in this area do not appear on Alzate's map.

Figure 11. The twentieth-century town of Xochimilco and its adjacent chinampa zone. The pattern here serves as a model for Tenochtitlan in 1519 with its solidly built-up center and chinampa periphery.

RESIDENCES AT TENOCHTITLAN/TLATELOLCO

Tenochtitlan/Tlatelolco in 1519 consisted of two major portions. One was an area of 1.3 square miles where the two civic centers were located, which consisted of solid ground gradually built up during the two centuries between the founding of the two cities and the Spanish Conquest. Around this solid core was a zone of small house lots and adjacent *chinampas* that covered an area of approximately 3.35 square miles (Figure 11).[2]

Ethnohistorian Edward Calnek studied the residential units of Tenochtitlan/Tlatelolco based on 128 land title records, dating to the sixteenth century, after the Spanish conquest. These documents give information on the owners of the properties, on inheritance patterns, and on the size of the house lot and its component parts. Many cases even included a map! Each house lot contained a residential compound, usually surrounded by a fence or wall and occupied by a number of related families. Each structure usually housed a nuclear family, sometimes including elderly or widowed parents, grandparents, or other relatives (Calnek 2003). The dwelling units were usually arranged around a common patio, where most daily household activities probably took place (Figure 12). In the peripheral areas of the city, additional space was devoted to chinampas

[2] Chinampas were artificial islands constructed in shallow areas of the lake, made from mud and floating vegetation and used in a highly productive system of agriculture, particularly in the southern lakes (see Chapter 2). Within the city, the chinampas were very small and served only as kitchen gardens.

Figure 12. House lot on the "Island" of Tenochtitlan.

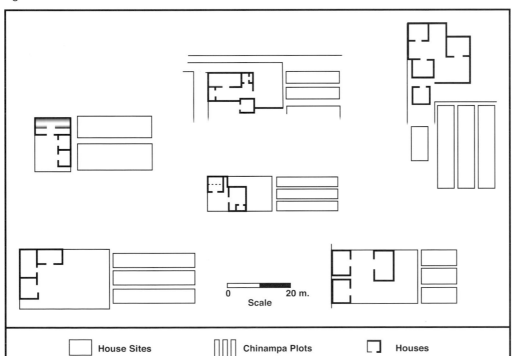

0 20 m.

Scale

☐ House Sites ‖‖‖ Chinampa Plots ⊏⊐ Houses

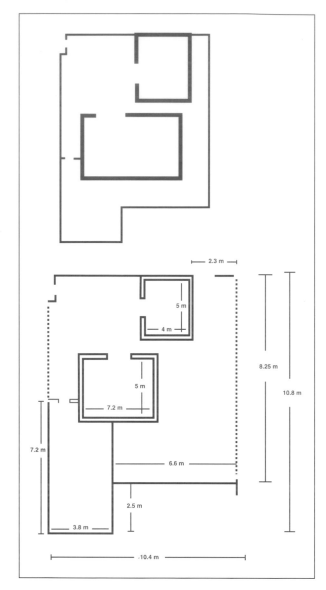

Figure 13. House lots and attached chinampas on the periphery of Tenochtitlan/Tlatelolco.

(Figure 13). Ethnohistoric accounts, confirmed by some archaeological data, indicate that craft workshops were located within the household space (see Chapter 6). The household served as a location for training new generations of craftsmen, and craftsmanship was inherited within households.

Most residential sites were small and accommodated three or four buildings, with a total area of less than 5,381 square feet. Frequently, they were even smaller. For example, one house lot was only 1,657 square feet and its two houses were 215 square feet and 376 square feet respectively. Excavations prior to construction of the Tepiton housing project in Mexico City yielded evidence of exceptionally dense occupation (Cepeda Cárdenas et al. 1977).

Some residential units, however, were much larger. A site referred to as a palace in the Barrio of Coatlan, originally occupied by a son of the Aztec ruler Ahuitzotl (1486–1502), covered an area of 40,472 square feet. This represents an order of magnitude different from all other residential sites for which dimensions are known.

According to Calnek, even the house lots and chinampas of lower status households were private holdings.

THE ECONOMY OF TENOCHTITLAN/TLATELOLCO

The economy of Tenochtitlan/Tlatelolco was very complex. It included three major components: the estate, the market, and the taxation system. Estates consisted of lands and sometimes labor attached to households for their support. Some of these were inherited private estates, but others were lands assigned by the ruler to support individuals while they served the state. Government officials supervised production on these estates and, in fact, the holder of an estate often did not even know exactly where it was located! The holder was not at all involved in estate administration, either in terms of the production or the transportation of goods. The goods were simply turned over to him.

The market was an extremely important economic institution. Households produced surpluses of food or other goods, sold them in the marketplace, and purchased food and other goods for the maintenance of their households. This activity reached its climax in the great marketplace of Tlatelolco. The description of the Tlatelolco market by Díaz del Castillo (1927:176–77) demonstrates of the extent of economic specialization found in the urban economy:

When we arrived at the great market place, called Tlatelolco, we were astounded at the number of people and the quantity of merchandise that it contained, and at the good order and control that was maintained, for we have never seen such a thing before. . . . Each kind of merchandise was kept by itself and had its fixed place in the market. Let us begin with the dealers in gold, silver, and precious stones, feathers, mantles, and embroidered goods. Then there were other wares consisting of Indian slaves both men and women . . . and they brought them along tied to long poles, with collars round their necks so that they could not escape, and others they left free. Next there were other traders who sold great pieces of cloth of cotton, and articles of twisted thread, and there were *cacahuateros* who sold cacao. . . . There were those who sold cloths of *henequen* [i.e., maguey] and ropes and the sandals with which they are shod, which are made from the same plant, and sweet cooked roots, and other tubers which they get from this plant, all were kept in one part of the market in the place assigned to them. In another part there were skins of tigers and lions, of otters and jackals, deer and other animals and badgers and mountain cats, some tanned and others untanned, and other classes of merchandise.

Let us go on and speak of those who sold beans and sage and other vegetables and herbs in another part, and of those who sold fowls, cocks with wattles [i.e., turkeys], rabbits, hares, deer, mallards, young dogs and other things of that sort in their part of the market, and let us also mention the fruiterers, and the women who sold cooked food, dough and tripe in their own part of the market; then every sort of pottery made in a thousand different forms from great water jars to little jugs, these also had a place to themselves; then those who sold honey and honey paste and other dainties like nut paste, and those who sold lumber, boards, cradles, beams, blocks and benches, each article by itself, and the vendors of *ocote* firewood, and other things of a similar nature. But why do I waste so many words in recounting what they sell in that great market?—for I shall never finish if I tell it all in detail. Paper, which in this country is called *amatl,* and reeds scented with liquidambar, and full of tobacco, and yellow ointments and things of that sort are sold by themselves, and much cochineal [a dye] is sold under the arcades which are in the great market place, and there are many vendors of herbs and other sorts of trades. . . . I am forgetting those who sell salt, and those who make the stone knives [made of obsidian], and how they split them off the stone itself; and the fisherwomen and others who sell some small cakes made from a sort of ooze which they get out of the great lake, which curdles, and from this they make a bread having a flavour something like cheese. There are for sale axes of brass and copper and tin, and gourds and gaily painted jars made of wood. I could wish that I had finished telling of all the things which are sold there, but they are so numerous and of such different quality and the great market place with its surrounding arcades was so crowded with people, that one would not have been able to see and inquire about it all in two days.

The daily market at Tlatelolco clearly indicates a highly urbanized economy with full-time craft specialization. A daily market is only necessary if artisans live day to day from the goods sold in the marketplace. Besides the great market at Tlatelolco, there was a large food market in

the center of Tenochtitlan, and local markets were scattered throughout the city undoubtedly associated with barrio centers (Cortés 1971). These numerous marketplaces are another indication that population depended, on a daily basis, upon the purchase of food.

The market list indicates specialization in different production stages. For example, the market list includes raw gold, as well as gold objects, indicating that one specialist sold the raw materials, and another bought them and processed them into the finished goods sold then to the consumer. The same generalization can be made about the production of wood products or lime, sold in the marketplace and purchased by specialized masons who used these materials for house construction. The case of cotton cloth is particularly fascinating, because unspun cotton, dyes for dyeing cotton thread, cotton thread, cotton cloth, and finished clothes were all sold, indicating a processing series that included several specialists before the product arrived to the consumer.

The market also provided services. Some people sold pulque in establishments that we could only call bars, and others operated restaurants. There is even a reference to hotels. Day laborers and craftsmen gathered in markets and plazas waiting to be hired similar to the style of life then found in Spain. Most urbanites purchased water from professional water carriers.

The marketplace was highly organized. Spanish accounts mention police who maintained order in the marketplace and government officials who examined measures to make sure they were not false and punished individuals for such infractions. A courthouse was located in the center of the marketplace, where thieves and other transgressors were punished summarily. The reasons for these actions are very obvious—marketplaces are cosmopolitan locations where people from different ethnic groups and communities meet, and the possibility of quarrels and disputes is very high.

The final century before the Spanish Conquest witnessed an extraordinary historical process—the evolution of Tenochtitlan with a population of 150,000–200,000 people, an urban conurbation of 300,000. Prior to the Industrial Revolution cities with more than 100,000 people were very rare and the product of unusual sets of circumstances. Rome, the capital of an empire of forty to fifty million people, only had a population of 300,000-500,000 according to a study by Glenn Story. In the New World, only two other cities had populations of more than 100,000: Teotihuacan in the Basin of Mexico in 200–600 A.D. and Cuzco, the capital of the Inca empire, in the sixteenth century. I have argued that the chain of lakes in the Basin of Mexico and the use of canoes for travel played a major role in this unusual urban development.

REFERENCES

Anonymous (El Conquistador Anónimo). n.d. *Relación de Algunas Cosas de la Nueva España y de la Gran Ciudad de Temestitan y México.* León Díaz Cardenas, ed. Mexico City: Editorial America.

Barlow, Robert H. 1949. "The Extent of the Empire of the Culhua-Mexica." *Ibero-Americana,* No. 28. Berkeley: University of California Press.

Calnek, Edward. 2003. "Tenochtitlan/Tlatelolco: The Natural History of a City." In *Urbanism in Mesoamerica* vol. 1. W. T. Sanders, A. G. Mastache, and R. H. Cobean, eds. University Park, Pa.: Instituto Nacional de Antropología and Pennsylvania State University.

———. 1972. "Settlement Pattern and Chinampa Agriculture at Tenochtitlan." *American Antiquity* 37:104–115.

Cepeda Cárdenas, Gerardo, Ernesto Gonzales Licón and Guillermo Ahuja Ormachea. 1977. "Rescate Archeológico en el Barrio de Tepito, México D.F." In *Los Processos de Cambio en Mesoamérica y Areas Circumvecinas.* XV Mesa Redonda de la Sociedad Mexicana de Antropología.

Cortés, Hernán. 1971. "Cartas de Cortez." In *Cartas de Relación de la Conquista de América,* vol. 1, pp. 91–591. Mexico City: Editorial Nueva España.

Díaz del Castillo, Bernal. 1927. *The True History of the Conquest of Mexico.* Maurice Keatinge, trans. New York: Robert McBridge and Company.

Durán, Diego. 1943. *Historia de las Indias de Nueva España e Islas de la Tierra Firme.* Mexico City: Porrua.

Gonzalez, Aparicio, Luis. 1973. *Plano Reconstructivo de la Región de Tenochtitlan.* INAH. Sept. Mexico City.

Lombardo de Ruiz, Sonia. 1973. *Desarrollo Urbano de México-Tenochtitlan según las fuentes históricas.* INAH. Sept. Mexico City.

López Luján, Leonardo. 1994. *The Offerings of the Templo Mayor of Tenochtitlan.* Niwot: University Press of Colorado.

Luis de Rojas, José. 1986. *México-Tenochtitlan: Economía y Sociedad en el Siglo XVI.* El Colegio de Michoacan. Mexico City: Fondo de Cultura Económica.

Marquina, Ignacio. 1960. *El Templo Mayor de México.* INAH. Mexico City.

Matos, Moctezuma, Eduardo. 1988. *The Great Temple of the Aztecs.* London: Thames and Hudson.

Solis, Felipe and David Morales. 1991. *Rescate de un Rescate: Colección de Objetos Arqueológicos del Volador, Ciudad de México.* Catalógo de las Colecciones del Museo Nacional de Antropologia. Mexico City.

Zorita, Alonso. 1891. *Breve Relación de los Señores de Nueva España.* Salvador Chavez Hayhoe, ed. Mexico City.

Figure 1: An Aztec woman. She kneels, a position that would enable her to grind maize or weave cloth on a back-strap loom. This is a conventional pose for women in art commissioned by the Aztec state, although household figurines more often depict women in a standing position.

FIVE

AZTEC WOMEN: CAPABLE PARTNERS AND COSMIC ENEMIES

ELIZABETH M. BRUMFIEL,
NORTHWESTERN UNIVERSITY

Aztec women faced contradictory conditions. On the one hand, much of their social interaction was based on the principle of gender complementarity, which defined female and male as distinctive but equal and interdependent parts of a larger productive whole. On the other hand, they were increasingly subject to an ideology of gender hierarchy sponsored by the Aztec state. This ideology glorified male warriors and portrayed women as agents of cosmic disorder and enemies destined for conquest (Figure 1).

Sixteenth-century documents indicate that gender equality prevailed in many areas of Aztec life (Evans 2005; Hendon 1999; Kellogg 1997; McCafferty and McCafferty 1988; Quezada 1996). Aztec men and women regarded themselves as equally related to their mothers' and their fathers' families. Men and women could own houses, land, and movable property, and they inherited these assets equally. Men and women had parallel positions of public authority in the market, in young men's and young women's houses, and in temples. Market women and noble women were not impoverished; in fact, they controlled substantial wealth. The Aztecs said that a woman born on the lucky day 7 Monkey "would be very rich. She would produce well, make her wares well, and bargain astutely. . . . Not failing or diminishing, her dealings . . . would turn out well" (Sahagún 1950-82 bk. 4, ch. 20).

But Aztec women also were assigned an inferior status, particularly in the art, ritual, and mythology sponsored by the rulers of the Aztec state. The state depicted women as the instigators of conflict and cosmic disorder, destined for defeat at the hands of more powerful Aztec warriors (Gillespie 1989; López 2005; Nash 1978; Rodríguez 1988).

GENDER COMPLEMENTARITY

Duality was inscribed in Aztec religion. Prior to anything else in the cosmos, there were two primordial gods, Ometecuhtli (Lord of Duality) and Omecihuatl (Lady of Duality). This couple engendered the four great creator gods (all male): Red Tezcatlipoca, Black Tezcatlipoca, Quetzalcoatl, and Huitzilopochtli. Lesser Aztec gods were paired in male-female couples, among them: Tlaloc and Chalchiuhtlicue, the male and female water deities; Mictlantecuhtli and Mictlancihuatl, the god and goddess of the underworld; Xochipilli and Xochiquetzal, the god and goddess of feasts, fine craftsmanship, and pleasure; and Centeotl and Chicomecoatl, male and female personifications of maize. In addition, it was understood that the birth of all living things, especially human beings and agricultural crops, required male and female contributions. Human life required sexual intercourse between a husband and wife; agricultural fertility required that a moist, dark, female earth be charged with the heat and energy of a male sun (Quezada 1996).

Gender complementarity also emphasized the equivalence and interdependence of men and women in economic and social life. In Aztec households, men and women were assigned different duties with the understanding that both sets of activities were necessary for the success of the family. Male activities generally occurred outside the house: farming, fishing, long-distance trading, and making war. Female activities were mostly connected with the house and its courtyard: sweeping, cooking, and weaving. Interestingly, childcare was not considered a particularly female activity. Women were responsible for educating their daughters, and men were responsible for training their sons (Joyce 2000) (Figure 2).

Men's and women's economic roles were marked at birth. In the ceremony for the newborn infant, a baby girl was presented with the implements for her future labor: a broom, a reed basket

Figure 2. A father teaches his son to fish; a mother teaches her daughter to weave.

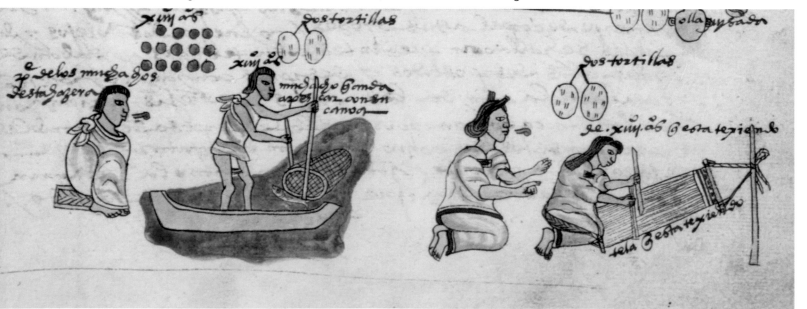

Figure 3: Spinning and weaving were important parts of Aztec women's gender identity. Here, a ceramic spindle whorl lies near the hand of an Aztec woman, placed there at her death in Xaltocan, Mexico.

containing unspun fiber, a spindle for spinning thread, and a small bowl to support the spindle. Baby boys were also given the things that they would use as adults: the tools of a carpenter, a feather worker, a painter of books, or a goldsmith, or the shield and arrows of a warrior. In accordance with the different roles expected of men and women, the umbilical cord of a newborn boy was given to a warrior to bury in some distant field of battle. The umbilical cord of a newborn girl was buried inside the house, beside the grinding stone and the hearth, where a woman would spend many hours each day, grinding maize and making tortillas (*Codex Mendoza* 1992, Sahagún 1950–82 bk. 4, ch. 1) (Figure 3).

Although Aztec women were associated with hearth and home, many activities took them beyond the confines of their patios. Women helped to gather the sap of maguey plants, which they fermented to make *octli* (pulque) or reduced to a sweet syrup or sugar by boiling. Women raised turkeys, and they traveled to the marketplace where they sold a range of goods: farm produce, wild herbs, salt, torches, firewood, prepared foods, and textiles. Women were also healers and midwives. Different qualities were admired in women, depending upon their station in life. Commoner women were honored for being "strong, rugged, energetic, wiry . . . exceedingly tough, animated, vigorous," while the ideal noblewoman was "patient, gentle, kind" and "worthy of being obeyed" (Sahagún 1950–82 bk. 10, ch. 13, 14).

WOMEN IN THE AZTEC ECONOMY

Aztec women were expected to be hard workers and able administrators of household wealth. They were supposed to join their labor with that of their husbands to achieve household well-being. Primary among a woman's domestic duties was providing food and clothing to her family. Ideally, the middle-aged woman was "a skilled weaver, a weaver of designs, an artisan, a good cook, a preparer of good food" (Sahagún 1950–82: bk. 10, ch. 3). In sixteenth-century documents, Aztec women are frequently pictured making food and weaving cloth, and instructing their daughters in these arts (Figure 1). These activities were essential to the success of both Aztec families and the Aztec empire.

Women spent long hours transforming dried maize into nutritious foods. They combined maize kernels with water and mineral lime, brought the mixture to a boil, and allowed it to cool overnight. This softened the maize, loosened the hulls from the kernels, and enriched the diet by releasing the niacin (vitamin B$_{12}$) in the maize and adding calcium to the food. Women ground the treated maize to a fine dough, increasing the digestibility of the maize and therefore the food energy that the maize provided to the body. The dough was patted into thin cakes (*tortillas*) and cooked on a ceramic griddle, or it was mixed with water and boiled to make a thin gruel (*atole*), or it was wrapped in corn husks and steamed to make maize dumplings (*tamales*). These maize dishes were flavored with many different sauces. Using mixtures of beans, tomatoes, avocados, tomatillos, chili, squash, diced cactus pads (spines removed!), wild greens, mushrooms, ground squash seeds, waterfowl, fish, rabbits, gophers, frogs, tadpoles, turkeys and dogs, Aztec women created sauces that were both tasty and nutritious. The sauces contributed protein and vitamins A and C to the diet. Preparing these foods was time consuming. In twentieth-century Mexico, a woman using a stone mano and metate spent about six hours a day grinding enough maize to supply her family with tortillas, atole, and tamales for their daily meals.

Aztec women also wove cloth. They worked primarily with two different fibers. One was *ichtli* fiber extracted from the leaves of the maguey plant. Maguey was a local plant, well suited to the thin soils, seasonal droughts, and frequent frosts in the Basin of Mexico (see Chapter 2). The maguey leaves were cut, soaked, and scraped to separate the flesh of the leaf from the fiber. The fiber was then washed and spun into thread using a spindle weighted with a ceramic spindle whorl (Figure 4). The thread was woven into cloth on a backstrap loom. Backstrap looms were little more than sets of sticks used to hold and manipulate warp threads during

Figure 4: At Xaltocan, Mexico, spindle whorls with sun and flower motifs suggest efforts to endow thread and cloth with *tonalli,* a light-heat-energy source that is the heat of life.

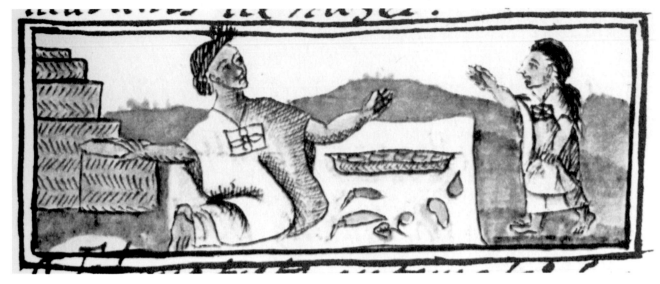

Figure 5: The chili seller sold red chiles, hot green chiles, yellow chiles, smoked chiles, and tree chiles, all imported from the warmer lowlands of Mexico. The baskets of wares behind this chile seller suggest that she is a specialized retailer and not just a vender of her own produce.

weaving. A belt connecting the loom to the weaver allowed the weaver to tighten and relax the warp threads as needed. Using these looms, Aztec women produced textiles with complex gauze and brocade designs.

Cotton was the other fiber used for cloth (Berdan 1987). Cotton could not be grown in high mountain valleys like the Basin of Mexico; it had to be brought by trade or tribute from nearby temperate regions in Morelos and Puebla or more distant lowland areas. Spinning the shorter cotton fibers into thread required only a lightly weighted spindle, but the end of the spindle was placed in a small ceramic bowl to improve control. Cotton cloth was also woven on a backstrap loom. Some designs were incorporated into the cloth during the weaving process; others were added by embroidery after the cloth had been completed using soft, dyed rabbit-hair thread, or by painting the cloth. Many of the designs had complex symbolic meanings that made the cloth more valuable. The looms produced rectangular pieces of cloth that could serve as capes and loincloths for men and skirts and overblouses for the women with little further tailoring (Anawalt 1980).

Sixteenth-century documents show that Aztec women were also vendors and merchants in local and regional markets (Figure 5). Some merchant women became wealthy. Women, along with men, served as marketplace administrators. As administrators, they were responsible for see-ing that goods were sold at fair prices and for assigning assessments of tribute and war provisions to vendors on behalf of the ruler (Sahagún 1950-82 bk. 8, ch. 19). War provisions consisted of finely ground toasted maize and chía seeds (*pinolli*), dried maize dough, and toasted tortillas. When war was declared, women prepared these foods to support the army as it marched to battle.

Women were also healers and midwives. They treated disease and aided childbirth with herbal medicines, massage therapy, and sweat baths. Biochemist Bernard Ortiz de Montellano (1990) analyzed the pharmacological effectiveness of many of the plants that Aztec women used as medicine. He concluded that 85 percent of them produced the physiological effects sought by Aztec curers. Sixty percent would be considered effective treatments according to Western biomedical standards.

Ortiz de Montellano suggests that Aztec medicine contained a mix of natural and supernatural elements. For example, a woman experiencing difficulty in childbirth would be given a drink made from the bark of the *cuauhalahuac* tree and the *cihuapahtli* herb, ground up in water with a red stone called *eztetl* (jasper) and the tail of an opossum. The *cihuapahtli* and the opossum tail are scientifically proven oxytocins, that is, they strengthen contractions. Elements of sympathetic magic included the *cuauhalahuac* ("slippery tree"), which was thought to lubricate the delivery, and the jasper, which was supposed to prevent hemorrhaging.

Figure 6: An Aztec sweat bath, presided over by Tlazolteotl, the goddess of purification and curing. Her mouth is smeared with the filth of sins consumed during confessions. On the left, an old woman, a curer or midwife, tends the fire.

Although both Aztec men and women visited sweat baths to cure disease, sweat baths were particularly associated with women (Figure 6). Women received regular treatments in the sweat baths before and after childbirth to ensure successful reproduction. Sweat baths were dark, warm, moist places that, like women's wombs, nurtured the proper maturation of the fetus. Wombs were regarded as analogous to jars, earth ovens, kilns, sweat baths, and caves in that they were all dark, moist containers that, when heated (by the sun, by fire, or by the male in sexual intercourse), could transform raw materials into finished products such as children, steamed tamales, roasted meat and maguey hearts, fired ceramic pots, charcoal, and slaked lime (Monaghan 2001; Sahagún 1950-82, bk. 1; Sullivan 1966). Women, then, were associated with the generative power of the dark, moist, fertile earth.

Aztec healers analyzed the causes and the prognoses of illnesses through various types of divination, which included casting maize kernels and tying knots in a cord (Figure 7). In Meso-america today, the proper interpretation of divination requires dialogue between the client and

Figure 7: A diviner determines the prognosis of an illness by casting maize kernels. Speech scrolls issuing from the diviner and her client suggest that they are engaged in dialogue, perhaps to determine the meaning of the pattern formed by the kernels.

the diviner. The client supplies information on his or her personal affairs and the diviner uses this knowledge of the client and of his or her social relationships to translate the divination into wise answers and useful advice. Thus, the casting of maize kernels, like psychological counseling, may have provided the client with advice on family affairs and inter-household relationships and improved the client's ability to manage these affairs productively (Colby and Colby 1981; Tedlock 1982).

The food, clothing, and health care provided by women were essential to the success of both Aztec families and the empire. Food, clothing and curing enhanced human survival and made possible population growth. The population of the Valley of Mexico increased tenfold in the centuries leading up to the Aztec empire, and this dense population made it possible to assemble a large labor force to construct raised *chinampa* fields in the southern Basin of Mexico. Produce from the chinampas fed the urban population of Tenochtitlan. Dense populations also enabled Aztec rulers to field large armies, able to defeat enemy forces and ensure the success of the Aztec tribute-based economy.

In addition, the cloth woven by Aztec women had both economic and social importance. The Aztec tribute lists indicate that the empire was financed by the more than 240,000 pieces of cloth collected in tribute by the Aztec empire annually (Berdan 1987). The Aztec emperor redistributed this cloth to government officials, priests, craft specialists, warriors, and other faithful servants of the state. Because cloth served as a kind of money in Aztec markets, state officials could take the tribute cloth to the market and use it to buy both food staples and luxury goods. Cloth was also used to establish social status: In both noble and commoner households, family events such as birth, marriage, and death were celebrated with distributions of food and cloth. Thus, cloth that women produced was an important means of organizing economic and social relations among the Aztecs both within the family and in the wider society. Women's work had an impact far beyond their homes.

WOMEN AND RITUAL

Female deities controlled many of the elements that sustained human life. Perhaps the most powerful, Cihuacoatl/Coatlicue, the earth goddess, was paradoxically a goddess of both life and death (Figure 8). As the earth, Cihuacoatl gave birth each morning to the sun, the source of energy for all living things, but Cihuacoatl also devoured the sun each night, marking its death. The earth was the dark repository of dead bodies, but rotting flesh and dry bone within the earth created a rich humus that nurtured further life. Cihuacoatl, like all of the deities, demanded sacrifice from humans in exchange for the gift of life. The sacrifices included incense, food offerings, the energy-rich blood of sacrificed quail, and blood drawn from the worshipper's ear lobes, all of which might be offered by commoners in their homes. Cihuacoatl also received the hearts and blood from human war captives and slaves sacrificed in state temples.

Four goddesses provided the staples of commoner existence: Chalchiuhtlicue, the goddess of lakes and rivers, Chicomecoatl, the maize goddess, Mayahuel, the maguey goddess, and Huix-tocihuatl, the goddess of salt. These goddesses were particularly venerated by commoners, who

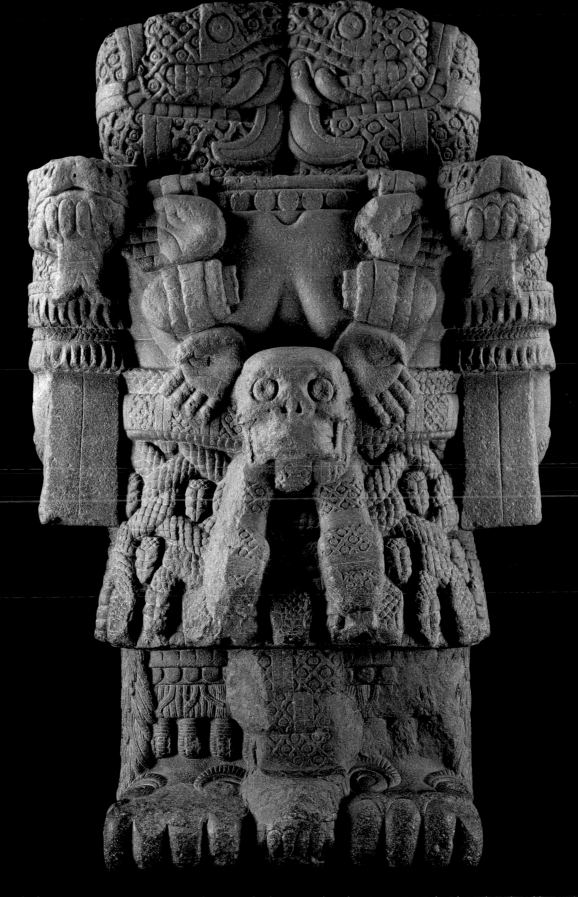

Figure 8: Coatlicue was both a monster and a victim. In this statue, her skirt is intertwined with rattlesnakes. Her necklace features a skull and the hearts and hands of sacrificial victims. Her feet have raptorial claws. Yet she herself has been sacrificed by decapitation. The two snakes that form her face are streams of blood that well up from her decapitated body.

were fishermen, farmers, and salt makers (Figures 9 and 10). Teteo innan/Toci, the goddess of healing, was also worshipped by commoners, who gathered the herbal remedies gathered from the fields and forests. Teteo innan/Toci was the patron of healers and midwives, as well as the diviners who interpreted the *tonalpoalli*, the 260-day ritual almanac. Tlazolteotl was an aspect of Cihuacoatl; she was concerned particularly with filth and purification, particularly the pollution associated with sexual intercourse. Confession to Tlazolteotl could purify a person's being and restore him to health. Xochiquetzal was the goddess of sensuality, feasting, fine craftsmanship and sexual pleasure (Figure 11). She was the patron of weavers, embroiderers, silversmiths, and sculptors. These goddesses stand in contrast with the male gods Huitzilopochtli, Tlaloc, Tezcatlipoca, Quetzalcoatl, and Xipe Totec, who were the focus of state religion.

Figure 9: (Left) Chalchiuhtlicue, the goddess of lakes and rivers. Her distinctive headdress consists of four thick bands bordered above and below by cotton balls. Two large pompoms are attached to the sides of her head. She wears a folded paper neck fan and a heavy necklace of jade beads that represent the green of exuberant vegetation nurtured by water. (Right) Chicomecoatl, the goddess of maize. Her face peers out from a towering square headdress, adorned at the corners with pleated paper rosettes. She kneels in the "woman's position" holding double ears of mature maize in each hand.

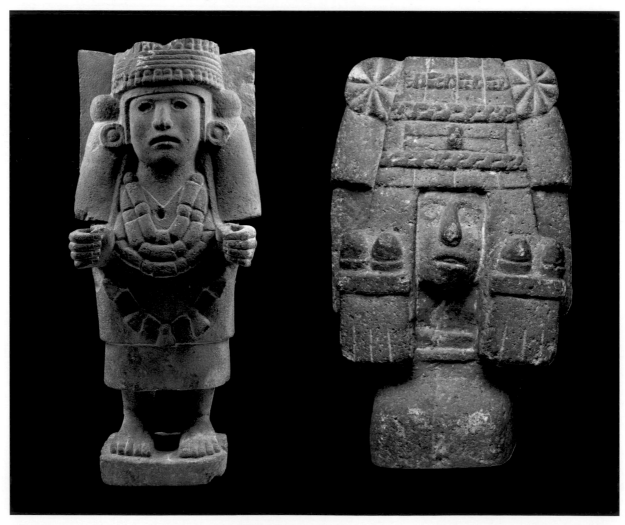

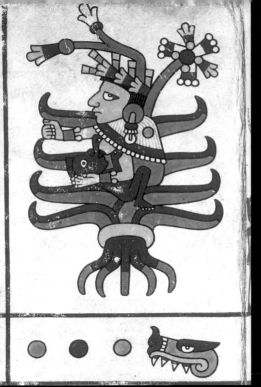
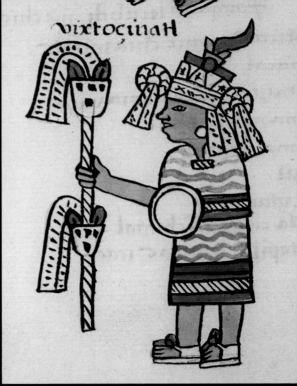

Figure 10: (Left) Mayahuel, the goddess of the maguey and pulque (*octli*) emerges from the leaves of a maguey plant. (Right) Huixtocihuatl, the goddess of salt. She wears a paper crown with a quetzal feather crest. Her blouse and skirt bear water designs with wavy blue lines. She carries a staff adorned with reeds.

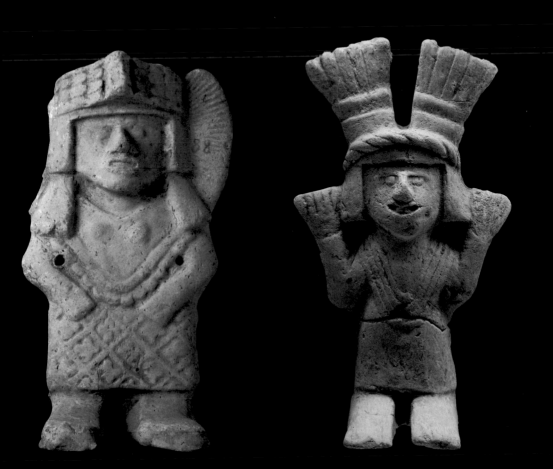

Figure 11: Ceramic figurines of Chalchiutlicue and Xochiquetzal. Xochiquetzal, the goddess of weaving and fine

Aztec women worshipped both the gods and goddesses. In their homes, women saw that the proper offerings were made to gods and goddesses at the household altar: They urged their sons and daughters to rise early, offer the gods food and incense at household altars, and sweep the house, an act of ritual purification. Archaeologists find small ceramic figurines in Aztec houses that may have served as god figures on household altars. In rural Aztec houses, there are as many as three female figurines for each male figurine, suggesting that household rituals were primarily concerned with subsistence production and health, which were under control of Aztec goddesses (Brumfiel 1996, Brumfiel and Overholtzer in press).

Women also served as priestesses in the state temples. Following the principle of gender complementarity, temples were staffed by both male and female priests. Some girls in their infancy were dedicated to serve in the temples by their parents. When these girls were older, they entered into religious service. Most of them stayed for only a year or two and then left to marry, but a few women continued as priestesses for their entire lives. These older priestesses supervised the younger women just entering service. According to Louise Burkhart (1997), Aztec temples were regarded as the houses of gods, and much religious ritual functioned as "a kind of cosmic house-keeping: priests guarded the temple fires, made offerings, prayed, and cleaned; female priests and attendants also spun and wove clothing for the deities and cooked their offerings of food." At household altars and in state temples, then, the religious acts of Aztec women honored the gods and helped to maintain cosmic order.

WOMEN AND THE AZTEC STATE

Despite the many areas of gender equality in Aztec culture, gender hierarchy was emphasized in the mythology, ritual, and art sponsored by the Aztec state.

Two myths provided the foundation for the Aztec state. One told the story of the birth of the Aztecs' patron deity, Huitzilopochtli. The other followed the Aztecs' migration from their homeland in Aztlan to the founding of the Aztec capital, Tenochtitlan. In both stories, powerful women were the source of conflict and warfare.

Huitzilopochtli was conceived while his earth-goddess mother performed religious service at a shrine at the top of Snake Mountain. Because the goddess's pregnancy shamed her daughter, the moon, and her other children, the stars, they decided to kill her. But as they reached the summit of Snake Mountain, Huitzilopochtli leapt from his mother's womb fully armed. He attacked his sister and cut her to pieces; her dismembered body fell to the base of the mountain (Figure 12). Huitzilopochtli then attacked his brothers, and they scattered across the heavens leaving Huitzilopochtli, the Aztecs' solar deity, in uncontested possession of the celestial field. Coyolxauhqui's defeat by her brother Huitzilopochtli symbolized the primordial victory of the forces of light and cosmic order over the forces of darkness and chaos, a drama that was repeated each morning at sunrise.

During the Aztecs' migration from Aztlan, social discord was sown by Malinalxochitl, another of Huitzilopochtli's sisters. Because Malinalxochitl opposed Huitzilopochtli's command that the Aztec people move on in search of their destined homeland, she was left behind when

the Aztecs continued their migration. Later, she stirred up hatred between the Aztecs and their neighbors in the Basin of Mexico. The Aztecs were attacked and driven from their encampment at Chapultepec, forced to continue their migration until they arrived at their predestined home, Tenochtitlan.

On the basis of these two narratives and others, Susan Gillespie (1989) concludes that Aztec legends depicted women both as the instigators of conflict and the enemy, destined for sacrifice and defeat. These powerful women threatened the cosmic order and human survival, and they were the reason that warfare was imperative. The narratives shifted the blame for Aztec warfare from the rulers who actually initiated campaigns of conquest to female deities of discord. According to these legends, it was female deities and not the Aztec state that condemned young men to risk injury and death on the battlefield. And the myths assigned cosmic importance to

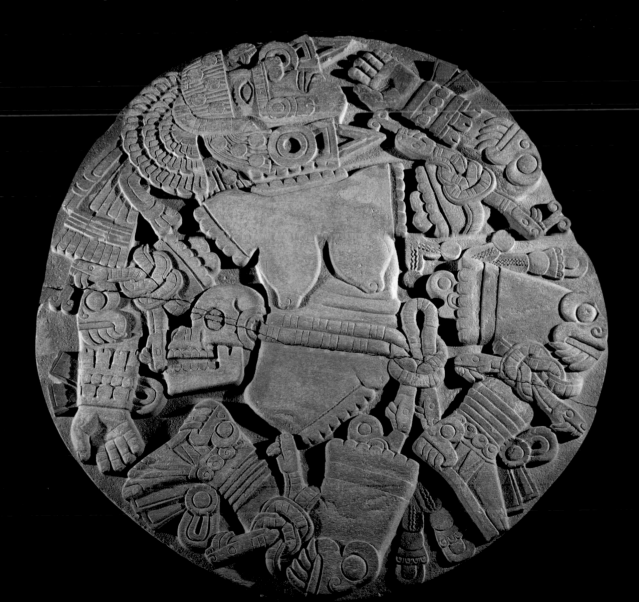

Figure 12: A monumental sculpture from the Aztec Great Temple depicting the dismembered Coyolxauhqui, slain in the battle against her brother Huitzilopochtli, Aztec patron deity.

Aztec warriors as the defenders of the life-sustaining order of the universe. The energy-rich hearts and blood of enemies captured in warfare nourished the sun and enabled it to succeed in its daily struggle against the forces of darkness and impending chaos (Figure 13). Aztec warriors were taught to believe that they fought not just for personal glory and wealth, but to protect their families and all of humanity from cosmic destruction.

These beliefs were communicated in the art commissioned by the Aztec state. In state art, gender was clearly marked, and it conveyed the message that the women who provoked conflict were destined for defeat at the hands of noble and powerful Aztec warriors.

Two of the best-known pieces of state-sponsored art are monumental sculptures of the goddesses Coatlicue and Coyolxauhqui (Figures 8 and 12). The female identity of both goddesses is unmistakable: Both have exposed chests with breasts clearly evident. And both are depicted as the victims of violence. Coyolxauhqui's limbs have been severed from her mostly naked body, and Coatlicue has been decapitated, her head replaced by two snakes representing two streams of blood surging from her neck (Pasztory 1983). These female deities represent defeated foes of the Aztec people: Coyolxauhqui was the enemy of Huitzilopochtli and his mother; and Coatlicue was the patron deity of Xochimilco, a town that resisted Aztec rule (Cline 1988).

The large ceramic statue of an elite eagle warrior found in a building near the Aztec Great Temple provides a striking contrast (Figure 14). The eagle warrior evoked the fate of soldiers slain in battle or sacrifice. Transported to the sky, they accompanied the sun during the sun's rise from daybreak to high noon. These fallen warriors assisted in the triumph of light over darkness (Sahagún 1950–82, bk. 6, ch. 29). Implicitly, this statue contrasts both with the sculptures of Coyolxauhqui and Coatlicue described above and with the images of Aztec women who died in childbirth (Figure 15).

In many ways, Aztec women who died in childbirth were the counterparts of warriors who died in battle or sacrifice. Like warriors who died in warfare or sacrifice, women who died in childbirth rose to the sky to accompany the sun on its journey across the heavens. But, whereas fallen warriors accompanied the sun during its morning rise to the zenith, women who died in childbirth accompanied the sun during its afternoon descent (Sahagún 1950–82, bk. 6, ch. 29). Moreover, women

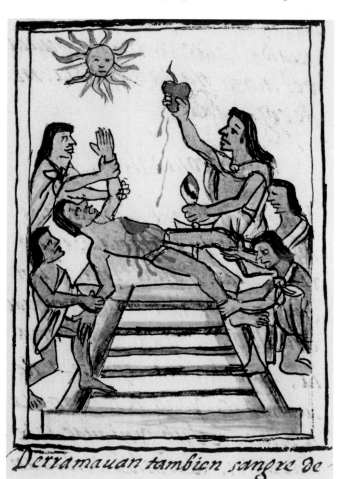

Derramauan tambien sangre de

Figure 13: The heart of a sacrificial victim is offered to the sun to replenish its strength.

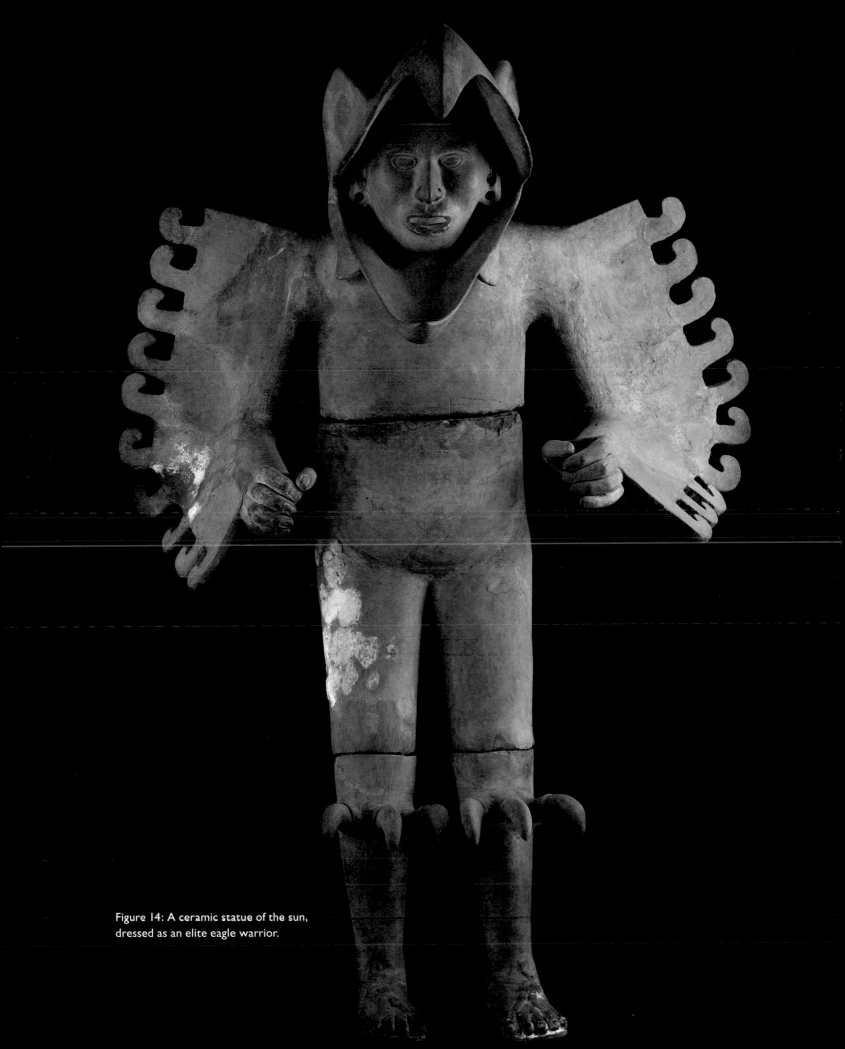
Figure 14: A ceramic statue of the sun, dressed as an elite eagle warrior.

who died in childbirth periodically returned to earth as violent spirits (the *cihuateteo*) who haunted crossroads at night, possessed and paralyzed adults, and stole children. The negative image of the disruptive and predatory *cihuateteo*, carved in stone and set by lonely crossroads, served to heighten the nobility of their male counterparts, the eagle warriors.

I believe that the depiction of gender in the Aztec empire was a part of a wider strategy that Aztec rulers used to construct state power. The Aztec state extolled the strength and valor of men and emphasized the creative acts of male deities acting without their female counterparts (López 2007). The state portrayed women as instigators of conflict, disrupters of cosmic harmony, and bringers of death. It also represented women as enemies who were destined for defeat at the hands of courageous male warriors.

To engage the loyalties of their male citizen-soldiers, Aztec rulers endowed the role of the Aztec warrior with cosmic significance (Brumfiel 1998). Male warriors were extolled as brave, strong, and altruistic—sacrificing their lives for the benefit of all. In addition, rulers showered male warriors with material rewards including flashy items of dress and tribute cloth. Thus, the state decreed that cloth, woven by women and alienated from them through tribute payment, would become the personal wealth of men. In addition, successful warriors were given offices in the state's military, judiciary, and administrative hierarchies. Thus, warfare in the Aztec state provided avenues of prestige, wealth, and power to men that were not available to women (Nash 1978).

This then explains the principal characteristics of the Aztec gender system: Gender hierarchy was promoted by Aztec rulers to reward the young men who formed the core of the Aztec army. Masculine strength and dominance were defined by their opposites: feminine weakness and submission. Gender hierarchy began to reshape the more egalitarian principle of gender complementarity. Gender hierarchy was a specific strategy intended to create a highly motivated military that enabled the ruler to dominate both his male and female subjects by force of arms.

CONCLUSIONS

Gender inequality was only incipient among the Aztecs. I expect that male dominance would have developed further under the Aztec state, but because of the Spanish conquest, we will never know. We do know, however, that the condition of women deteriorated during the colonial period under Spanish rule (Kellogg 1997). Like the Aztec state, the Spanish crown rewarded its male warriors with land and tribute goods. But the Spaniards excluded women from the political and religious hierarchies of colonial Mexico. Spanish priests preached an ideology of female purity and enclosure. During the sixteenth century, women's economic activities continued: Women bought, sold, and inherited property, and they sold goods in the market. They also took part in legal proceedings in colonial courts where they served as litigants, defendants, and witnesses (but not as judges). By the seventeenth century, however, women's status had declined. Their access to property became more limited, and increasingly, they came to be viewed as needing the patriarchal authority of husbands and fathers. The privileging of men by colonial Spain, the abolition of public offices for women, and the ideology of women's purity and honor together took their toll.

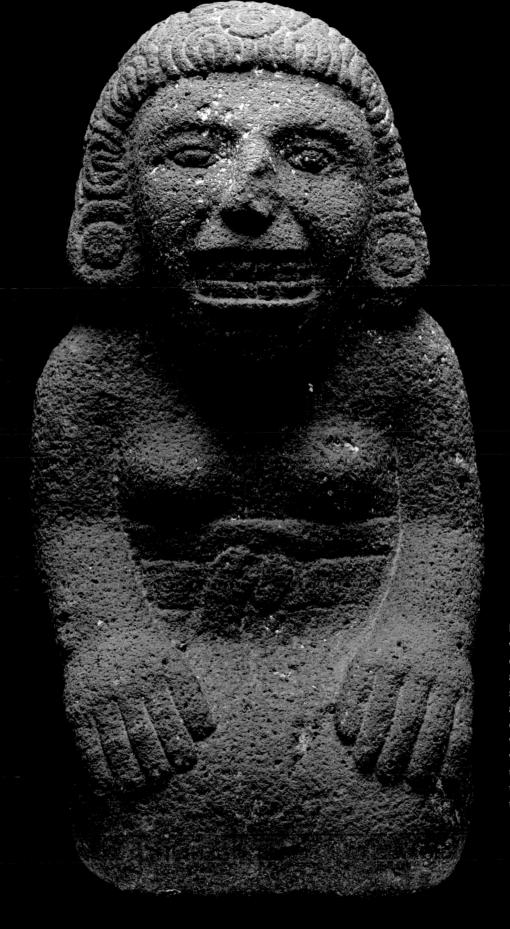

Figure 15: Cihuateotl, a woman who had died in childbirth. Her round eyes and bared teeth have a skeletal quality. Her matted and tangled hair symbolizes cosmic disorder. Although women who died in childbirth were hailed as heroic figures, they returned to earth as terrifying demons who threaten human well-being.

REFERENCES

Anawalt, Patricia R. 1981. *Indian Clothing Before Cortés*. Norman: University of Oklahoma Press.

Berdan, Frances F. 1987. Cotton in Aztec Mexico: Production, distribution, and uses. *Mexican Studies/Estudios Mexicanos* 3:235–62.

Brumfiel, Elizabeth M. 1991. "Weaving and cooking: Women's production in Aztec Mexico." In *Engendering Archaeology*, J.M. Gero and M.W. Conkey, eds., pp. 224–51. Oxford: Blackwell.

———. 1996. "Figurines and the Aztec State: Testing the effectiveness of ideological domination." In *Gender and Archaeology*, R.P. Wright, ed., pp. 143–66. Philadelphia: University of Pennsylvania Press.

———. 1998. "Huitzilopochtli's thirst: Aztec ideology in the archaeological record." *Cambridge Archaeological Journal* 8:3–13.

Brumfiel, Elizabeth M. and Lisa Overholtzer. In press. "Alien bodies, everyday people, and internal spaces: Embodiment, figurines and social discourse in Postclassic Mexico." In *Mesoamerican Figurines: Small-Scale Indexes of Large-Scale Phenomena*. C. Halperin, K. Faust, R. Taube, and A. Giguet, eds. Gainesville: University Press of Florida.

Burkhart, Louise M. 1997. "Mexica women on the home front: Housework and religion in Aztec Mexico." In *Indian Women of Early Mexico*, S. Schroeder, S. Wood, and R. Haskett, eds., pp. 25–54. Norman: University of Oklahoma Press.

Caso, Alfonso. 1958. *The Aztecs: People of the sun*. Norman: University of Oklahoma Press.

Codex Mendoza. 1992. *The Codex Mendoza*. F. F. Berdan and P. R. Anawalt, eds. 4 vols. Berkeley: University of California Press.

Colby, Benjamin N. and Lore M. Colby. 1981. *The Daykeeper: The life and discourse of an Ixil diviner*. Cambridge, Mass: Harvard University Press.

Evans, Susan Toby. 2005. "Men, women, and maguey: The household division of labor among Aztec farmers." In *Settlement, Subsistence, and Social Complexity: Essays honoring the legacy of Jeffrey R. Parsons*, R. E. Blanton, ed., pp. 198–228. Los Angeles: Cotsen Institute of Archaeology.

Gillespie, Susan D. 1989. The *Aztec Kings: The Construction of Rulership in Mexica History*. Tucson: University of Arizona Press.

González Torres, Yólotl. 1979. El panteón mexica. *Antropología e Historia* 25:9–19.

Hendon, Julia A. 1999. "Multiple sources of prestige and the social evaluation of women in Prehispanic Mesoamerica." In *Material Symbols*, J. E. Robb, ed., pp. 257–76. Carbondale: Southern Illinois University, Center for Archaeological Investigations, Occasional Paper No. 26.

Houston, Stephen D. 1996. "Symbolic sweatbaths of the Maya." *Latin American Antiquity* 7:132–51.

Joyce, Rosemary A. 2000. Girling the girl and boying the boy: The production of adulthood in ancient Mesoamerica. *World Archaeology* 31:473–83.

Klein, Cecelia F. 1988. "Rethinking Cihuacoatl: Aztec political imagery of the conquered woman." *In Smoke and Mist: Mesoamerican studies in memory of Thelma D. Sullivan*, J. K. Josserand and K. Dakin, eds., pp. 237–77. Oxford: British Archaeological Reports, International Series, 404.

Kellogg, Susan. 1997. "From Parallel and Equivalent to Separate but Unequal: Tenochca Mexica women, 1500-1700." In *Indian Women of Early Mexico*, S. Schroeder, S. Wood, and R. Haskett, eds., pp. 121–43. Norman: University of Oklahoma Press.

McCafferty, Sharisse D. and Geoffrey G. McCafferty. 1988. Powerful women and the Myth of Male Dominance in Aztec society. *Archaeological Review from Cambridge* 7:45–59.

Nash, June. 1976. The Aztecs and the Ideology of Male Dominance. *Signs* 4:349–62.

Ortiz de Montellano, Bernard R. 1990. *Aztec Medicine, Health, and Nutrition*. New Brunswick, N.J.: Rutgers University Press.

Pasztory, Esther. 1983. *Aztec Art*. New York: Harry N. Abrams.

Quezada, Noemí. 1996. Mito y género en la sociedad mexica. *Estudios de Cultura Náhuatl* 26:21–40.

Rodríguez, María J. 1988. *La Mujer Azteca*. Toluca: Universidad Autónoma del Estado de México.

Tedlock, Barbara. 1982. *Time and the Highland Maya*. Albuquerque: University of New Mexico Press.

Sahagún, Bernardino de. 1950–82. *Florentine Codex: General History of the Things of New Spain*. A. J. O. Anderson and E. E. Dibble, transl. Santa Fe and Salt Lake City: School of American Research and the University of Utah Press.

SIX

ARTISANS, MARKETS, AND MERCHANTS

DEBORAH L. NICHOLS, DARTMOUTH COLLEGE

By the early 1500s at least five to six million people lived in Central Mexico, and the Basin of Mexico, the geopolitical core of the Aztec empire, was especially densely settled. The Aztecs sustained their large populations, their cities, towns, and villages, palaces, temples, schools, and noble class without animals for transportation or farming. Despite this constraint, their complex economy involved both intensive agriculture and specialization. Craft specialists and artisans manufactured all kinds of goods, ranging from ordinary cooking pots to fancy feather shields. Goods were distributed through a hierarchy of marketplaces and tribute systems. Archaeologist Bruce Trigger (2003:115) noted that the Aztec empire was more integrated economically than politically. Scholars once viewed all ancient states as having command, or politically dominated, economies. Although politics and economics were intertwined in the Aztec empire, commerce played an important role in Aztec society.

SPECIALIZATION AND DIVISION OF LABOR

A complex division of labor and specialization characterized the Aztec economy. There were administrative specialists who served the state bureaucracy (e.g., judges, tax collectors, scribes, military officers) and a hierarchy of priests for temples, along with private entrepreneurs who provided various services. Nearly everyone consulted diviners, for example, along with medical specialists that included physicians, bonesetters, midwives, and herbalists. Most Aztecs were farmers but, as Jeffrey Parsons describes in Chapter 2, aspects of food production also were specialized. Spanish chronicler Fray Sahagún (1950–82 Bk. 10) tells of some of the many craft specialists: gold casters, lapidaries, carpenters, stonecutters, masons, scribes, tailors, spinners, weavers, potters, cooks, seamstresses, woodcutters, basketmakers, salt makers, and more.

The craftsman [is] well instructed, [he is] an artisan. There were many of them. The good craftsman [is] able, discreet, prudent, resourceful, retentive. The good craftsman [is] a willing worker, patient, calm. He works with care, he makes works of skill; he constructs, prepares, arranges, orders, fits, matches [materials]. The stupid craftsman [is] careless—a mocker, a petty thief, a pilferer. He acts without consideration; he deceives, he steals. (Sahagún 1950–82: Bk. 10:25)

In considering how the Aztecs organized craft production, it is useful to distinguish between utilitarian goods, such as pottery, stone tools for cutting and grinding, and baskets that were widely used, and luxury or sumptuary goods (Brumfiel 1987). Luxury goods had a more restricted distribution because of their cost and, in some cases, because laws limited their use to nobility and high-ranking military orders.

Households, usually consisting of nuclear or joint families, formed the backbone of the Aztec economy; men and women and girls and boys had complementary and parallel roles and responsibilities. Aztec craft specialists and artisans began to learn their skills as children from their parents. Most craft specialists had workshops in their houses and courtyards to take advantage of the family division of labor. Although household workshops are often described as small-scale, Aztec workshops could produce large amounts of goods using techniques of mass production, such as molds for pottery. Craft specialists tended to concentrate in urban centers. Depending on the types of goods they manufactured, the level of demand, and access to markets and raw materials, some specialists made only one commodity, while others made several kinds of goods. In large towns and cities specialists in certain crafts clustered together in the same neighborhoods and some producers of luxury goods were employed in the ruler's palace or worked directly for a noble patron, although many had their own workshops. In smaller towns and villages, households diversified their incomes by combining craft production and farming.

FEATHER FANS, EAR SPOOLS, AND LIP PLUGS: LUXURY GOODS

Manufacturing luxury goods required great skill and training and access to exotic raw materials. Especially valued in Aztec society were creations of feathers, gold, silver, and precious stones that elites used to mark and negotiate their class and status. Although not considered nobility, feather workers, lapidaries, and metal smiths held an elevated status above commoners and were called *tolteca* (Berdan 2005:31). Their name derives from the earlier Toltec state centered at the city of Tula, north of the Basin of Mexico. The Aztecs greatly revered the Toltecs, and Aztec rulers sought legitimacy by claiming descent from the Toltecs. Aztec tolteca artisans resided in major cities and were of diverse ethnicities, but according to chroniclers, the feather workers and gold and silversmiths had restrictive guildlike organizations that regulated their membership, ran their schools, and supported their patron deities.

Among the best known of the guild artisans were the feather workers. Frances Berdan (2005:32) explains that feather working was an old craft in pre-Hispanic Mesoamerica that

probably began with feathers of turkeys, ducks, and herons that lived around the lakes in the Basin of Mexico. As the Aztec empire grew and conquered tropical regions, trade and tribute expanded to create a regular supply of exotic and colorful feathers of birds such as parrots and the famous quetzal. With these feathers Aztec artisans created elaborate headdresses, warrior regalia, shields, and fans (Figure 1).

Making a feather mosaic began by creating a stiff backing of cotton and *maguey* fibers held together and stiffened with layers of glue (Sahagún 1950 82: Bk. 9:83–97; Smith 2003:94). Master artisans drew design stencils on paper and cotton and transferred them to the backing where they attached the feathers with maguey fibers and glue. Women dyed the feathers, and children made the glue. They began with an under layer of local feathers over which they laid colorful exotic feathers and added ornaments of gold and precious stones.

The feather workers, *amanteca,* of Tenochtitlan-Tlatelolco lived in their own ward where they were permitted to run a *calmecac*, a school normally reserved for noble children, and to offer human sacrifices to their patron deities (Berdan 2005:32). Feather workers used their wealth to gain status by sponsoring ceremonies and buying slaves to be sacrificed. Rulers directly employed some feather workers to make royal attire, to create gifts for them to bestow, and to dress Huitziliopochtli, the Aztec patron deity. Other feather workers worked for noble patrons or manufactured their creations in household workshops.

Rulers also held gold and silver workers and lapidaries in high regard (Figure 2). Gold workers used a lost wax process (Sahagún 1950–82: Bk. 9:73–78), but the Spanish melted down most Aztec gold. However, Bernal Díaz, one of Cortés's soldiers, described the rich adornment of a litter belonging to the Lord of Texcoco whom Motecuhzoma II had sent to greet the Spanish on the outskirts of Tenochtitlan-Tlatelolco:

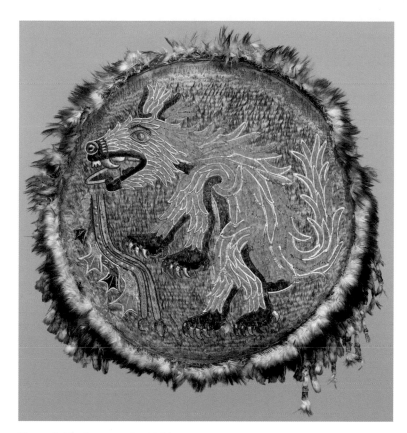

Figure 1. Feather mosaic shield.

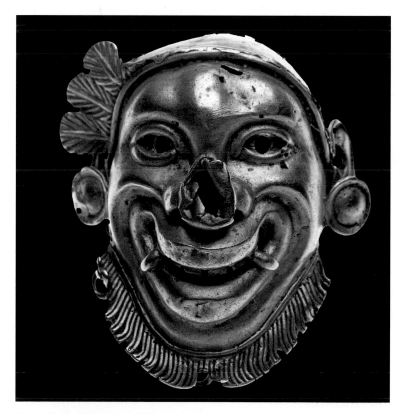

Figure 2. Gold pendant of Xiuhtecuhtli.

Figure 3. (Left) Obsidian ear spool; (Right) Obsidian bead.

Figure 4. Textile stamp.

Figure 5. Wood spindle and whorl.

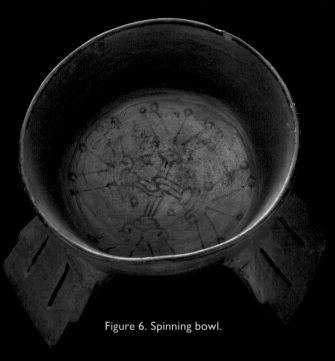

Figure 6. Spinning bowl.

He came borne on a litter, most richly worked in green feathers with much silver decoration and precious stones set in tree designs that were worked on the finest gold. (Díaz 1963:213)

Lapidaries made lip pendants, labrets, ear spools, necklaces, and bracelets of precious and exotic stones such as obsidian, alabaster, and jade. Jewelry signaled the wealth, class, and sometimes ethnicity of the wearer (Sahagún 1950–82 Bk. 9:80) (Figure 3). In addition to feather workers, metal workers, and lapidaries, palaces also employed master painters and sculptures.

CLOTH: BOTH FANCY AND PLAIN

Textiles played multifaceted roles in Aztec society, where cloth was both a utilitarian and luxury good and imbued with economic, social, and ritual values. Clothing provided protection but people also wore clothing that expressed their status, ethnicity, and gender. Insignia designated occupations, such as judges and grades of warriors (Anawalt 1981:30-31; Berdan 1987). Nobles donned elaborately embroidered cloaks woven of cotton and fine maguey thread. Motecuhzoma I, who ruled the Aztec empire in the mid-1400s, issued laws that prohibited commoners from wearing cotton clothing. Commoners wore clothing woven from maguey, yucca, and palm fibers (Durán 1964:102–103) (Figure 4).

Nobles gave gifts of fine garments to create and reinforce alliances and reward loyalty; warriors received cloaks for capturing enemies, and they wore specially decorated quilted cotton armor in battle. Aztecs dressed images of deities with textiles and wrapped their dead in cloth. Cloth was used for awnings and decorative hangings, and also for more mundane items, such carrying loads and tortilla covers (Berdan 1987; Hicks 1994:90). Cloth served as a currency in marketplaces, and textiles were the most common item on Aztec tribute lists (Berdan 1987).

Chroniclers tell how women spun, wove, dyed, and embroidered cloth, and Aztec women's identities, both

nobles and commoners, were intertwined with spinning and weaving. They spun various kinds of fibers, including rabbit fur, feathers, yucca, and palm, but most important were cotton and maguey (Berdan 1987). Cotton had to be imported to the Basin of Mexico, as it is too cold above 5,905 feet for cotton to grow. Maguey fibers, however, were a specialty of the drier, northern Basin.

In their houses women and girls spun thread with a wooden spindle and a perforated ceramic disk or whorl (Figure 5). To spin fine cotton thread women supported the spindle whorl using a small ceramic bowl (Sahagún 1950–82 Bk. 6:201) (Figure 6). Using backstrap looms, women and their daughters wove large amounts of cloth for tribute and for sale in markets, as well as for their family's needs. Some women in palaces where nobles had multiple wives and priestesses housed in temples may have devoted much of their time to spinning and weaving, but most women combined textile production with other household activities. We do not know what the total production of cloth was for the empire, but the *Matrícula de Tributos* recorded a total annual tribute of 241,600 pieces of cloth (Berdan 1987:235). Each tribute cloth was a large square, about 6.7 yards on a side (Hicks 1994).

POTS, FIGURINES, AND OBSIDIAN KNIVES

Specialists also manufactured the items of everyday life but chroniclers' accounts say much less about the production of utilitarian goods—baskets, reed mats for sleeping, stone tools for cutting and grinding, and pottery of diverse forms and function (Brumfiel 1987). Fortunately, stone and ceramics preserve well and are abundantly represented in the archaeological record, making it possible for archaeologists to study Aztec techniques of manufacturing and the organization of production.

Remains of pottery, mostly shards, are ubiquitous at Aztec sites because households used different kinds of pottery for storing, preparing, cooking, and serving food: water jars, bowls with tripod legs and scored bottoms (*molcajetes*) for grinding chiles and tomatoes, flat griddles (*comales*) for cooking tortillas, cooking pots, coarse pots impressed with fabric designs that held salt, and bowls, plates, dishes, and cups to serve food (Figures 7 and 8). Incense burners and small figurines, often of a female deity holding a child, were made of ceramics for use in household rituals. Aztecs played music on ceramic flutes and whistles, and they smoked tobacco in ceramic pipes.

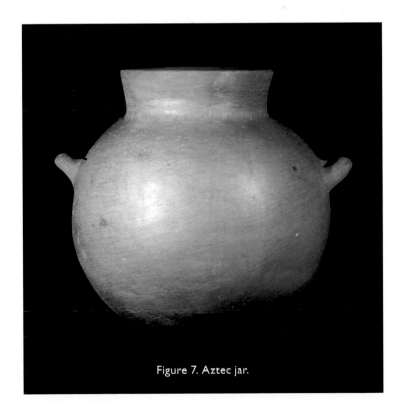

Figure 7. Aztec jar.

Aztec ceramics were earthenwares that were handmade, although potters often employed molds. Potters commonly decorated serving wares with black designs painted on an orange base and black-and-white designs on red painted bowls (Figures 9 and 10). Feasting was important for negotiating status and acknowledging rites of passage in Aztec society, and chocolate (cacao) was drunk on such occasions from fancy goblets. Motecuhzoma II dined exclusively on "earthware either red or black" imported from the city of Cholula, south of the Basin of Mexico (Díaz 1963:210)

Sahagún (1950–82 Bk. 10:82) describes how some potters were generalists—"the clay worker"—and others made only one kind of pottery—"the griddle maker"—but both sold their pots in marketplaces. Archaeologists have not found remains of Aztec pottery kilns, but geochemical studies make it possible to determine the general area where pottery was made (Nichols 2004:277–78). These studies reveal that the Aztecs traded large amounts of pottery. For example, at the provincial capital of Xaltocan in the northwestern Basin of Mexico, 60 percent of Aztec decorated pottery was imported from surrounding areas (Nichols et al. 2002).

Along with ceramics, remains of stone tools litter Aztec sites. Stone-tool making involved carefully chipping pieces of obsidian to fashion a tool, thus creating distinctive waste debris with each stage of manufacturing. By studying this waste, called debitage, archaeologists can reconstruct what tools were made and how they were made.

Figure 8. Aztec molcajete used for grinding.

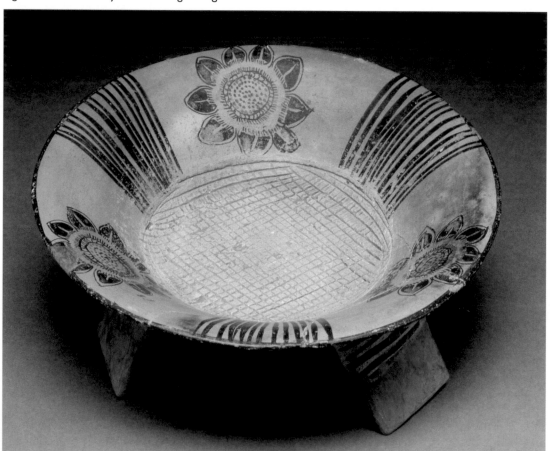

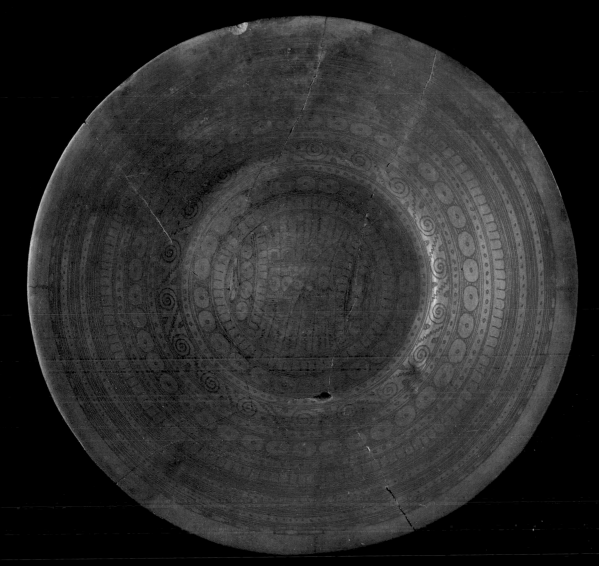

Figure 9. Aztec Black-on-Orange plate.

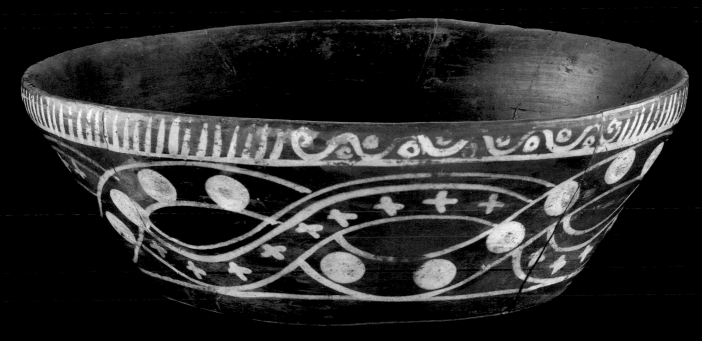

Figure 10. Aztec Black-and-White-on-Red bowl.

Aztec stone knappers were masters of working obsidian, a volcanic glass of various colors that naturally occurs in the mountains of Mexico. Knappers prized this stone because obsidian can be fractured to create extremely sharp edges. Gray obsidian is found in outcrops above Otumba in the northeastern Basin of Mexico, and the most important source of green obsidian comes from Pachuca, just north of the Basin. Using basalt picks, workers quarried obsidian from hillsides, pits, and shafts. They exported it from the quarries as roughly shaped blocks or macrocores (Parry 2001:104). In turn, obsidian workshops specialized in making different types of tools. Some workshops manufactured long prismatic blades from polyhedral cores. Knappers preferred Pachuca obsidian for these long thin blades, which were used as knives and also hafted onto wooden handles for razors and other tools (Figure 11). The blades could be reworked to make other tools such as drills. Other obsidian workshops made large scrapers for processing maguey and arrow points, dart points, and knives from gray-black obsidian. Carpenters, basketmakers, and other specialists employed obsidian tools in their crafts as well.

In addition to domestic uses, obsidian blades were set into a wooden shaft to create a sword sharp enough to decapitate a person. Lapidaries fashioned jewelry and ornaments, lip plugs, ear spools, and beads of obsidian by careful pecking, grinding, and polishing (Figure 12).

Other specialists manufactured tools of basalt for grinding. Women ground maize on *metates* (stone slabs) with *manos* (stone rolling pins) made of tough basalt. Axes and polishing tools also were ground from basalt as were beaters to make bark paper (Figure 13). Although usually not preserved at archaeological sites, other crafters made household goods from perishable materials such as reeds for mats and baskets.

CRAFT PRODUCTION AT AN AZTEC TOWN

Archaeological investigations at Otumba, a regional Aztec craft production center in the northeast Basin of Mexico, have provided archaeologists with a good look at Aztec household workshops (Charlton et al. 1991, 2000; Nichols 1994; Otis Charlton et al. 1993). One group of ceramic

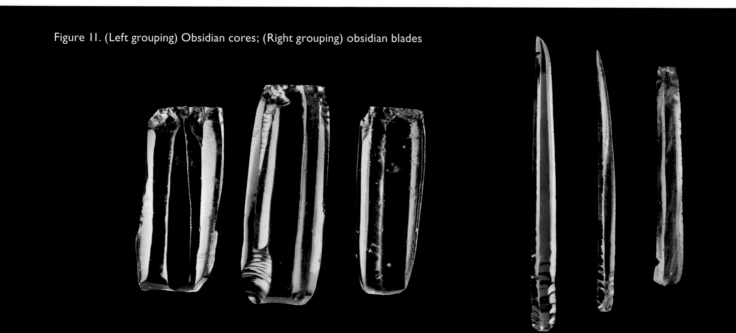

Figure 11. (Left grouping) Obsidian cores; (Right grouping) obsidian blades

specialists who lived in a single barrio of Otumba mass-produced mold-made figurines, figurine molds, and spindle whorls used to spin cotton and maguey thread, along with a local style of Redware pottery, marbles, stamps, whistles, censers, and other pottery molds (Figure 14). Censer molds were also loosely clustered at low densities in another part of the town. Households of maguey-fiber specialists grouped together to form another barrio. These workshops processed maguey leaves to make fibers, they spun fibers, and presumably wove and perhaps dyed cloth, and they also mass produced spindle whorls in molds and made the molds. One maguey workshop also engaged in some lapidary production, and a work-

Figure 12. Obsidian ear spool blanks from Otumba.

shop for making grinding tools was in the midst of the maguey specialist households (Biskowski 2000; Nichols et al. 2000). We think maguey specialists had some kind of suprahousehold organization or cooperative labor arrangement for processing maguey.

Households specializing in obsidian core-blade manufacturing were scattered at Otumba in the elite nucleated core and dispersed residential zone (Parry 2000, 2002). In separate workshops lapidaries recycled used prismatic cores from the core-blade workshops to create lip plugs, earspools, and other ornaments of obsidian and rare stones. To do this they used basalt grinding tools also made at Otumba (Otis Charlton 1993, 1994; Biskowski 2000). The lapidaries enjoyed a slightly higher standard of living than other crafters, but at Otumba they were not directly attached to elite households.

Almost all households in the town and surrounding villages spun thread and wove cloth. Rural households diversified and intensified production with irrigation and the cultivation of maguey, along with maize. In a few rural villages some household workshops made bifacial tools, scrapers and dart and arrow points, of the local gray obsidian.

MARKETS, MERCHANTS, AND TRIBUTE

Commerce and tribute predated the Triple Alliance, but Aztec imperialism increased marketplace trade and expanded tribute systems.

MARKETPLACES

Aztec potters, knappers, basketmakers, lapidaries, and other craft specialists and farmers sold their goods in bustling open-air markets where they also exchanged news and gossip (Berdan 1985:339). Goods were arranged by type, and most people traded by bartering. Cotton cloth, copper axes, gold-filled quills, and cacao beans served as money (Figure 15), but people had to beware of "the bad cacao seller, [the bad] cacao dealer, the deluder counterfeits cacao" (Sahagún 1950–82 Bk. 10:64).

Figure 13. Basalt bark beater used to make paper.

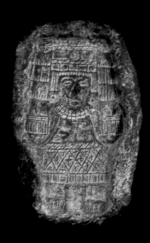

Figure 14. Ceramic mold for figurines.

Figure 15. Copper ax.

To deal with disputes, judges, probably appointed from the professional merchants guild, oversaw marketplaces.

Most towns held a market every five days (one Aztec week), and market day drew in people from the surrounding countryside (Hassig 1985). Large cities needed daily markets. The largest and most famous market in Mesoamerica was the one held at Tlatelolco, which was visited by 20,000 to 25,000 people daily. Once a week, that number swelled to 40,000 people. The Tlatelolco market carried goods from all parts of the empire and beyond, and Spanish soldiers "were astounded at the great number of people and the quantities of merchandise, and at the orderliness and good arrangements that prevailed, for we had never seen such a thing before. . . . Every kind of merchandise was kept separate and had its fixed place market for it" (Díaz 1963:232). Bernal Díaz described some of the goods for sale: "Next there were those who sold coarser cloth, and cotton goods and fabrics made of twisted thread, and there were chocolate merchants with their chocolate. In this way you could see every kind of merchandise to be found anywhere in New Spain" (Díaz 1963:232).

Some markets attracted buyers by emphasizing local specialties; Coyoacan in the southern Basin of Mexico sold wood products, while the Texcoco market was known for ceramics and cloth (Berdan 1985). The Acolman market was famous for its dogs.

> One day I went to observe the market day there, just to be an eyewitness and discover the truth. I found more than four hundred large and small dogs tied up in crates, some already sold, others still for sale. When a Spaniard who was totally familiar with that region saw [my amazement], he asked, "Why are you astonished? I have never seen such a meager sale of dogs as today! There was a tremendous shortage of them!" (Durán 1971:278)

Many craft specialists and farmers sold their own products at market, such as the "maguey syrup seller" who was "the owner of the plants" (Sahagún 1950–82: 73-74). Some specialists even practiced their crafts in the marketplace.

> The obsidian seller is one who, [with] a staff with a cross-piece, forces off [blades; he is] one who forces off [blades],

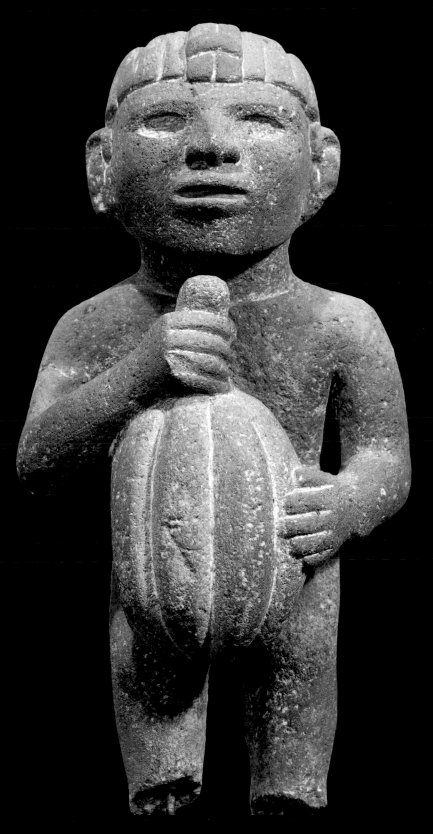

Figure 16. Man carrying a cacao pod. Cacao beans were a valuable
tropical import handled by Aztec long-distance merchants.

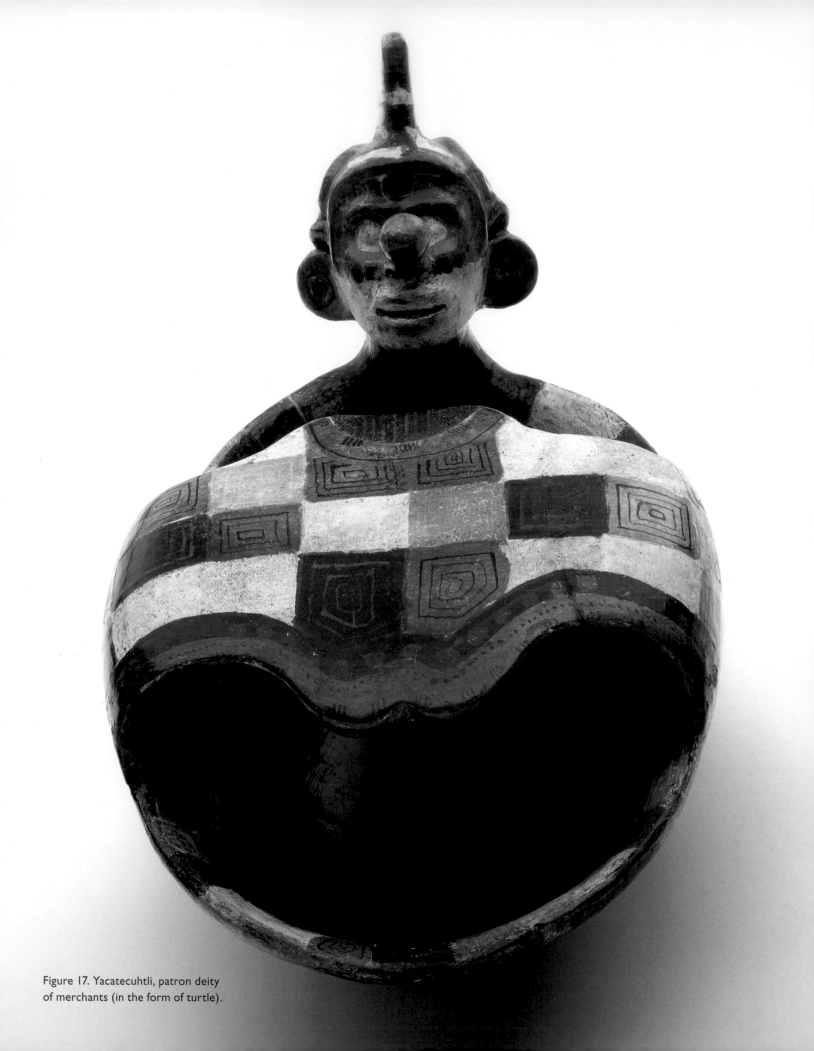

Figure 17. Yacatecuhtli, patron deity of merchants (in the form of turtle).

who forces off obsidian blades. He forces off obsidian blades, he breaks off blades. He sells obsidian, obsidian razors, blades, single-edged knives, double-edged knives, unworked obsidian, scraping stones, V-shaped pieces. He sells white obsidian, clear blue obsidian, yellow obsidian. (Sahagún 1950–82 Bk. 10:85)

In addition to vendors who sold their own goods and crops, itinerant regional merchants, *tlanecuilo*, traveled a circuit of markets and traded in household goods, maize, amaranth, chili, tortillas, baskets, gourd bowls, sandals, turkeys, cotton, and cacao (Berdan 1985, 1986:289; Hassig 1985). Some specialized in particular commodities: "he sets out on the road, travels with it, goes from market to market, makes use of markets, sells salt. He sells salt balls, salt bars, salt ollas" (Sahagún 1950–82: Bk. 10:85).

Another group of merchants were the famous Aztec *pochteca*, who conducted long-distance trade within the empire and beyond its borders (Berdan 1986, 1988; Hassig 1985). They operated as private entrepreneurs but sometimes traded on behalf of the ruler and acted as spies for him. The *pochteca* were based in twelve towns in the Basin of Mexico, where they lived in their own wards or *calpolli* (Soustelle 1972:76). The pochteca traded in valuable but low bulk goods, as everything had to be transported by human porters. They exported items such as obsidian jewelry and knives, elaborately decorated cloth, cochineal (a dye), and rabbit fur and imported exotica including jade, turquoise, shell, tropical bird feathers, and cacao (Berdan 1988) (Figure 16). Certain high-ranking pochteca also traded in slaves.

The pochteca, like the tolteca luxury artisans, occupied an intermediary position in Aztec society; they were not nobles but the ruler accorded them special privileges. They were exempted from the labor tax, but Aztec rulers got their share of the merchants' wealth by taxing their goods. Successful merchants could accumulate substantial wealth, but unlike nobles whose wealth derived from their land holdings and income attached to offices they held, pochteca acquired their wealth (Soustelle 1972:82). Aztec rulers prohibited pochetca from displaying their wealth in public and they were expected to behave and dress humbly.

The pochteca regulated their membership, and within their guild and inside their residences they employed their wealth to compete with each other for status. They had an elaborate system of ranking from merchant lords to young novice traders, and movement up the ranks required sponsoring ceremonies and lavish feasts: "he who held a banquet, when his possessions, his goods, were already many; when already he had attained his fortune, his wealth" (Sahagún 1950–82: Bk. 9:33) (Figure 17). Pochteca traveled in large caravans for protection; merchants were also trained as warriors, and killing Aztec merchants was a pretext for the Triple Alliance to declare war (Hassig 1985:121).

TRIBUTE

The Aztec empire and the formerly independent city-states it incorporated were tributary states where a small noble class had rights to extract goods and labor from commoners. The Aztecs established their own system of tribute administration in conquered areas, and the empire was divided into thirty-eight tribute-paying provinces. Tribute was assessed on the basis of cost-distance

factors, ecological variations, and politics—kingdoms that "joined" the empire were given more favorable treaty terms than those who resisted (Berdan and Smith 1996:209). Provinces near the imperial capitals provided bulky goods such as staple foods and warrior costumes while distant provinces provided exotic goods and raw materials. For example, tribute paid by Tochtepec on the Gulf Coast included 16,000 rubber balls for the Aztec ritual/recreational ball game (Berdan 2005:42).

Commoners in the Basin of Mexico also paid a labor tax for public works and military service. The increased tribute stimulated market trade and specialization. Nobles exchanged tribute they received for other goods in the marketplace. Commoners, on the other hand, often had to purchase materials, such as raw cotton, to manufacture tribute goods demanded by the Triple Alliance. Rulers gained additional revenue from the increased market activity by taxing vendors. The flow of tribute into the imperial capitals prompted people in the areas immediately surrounding Texcoco and Tenochtitlan-Tlatelolco to intensify farming to supply the urban centers, while in peripheral towns, such as Otumba, households expanded both craft production and farming (Hassig 1985; Charlton et al. 2000).

Tribute primarily benefited the nobility. Tribute goods supplied the imperial palaces—the food sent to the palace of Texcoco was enough to feed 2,200 people each day (Berdan 2005:45) Tribute, along with taxes, financed government activities and the military. From exotic raw materials extracted as tribute, luxury artisans made gifts for imperial rulers to bestow on warriors and others for state service and loyalty.

Economic, along with political and ideological motives, drove Aztec imperialism, which brought an influx of wealth to the imperial capitals. Nobles benefited from the additional wealth, but commoners also took advantage of opportunities to diversify their household incomes and to advance socially through the military (Hassig 1999:372). The cost of providing tribute to the Triple Alliance, however, may have contributed to a decline in the standard of living in some provincial areas (Smith 1992; Brumfiel 2005) and created resentments against the Triple Alliance that Hernán Cortés exploited in the conquest of the Aztec empire.

REFERENCES

Anawalt, Patricia R. 1981. *Indian Clothing Before Cortes: Mesoamerican Costumes from the Codices*. University of Oklahoma Press, Norman.

Berdan, Frances F. 1983. The Reconstruction of Ancient Economies: Perspectives from Archaeology and Ethnohistory. In *Economic Anthropology: Topics and Theories*, edited by Sutti Ortiz, pp. 83–95. Monographs in Ecology Anthropology No. 1. University Press of America, Lanham, MD.

———. 1985. Markets in the Economy of Aztec Mexico. In *Markets and Marketing*, edited by Stuart Plattner, pp. 339–367. Monographs in Economic Anthropology No. 4. University Press of America, Lanham, MD.

———. 1986. Enterprise and Empire in Aztec and Early Colonial Mexico. *Research in Economic Anthropology Supplement 2: Economic Aspects of Prehispanic Highland Mexico* edited by Barry L. Isaac, pp. 281–302. JAI Press, Greenwich, Conn.

———. 1987. Cotton in Aztec Mexico. *Mexican Studies* 3:235–62.

1988 Principles of Regional and Long-Distance Trade in the Aztec Empire. In *Smoke and Mist, Mesoamerica Studies in Memory of Thelma D. Sullivan*, edited by J. Kathryn Josserand and Karen Dakin, pp. 639–56. BAR International Series 402 (ii).

_____. 2005. *The Aztecs of Central Mexico: An Imperial Society.* Thomson Wadsworth, Belmont, Calif.

Berdan, Frances F., and Patricia Reiff Anawalt. 1997. The *Essential Codex Mendoza.* University of California Press, Berkeley.

Berdan, Frances F. and Michael E. Smith. 1996. Imperial Strategies and Core-Periphery Relations. In *Aztec Imperial Strategies,* edited by Frances R. Berdan, Richard E. Blanton, Elizabeth Hill Boone, Mary G. Hodge, Michael E. Smith, and Emily Umberger, pp. 209–18. Dumbarton Oaks Research Library and Collections, Washington, D.C.

Biskowski, Martin. 2000. Maize Preparation and the Aztec Subsistence Economy. *Ancient Mesoamerica* 11:293–306.

Brumfiel, Elizabeth M. 1987. Elite and Utilitarian Crafts in the Aztec State. In *Specialization, Exchange, and Complex Societies,* edited by Elizabeth M. Brumfiel and Timothy K. Earle, pp. 102–18, Cambridge University Press, Cambridge.

_____. 2005. Conclusions: Production and Power at Xaltocan. In *Production and Power at Postclassic Xaltocan,* edited by Elizabeth M. Brumfiel, pp. 349–68. Pittsburgh and Mexico City: University of Pittsburgh, Department of Anthropology and the Instituto Nacional de Antropología e Historia.

Charlton, Thomas H., Deborah L. Nichols, and Cynthia Otis Charlton. 1991. Aztec Craft Production and Specialization: Archaeological Evidence from the City-State of Otumba, Mexico. *World Archaeology* 23:98–114.

_____. 2000. Otumba and Its Neighbors: Ex oriente lux. *Ancient Mesoamerica* 11:247–265.

Díaz, Bernal. 1963. *The Conquest of New Spain.* Trans. by J. M. Cohen. Penguin Books, Middlesex.

Durán, Fray Diego. 1964. *The Aztecs: The History of the Indies of New Spain.* Trans. by Doris Heyden and Fernando Horcasitas. Orion Press, New York.

_____. 1971. *Book of the Gods and Rites and the Ancient Calendar.* Trans. by Fernando Horcasitas and Doris Heyden. University of Oklahoma Press, Norman.

Hassig, Ross. 1985. *Trade, Tribute, and Transportation: The Sixteenth-Century Political Economy of the Valley of Mexico.* University of Oklahoma Press, Norman.

_____. 1999. *The Aztec World. In War and Society in the Ancient and Medieval Worlds,* edited by Kurt Raaflaub and Nathan Rosenstein, pp. 361–87. Harvard University Press, Cambridge, Mass.

Hicks, Frederic. 1994. Cloth in the Political Economy of the Aztec State. In *Economies and Polities in the Aztec Realm,* edited by Mary G. Hodge and Michael E. Smith, pp. 89–112. Institute for Mesoamerican Studies, State University of New York, Albany.

Nichols, Deborah L. 1994. The Organization of Provincial Craft Production and the Aztec City-State of Otumba. In *Economies and Polities in the Aztec Realm,* edited by Mary G. Hodge and Michael E. Smith, pp. 175–93. Institute for Mesoamerican Studics, State University of New York at Albany and University of Texas Press, Albany and Austin.

_____. 2004. The Rural and Urban Landscapes of the Aztec State. In *Mesoamerican Archaeology: Theory and Practice,* edited by Julia Hendon and Rosemary Joyce, pp. 265–95. Blackwell Publishing, Oxford

Nichols, Deborah L., Elizabeth M. Brumfiel, Hector Neff, Mary Hodge, Thomas H. Charlton, and Michael D. Glascock. 2002. Neutrons, Markets, Cities, and Empires: A 1,000 Year Perspective on Ceramic Production and Distribution on the Postclassic Basin of Mexico. *Journal of Anthropological Archaeology* 21:231–44.

Nichols, Deborah L., Mary Jane McLaughlin, and Maura Benton. 2000. Production Intensification and Regional Specialization: Maguey Fibers and Textiles in the Aztec City-state of Otumba. Ancient Mesoamerica 11:267–291.

Otis, Charlton, Cynthia. 1993. Obsidian as Jewelry: Lapidary Production in Aztec Otumba, Mexico. *Ancient Mesoamerica* 4:231–43.

_____. 1994. Plebeians and Patricians: Contrasting Patterns of Production and Distribution in the Aztec Figurine and Lapidary Industries. In *Economies and Polities in the Aztec Realm,* edited by Mary G. Hodge and Michael E. Smith pp. 195–220. Studies on Culture and Society, vol. 6. Institute for Mesoamerican Studies, State University of New York at Albany and University of Texas Press, Albany and Austin.

Otis Charlton, Cynthia, Thomas H. Charlton, and Deborah L. Nichols. 1993. Aztec Household-Based Craft Production: Archaeological Evidence from the City-State of Otumba, Mexico. In *Household, Compound, and Residence: Studies of Prehispanic Domestic Units in Western Mesoamerica,* edited by Robert S. Santley and Kenneth G. Hirth, pp. 141–71. CRC Press, Boca Raton, Fla.

Parry, William J. 2000. Production and Exchange of Obsidian Tools in Late Aztec City-States. *Ancient Mesoamerica* 12:101–11.

———. 2002. Aztec Blade Production Strategies in the Eastern Basin of Mexico. In *Pathways to Prismatic Blades: A Study in Mesoamerican Obsidian Core-Blade Technology*, edited by Kenneth Hirth and Bradford Andrews, pp. 39–48. UCLA Institute of Archaeology, UCLA, Los Angeles.

Sahagún, Bernardino de. 1950–82. *Florentine Codex: General History of the Things of New Spain*. 12 books. Translated and edited by Arthur J. O. Anderson and Charles E. Dibble. School of American Research and the University of Utah Press, Santa Fe and Salt Lake City.

Smith, Michael E. 1992. *Archaeological Research at Aztec-Period Rural Sites in Morelos, Mexico, vol. 1: Excavations and Architecture/Investigaciones arqueológias en sitios rurales de la epoca Azteca en Morelos, tomo 1: Excavaciones y arquitectura*. University of Pittsburgh, Memoirs in Latin American Archaeology, vol. 4. University of Pittsburgh, Pittsburgh. 2003 *The Aztecs*. 2nd edition. Blackwell Publishing, Oxford.

Trigger, Bruce G. 2003. *Understanding Early Civilizations*. Cambridge University Press, Cambridge.

THE AZTEC EMPIRE

MICHAEL E. SMITH, ARIZONA STATE UNIVERSITY

The Empire of the Triple Alliance—often called the Aztec empire—occupied a somewhat paradoxical place in Aztec history and society. On the one hand the empire was the dominant political and economic force in central Mexico at the time of Spanish conquest (1521). Many or most of the best-known art objects from Aztec culture were produced for imperial rulers and elites, and they only make sense within the context of the empire. On the other hand, the effects of Aztec imperialism on people were sometimes quite modest. Unlike the Roman or Inkan emperors, whose armies and bureaucrats interfered greatly in provincial society, Aztec emperors were content to leave things alone in the provinces so long as people paid their taxes. In this essay I explore this paradox, emphasizing two aspects of Aztec imperialism: its effects on people and its manifestation in art and archaeology.

The rise to power of Tenochtitlan, the dominant imperial capital, is a dramatic story that is preserved in numerous official historical accounts written down after the Spanish conquest. The chronicle includes dramatic battles, courtly intrigue, and a story of religious predestination in which the gods guided and protected the Mexica rulers and people on their imperial journey. But in order to understand the empire, we need to begin with its background of city-states (*altepetl* in Nahuatl).

BACKGROUND TO EMPIRE: AZTEC CITY-STATES (ALTEPETL)

The ancestors of the Aztec peoples migrated to central Mexico from a semi-mythical northern homeland they called Aztlan. When groups of immigrants settled in the valleys of highland central Mexico—most likely during the twelfth and thirteenth centuries A.D.—they established dozens of small, independent kingdoms, the *altepetl* (see Chapter 2). Each king (*tlatoani*) claimed his right to rule on the basis of descent from the ancient and holy Toltec kings of Tula. Kings

were aided by various councils of nobles, warriors, and priests, and a small but growing bureaucracy of judges, tax collectors, and other officials. The altepetl consisted of this government apparatus, the commoners who were subject to the king, and the land they farmed. These were small polities defined not by territories with boundaries, but rather by the relationships of the constituent commoners and nobles with their king. In some areas, villages and farms subject to different kings were interspersed across the landscape.

Each altepetl had a small central urban settlement in which the polity's political, economic, religious, and social institutions were concentrated. The royal palace housed the king and his family as well as the institutions of rule. It was typically located adjacent to a spacious public plaza where large gatherings—from markets to religious ceremonies—took place. Temple-pyramids dedicated to the patron gods of the altepetl loomed over the plaza; the central pyramid of Ixtapaluca has been cleared off but not restored (Figure 1). The main plazas of altepetl capitals were also flanked by a series of smaller and more specialized temples and shrines (Figure 2). Outside of the central plaza area lived neighborhoods of commoners, including many farmers who walked out to their fields each day. These capital towns were not large—most had only 5,000 to 10,000 inhabitants—but they were the only urban settlements within their altepetl (Smith 2008).

Kings of nearby altepetl both competed and cooperated with one another. They continually built larger and better temples and cities to show off their power and magnificence, and in many cases kings warred with one another. These wars were true antagonistic events, not ceremonial raids, but the goal was not to conquer territory. Instead, the goal of warfare among altepetl was to conquer other kings and force them to pay tribute to the victor. At the same time, nearby altepetl engaged in more friendly forms of interaction. Merchants traded among otherwise antagonistic altepetl, and nobles married across political lines for diplomatic purposes. The joint result of these simultaneously friendly and antagonistic interactions among numerous petty kings was a volatile and dynamic political situation which generated the formation and expansion of several successive empires (Hodge 1984). In many respects, Aztec city-states and their dynamic interactions were similar to other city-state systems of the ancient world (Hansen 2000).

IMPERIAL EXPANSION AND CONTROL

The interval from ca. 1100 to 1300 A.D.—known to archaeologists as the Early Aztec period—was a time of urban expansion and cultural development among the Aztec altepetl. By the end of this period, several cities were starting to expand at the expense of their neighbors. The kings of cities such as Texcoco and Azcapotzalco in the Basin of Mexico, and Cuauhnahuac and Calixtlahuaca in surrounding valleys, conquered numerous altepetl to forge small tributary empires. These empires employed strategies of expansion and control that had been developed by earlier altepetl. Conquered kings and governments were left in power so long as they acknowledged the supremacy of the conquering king and paid an annual tribute in goods and services. Unfortunately little is known about these earliest Aztec empires. The largest and most powerful of these—the Azcapotzalco Empire ruled by king Tezozomoc from 1374 to 1427—was defeated by the Tenochtitlan and its Triple Alliance in 1428. The rulers of Tenochtitlan then engaged in

Figure 1. The unreconstructed central temple-pyramid at the city-state capital of Ixtapaluca, also known as Acozac.

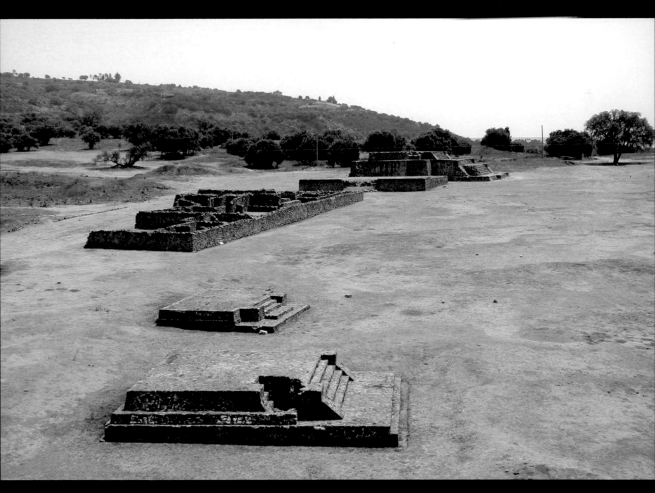

Figure 2. The main plaza of Ixtapaluca, looking north from the central temple-pyramid.

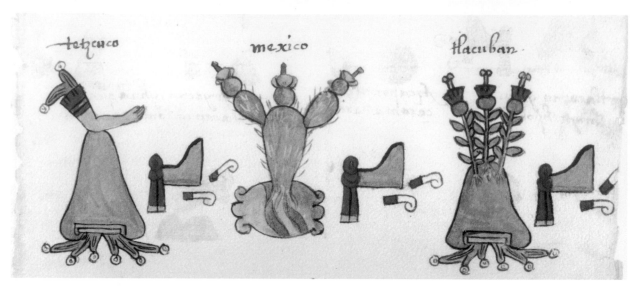

Figure 3. Glyphs representing the Triple Alliance from the *Codex Osuna.*

a systematic program of burning the history books to erase references to the glory and might of Azcapotzalco (Santamarina 2006).

The Empire of the Triple Alliance was formed in the aftermath of the war that defeated Azcapotzalco in 1428. Figure 3, an image from the *Codex Osuna* (1947) shows the toponyms (place names) of the three capitals of the empire: Texcoco, head city of the Acolhua confederacy; Tenochtitlan (labeled "Mexico"), the central city of the Mexica peoples; and Tlacopan, a former rival of Azcapotzalco within the Tepanec domain. Each place name in the codex is accompanied by two emblems, or symbols, of legitimate kingship: a turquoise diadem or crown, and a pair of speech scrolls. These three capitals agreed to jointly conquer other altepetl and split the tribute, with two-fifths going to Texcoco, two-fifths to Tenochtitlan, and one-fifth to Tlacopan. Their program of imperial expansion began right away and proved to be quite successful; within ninety years the Triple Alliance had conquered most of northern Mesoamerica to become the largest and wealthiest empire north of Peru. By the time Hernán Cortés arrived in 1519, Tenochtitlan had emerged as the dominant power in the empire, with the other capitals clearly subservient to the Mexica kings (Carrasco 1999).

The primary goal of imperial expansion was to subjugate distant city-states and force them to pay tribute to the empire (Berdan et al. 1996). The tribute goods demanded of each province were recorded in pictorial codices such as the *Codex Mendoza* (Berdan and Anawalt 1992) (Figure 4). These goods were paid four times a year. When the totals are added up, we see an enormous amount of material—food, textiles, luxury items, warriors' costumes—that entered and enriched Tenochtitlan each year (Rojas 1986).

Aztec imperial expansion was carried out by military action. Armies were led into battle by the most experienced warriors, spurred on by drums and trumpets. Three primary weapons were used: swords whose edges were composed of rows of razor-sharp obsidian blades (Figure 5); thrusting spears; and bows and arrows (Hassig 1988). Aztec warfare was considered a sacred duty in several respects. First, all men were subject to military service, a basic duty to one's king and

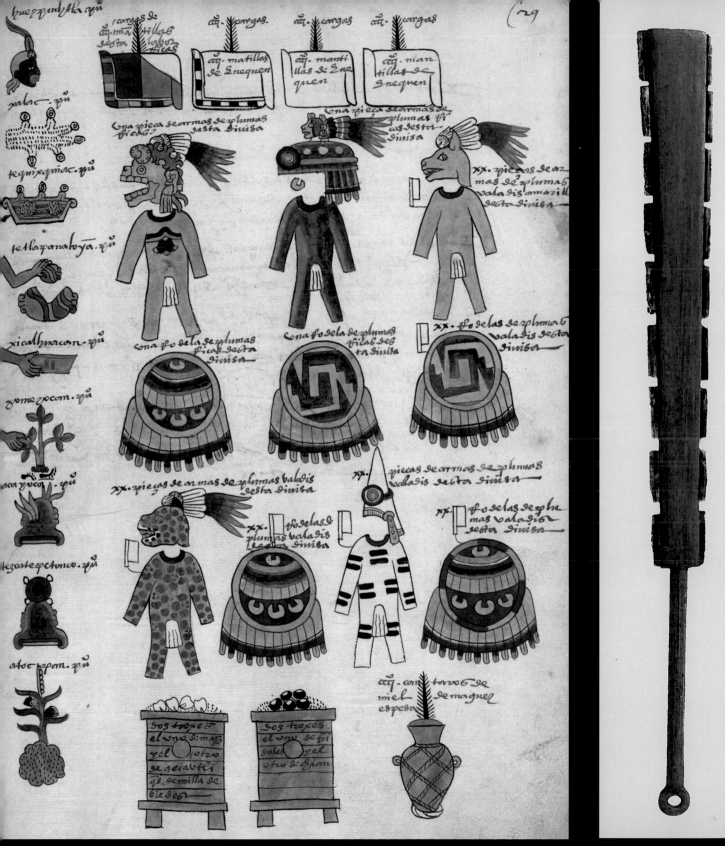

Figure 4. List of tribute from the imperial province of Huexpuchtla as recorded in the *Codex Mendoza*

Figure 5. Obsidian-edged sword

altepetl. Second, warfare was considered a cosmic struggle that paralleled battles between light and darkness and between gods such as Quetzalcoatl and Tezcatlipoca.

The twin elements of warfare as political expansion and warfare as cosmic duty had a strong effect on battlefield actions. On the one hand, armies sought to kill opposing soldiers and gain battlefield victory. On the other hand, soldiers tried to injure or cripple enemy fighters in order to capture them alive (Isaac 1983). Battlefield captives were the primary source of victims for human sacrifice (see Chapter 8), and taking such captives was one part of the sacred mission of war. Soldiers gained prestige and moved up the military hierarchy based upon the number of enemies they captured. The various warrior ranks were signaled publicly by dress and jewelry, and the most successful warriors joined elite military orders such as the Eagle Warriors and the Jaguar Warriors. The advancement of a young man up the military hierarchy was a source of pride for his family and neighborhood.

Warriors were a major theme of Aztec art; they are depicted in the codices, in murals, and in stone sculpture (Figure 6). The privileges of accomplished warriors, as described by the chroniclers, went beyond their special clothing and jewelry. Warriors participated in special ritual dances and other ceremonies, and they often gathered together in special halls, such as the House of the Eagles. Military activities were celebrated in the gladiator sacrifice, in which the victim (an accomplished enemy soldier) was given false weapons, tied to a sacrificial stone, and fought Mexica warriors armed with real weapons.

A major reason for the rapid success of the Triple Alliance Empire was the size and skill of its armies. The Empire could field more soldiers than most of the altepetl it faced, and soon there were few armies that could withstand sustained battle with imperial forces. By 1519 it had conquered much of northern Mesoamerica (Figure 7). Most areas were tributary provinces; they paid regular tribute as recorded in the Codex Mendoza (see Figure 4). More distant conquered ar-

Figure 6. Relief showing Aztec warriors, from a bench in the House of the Eagles.

eas, called strategic provinces, were exempt from regular tribute requirements of the sort paid by the tributary provinces. The strategic provinces provided soldiers for imperial armies, they helped guard imperial borders, and they gave "gifts" to the Mexica emperor.

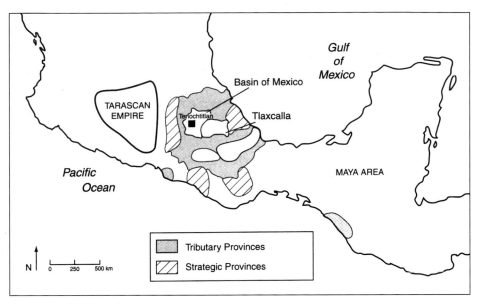

Figure 7. Map of the Aztec Empire.

One reason for the existence of the strategic provinces was the presence of two major unconquered enemy states (Figure 7). To the west of central Mexico, the Tarascan Empire based in Tzintzuntzan engaged in a parallel process of imperial expansion. When Tarascan conquests reached the Toluca Valley of central Mexico (immediately west of the Basin of Mexico) in the 1470s, Tenochtitlan sent a large force to do battle. The Tarascans won the battle, but not definitively, and in the aftermath the two empires established a fortified border zone that remained until the arrival of the Spaniards (Pollard 1993).

Whereas the Tarascans were ethnically and linguistically distinct from the Aztec peoples of central Mexico, the second unconquered enemy area—Tlaxcala—was inhabited by Nahuatl-speaking Aztec peoples. The Triple Alliance surrounded Tlaxcala with conquered provinces (Figure 7) and warfare was constant in the final decades of the Aztec period, but the Triple Alliance could not succeed in conquering Tlaxcala. Embarrassed by this failure, which contradicted official Mexica propaganda of an all-powerful empire, Aztec nobles after 1519 invented stories to explain it away. They told the Spaniards that the Mexica could have conquered Tlaxcala any time they wanted, but they preferred to engage in limited practice battles rather than a war of all-out conquest. They made up the concept of the "flowery war" to describe ritualized practice battles. But it is easy to see through such rationalizations today; the Triple Alliance badly wanted to conquer Tlaxcala and they probably would have succeeded if Hernán Cortés had not arrived in 1519 (Smith 2003).

The failure of Tlaxcala to succumb to Aztec imperial armies suggests that many or most provincial city-states were not anxious to participate in the Triple Alliance Empire. Imperial control was indirect—the empire relied on provincial kings to collect and forward tribute rather than sending governors and armies or building cities in the provinces. On many occasions subject kings rebelled against the empire; such "rebellions" were not armed insurrections, however. Rather, they usually meant that a subject king merely elected to stop sending tribute to Tenochtitlan. To keep such events to a minimum, provincial elites were "bought off" with privileges (see discussion that follows) so that they would have greater allegiance to the Triple Alliance than to their own subjects (Berdan et al. 1996).

PEOPLE AND THEIR LIVES UNDER THE EMPIRE

The Aztec empire had a profound effect on the several million people in its orbit. But the nature of its effects varied greatly with location, social class, and other social categories. For the nobles of Tenochtitlan, for example, the expansion of the empire generated wealth, power, prosperity, and the good life. For provincial peasants, on the other hand, the empire brought increased taxes and lowered standards of living. For many people's lives, the empire had effects both positive and negative. The numerous material objects produced throughout the empire provide a window on these varied social effects.

WEALTH, POWER AND IDEOLOGY IN TENOCHTITLAN

The island capital Tenochtitlan was one of the last Aztec cities to be founded, but once the Triple Alliance was formed in 1428 the city rapidly outgrew its contemporaries in size and magnificence. By 1519 Tenochtitlan was the largest city ever seen in the pre-Hispanic New World

Figure 8. The Tizoc stone, an imperial style stone sculpture.

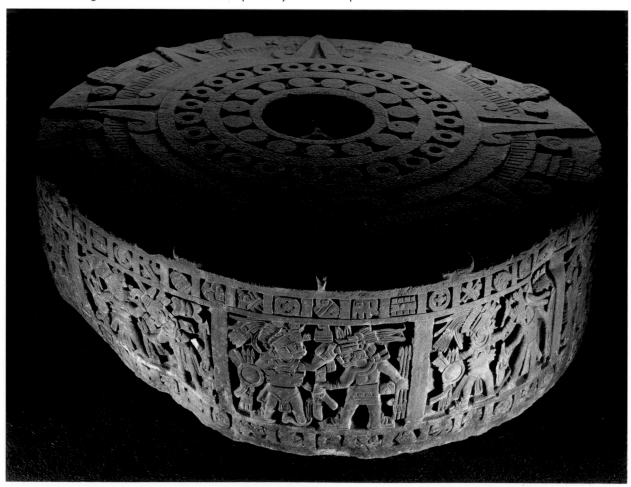

(see Chapter 4). The major reason for the city's phenomenal growth was the successful military expansion of the Aztec empire. Increasing amounts of booty and tribute flowed from the provinces into the city, enriching not only the nobility but most of the urban commoners as well. All kinds of economic activity—from the production of everyday tools and objects to the fashioning of elite art to commerce—was stimulated by the new imperial wealth, and people from all over moved to the capital.

The most spectacular imperial effects in the capital were in religious art and architecture. As in all ancient states and empires, religion was closely entwined with politics. The gods sanctioned and encouraged imperial expansion, and the rulers, nobles and priests of Tenochtitlan invested considerable resources in thanking the gods for their help. The Templo Mayor was continually rebuilt and expanded to become one of the largest pyramids in Aztec central Mexico (Matos Moctezuma 1988). The sacrificial rites carried out at the Templo Mayor were increasingly elaborate ceremonies involving numerous participants and theatrical spectacles (Brumfiel 1998). Fine stone sculptures (Figure 8) and elaborate ceramic offering vessels (Figure 9) were crafted for use at ceremonies in this and other temples. These imperial objects had significance in two related realms: religion (direct worship of the gods) and ideology (political legitimacy for the ruler).

Much of the wealth generated by the empire went to the king and other nobles of Tenochtitlan. Noble lifestyles grew increasingly luxurious and elaborate, much more so than in other Aztec city-state capitals. But the economic activity of the capital must also have benefited the lives of artisans, merchants, and other commoner residents of the city. Unfortunately there is little direct information on such changes; written sources have little to say about changes in commoner lifestyles of Tenochtitlan, and archaeologists have excavated few commoner houses in the capital.

ECONOMIC TRANSFORMATION IN THE BASIN OF MEXICO

Outside of Tenochtitlan, the expansion of the Aztec Empire had varied effects on the peoples of the Basin of Mexico. Many altepetl capitals continued to flourish, as evidenced by continued architectural rebuilding (Figures 1 and 2) and increased economic activity. Many subject kings and nobles cooperated with the Triple Alliance rulers and secured favors and imperial support for their local rule. But for most commoners, imperial expansion entailed a double economic burden that must have made life difficult. First, imperial taxes were added to the local altepetl tax burden of goods and services. Second, the explosive growth of Tenochtitlan led to problems in urban food supply, and farmers had to step up their efforts to grow food for the use of urbanites. Previously, many peasant families had engaged in the production of pottery and other goods as supplementary economic activities. Although we are not sure of the role of coercion in the turn to intensive grain production, its effects on domestic life were significant. Although clear evidence is scarce, it is likely that many imperial subjects in the Basin of Mexico resented the impositions and burdens posed by the empire.

Archaeological fieldwork at two towns shows the varied effects of the empire on commoners in the Basin of Mexico. At Huexotla, an altepetl capital close to Texcoco, Elizabeth Brumfiel's research has documented the turn to heavy grain production for urban food supply. The only

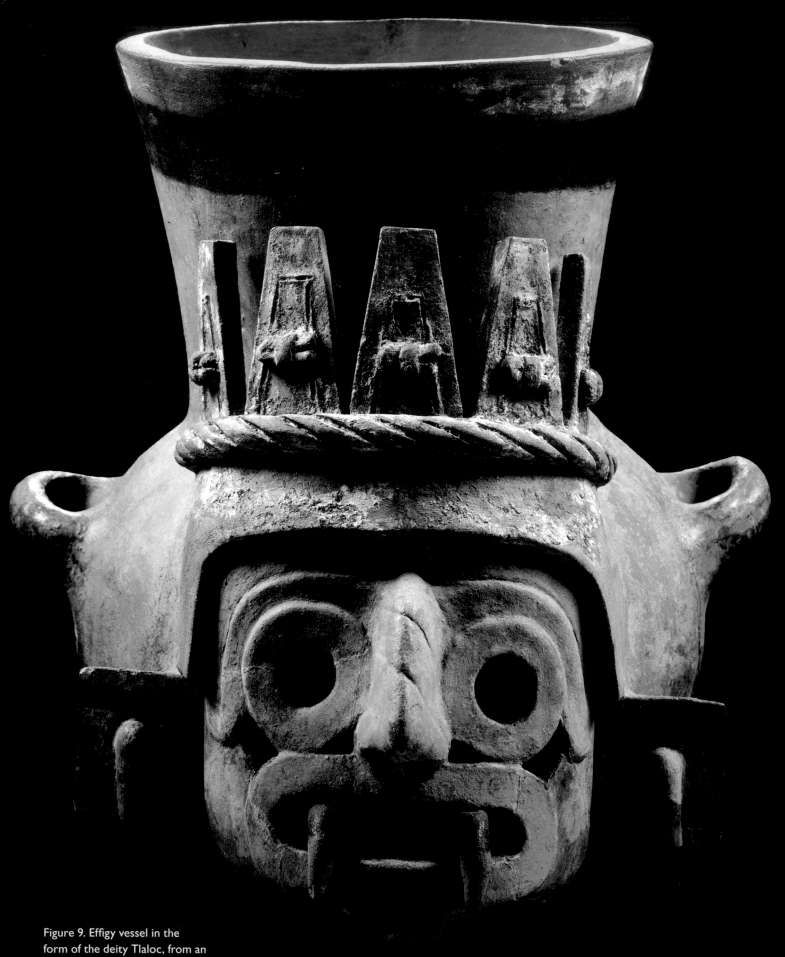

Figure 9. Effigy vessel in the form of the deity Tlaloc, from an offering at the Templo Mayor.

other economic activity that people engaged in was textile production. As discussed in Chapter 5, all Aztec women spun and wove, and ceramic spindle whorls used for spinning thread of cotton and maguey were abundant in Huexotla. Under imperial control, however, the numbers of whorls declined, suggesting that people may have been devoting so much effort to growing grain that they had to reduce their cloth production activities (Brumfiel 1980). Economic activities at Otumba, a more distant altepetl capital, were quite different. Fieldwork by Thomas Charlton, Deborah Nichols, and Cynthia Otis Charlton (1991) revealed a large number of craft workshops that produced tools and other objects for exchange in the markets (see Chapter 6).

DAILY LIFE IN THE PROVINCES

As in the Basin of Mexico, the effects of the Aztec Empire on people varied greatly in the outer imperial provinces. In some areas, commoner life continued with little change. People had to pay higher taxes (like the Basin of Mexico, imperial tribute or taxes were merely added to preexisting altepetl taxes), but the indirect nature of imperial control left many aspects of provincial life alone. This is what I found in excavations of commoner houses at several sites in the Mexican state of Morelos (Smith 1997). Both before and after imperial conquest of this area, people lived in small houses built of adobe bricks laid on stone foundation walls (Figure 10). Their basic nonperishable domestic goods—pottery, obsidian, stone grinding tools, and rare luxuries such as stone jewelry and bronze tools—remained the same after their conquest by the Triple Alliance in the 1430s. One subtle change, however, was a reduction in the numbers of local decorated ceramic serving vessels and imported serving vessels, suggesting a somewhat lowered standard of living under the empire.

Figure 10. Wall foundations and floor of a commoner house excavated at the village of Capilco in Morelos.

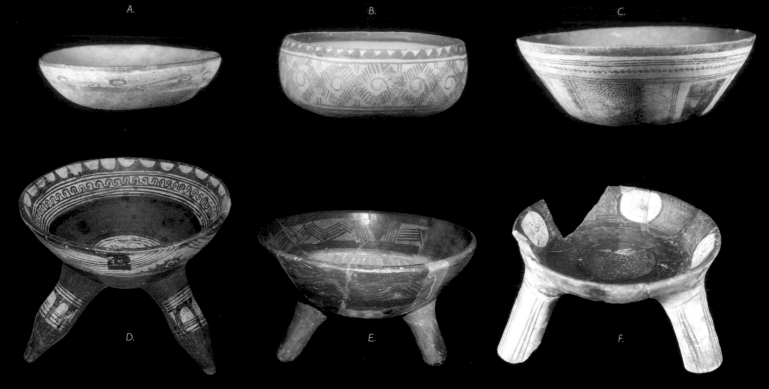

Figure 11. Ceramic vessels from distinctive Aztec-period regional styles. A: Malinalco; B: Southeastern Morelos; C: Western Morelos; D and E: Toluca Valley; F: Chalco. A, B, C, and F are from excavations in Morelos; D and E are from excavations at Teotenango in the State of Mexico.

Figure 12. Long-handled incense burners excavated from an offering in the ballcourt at the provincial Aztec city of Coatetelco. Excavations of Aztec houses turn up numerous fragments of censers like these, indicating that they were used in domestic rituals as well as in the temples.

Throughout central Mexico, most commoner households had access to decorated serving ware. Potters in each region produced distinctive styles of vessels (Figure 11). This kind of aesthetically pleasing and well-made serving ware was not limited to nobles or to ceremonies, as is sometimes claimed. Archaeologists have excavated numerous broken fragments of such vessels at both commoner and elite houses. Provincial peoples also had access to a number of imported goods, including obsidian tools and ceramic vessels. The most widely traded ceramic ware was the type called Aztec III Black-on-Orange. These vessels were the everyday serving ware in the Basin of Mexico, where they were produced in several centers, but they are also found as rare additions to most household inventories of provincial peoples (again, both commoners and elites).

Domestic life in the provinces also included a sacred dimension (Smith 2002). Two types of ritual objects made of pottery are commonly found in archaeological collections from provincial houses—figurines and incense burners (Figure 12). Figurines (Kaplan 2006) in the distinctive Aztec style are abundant in domestic contexts throughout central Mexico. In my excavations in Morelos, I found that some of these were made of clay from the Basin of Mexico (and thus clearly imported), while others in the same style were made of local clays. The presence of figurines of the first category can be accounted for by commerce, whereas the second category shows that styles and religious concepts had a broad distribution throughout central Mexico. Although there is much that we do not know about Aztec figurines, it seems clear that they were used in some kind of domestic rites, most likely involving curing, fertility, and divination. Incense burners are another common find in excavations of domestic contexts throughout central Mexico. Each region had its distinctive type of censer to burn copal incense in domestic rites.

The presence at provincial sites of Aztec-style figurines made of local clays points to the existence of a network of shared styles and concepts throughout central Mexico, including Tenochtitlan, the Basin of Mexico, and the exterior imperial provinces. This is but one example among many cases of widespread similarities in material culture within this area. Several reasons for these stylistic similarities can be identified. First, the Aztec peoples of central Mexico shared a common history and heritage. According to local historical accounts, their ancestors had all come from the semi-mythical homeland of Aztlan, presumably located somewhere to the north of central Mexico. The Aztlan migrants shared the Nahuatl language and many cultural traits, and it is only logical that their descendants throughout central Mexico would have numerous similarities in styles and practices.

A second reason for widespread similarities in material culture was the importance of commercial networks that tied different regions together. In their local weekly market, people could not only purchase imported goods, but they also had the chance to see foreign styles and goods and to get news from different areas. A third explanation for the distribution of Aztec styles is found in the practices and concepts that made up Aztec elite culture.

AZTEC ELITE CULTURE

The Aztec nobility constituted a single integrated social class that extended throughout the entire empire and beyond. Just as nobles from nearby altepetl visited one another and formed marriage alliances and other diplomatic ties (see above), so too did nobles in a much larger arena interact

intensively. One result was the forging of a distinctive elite culture that transcended political boundaries. This elite culture was responsible for much of the art shown in *The Aztec World*.

Monumental public architecture was the most dramatic material expression of Aztec elite culture. The Templo Mayor of Tenochtitlan is both the best-documented Aztec building and the building with the most extravagant offerings. The Mexica kings who built and enlarged this structure did not invent its form or style overnight. Rather, they drew on an ancient tradition of double-stairway pyramids begun by the earliest Aztec kings in the Early Aztec period. The temple of Teopanzolco, located in downtown Cuernavaca, was one of the earliest double-stairway pyramids (Figure 13); the first was probably that of Tenayuca. The kings of Tenochtitlan, Tlatelolco, and Texcoco built and rebuilt huge pyramids to demonstrate their power and glory. For the forms of their pyramids they avoided the standard Aztec single-stairway pyramid (Figure 1) and copied the ancient double-stairway temples of Tenayuca and Teopanzolco (Smith 2008).

This historical tradition of temple architecture was but one component of Aztec elite culture. Although each Aztec city had its own layout and its own public monuments, the forms of buildings were remarkably uniform throughout central Mexico. For example, circular temples, dedicated to the wind god Ehecatl (who did not like corners), were similar—but not identical—at many Aztec cities (Figure 14).

Elaborately carved stone sculpture was another material manifestation of Aztec elite culture. The imperial sculptural style shown on many objects in *The Aztec World* was developed in the workshops of Tenochtitlan, but examples have been recovered at other Aztec cities in central Mexico (Figure 15). These provincial examples could have been transported from the imperial capital, or perhaps Mexica artists traveled to distant cities, or provincial sculptors could have received train-

Figure 13. Early Aztec period double-stairway pyramid Teopanzolco, a site located in modern Cuernavaca.

Figure 14. Plans of circular temples at several Aztec capital cities.

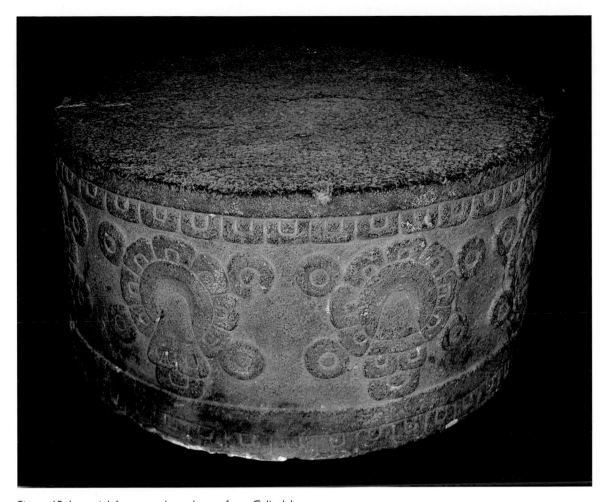

Figure 15. Imperial Aztec–style sculpture from Calixtlahuaca.

ing in the capital. Regardless of the mechanisms, however, the presence of such fine, imperial-style sculptures at other cities shows that distant rulers shared both aesthetic tastes and religious-political concepts with the nobles of Tenochtitlan (Umberger 2007). Many other fine objects present similar patterns of distribution with similar implications of shared elite culture: elaborate ceramic censers and effigy vessels; feather art; jewelry of precious stones and gold; and clothing.

ART AND EMPIRE IN THE AZTEC WORLD

The Triple Alliance Empire influenced many aspects of life and society in Aztec-period Meso-america. For rulers and nobles in the imperial capitals, imperial expansion was a source of wealth and power. Imperial tribute fed much of the elite conspicuous consumption that involved the sculptures and other luxury items shown in *The Aztec World*. Regular injections of tribute wealth stimulated economic activity that also benefited the commoners in the capitals. In the provinces, the benefits of empire accrued mainly to the ruling elites, who were rewarded for participation in the imperial system. The burden of tribute, on the other hand, fell squarely on the backs of provincial commoners. The fact that many art styles and objects were very widely distributed throughout

the empire (and beyond) was due largely to the fact that art was used as a tool of imperial policy. Gifts and exchanges of goods among nobles cemented the bonds of Aztec elite culture, and the use of imperial styles in provincial areas also signaled the participation of distant elites in these networks. In this way, Aztec art was an important part of the glue that held the empire together.

REFERENCES

Berdan, Frances F., and Patricia R. Anawalt, eds. 1992. *The Codex Mendoza*. 4 vols. Berkeley: University of California Press.

Berdan, Frances F., and Patricia Reiff Anawalt. 1997. *The Essential Codex Mendoza*. Berkeley: University of California Press.

Berdan, Frances F., Richard E. Blanton, Elizabeth H. Boone, Mary G. Hodge, Michael E. Smith, and Emily Umberger. 1996. *Aztec Imperial Strategies*. Washington, D.C.: Dumbarton Oaks.

Brumfiel, Elizabeth M. 1980. Specialization, Market Exchange, and the Aztec State: A View From Huexotla. *Current Anthropology* 21:459–78.

———. 1998. Huitzilopochtli's Conquest: Aztec Ideology in the Archaeological Record. *Cambridge Archaeological Journal* 8:3–14.

Carrasco, Pedro. 1999. *The Tenochca Empire of Ancient Mexico: The Triple Alliance of Tenochtitlan, Tetzcoco, and Tlacopan*. Norman: University of Oklahoma Press.

Charlton, Thomas H., Deborah L. Nichols, and Cynthia Otis Charlton. 1991. Aztec Craft Production and Specialization: Archaeological Evidence from the City-State of Otumba, Mexico. *World Archaeology* 23:98–114.

Códice Osuna. 1947. *Códice Osuna: reproducción facsimilar de la obra del mismo título, editada en Madrid, 1878*. Translated by Luis Chávez Orozco. Mexico City: Instituto Indigenista Interamericano.

Hansen, Mogens Herman (editor). 2000. *A Comparative Study of Thirty City-State Cultures*. Copenhagen: The Royal Danish Academy of Sciences and Letters.

Hassig, Ross. 1988. *Aztec Warfare: Imperial Expansion and Political Control*. Norman: University of Oklahoma Press.

Hodge, Mary G. 1984. *Aztec City-States*. Memoirs, vol. 18. Museum of Anthropology, Ann Arbor: University of Michigan.

Isaac, Barry L. 1983. Aztec Warfare: Goals and Battlefield Comportment. *Ethnology* 22:121–31.

Kaplan, Flora S. 2006. *The Post-Classic Figurines of Central Mexico*. Occasional Papers, vol. 11. Albany: Institute for Mesoamerican Studies.

Matos Moctezuma, Eduardo. 1988. *The Great Temple of the Aztecs*. New York: Thames and Hudson.

Pollard, Helen Perlstein. 1993. *Tariacuri's Legacy: The Prehispanic Tarascan State*. Norman: University of Oklahoma Press.

Rojas, José Luis de. 1986. *México Tenochtitlan: economía e sociedad en el siglo XVI*. Mexico City: Fondo de Cultura Económica.

Santamarina, Carlos. 2006. *El sistema de dominación azteca: el imperio tepaneca*. Madrid: Fundación Universitaria Española.

Smith, Michael E. 1997. Life in the Provinces of the Aztec Empire. *Scientific American* 277(3):56–63.

———. 2002. Domestic Ritual at Aztec Provincial Sites in Morelos. In *Domestic Ritual in Ancient Mesoamerica*, edited by Patricia Plunket, pp. 93–114. Monograph, vol. 46. Cotsen Institute of Archaeology, UCLA, Los Angeles.

———. 2003. *The Aztecs*. 2nd ed. Blackwell Publishers, Oxford.

———. 2008. *Aztec City-State Capitals*. Series: Ancient Cities of the New World. Gainesville: University Press of Florida (in press).

Umberger, Emily. 2007. Historia del arte e Imperio Azteca: la evidencia de las esculturas. *Revista Española de Antropología Americana* 37:165–202.

EIGHT
AZTEC HUMAN SACRIFICE

ALFREDO LOPÉZ AUSTIN,
UNIVERSIDAD NACIONAL AUTÓNOMA DE MÉXICO, AND
LEONARDO LÓPEZ LUJÁN,
INSTITUTO NACIONAL DE ANTROPOLOGÍA E HISTORIA

Stereotypes are persistent ideas of reality generally accepted by a social group. In many cases, they are conceptions that simplify and even caricaturize phenomena of a complex nature. When applied to societies or cultures, they may include value judgments that are true or false, specific or ambiguous. If the stereotype refers to one's own tradition, it emphasizes the positive and the virtuous, and it tends to praise: The Greeks are recalled as philosophers and the Romans as great builders. On the other hand, if the stereotype refers to another tradition, it stresses the negative, the faulty, and it tends to denigrate: For many, Sicilians naturally belong to the Mafia, Pygmies are cannibals, and the Aztecs were cruel sacrificers.

As we will see, many lines of evidence confirm that human sacrifice was one the most deeply rooted religious traditions of the Aztecs. However, it is clear that the Aztecs were not the only ancient people that carried out massacres in honor of their gods, and there is insufficient quantitative information to determine whether the Aztecs were the people who practiced human sacrifice most often. Indeed, sacred texts, literary works, historic documents, and especially evidence contributed by archaeology and physical anthropology, enable religious historians to determine that the practice of human sacrifice was common in most parts of the ancient world. For example, evidence of sacrifice and cannibalism has emerged in many parts of Europe, dating to the Neolithic and Bronze Ages. Furthermore, human sacrifice is well documented for Classical Greece and Rome. In Africa and Asia, sacrifice arose thousands of years ago: We know that the Egyptian pharaohs habitually immolated prisoners of war and the highest governors of Ur were buried with their families and entourage. Many other examples of ritual violence have been recorded in the history of India, China, Japan, and the Fiji Islands. Evidently, the American continent was no exception. There is ample archaeological and iconographic evidence of the bloody

massacres carried out by the Moche civilization of Peru, by many Mesoamerican peoples of the Maya region, Oaxaca, the Gulf Coast, and Teotihuacan, and by peoples that lived much farther north, including Mississippian peoples and natives of the southwestern United States.

There were all sorts of massacres in the ancient world. In the Nubian kingdom of Kerma, the bodies of men, women, and children shared the same sacrificial grave; in India, a woman was beheaded annually in honor of the goddess Kali; in Carthage, children were dedicated to the god Baal when there was threat of war. Some peoples stand out for their cruelty, such as the Japanese, who buried victims alive to protect castles and bridges; the Celts, who caged victims and set them afire, or the Dayaks of Borneo, who executed victims with bamboo needles. Certain peoples—including the inhabitants of Bengal and Dahomey—are famous for their mass immolations, some of which were still performed in the nineteenth century.

THE AZTEC IMAGE

If the practice of human sacrifice was so widespread in the ancient world, why is it so often associated with the Aztecs? Part of the answer lies in Spanish efforts to justify conquest from the very moment they arrived on the American continent. Spain and Portugal had to justify to the other European monarchies the privilege granted by Pope Alexander VI in 1493 to take possession of the New World in order to "indoctrinate these natives and inhabitants in the Catholic faith and impose the good ways upon them." As a consequence, the Spanish assumed the role of defenders of Christianity. To legitimize their conquest, they claimed that their mission included the eradication of human sacrifice and cannibalism by force in order to save innocent lives and souls.

During their stay on the Veracruz coast and their ascent to highland Mexico, the Spanish witnessed multiple human sacrifices performed by peoples who were enemies, subjects, or allies of the Aztecs. However, their extended stay at Tenochtitlan, capital of the Aztec empire, allowed them to observe, in all its complexity, the very diverse ceremonies that climaxed in ritual killing. This experience and the achievement of the destruction of Tenochtitlan throughout the process of conquest, solidified the stereotype of the Aztecs as sacrificers par excellence. It is not surprising that, taking advantage of this charge leveled by the Spanish, other native peoples who were conquered subsequently denied their own tradition and accused the Aztecs of originating these bloody rituals in their territories.

As centuries passed, the stereotype of the cruelty of the Aztecs spread, acquiring new nuances among both the dominant classes and the general population of New Spain and Europe. However, nationalistic ideologies in New Spain at the end of the colonial era and later in independent Mexico prompted a reassessment of pre-Hispanic human sacrifice, sometimes objectively and other times falling into an opposite stereotype.

Currently, both in Mexico and the rest of the world, there is an entire range of popular opinion on this multifaceted subject. At one extreme, there are those who perceive the Aztecs as the biggest sacrificers in world history. Such a view is often found in literature, magazines, and television documentaries, where the subject is usually dealt with in a sensationalistic manner, as if human sacrifice were the only aspect of the Aztec culture that is worthy of attention. Surprisingly,

this view continues as the justification for the brutal process of invasion, genocide, dominance, and marginalization of native Mexican peoples that have taken place for more than five centuries. At the other extreme, and also oversimplified, are those who deny that the Aztecs and their contemporaries offered human lives to the gods. They claim that the documentary sources of the sixteenth and seventeenth centuries are invalid, arguing that the texts and images that describe ritual human sacrifice and cannibalism are distorted works of the conquistadors and evangelizers themselves, or of the converted or subjected natives. Some fundamentalist groups went so far as to idealize the pre-Hispanic past, imagining peaceful societies engaging in astronomy, mathematics, philosophy, and poetry, and recommend an artificial revival of their values.

THE EVIDENCE OF HUMAN SACRIFICE

There are other much more rigorous ways to study such a complex phenomenon, with its economic, political, religious, and ethical implications. The social sciences offer a framework free of oversimplification based on varied, objective forms of evidence. The scientific method offers an objective, critical means to evaluate the hypotheses and theories that try to explain social institutions and processes in their historic and cultural context. In the specific case of Aztec sacrifice, a good number of serious, reliable scientific publications of different orientations exist. Among them, we can recommend *La fleur létale* [The Lethal Flower] by Christian Duverger, *Ritual Human Sacrifice in Mesoamerica* edited by Elizabeth H. Boone, *El sacrificio humano entre los mexicas* [Human Sacrifice among the Mexicas] by Yólotl González Torres, *The Human Body and Ideology* by Alfredo López Austin, *City of Sacrifice* by Davíd Carrasco, *Le sacrifice humain chez les aztèques* [Human Sacrifice Among the Aztecs] by Michel Graulich, and *Sacrificio mesoamericano* [Mesoamerican Sacrifice] edited by Leonardo López Luján and Guilhem Olivier. These publications rely mainly on the documentary sources produced in the first decades of the colonial period: the Nahuatl pictographs and texts written in Latin characters by the natives; the tales of the conquistadors, eyewitnesses to the religious life of Tenochtitlan, and descriptions of the Aztec cult made by the missionary friars. The seven publications mentioned above are notable due to their attempts to identify and evaluate the contexts and distortions of these sources, distancing themselves from literal and naïve reading of the historical information.

However, no matter how rich the information provided by the documentary sources, it must always be compared with data obtained from archeology and physical anthropology. Given that most of the historical information relative to Aztec sacrifice refers to the sacred precinct of Tenochtitlan, we quickly see the importance of material evidence recovered from this site during the excavations of the Templo Mayor Project between 1978 and 2007.

Among the discoveries made, the *téchcatl,* or stone upon which sacrificial victims were stretched as they were ritually killed, provides the most solid evidence of human sacrifice. Two of these stones were exhumed at the summit of one of the oldest stages of the Templo Mayor (c. 1390) (López Austin and López Luján 2001). They were located at the entrances of the two chapels that guard the images of Huitzilopochtli (the sun god) and Tlaloc (the god of rain), where they were visible to the multitude that congregated at the base of the pyramid to attend

ceremonies. Huitzilopochtli's stone was a smooth basalt polyhedron that rose 50 centimeters from the floor. The stone of Tlaloc was a sculpture of the rain god (Figure 1), lying on its back with a cylindrical altar fastened to his abdomen, which reached a height of 51 centimeters. The form and height of both stones assured their ability to function as tables for supporting the victims in the lumbar area, so that they could be bent backward in order to remove their hearts.

Sacrificial knives were similarly important (López Luján 2005) (Figure 2). A little more than one thousand knives have been recovered to date. These instruments are made of flint, a hard stone of great strength, which can be sharpened. The knives are lanceolated with an acute point to penetrate the body before cutting out the heart. A number of them have an ornament representing monstrous faces converting them into personified symbols of the sacrificial instrument, though they are ineffective for performing the rite. These have been identified by specialists as mere votive objects.

We should also consider the remains of the victims that were buried by the Aztecs at the Templo Mayor and adjoining buildings. If we add up the data from four successive archaeological projects in the area, the total reaches 126 individuals (Estrada Balmori 1979; Angulo 1966; Peña Gómez 1978; Román 1990; López Luján 2005; Chávez 2005). Among these are forty-two children—mainly males and suffering from anemia, parasitism, and gastrointestinal diseases—whose throats were slit in honor of the god of rain, and a forty-third child, killed by removal of the heart and dedicated to Huitzilopochtli. A second group is made up of forty-seven adult heads, almost all men, whose skulls and first vertebrae were found in the main architectural axes of the pyramid. Another group includes three skulls with perforations at the temples, which indicate that they come from *tzompantli*, the rack where trophy heads impaled on wooden poles were exhibited. Last, we must mention thirty-three skull-masks representing Mictlantecuhtli, god of death (Figure 3); these consist of the facial portion of the skulls adorned with shells and pyrite as eyes, and with sacrificial knives to simulate the nose and tongue.

Figure 1. A drawing of a sacrificial stone (*chacmool*) found at the entrance to the chapel of the god of rain, Templo Mayor, Tenochtitlan, Phase II (c. 1390 AD). *Drawing by Fernando Carrizosa Montfort, courtesy of Proyecto Templo Mayor, INAH.*

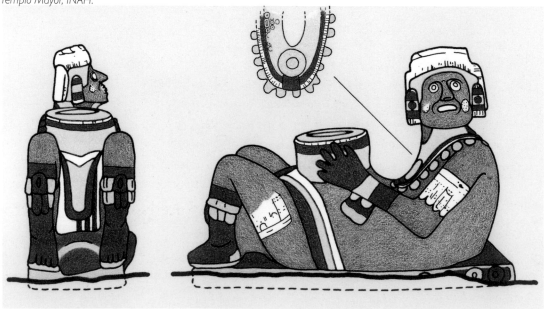

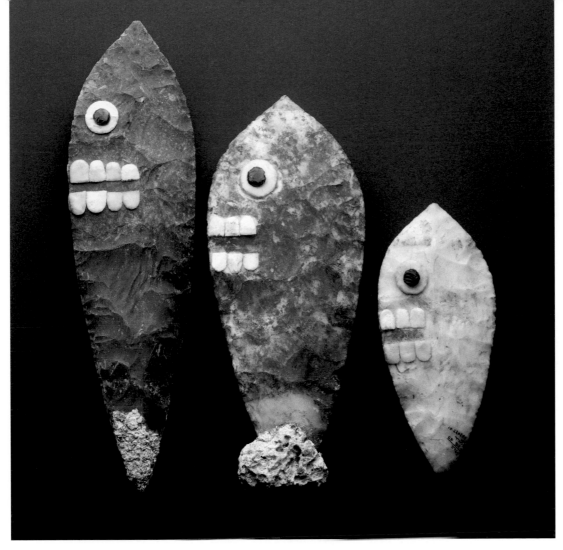

Figure 2. Sacrificial flint knives from an offering at the Templo Mayor, Tenochtitlan.

Recently, traces of blood on the surfaces of divine images, altars, and stucco floors have been identified (Figures 4 and 5). Thanks to modern techniques, significant concentrations of iron, albumin (the main protein in blood), and human hemoglobin were detected (López Luján 2006).

These and other pieces of evidence corroborate the graphic and textual information contained in the documentary sources of the sixteenth century, and they lead us to conclude, without doubt, that human sacrifice was a basic practice of the Aztec religion. At the same time, the evidence demonstrates that the numbers in the historical sources may be wildly exaggerated. There is quite a long way from the skeletal remains of the 126 individuals found so far in all construction stages of the Templo Mayor and its thirteen adjoining buildings to the 80,400 victims mentioned in a couple of documents for one single event: The dedication of an expansion of the Templo Mayor in 1487. In this regard, it is interesting to add that the largest number of bodies associated with a religious venue in Central Mexico was recorded in the classical city of Teotihuacan and not in Tenochtitlan. The excavations done at the Feathered Serpent Pyramid brought to light that this religious building, which dates from 150 A.D., was consecrated with the sacrifice of at least 137 individuals, almost all warriors (Sugiyama 2005). Recently, the remains of thirty-seven individuals were found inside the Moon Pyramid (Sugiyama and López Luján 2007).

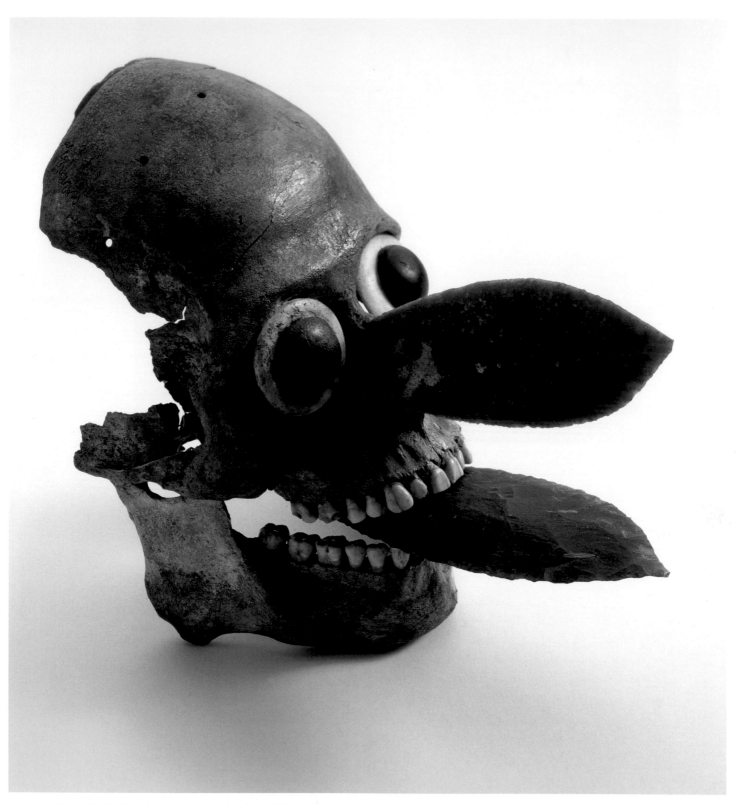

Figure 3. Skull-mask representing the God of Death, found at an offering of the Templo Mayor, Tenochtitlan.

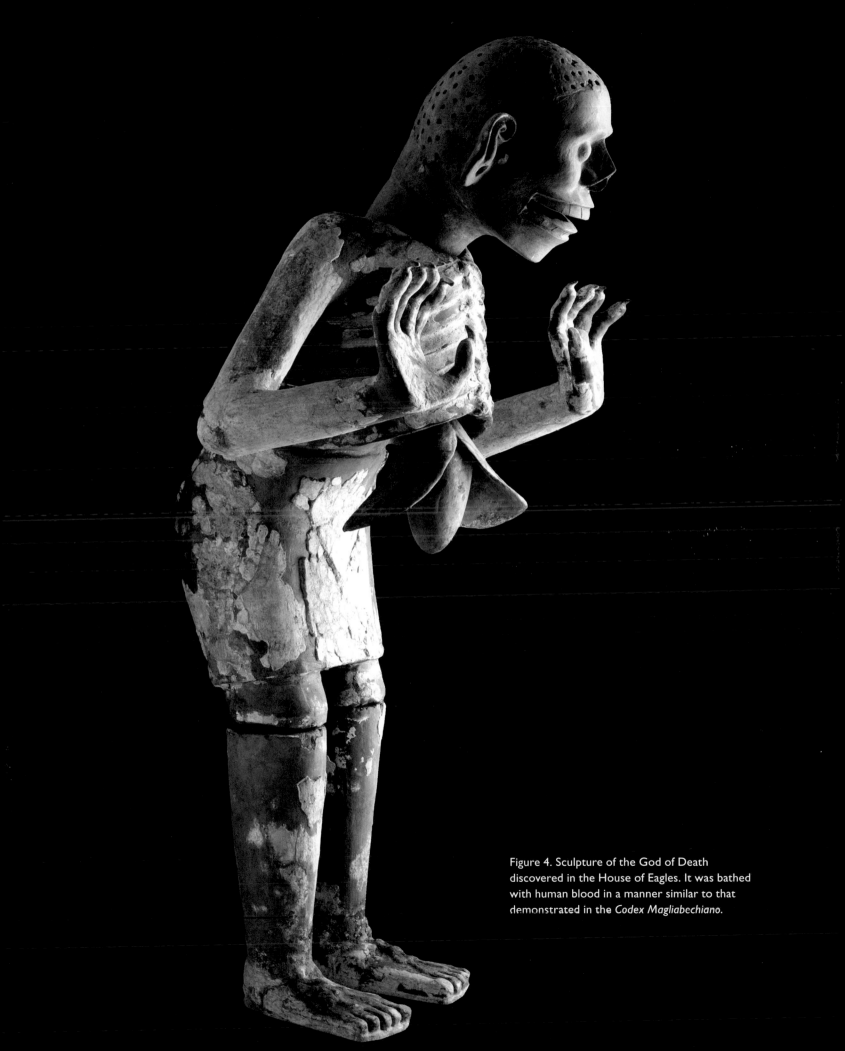

Figure 4. Sculpture of the God of Death discovered in the House of Eagles. It was bathed with human blood in a manner similar to that demonstrated in the *Codex Magliabechiano*.

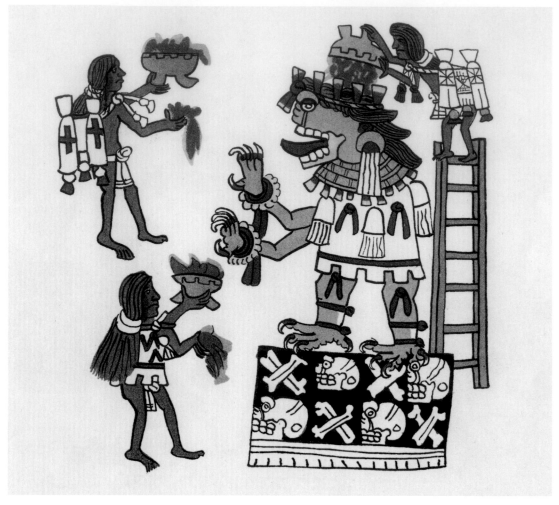

Figure 5. Image of the God of Death being bathed in human blood from the *Codex Magliabechiano*.

SACRIFICE AND WORLDVIEW

In order to fully understand human sacrifice in the Aztec culture, it is necessary to analyze the links between this practice and pre-Hispanic conceptions of the universe, the gods, man, and all of the creatures with which they interacted in daily life. Human sacrifice is incomprehensible to us if we do not take into account its location and its connection to the immense puzzle we call worldview (López Austin, 1988).

A simplistic perception of sacrifice as an isolated phenomenon will bring about an easy condemnation and an immediate repudiation of the people who practice it. In contrast, a scientific perspective will go beyond passing judgment since it will attempt to develop explanations that are based on the study of historical conditions, religious customs, and social institutions and relations surrounding sacrifice.

In the Mesoamerican religious tradition, humans imagined a universe in which the space-time belonging exclusively to the gods (the beyond) was distinguished from the space-time created by the gods for the creatures (the world). The latter was occupied by human beings, animals, plants, minerals, meteors, and stars, but it was also for the gods and supernatural forces whose

invisible presence meshed with the mundane. Divinity infiltrated all creatures, to give them their essential characteristics and to enliven, energize, transform, damage, and destroy them. In other words, creatures were conceived by the Aztecs and their contemporaries as mixed entities, made up of divine substances (subtle, eternal, predating the formation of the world) and worldly substances (hard, heavy, perceptible, destructible, which enveloped the divine elements).

The Aztecs believed that in primitive times many gods had been expelled from their heavenly dwelling for having violated the established order. One of the exiled, called Nanahuatzin, then decided to immolate himself in a bonfire. As a consequence of his courageous effort, Nanahuatzin descended to the netherworld in order to reemerge from there in the east, transformed into the first creature: the Sun. In this way he became the king of the world in gestation. However, the Sun refused to go to the sky until all his brothers imitated him, accepting sacrifice. The expelled gods could not avoid death, through which they descended to the cold place of darkness, where they acquired—like the Sun—a heavy and destructible shell. Thus it was that they were transformed into every type of worldly being: Pilzintecuhtli created the deer, Xolotl the amphibians called *axolotl*, Yappan the dark scorpions, his wife, Tlahuitzin, the light scorpions, et cetera. In short, through sacrifice the gods became creature creators. From that time, the Sun could begin its daily movement, and day and night followed each other.

The world of creatures communicated with the beyond through multiple portals. When the Sun began to move, the portals allowed the formation of cycles, since the gods and the supernatural forces used them to enter the world and withdraw from it. One cycle, for example, was that of life and death: When creatures passed on, their divine substance was stripped from the heavy worldly shell. The divine substance, now released, was sent to the netherworld, and there it waited for an opportunity to return to the world of creatures, giving rise to a new individual of the same type. Another cycle was the succession of the dry and rainy seasons. Another was time, shaped by the orderly appearance of gods who, with individual talents, periodically burst to the surface of the earth and in their passing changed everything that existed.

As the gods passed through the world and fulfilled their roles, they got tired and eventually lost their power. To recover their strength they had to be fed. That is why they created the human beings, creatures who were forced to worship them and feed them with offerings and sacrifices. Man perceived himself to be a privileged being because of his close relationship with the gods, but at the same time he was indebted to them because they had created him. Man also felt obligated because he received vital energy from the fruits arising from Mother Earth and ripened by the Sun. His debt was so great that the products of his labor were not sufficient to repay what he had acquired, and therefore, he had to offer his own blood and, at the end of his life, the remains of his body.

The relationship between human beings and the gods was interdependent. Human beings felt they were the beneficiaries of divine favors in their daily lives and at all important moments of their existence; they gratefully received rain, the fertility of the land, health, their own reproductive power, victory in war, et cetera. However, erratic rains, bad harvests, illnesses, and military defeats created the belief in fickle, very strict, and, on occasion, avaricious gods. Therefore, the faithful felt obligated to provide offerings and sacrifices to the gods to repay them for their gifts, to please them, or to appease their wrath. They offered the gods the aroma of flowers, incense, tobacco smoke, the first fruits of harvests, and blood and flesh that sustained them. Human beings

thus fulfilled an eternal exchange, preventing the disruption of the cycles, of the course of the Sun, of the passage of time, and of the succession of life and death. In this manner, they became participants in the proper functioning of the world.

With this logic, sacrificial victims had one of two main meanings. On the one hand, some of them were called *nextlahualtin,* or "restitutions." These individuals were considered simply means of payment, the most prized food to compensate the gods. On the other hand, other victims were the *teteo imixiptlahuan* or "images of the gods." It was believed that these persons were possessed by the divinities to relive the sacrificial death they had suffered in primitive times. Thus, the divinities, worn out by their work, ended their own cycle on earth: After succumbing to the edge of a flint knife, they traveled to the region of the dead to recover their strength and be born again there.

THE POLITICAL AND ECONOMIC DIMENSIONS OF SACRIFICE

In the tradition of ancient Mexico, man obeyed for thousands of years the terrible obligation of maintaining the world with his own blood and that of his kind. The roots of human sacrifice and cannibalism are ancient. The most ancient evidence of human sacrifice in Mexico comes from the cave of Coxcatlán in the Tehuacán Valley, dating to the hunter-gatherer societies of the El Riego phase (6000–4800 BC). The earliest evidence of cannibalism was recovered at the Late Formative site of Tlatelcomila, Tetelpan, in the Federal District (700–500 BC) (Pijoan and Mansilla 1997).

As the centuries passed and Mesoamerican societies were transformed into chiefdoms and states, ritual killing became increasingly complex. The transformation of their basic principles, with their devotional practices and concepts, must have been very gradual. In contrast, the immediate reasons for this practice changed much more rapidly, following the pace of political and economic change. The chiefdoms and states changed the meaning of this rite, intensified its practice, and began to use human sacrifice as a pretext for expanding their domains and pillaging the weak. This happened mainly during periods when political units competed for military supremacy. The people who experienced this hegemonic zeal most intensely were the Toltecs, the Maya of Chichen Itza, the Tarascans and, of course, the Aztecs. The latter, from 1430 and for nearly a century, waged wars of conquest that expanded their borders from the Pacific coast to the shores of the Gulf of Mexico, and southward to the borders of what is now Guatemala.

During the Late Postclassic period, wars of conquest were sanctioned as a way for men to fulfill their holy mission to perpetuate the existence of the world through human sacrifice (Hassig 1988). Aztec armies and those of their allies carried out ambitious military campaigns from which they returned victorious with numerous prisoners for their large sacrificial festivals. One of the purposes of these festivals was to boast of the military prowess of Tenochtitlan, instilling fear in its enemies. This explains why the leaders of the allied, subject, and independent peoples were invited to these occasions to witness the death of those who had opposed the Aztec rule.

Huitzilopochtli—patron god of the Aztecs—was conceived as the sun and a warrior. His main temple, the great pyramid known as Coatepetl ("Hill of the Snakes"), was considered the center not only of Tenochtitlan, but of the world. In this and many other temples in the sacred precinct and in various districts of the city, the Aztecs sacrificed their enemies with the convic-

tion that their actions made them the saviors of humanity. The common people suffered the consequences of the violent behavior of their rulers; nevertheless, they participated in this ideology, because they were immersed in a militaristic atmosphere, which exalted from childhood the glory of weapons and the demands of bloodthirsty gods. Accordingly, the school, the temple, and the militia were institutions strictly controlled by the government, which imprinted the values of death on each subject of this "benefactor" state.

Evidently, the Aztecs were not the only ones who developed such a militaristic mentality. All neighboring peoples shared this worldview, worshipped the same gods, and honored them with similar rituals. This gave rise to *xochiyaoyotl,* or "the war of the flowers," an institution created by the Aztecs and their enemies of the Puebla-Tlaxcala Valley. *Xochiyaoyotl* was based on a pact of controlled, periodic battles, in which the contending armies faced each other until one of them asked for a truce. Curiously, there was no interest in gaining spoils, territory, or tribute. At the end of the battle, both groups returned to their capitals bringing as a prize the enemies they had captured alive for sacrifice (Figure 6). But little by little, the Aztecs reduced the male population of the Puebla-Tlaxcala Valley, weakening it economically and militarily. It is noteworthy that a sacred kinship was established between captor and prisoner, who called each other respectively "father" and "son." Some authors have explained this association by the need of the offerer to deliver to the gods someone of his own nature, his true substitute.

THE DIVERSITY OF SACRIFICE

Not all individuals ritually sacrificed were warriors captured in battle. The rites of killing had a broad range of victims. Liturgy strictly dictated the origin, gender, age, and condition of those who would die in ceremony. For example, a middle-aged woman, descendant of one of the main noble families of Tenochtitlan, was chosen every year as victim for one of the most important festivals of the agricultural calendar (Figure 7); children with two cowlicks in their hair and

Figure 6. Sacrifice of prisoners of war during the inauguration of the Templo Mayor, Tenochtitlan in the year 1487.

Figure 7. Sacrifice of a woman personifying the goddess of salt.

who had been born under a favorable sign were offered by their own parents to the gods of rain to guarantee rains for the next season (Figure 8); albinos were a precious gift to strengthen the Sun during the feared eclipses, and a large group of dwarfs, humpbacks, and servants of the king were sacrificed after his death in order to help him in the other world. Evidently, there was no lack of those whose devotion drove them to deliver themselves voluntarily, as did certain priests, musicians, and prostitutes. Another important group was made up of slaves (Figure 9). We must clarify, however, that slavery among the Aztecs and their neighbors was of a less strict nature than, for example, among the Romans. In Tenochtitlan, the slave was generally a debtor subject to his creditor as a domestic servant. He remained a slave until he was able to repay his debt. During his service he could not be mistreated, nor could ownership be transferred to another person without his consent. However, if he was unruly and did not comply with the demands of his master, he could be condemned to the condition of "wooden-collar slave" (Figure 10); from then on, he could be sold to merchants or other groups of professionals who wished to offer him to the gods. For this purpose he was ritually bathed and after purification, made a victim of sacrifice.

On many occasions the victims went to death adorned in garments that symbolically joined them to the deities they personified. Dressed this way, they reenacted mythical events, recreating divine actions in the time of man. Depending on the ceremony, the liturgy dictated the method of sacrifice and the disposal of the bodies. The most common death was by cutting out the heart of the victim, who was placed face up on a *téchcatl* (Figure 11). Whether the sacrificer cut out the heart by penetrating the thoracic cavity through the abdomen and diaphragm, breaking the sternum lengthwise, making a small intercostal cut on the left side of the thorax, or a long intercostal cut from side to side, rupturing the sternum transversely, is still under debate. In some ceremonies, before the removal of the heart, the victim was subjected to a bonfire (Figure 12), injured by darts or arrows (Figure 13), or "scratched" with an obsidian sword in a gladiator-like confrontation (Figure 14). In other circumstances, the victim's throat was slit, or victims were locked away in caves or cavities made in a temple to die of suffocation or starvation; or they were drowned; or they were thrown down from the top of a tall pole. It is possible that the Aztecs also shared customs used by other Mesoamerican peoples, such as strangulation with a net, evisceration, and cooking in a steam bath. The Aztecs threw the dead bodies of the victims from the top of the pyramids, decapitated them, quartered them, skinned them, or kept the head and the femur as sacred objects. At certain festivals they practiced the ritual consumption of the victims' flesh, a cannibalistic practice whose purpose was the communion of the faithful with the body that had been made divine through sacrifice (Figure 15).

The occasions for sacrifice were varied. The large majority occurred within the framework of the solar calendar, associated with the eighteen months of twenty days into which the 365-day year was divided. Sacrifices were also performed in the context of other cycles, such as the 260-day ritual calendar and cycles of fifty-two years. Outside of predetermined ritual days, individuals were offered for military battles (Figure 16), either before the battle to avoid or win it, or subsequently to celebrate victory. Numerous prisoners of war were also sacrificed to strengthen and consecrate with their blood the foundations of religious buildings and to inaugurate their subsequent expansions (Figure 17). Some rites intended to reestablish the safety and order lost during diseases, droughts, floods, famines, and eclipses.

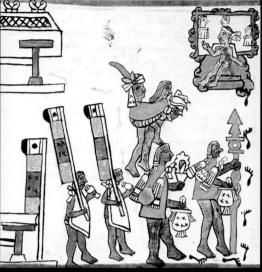

Figure 8. Sacrifice of a child personifying one of the little gods who assist the god of rain.

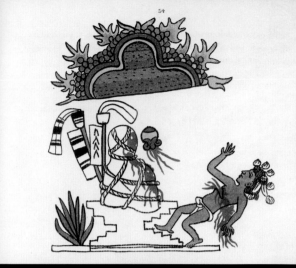

Figure 9. Sacrifice of a slave during the funeral of a master.

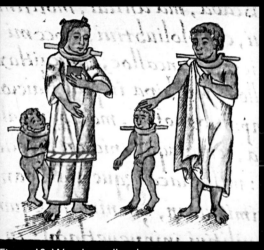

Figure 10. Wooden-collar slaves.

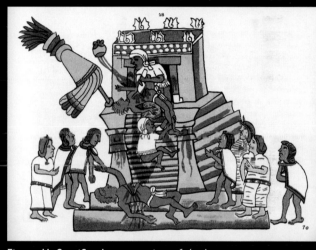

Figure 11. Sacrifice by extraction of the heart.

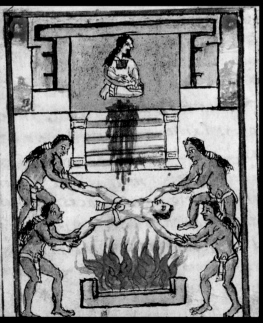

Figure 12. Subjecting a sacrificial victim to fire.

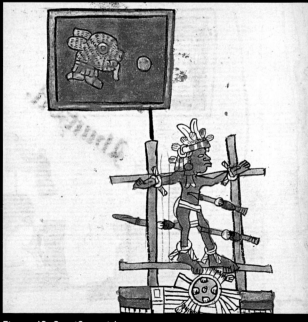

Figure 13. Sacrifice with arrows.

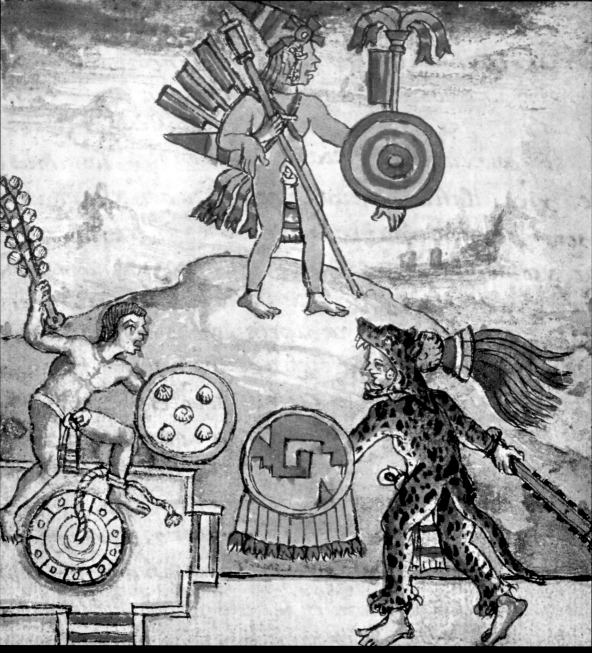

Figure 14. "Scratching" ceremony or gladiator sacrifice.

Figure 15. Ritual cannibalism.

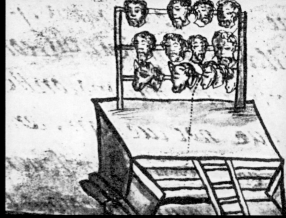

Figure 16. Heads of Spanish soldiers and horses exhibited as trophies at the *tzompantli* (skull rack).

It is clear that the social phenomena of the remote past, including sacrifice and cannibalism, must be viewed as existing beyond the simple dichotomy of good and evil. They must be critically evaluated using the largest quantity of evidence possible. This is the only way in which we will understand that the Aztecs—with their virtues and faults, with their great contributions and their exaggerated ritual violence—were as human as any other ancient people.

Figure 17. Monolith of the goddess of earth Tlaltecuhtli found in 2006 at the foot of the Templo Mayor. This divinity was fed human blood.

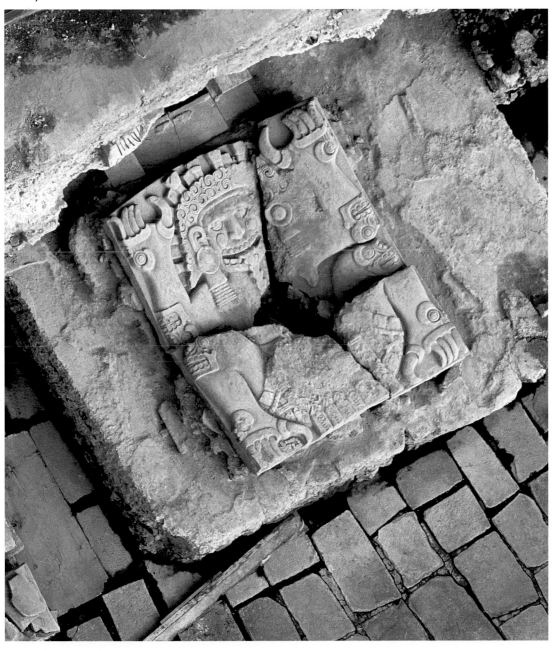

REFERENCES

Angulo, Jorge. 1966. "Una ofrenda en el Templo Mayor de Tenochtitlan" [An offering at the Templo Mayor of Teno-chtitlan]. *Boletín INAH*, 26:1–6.

Boone, Elizabeth H., ed. 1984. *Ritual Human Sacrifice in Mesoamerica*. Washington, D.C.: Dumbarton Oaks.

Carrasco, Davíd. 1999. *City of Sacrifice: The Aztec Empire and the Role of Violence in Civilization*. Boston: Beacon Press.

Chávez Balderas, Ximena. 2005. "Sacrificio humano y tratamientos mortuorios en el Templo Mayor de Tenochtitlan" [Human sacrifice and funeral treatment at the Templo Mayor of Tenochtitlan]. Final report, FAMSI Project 05054, Mexico City.

Duverger, Christian. 1979. *La fleur létale: économie du sacrifice aztèque* [The lethal flower: Economy of Aztec sacrifice]. Seuil, Paris.

Estrada Balmori, Elma. 1979. "Ofrendas del Templo Mayor de Mexico-Tenochtitlan" [Offerings at the Templo Mayor of Mexico-Tenochtitlan], in *Trabajos arqueológicos en el Centro de la Ciudad de México (Antología)* [Archeological works in the Center of Mexico City (Anthology)], Eduardo Matos Moctezuma, ed. Mexico City: Instituto Nacional de Antropología e Historia: 183–89.

Graulich, Michel. 2005. *Le sacrifice humain chez les Aztèques* [Human sacrifice among the Aztecs]. Paris: Fayard.

González Torres, Yólotl. 1985. *El sacrificio humano entre los mexicas* [Human sacrifice among the Mexicas], Mexico City: Fondo de Cultura Económica/Instituto Nacional de Antropología e Historia.

Hassig, Ross. 1988. *Aztec Warfare. Imperial Expansion and Political Control*. Norman: University of Oklahoma Press.

López Austin, Alfredo. 1988. *The Human Body and Ideology. Concepts of the Ancient Nahuas*, 2 vols. Salt Lake City: University of Utah Press.

López Austin, Alfredo and Leonardo López Luján. 2001. "El chacmool mexica" [The Mexica Chacmool]. *Caravelle*, 76–77:59–84.

López Luján, Leonardo. 2005. *The Offerings of the Templo Mayor of Tenochtitlan*, rev. ed. Albuquerque: University of New Mexico Press.

———. 2006. *La Casa de las Águilas: un ejemplo de la arquitectura religiosa de Tenochtitlan* [The House of the Eagles: An example of religious architecture of Tenochtitlan]. Mexico City: Harvard University/Fondo de Cultura Económica/Instituto Nacional de Antropología e Historia.

López Luján, Leonardo and Guilhem Olivier, eds. In press. *Sacrificio mesoamericano* [Mesoamerican Sacrifice]. Mexico City: Instituto Nacional de Antropología e Historia/Universidad Nacional Autónoma de México.

Peña Gómez, Rosa María. 1978. "Análisis de los restos humanos en las ofrendas a Coyolxauhqui" [Analysis of human remains of offerings at Coyolxauhqui]. *Antropología e Historia*, 24:39–51.

Pijoan, Carmen Ma. and Josefina Mansilla Lory. 1997. "Evidence for Human Sacrifice, Bone Modification and Cannibalism in Ancient Mexico," in *Troubled Times: Violence and Warfare in the Past*, Debra L. Martin and David W. Frayer eds. Amsterdam: Gordon and Breach: 217–39.

Román, Juan Alberto. 1990. *Sacrificio de niños en el Templo Mayor* [Sacrifice of Children at the Templo Mayor]. Mexico City: Instituto Nacional de Antropología e Historia.

Sugiyama, Saburo. 2005. *Human Sacrifice, Warfare, and Rulership: Materialization of State Ideology at the Feathered Serpent Pyramid, Teotihuacan*. Cambridge: Cambridge University Press.

Sugiyama, Saburo and Leonardo López Luján. 2007. "Dedicatory Burial/Offering Complexes at the Moon Pyramid, Teotihuacan: A Preliminary Report of 1998–2004 Explorations." *Ancient Mesoamerica*, 18:1–20.

THE ART OF THE AZTEC ERA

FELIPE SOLÍS OLGUÍN,
MUSEO NACIONAL DE ANTROPOLOGÍA

Most of the historical and archaeological testimony of ancient Mexico comes from the Aztec world and, in particular, its capital city, Mexico City–Tenochtitlan. Especially striking within this voluminous store of information is the large number of sculptures found beneath Mexico City—fragments of the imperial capital's grandeur—and from the ruins of the indigenous capitals that were allied with or enemies of the Aztecs. These provide reliable evidence of a way of seeing and thinking that dominated two centuries of Mesoamerican history (the Late Postclassic period from 1300 to 1521 CE), ending with the Spanish conquest of indigenous territory.

The sculptures, in conjunction with the architecture and the few surviving examples of mural painting and ceramic art, chiefly ritual in nature, constitute a representational system with consistent formal and iconographic elements. These features were shared by various peoples, most of whom spoke the Nahuatl language.

Scholars of Late Postclassic artistic expression have traditionally defined it as the Aztec style, but we must point out that recent research in archaeology and art history confirms that this mode of artistic expression was forged toward the end of the Toltec era (c. 1100 CE)—a period preceding the flowering of the Mexica capital—and all the most important cultures of the Central Plateau participated in its formation. Priests and artists gave this style an international character that is distinctive of this last cultural period of Mesoamerica (between 1300 and 1521). We should, therefore, refer to this artistic expression as the "Late Postclassic International Style."

We call special attention to the wealth and importance of the sculptural mode of expression, because these stone testimonials are the best preserved examples of the period and, in and of themselves, they demonstrate the high accomplishments of native artists who achieved extraordinary triumphs using the volcanic stone so abundant in the bedrock of the Mexico Basin as their essential material.

But we should not forget that this sculptural assemblage was part of a comprehensive discourse that the Mexicas and their neighbors carefully installed on or around their ritual buildings, palaces, and plazas over a period of at least one hundred years. Thus, architecture, sculpture, and mural painting as a whole represented for those populations the worldview that was the fundamental reason for their existence in the universe, according to their understanding of the world.

The major arts were supplemented by smaller works in other media, such as wood carvings, ceramic vessels, small clay figures, textiles, feather arrangements, metallurgy, and painted books on paper made from the bark of the Mexican fig tree (*Ficus tecolutensus*)—to mention only the best known—all of which share the same identifying features with the major arts in a single coherent representational system. Accordingly, although we now admire these objects in museum cases or on storeroom shelves, we should always bear in mind that they are only fragments of a broader cultural reality.

The studies and classifications of the different artistic expressions of the Mexica era have generally been oriented to the study of major complexes such as the style and characteristics of the architecture, or the types and variants of sculptures. Analyses of ceramic expressions and the minor arts have achieved the greatest degree of depth. We therefore attempt in this text to reflect on the coherence of the Late Postclassic representational system, as exemplified by some objects that are characteristic of the period.

THE FOUR-PART VISION OF THE UNIVERSE

Different authors have focused on the principles that define the worldview of the Aztecs and their neighbors, undoubtedly the legacy of the periods and cultures that preceded them. We do not have an Aztec pictographic document comparable to the *Fejérváry-Mayer Codex* (Figure 1) that shows so precisely the vision of the universe divided in four parts, which prevailed in Puebla-Tlaxcala, a region adjoining the Basin of Mexico. But a local Basin of Mexico version appearing in the *Codex Mendoza* demonstrates a shared vision of territorial space that organized the urban development of the city of Huitzilopochtli, an organization of space based on a quadrangular plane whose sides are oriented toward the four points of the compass (Chapter 10, Figure 11). The *Codex Mendoza* illustration implies that there was an urban-constructive norm that was respected throughout the history of the Aztecs. Though there would be expansions, demolitions, or new constructions, none of them would depart from that right-angled vision of the city, which is in every sense consistent with the conception of a quadrangular universe created by the gods. This enduring plan is a testimony to the close tie between the work of humans and that of the gods.

The city-island, built with the enormous efforts of entire generations of hardworking laborers, was divided into four major sectors that were identified with the directions and corners of the cosmos. At the center, the intersection of the sacred directions, lay the capital city's most important ritual complex in the form of an enormous quadrangular open space bounded by platforms that separated profane residential space from the territory of the deities.

The image closest to this original vision, lost forever as a result of the European conquest, was recreated by anonymous indigenous artists at the request of Fray Bernardino de Sahagún when

Figure 1. *Fejérváry-Mayer Codex.*

he was constructing his chronicle of Aztec history and culture known as the *Primeros Memoriales* (Figure 2). There we recognize the sacred space where the priests and their architects and builders carefully arranged all the buildings comprising this precinct popularly known as the Templo Mayor (Great Pyramid).

In the central area stood the dual pyramid devoted to the worship and veneration of Huitzilopochtli, the warrior sun, and Tláloc, the patron of rain. This peculiar sacred building joined two foundations, each with its own staircase. At the top of the double pyramid, the temple of the patron of war was separated from that of the protector of farmers, a metaphor for two dazzling aspects of the indigenous worldview. The southern architectural portion, associated with

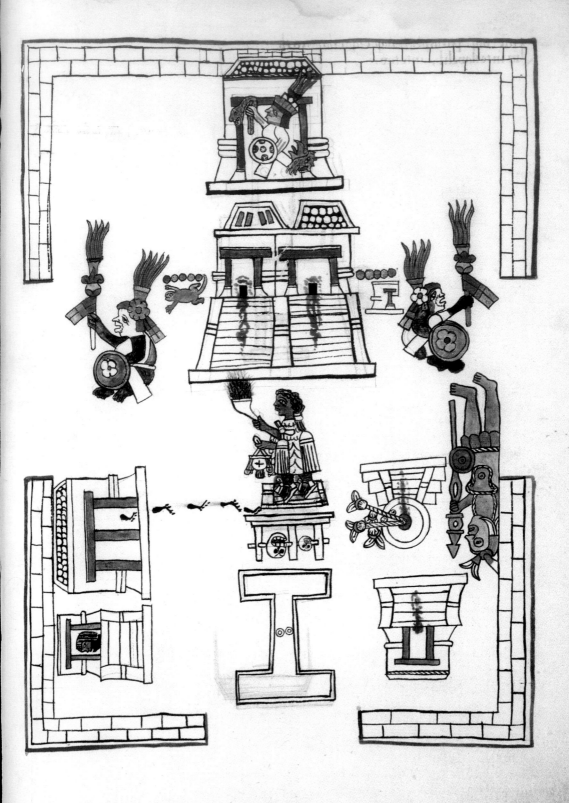

Figure 2. The Aztec ceremonial precinct. The double pyramid at the center is the Templo Mayor, dedicated to Tlaloc, the patron of rain, and Huitzilopochtli, the warrior sun.

Huitzilopochtli, re-created Coatépec, the Mountain of the Serpents, while the northern section was the Tonacatépetl or Mountain of Sustenance.

Though joined, both pyramids had architectural ornamentation of their own that gave them distinct identities, to such an extent that the two sides of the pyramid even had different designs for each of the tiers. Reinforcing the distinctive identities of Tláloc and Huitzilopochtli, the still-surviving serpents and the braziers that flanked them, from the fourth stage of construction, re-iterated the ritual vocation of the Mexicas' supreme building vis-à-vis three of the universe's four cardinal directions: east, north, and south. Warrior sun side of the Great Temple is surrounded by ritual braziers with a large tie, a motif that mimicked the original paper element; while the northern side of the building devoted to the god of rain was decorated with serpents with rings on their heads surrounding Tláloc braziers, whose dominant color was blue.

As has been mentioned by all the authors who have studied it, this sacred building had a quadrangular shape, and each side offered the chance to honor the deities associated with its direction. However, its facade, where the largest number of ornamental or symbolic elements were concentrated, faced west, toward the Cihuatlampa, the Land of Women. At certain times of the year, the western sky was red tinged at sunset, which was interpreted as the struggle

Figure 3. Successive building stages at the Templo Mayor.

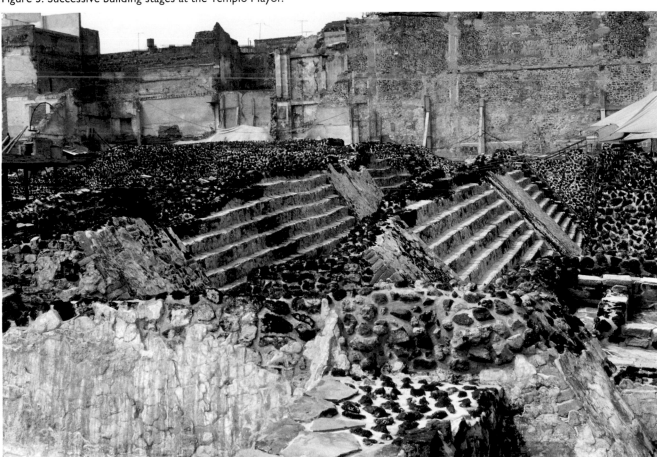

and the end of the daily sun, preparing the universe for the hours of the night and foreshadowing the dawn when the sun, like a precious child, would emerge from the mountains to the east.

Discoveries made at the Templo Mayor Project have revealed extremely valuable information for Aztec studies in the past three decades, which gives coherence and meaning to the findings made in the center of the city—especially those at Calle de las Escalerillas, made by Leopoldo Batres in the early twentieth century. These discoveries make it possible for us today to understand the meanings inherent in Aztec architecture, sculpture, and painting.

Two constructions located on the northern and southern sides of the pyramid of Huitzilopochtli and Tláloc, called "the Red Temples" and composed of a peculiar "revival" of the talud-tablero architectural style reminiscent of Teotihuacan (Figure 4). These two buildings have an extraordinary and unique open space in front, which serves as a kind of atrium, bounded by walls topped by a kind of openwork lattice with circles. Their name, the "Red Temples," comes from the prevailing bright red color on the facade and, obviously, on the interior, which today, unfortunately, has been destroyed. Red was associated with the sun, the star the Aztecs welcomed every day.

The murals that cover both structures' foundations also capture the symbolism characteristic of ancient Teotihuacan. In contrast to the walls that surround the abovementioned open spaces,

Figure 4. Red Temple, in the Templo Mayor archaeological zone.

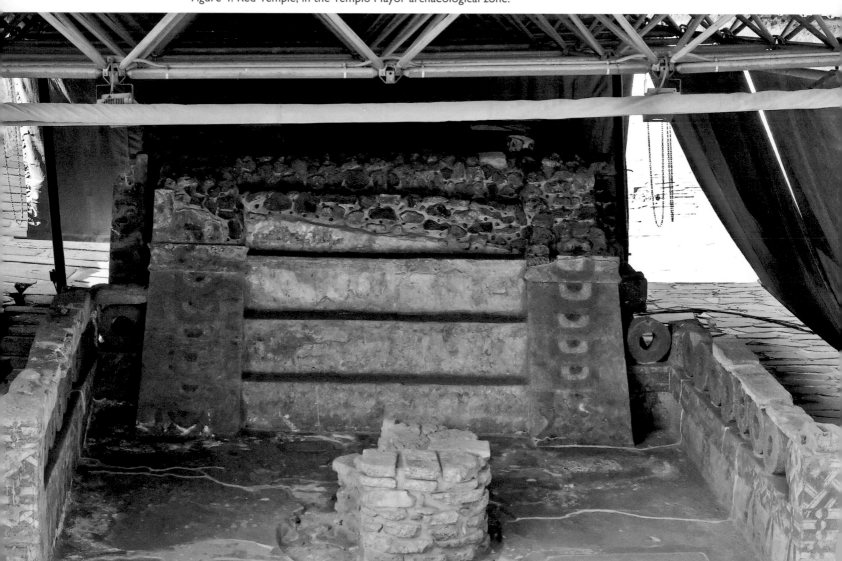

the murals were decorated with a design resembling an interweaving of paper with the straw mat pattern where red and white colors mingle (Figure 5). Strips of the same color hang from this design, re-creating the form in which the buildings must have been decorated. They were covered with indigenous paper in specific shades whose complete effect was a daily exaltation of the sun's presence from the early morning hours on.

On the north side of the ceremonial precinct is an extraordinary platform whose walls are covered with sculpted stone skulls (Figure 6) that re-creates a building associated with the northern quarter of the universe, the region of the dead, the land where the dead begin their journey without return. In this north section of the ceremonial precinct stands another unique construction with staircases facing east and west. It undoubtedly honored the sun's path, also interpreted as linking masculine to feminine.

Referring specifically to this subject of such great importance for the religious ideology of the founders of Mexico City–Tenochtitlan, we must note that, though we do not know which elements linked the east side of the ceremonial precinct to the shore of the island in that direction, numerous accounts of the west side describe the concern felt by the priests and artisans to build spectacular monuments that call attention to this daily transit of the sun and the vicissitudes of its heavenly journey.

Figure 5. Detail of the walls of the Red Temple in the Templo Mayor archaeological zone.

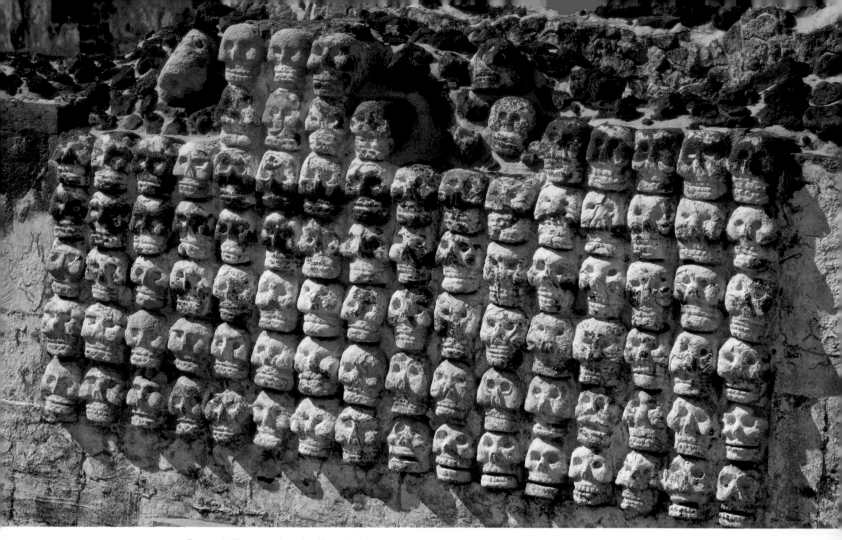

Figure 6. *Tzompantli* in the Templo Mayor archeological zone.

COYOLXAUHQUI, PARADIGMATIC SYMBOL OF THE ENEMY'S DEFEAT

The Aztecs' religious ideology found its artistic expression in the re-creation of the myth of the birth of the warrior sun, Huitzilopochtli, who rises with the defeat of his sister and enemy Coyolxauhqui, a deity that is unique to the Aztecs.

In fact, the construction of the most important pyramidal base of Mexico City–Tenochtitlan, which supported the temple of the supreme god, expressed this ancestral story of Huitzilopochtli's birth from the womb of Coatlicue, the earth, and the opposition to his birth by Coyolxauhqui, the warrior moon. Taking advantage of the fact that the sun produced the effect of light and shadow during its journey, images of this female deity were placed at the base of the staircase and on the platform facing the temple of Huitzilopochtli so that, whether in the skeletal body form of the goddess belonging to an earlier building phase or with the extraordinary relief of Coyolxauhqui in the circular space belonging to the great disk discovered in 1978 (Chapter 5, Figure 12), the progression of the light as the sun advances results in a retreat of the shadows. Through the play of light and shadow, amazed spectators witnessed metaphorically the sequence of dismember-

ment, a kind of quartering, cutting the limbs from the body, leading to the decapitation that is the climax of the story, when the warrior sun severs the head from the body of the warrior moon with one stroke of his flaming weapon, the *Xiuhcoatl* (Figure 7). The sun's effect also replicated the third-quarter, first-quarter, new, and full moon cycles through this striking artistry, in which the Aztecs commemorated the victory of their patron god and guide, and provided the model for the Aztec armies' triumph over their enemies. This interpretation gives life to these ingenious works by extraordinary artists.

The beauty of this figure was expressed in striking three-dimensional sculptures, masks, and even gold ornaments. Eduardo Matos Moctezuma described the form and variation of this ritual subject some time ago, so we will only call attention to the contrast achieved by the Aztec sculptors with the volume of Coyolxauhqui's head carved in diorite (Figure 8), where the principal motif is the goddess's face with her eyes half closed, a result of death by sudden decapitation. Note the vitality of the golden bells that decorate her cheeks, giving her identity.

In contrast, the creators of the great disk discovered in 1978 represented the deity head to foot, with the torso facing the spectators while the face and limbs are shown in profile (Chapter 5, Figure 12). The figure's position expresses life and death as an eternal sequence. It evokes how a sacrificial victim's body plunges from the top of the pyramid and rolls down the staircase, hitting the great platform. With her arms and legs bent, she seems to dance, turn, and spin. As a special note, the figure's blatant nudity not only recalls the final humiliation to which prisoners of war were subjected, but also the detailed anatomical knowledge that Aztec artists possessed, which we again find on full display in the "Venus of Texcoco," as the singular and unique sculpture of a naked woman made at the workshops of Texcoco is popularly known.

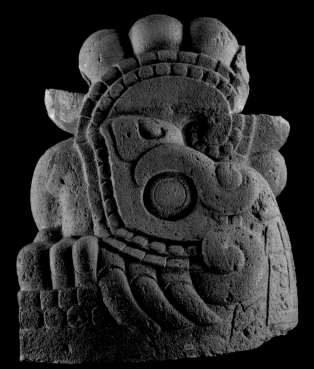

Figure 7. Monumental Xiuhcóatl in the Mexica Room, Mexican National Museum of Anthropology.

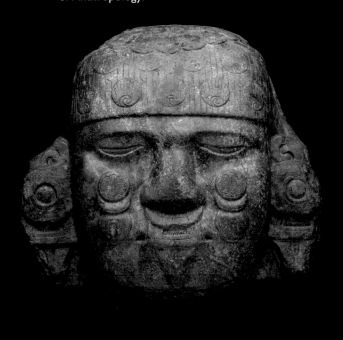

Figure 8. Diorite head of Coyolxauhqui, Mexica Room, Mexican National Museum of Anthropology.

Coyolxauhqui's mask, in the collections of the Peabody Museum (Figure 9), reiterates the message of the diorite head: the face of the dead goddess, with her identity shown through the metal bells on her cheeks. The golden pendant at the Mexican National Museum of Anthropology shows the deity in descending position with her arms and legs bent. In this precious ornament, the warrior moon has her eyes open and her enormous pupils gaze at eternity.

THE CULT OF THE SUN DISK IN THE AZTEC WORLD

Despite the meager evidence of the sun disk cult at the Templo Mayor, an extraordinary polychrome receptacle recovered early in the twentieth century corroborates the link of this cult to the sacred building (Figure 10). The receptacle's main motif is Tonatiuh, the Sun. It is an effigy vessel that has rings on the edge that could be used to secure its contents in the pre-Hispanic manner. The striking polychrome decorative technique is related to the international ceramic style that was shared by the inhabitants of Puebla, Tlaxcala, and the Mixtecs during the Late Postclassic period.

The figure wears a style of clothing found in a number of pictorial manuscripts and on some sculptures. The deity's head emerges from the center of the disk, which surrounds it with magnificent radiance. Most striking of its adornments is a circular golden breastplate with the symbol

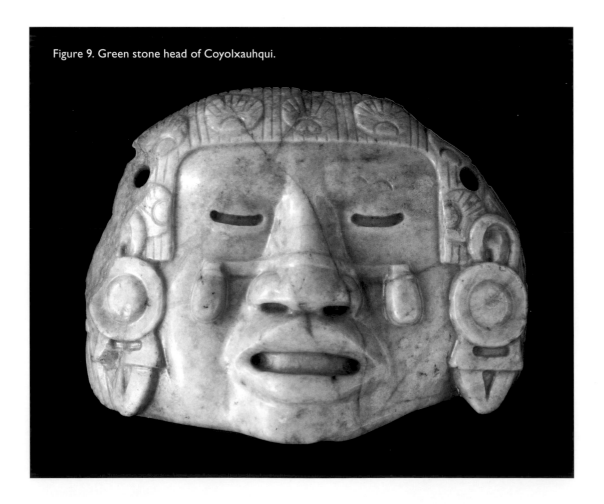

Figure 9. Green stone head of Coyolxauhqui.

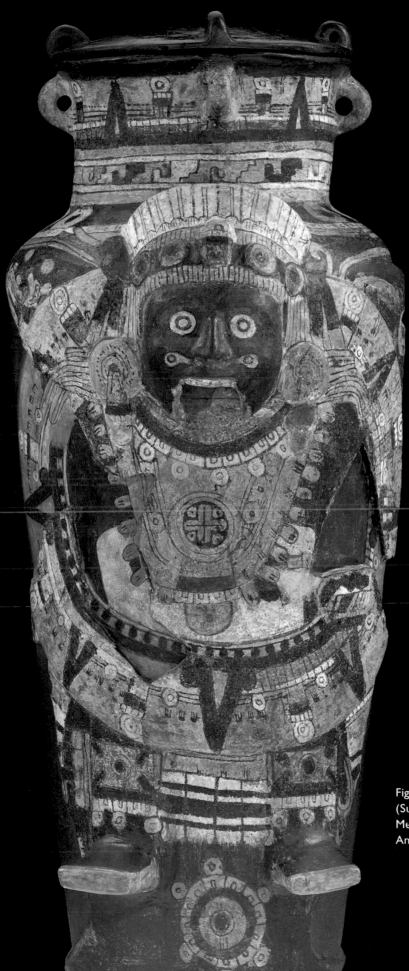

Figure 10. Effigy vase of Tonatiuh (Sun God) in the Mexica Room, Mexican National Museum of Anthropology.

of gold, that precious metal called *teocuitlacomalli*. The dominant colors on the vessel are red and yellow, the same colors that originally colored the Sun Stone and are repeated in a number of codices with representations of this deity, most importantly, in the *Borgia Codex*.

Note that this receptacle, found in pieces, was accompanied by a remarkable offering of polychrome ceramic long-handled incense burners and an open receptacle that re-creates the figure of the Xiuhcóatl, the fire serpent that was the sun's weapon in war and accompanied him through the firmament.

The most important artistic expressions of this cult of the sun disk, associated with the sun's sponsorship of the Aztec military victories and also unique to the founders of Mexico City–Tenochtitlan, are the magnificent *temalácatl* (Figure 11). These are stone rings that originally secured prisoners at the gladiatorial sacrifices during *Tlacaxipehualiztli,* later transformed into monumental platforms on which this colorful ritual was carried out.

Three of these monuments have been preserved. One of them, found incomplete, is known as the Sun Stone; we will speak about it below in view of the multitude of iconographic symbols that cover its circular face. The other two temalácatl are the Tízoc Stone (Chapter 7, Figure 8), which was originally identified as the Sacrificial Stone, discovered in 1791, and the Archbishop Stone, whose production is attributed to Moctezuma Ilhuicamina (Figure 12).

In chronological terms, this last one is considered the oldest. It dates from the middle of the fifteenth century and, if we accept the chronicles of Fray Diego Durán, it was created at the suggestion of the Aztec counselor Tlacaélel, who imagined an exceptional monument that would depict the most important conquests of the Aztec ruler and his ancestors. It was made to give homage to Tonatiuh-Huitzilopochtli-Xiuhtecuhtli, a synthesis of the supreme heavenly body's triumph over his celestial enemies.

The outcome was a striking cylinder that combines the story of the eleven conquests on the side and the shining sun disk on top, which served as a platform on which a prisoner would battle five Aztec warriors, one after another. For the first time in the annals of central Mexico's history, the victories of Mexico City–Tenochtitlan were displayed before the eyes of its own people, being carved for the benefit of posterity.

The Tízoc Stone—better made—continues the same formal and iconographic scheme, expanding the conquests to four more peoples to yield a total of fifteen triumphs for Tízoc and his ancestors. The most important thing we see in this monument is the presentation made by the priests and their sculptors of their worldview. The scenes of conquest are integrated with the vertical layers of the universe in such a way that the earthly plane is shown as the earth-monster Cipactli-Tlaltecuhtli, on which the battles are fought, while the heavenly plane is composed of the sequence of stars and Venus, which support the sun, supreme patron of warfare, who sponsors the Aztecs and favors their victory.

The Sun Stone (Figure 13)—popularly known as the Aztec Calendar—completes this trilogy. Though not completed, it is evident that its original purpose was to serve as another pedestal such as those described above. The side band repeats the heavenly skirt with the planet Venus adorned with sacrificial knives. The sun disk on the upper face is what has fascinated its admirers since the time of its discovery in 1790. Never before had so many elements honored the sun's pre-eminence as the ruler of the five eras of creation, responsible for the transit of time, the ultimate

Figure 11. Basalt temalácatl in the Mexica Room, Mexican National Museum of Anthropology.

Figure 12. Stone from the ex-Archbishop or temalácatl of Moctezuma Ilhuicamina, Mexica Room, Mexican National Museum of Anthropology.

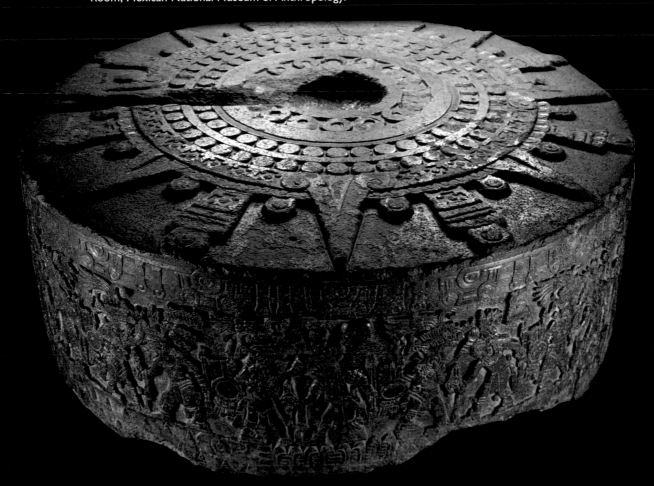

reason for the supreme acts of living and dying, the perfect symbol of virility, warmth, light, and fecundity, all brought together in an exaltation of the colors red and yellow.

The cult of the sun disk extends through several regions of Mesoamerica, where we recognize it as a key component of the rituals and conquests that are described in the codices of the Mixtec world and the Puebla-Tlaxcala region. The sun with its distinctive elements, the rays and the barbs of sacrifice, adorn polychrome vessels and sculptural reliefs. They are also present on the rings of the ball court where players sought to make the ball pass through the center ring by hitting it with their forearms or hips.

The conjunction of the four-sided model of the universe, the pyramid with its temple, and the cult of the sun disk is found on the *Teocalli* of the Sacred War (Figure 14), another one-of-a-kind monument that reflects the creative ingenuity of the artists of Mexico City–Tenochtitlan. The sculptors re-created the sacred foundation with its access staircases, the

Figure 13. Sun Stone, Mexica Room, Mexican National Museum of Anthropology.

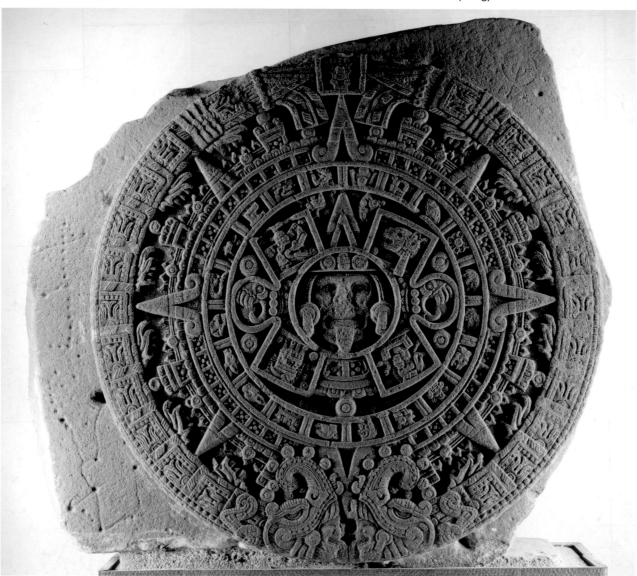

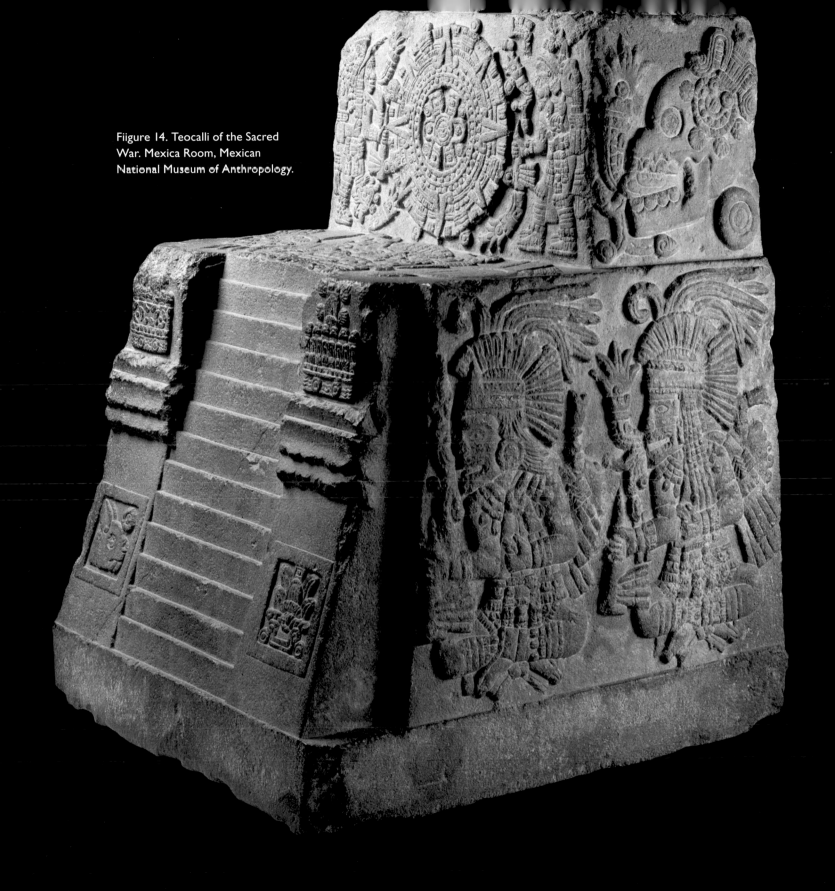

Fiigure 14. Teocalli of the Sacred War. Mexica Room, Mexican National Museum of Anthropology.

deities of the four cardinal directions on the sides, and at the back, the symbol of their glorious destiny, the eagle-sun perched on the prickly pear, whose fruit provides nourishment (the cactus represents the people themselves, who were known not only as Aztecs but also as Mexicas and Tenochcas, i.e., the people of the stone prickly pear) (Chapter 12, Figure 9).

At the top of the model universe, they carved the sun disk flanked by the supreme deity Huitzilopochtli and the principal ruler, the tlatoani, probably alluding to Moctezuma Xocoyotzin. The metaphor is complete. At the center of the cosmos emerges the god's house, the pyramid as a sacred mountain that supports the divine habitation where gods and humans worship the sun, and everything happens starting with the beginning of Aztec history with the founding of their city in the year 2 Reed, or 1325 by our calendar.

THE EARTH, THE SUSTAINER OF LIFE AND THE FINAL DESTINY OF HUMANS

The chroniclers explain that the rulers and their people devoutly offered their first food to the sun and the earth every day. This rite tells us that both acts had the same significance: The respect and the power of the sun had its equivalent with regard to the earth. This explains the numerous and varied representations of the earth, known by the Aztecs as Cipactli, Tlaltecuhtli, Coatlicue, and chiefly, Cihuacóatl.

The earth's power manifests itself in a variety of ways: Cipactli is the mythical being covered by spines that moves through the universal waters, and was so represented (Figure 15); Tlaltecuhtli is the earth as a base of support, and was represented as a crouching being with bent arms and legs whose position recalls that of a frog, and we see him mainly in two versions—on slabs covering offerings or burials, and as a relief supporting other deities (Figure 16). His best-known image is the one found at the base of the great Coatlicue.

Coatlicue-Cihuacóatl, the serpent woman, who wears a skirt of serpents, is in essence the earth, which gives and takes human life. She was viewed not only as the mother and progenitor of human beings but also as the mother of the supreme god, Huitzilopochtli. In her honor and for her veneration the Aztecs carved one of the most terrifying images in universal art, uniting devotion and love with respect and

Figure 15. Green stone Cipactli in the Brooklyn Museum's collection.

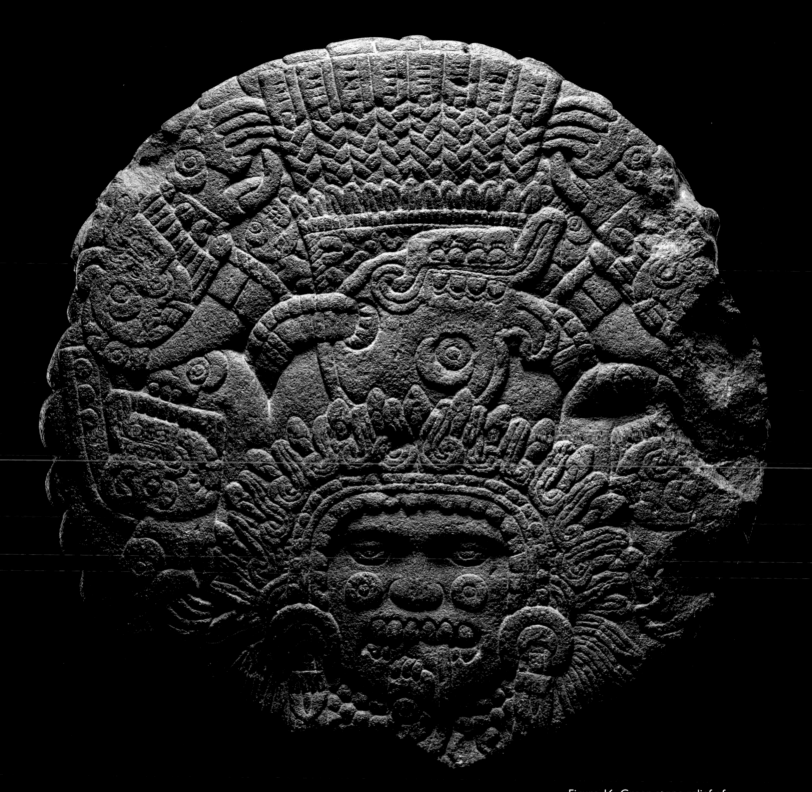

Figure 16. Green stone relief of Tlaltecuhtli at the base of the altar. Mexica Room, Mexican National Museum of Anthropology.

fear. The sculpture in question, of colossal size, shows the female essence of nature as a mature woman, decapitated and with mutilated hands, whose blood is transformed into serpents that create the combination snake-woman (Chapter 5, Figure 8). Her necklace of severed human hands and hearts evokes sacrifice as the final destiny of humankind and as precious food for the deities.

In other versions, the goddess shows a fleshless face suggesting a living corpse (Chapter 13, Figure 11), which reminded her followers that she endowed them with life but also reclaimed the remains of the dead.

This last aspect is characteristic of Aztec art. Death is present in all its manifestations. The receptacles with which the deities were fed were decorated with crossed femurs and skulls facing front or in profile. Skulls of sacrificial victims were strung on the skull rack (*tzompantli*) to commemorate the sun's victories through the sacrifice and decapitation of war captives. These skulls were also re-created in dramatic sculptures that adorned the walls of the buildings that metaphorically re-created the kingdom of the dead. The sun symbolized existence itself, the warmth that makes the earth fertile and allows the growth of nature and human life. But the sun also reclaims humans' vital essence in order to continue its movement. Coatlicue-Cihuacóatl, for her part, is the sun's complement. She is the beginning and end of existence; the sun and humans are born from her only to reach their final encounter, once again protected within her entrails.

NATURALISM IN ANIMAL AND HUMAN FIGURES

The Late Postclassic period represents the culmination of Mesoamerican sculptural expression. In fact, the naturalism of human and animal representations is quite exceptional; never before had such vitality been achieved in Mesoamerican art. The serpents, monkeys, eagles, jaguars, coyotes, and many other images of native Mexican fauna are carved in different kinds of stone whose hardness and colors complement their representations (Figure 17). The representations of some plants even share this tendency, as in the case of squashes, for which green and white diorites were chosen to reflect the plants' original colors (Figure 18).

Figure 17. Carved stone frog from Tetzcozinco, Mexico.

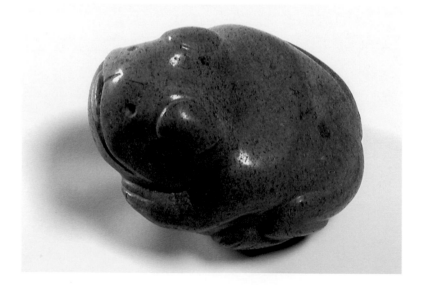

Figure 18. Diorite squash, Mexica Room, Mexican National Museum of Anthropology.

But it is in the human figures that Aztec sculptural workshops produced works of remarkable fame. The deities and their personifications are represented as individuals whose maturity shares in the vigor of youth. This is the fleeting moment when the individual achieves the zenith of his physical body for a few years before wrinkles begin to appear on his face and his body begins to decay; this is the age that the artists chose as the culminating moment of humans on earth (Figure 19).

Some sculptures, which have been carelessly identified as commoner men or subjects, appear as robust, sound, and virile individuals who show off their fully developed anatomy by wearing only a loincloth or *máxtlatl* that allows the viewer to recognize this characteristic of their manhood. Some images—very few to be sure—show individuals with an erect penis, insisting on the sexual power of mature youth; the chroniclers state these images were covered with real clothing.

Chief among the personifications that combine artistic excellence and the full development of male anatomy with the garment or ornament that identifies the deity is the "Ehécatl of Calixtlahuaca," which, because of its true human proportions and its superb sculptural quality, is unquestionably the finest example of this style of artistic expression (Figure 20).

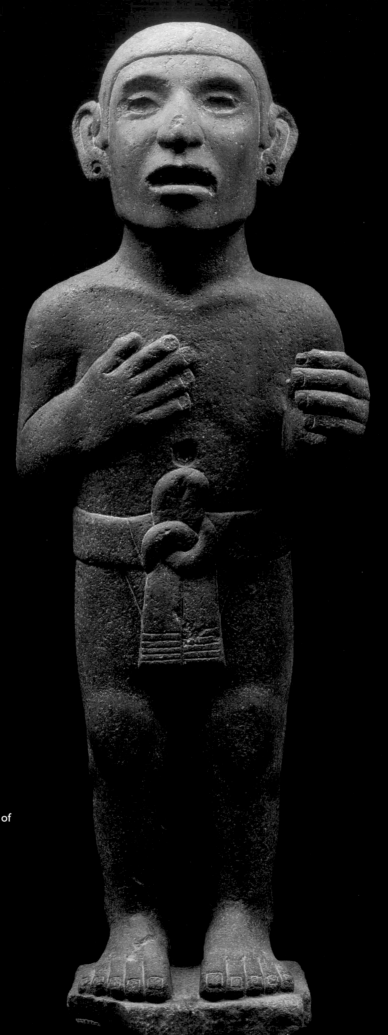

Figure 19. Macehual, in the Mexica Room, Mexican National Museum of Anthropology.

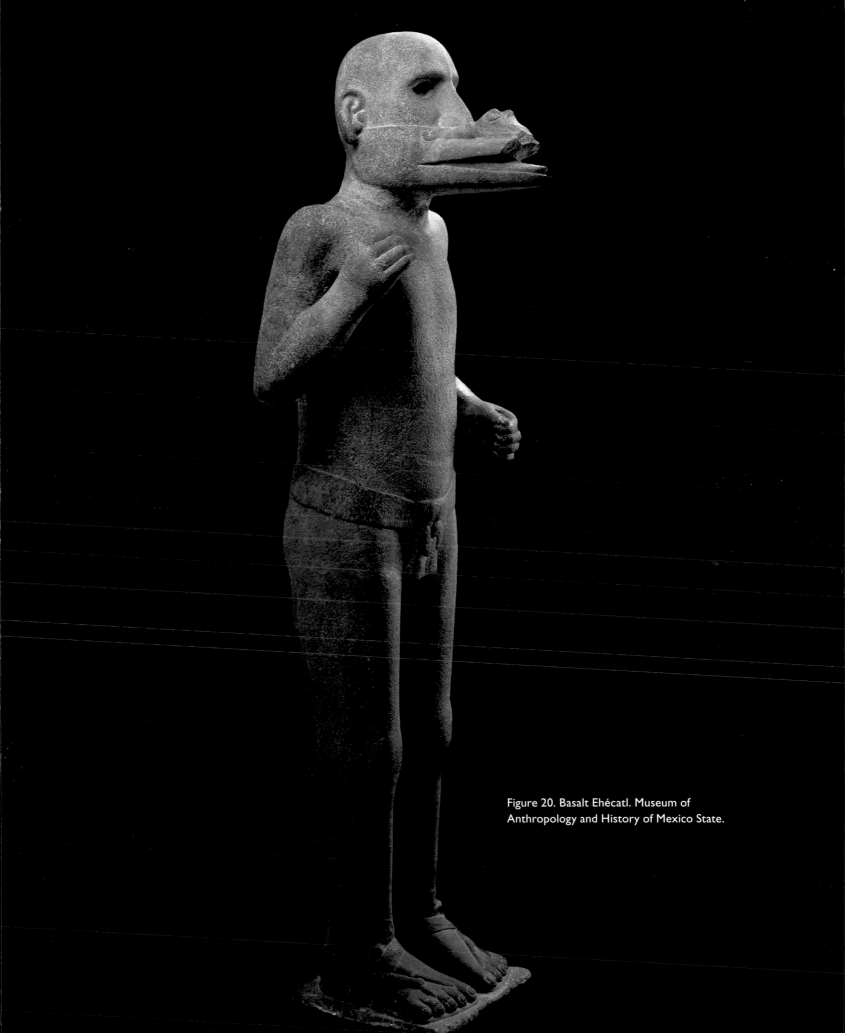

Figure 20. Basalt Ehécatl. Museum of
Anthropology and History of Mexico State.

With regard to female representations, most are deities or their personifications clothed in typical feminine garments, a skirt or wrap-around, the *huipil* or long blouse, the *quechquémitl* or triangular cape, with variations in their hairdos and other ornaments depending on the person in question. Some of them are truly exceptional in their proportion, their anatomical details, and the quality achieved in depicting the richness of their jewelry, as well as the textures of the different components of their hairdos (Figure 21).

A unique example is the "Venus of Texcoco," to which we referred in our discussion of Coyolxauhqui (Figure 22). This sculpture is unique in all of pre-Columbian art. There is no other example of this degree of quality and esthetic accomplishment. Though this is a representative example of the collective work done in the indigenous workshops where the contribution of multiple hands can be noted, there is a masterful spirit at work here that conceives of the human figure as a whole and breathes the spirit of life into the sculpture, giving the nude woman a degree of realistic sensuality in her abdomen and thighs.

The subject of the art of this period is vast and complex, but each of its expressions, be it architecture, sculpture, or ceramics, allows us to recognize the iconographic uniformity that endowed this society with its identity and permitted the communication among the ruling elites that established the society's political, commercial, and military successes.

REFERENCES

Batres, Leopoldo. 1902. *Exploraciones arqueológicas en la Calle de las Escalerillas* [Archeological excavations at Calle de las Escalerillas]. Inspección y Conservación de Monumentos Arqueológicos de la República Mexicana [Inspection and Conservation of Archeological Monuments of Mexico]. Mexico.

Carrasco, David. 2004. Description of the object 176 "Coyolxauhqui" of the *El Imperio Azteca* [The Aztec Empire] catalogue, an exhibit curated by Felipe Solís. Fomento Cultural Banamex. Mexico City.

Cartwright, Burr. 1982. *El Quinto Sol, dioses y mundo azteca* [The Fifth Sun, Gods and the Aztec World]. Mexico City: Editorial Diana.

1994. *Fejérváry-Mayer Codex*, Copy, Mexico-Graz.

1979. *Mendocino Codex* or *Mendoza Collection*, Mexico.

García Cook, Angel and Raúl Arana. 1978. *Rescate arqueológico del monolito Coyolxauhqui* [Archeological Salvage of the Coyolxauhqui Monolith]. Preliminary Report. Mexico City: INAH.

Matos Moctezuma, Eduardo. 1991. "Las seis Coyolxauhqui: variaciones sobre un mismo tema" [The Six Coyolxauhqui: Variations on a Theme] in *Estudios de Cultura Náhuatl* [Studies of Náhuatl Culture]. Vol. 21. Edited by Miguel León-Portilla. Mexico City: UNAM.

————. 1992. "Cosmovisión" ["Worldview"] in *Azteca Mexica: Las culturas del México Antiguo* [*Mexica Aztecs: The Cultures of Ancient Mexico*], by José Alcina Franch, Miguel León Portilla, and Eduardo Matos Moctezuma. Madrid: INAH-Quinto Centenario-Lunwerg Editores S. A.

————. 1992. "El Templo Mayor" [The Great Pyramid] in *Azteca Mexica: Las culturas del México Antiguo*, by José Alcina Franch, Miguel León Portilla, and Eduardo Matos Moctezuma. Madrid: INAH-Quinto Centenario-Lunwerg Editores S. A.

————. 1997. "Tlaltecuhtli, señor de la tierra" ["Tlaltecuhtli, Lord of the Earth"] in *Estudios de Cultura Náhuatl*. Vol. 27. Edited by Miguel León-Portilla. Mexico City: UNAM.

————. 2000. *Los Aztecas* [The Aztecs], Milan: Hakabook-CONACULTA.

————. 2004. "Excavaciones en el Templo Mayor" ["Excavations of the Great Pyramid"] in *El Imperio Azteca*, exhibit curated by Felipe Solís. Fomento Cultural Banamex. Mexico City.

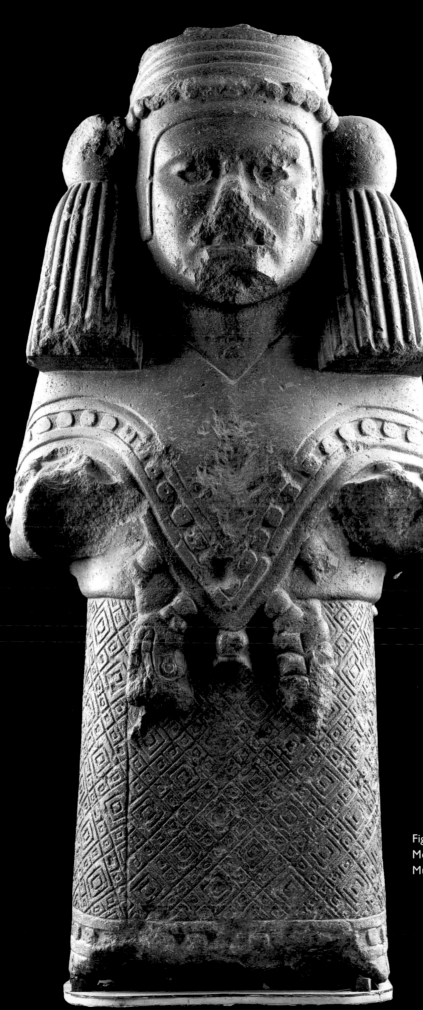

Figure 21. Diorite Chalchiuhtlicue, Mexica Room, Mexican National Museum of Anthropology.

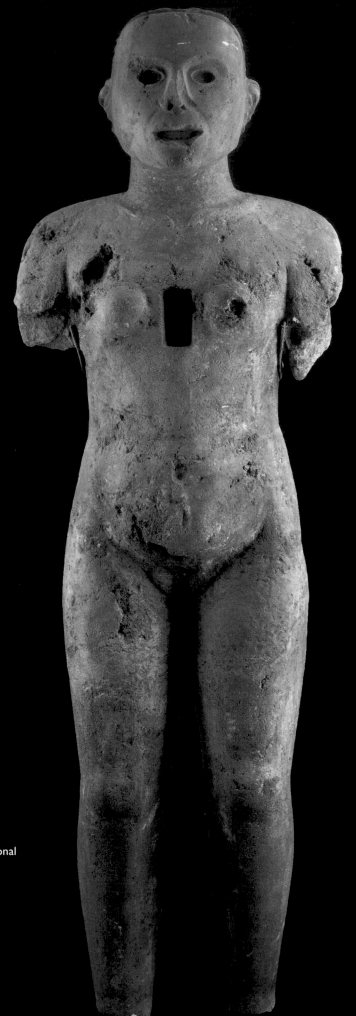

Figure 22. Venus of Texcoco, Mexica Room, Mexican National Museum of Anthropology.

Matos Moctezuma, Eduardo, Felipe Solís, and Roberto Velasco Alonso. 2004. *El calendario azteca y otros monumentos solares* [*The Aztec Calendar and Other Solar Monuments*], Mexico City: INAH-Azabache.

Nicholson, Henry B. 1971. "Major sculpture in pre-Hispanic Central Mexico" in *Handbook of Middle American Indians*. Vol. X, *The archaeology of northern Mesoamerica* Austin: University of Texas Press, part I, pp. 92–134

Olmedo, Bertina. 2002. *Los Templos Rojos del recinto sagrado de Tenochtitlan* [The Red Temples of the Tenochtitlan Sacred Precinct]. INAH, Museo Nacional de las Culturas. Mexico City.

Pasztory, Esther. 1983. *Aztec Art.* New York: Harry N. Abrams, Inc., Publishers.

Primeros Memoriales. 1992. Facsimile edition, Norman: University of Oklahoma Press.

Pohorilenko, Anatole. 1990. *The structure and periodization of the Olmec representational system.* Ann Arbor Mich.: University Microfilms International.

Rojas, José Luis. 2004. Description of object 130 "Female Anthropomorphical Sculpture" of the *El Imperio Azteca* catalogue. Exhibit curated by Felipe Solís. Fomento Cultural Banamex. Mexico City.

Solís, Felipe. 1991. *Gloria y fama mexica* [*Mexica Glory and Fame*]. Mexico City: Smurtfit Cartón y Papel de México, S. A. de C. V.

———. 1992. "The Temalácatl-Cuauhxicalli of Moctezuma Ilhuicamina" in *Azteca Mexica: Las culturas del México Antiguo*, by José Alcina Franch, Miguel León Portilla, and Eduardo Matos Moctezuma. Madrid: INAH-Quinto Centenario-Lunwerg Editores S. A.

———. 2000. "La Piedra del Sol" [The Sun Stone] in *Arqueología Mexicana.*, Vol. VII, no. 41. pp. 32–39.

———. 2004. "El hombre mesoamericano y su cosmos" ["Mesoamerican Man and his Cosmos"] in *El ImperioAzteca*, exhibit curated by Felipe Solís. Fomento Cultural Banamex. Mexico City, F. D.

———. 2004. "Orígenes y formas del arte en el imperio azteca" [Origin and Art Forms in the Aztec Empire] in *El Imperio Azteca*. Exhibit curated by Felipe Solís. Fomento Cultural Banamex. Mexico City.

———. 2004. *El Imperio Azteca.* Exhibit curated by Felipe Solís. Fomento Cultural Banamex. Mexico City.

———. 2006. "Imagen de Tonatiuh en el Templo Mayor" ["The Image of Tonatiuh in the Great Pyramid"] in *Homenaje a Eduardo Matos Moctezuma* [*Homage to Eduardo Matos Moctezuma*]. Mexico City: INAH, 567–77.

Solís, Felipe and Roberto Velasco. 2004. "Testimonios del culto solar" ["Testimonies of the Sun Cult"] in *El calendario azteca y otros monumentos solares.* Mexico City: INAH-Azabache, 76–147.

Townsend, Richard F. 1979. *State and Cosmos in the art of Tenochtitlan,* Studies in Pre-Columbian Art and Archaeology. No. 20. Washington D.C.: Dumbarton Oaks.

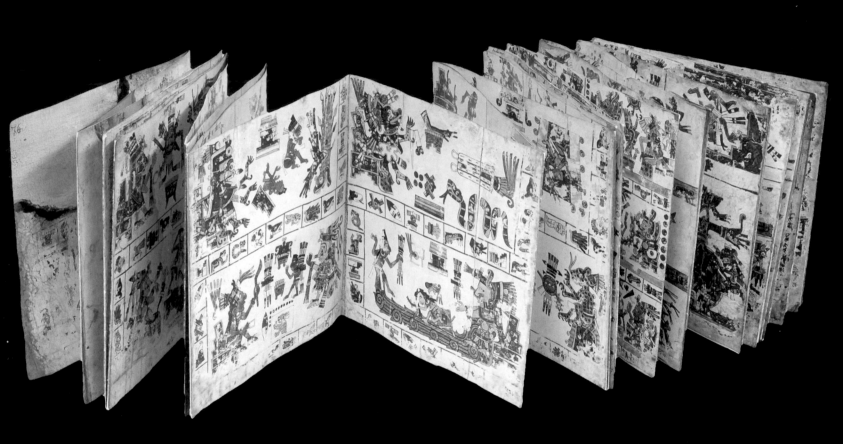

Figure 1. A screenfold of deer hide, the *Codex Borgia* contains twenty-eight almanacs used in divination, as well as a genesis narrative.

TEN
AZTEC WRITING AND HISTORY

ELIZABETH HILL BOONE, TULANE UNIVERSITY

Although the acts of reading and writing were specialist enterprises in Aztec Mexico, what was written and what was read touched the lives of everyone and made its influence felt in all social realms. One's exposure to the wisdom of the books and writings came early in life. Within days of a child being born, the new parents would take him or her to a calendar priest, who would read out the infant's fate from one or more divinatory books, called *tonalamatl* ("book of days"). This act was dramatic, colorful, highly visual, and sonorous, and it located the child within a structured world whose organization was reinforced and documented by graphic expression.

As physical objects, the books (usually called "codices" by Mexicanists) looked nothing like our modern books (León-Portilla 2003) (Figure 1). They were fashioned of long panels of deer hide or bark paper, usually folded back and forth accordion-style to create a continuous sequence of rectangular "pages." Some were large, with pages measuring about 15 inches and stretching out over 46 feet when fully extended, whereas others were smaller with pages only about 5 inches on a side, all coated with a white gesso that stiffened the pages (Boone 2007:18). The "writing" exposed on these pages did not rely on letters, words, and sentences to record spoken language, but instead employed hand-painted figures and symbols arranged in complex but conventional ways to record information and preserve understood truths. The Aztecs wrote in images rather than alphabetically in words.

Thus when the parents and newborn child sat before the calendar priest to have the child's fate read—after having brought their presents and made their offerings and prayers—they heard the cracking of the stiff pages as the priest unfolded the book and spread it out before them, and they looked on as the priest viewed the vividly painted images, hieroglyphs, and signs that would reveal the child's destiny (Sahagún 1953–80: bk. 6:197–99). As the priest consulted one almanac after another, turning through the book and even flipping it over to a backside equally filled with

painted images, they saw the figures of the different gods and spiritual forces that governed the day, week, and other units of time connected with the child's birth (Figure 2). They heard the priest's words as he voiced the names, realms, and influences of each figure and symbol and as he wove these individual readings into a full exposition of the child's essential character and of the fates and forces that would continue to govern his life.

This first exposure was the most critical experience an Aztec person would have had with writing and reading, for the content of the divinatory books, as interpreted by the special-ist, largely determined his or her destiny. Thereafter, throughout the person's life and prior to significant events, the person would return to the divinatory specialists and again seek out the

Figure 2. The thirteen days in an Aztec week, pictured along the bottom and in a vertical row on the near right, are associated with multiple gods and forces, all presided over by the singing gods in the main panel.

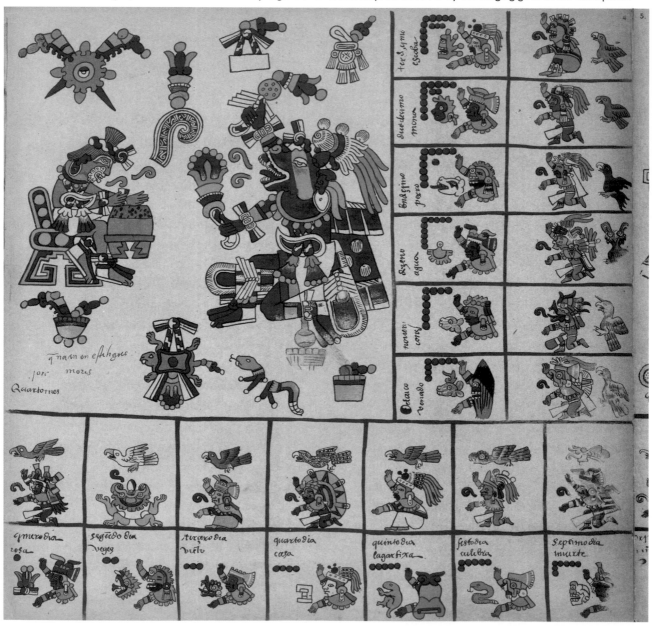

knowledge contained in the sacred books in order to know whether the gods and forces were favorable or not. A man chose a wife only after such a consultation; merchants relied on almanacs in the codices to know when to initiate and return from their journeys; and rulers looked to the divinatory books to tell them when to go into battle. Recurrent use made the divinatory manuscripts familiar to most individuals, although specialist knowledge of the most learned kind was required to access the esoteric messages.

These sacred manuscripts contained a body of knowledge that sits somewhere between our conceptions of science and cosmology, for they articulate the organization of the cosmos and the unseen spiritual realm in all their humanly relevant detail. The books also contained knowledge Aztec priests needed to conduct efficacious rituals, for they included directives for making prayers and offerings, prescribing exactly what should be done, when, and in what quantities.

The Aztecs also relied on painted documents to record the pragmatics of economic and social relationships among people. To these ends, local specialists kept census and property records, documenting to whom communal fields were assigned, for example, or specifying private lands. Officials of the judicial system employed painters to keep records of their court cases; newlyweds relied on painted inventories to verify what private property each side brought into the marriage. Imperial officials kept tribute rolls that specified the kinds and quantities of goods that were received quarterly from near and far-flung provinces (Figure 3). Mapmakers described territory and noted routes for safe travel (see Boone 1998:150–55 for the different genres of painted manuscripts). Although most of the common people saw little of these practical writings on a day-to-day basis, they lived their lives within the legal and economic structures the painted records defined.

The nobles and especially the ruling families—people concerned with maintaining their sociopolitical position and the strength of their communities—also commissioned histories and historical writings to recount the significant events of their past and explain how they and all around them came to be as they were. Cosmogonic histories described the origin and very nature of the world, but most historical documents focused on the dynastic and political affairs of the individual polity. Such histories reaffirmed friendships and enmities, and reassured their audience of its proper place in the world.

Rulers also commissioned stone monuments to describe and mark events of special importance. Reliefs carved to commemorate the dedication of temples, the binding of the years at the end of a fifty-two-year cycle, or the inauguration of a ruler then became permanent records of these happenings. Their depiction and presentation reminded all who saw them of the nature and significance of these events within the collective conscious.

SCRIBES AND SAGES

The scribes and sages who painted, owned, and controlled the content of the writings were highly esteemed individuals in Aztec society. Called *tlacuiloque* (painters) or, more exaltedly, *tlamatinime* (wise men, wise women, or sages), they included women as well as men (Sahagún 1953–82, bk. 6:29–30). All were trained in the *calmecac*, the elite school for advanced learning,

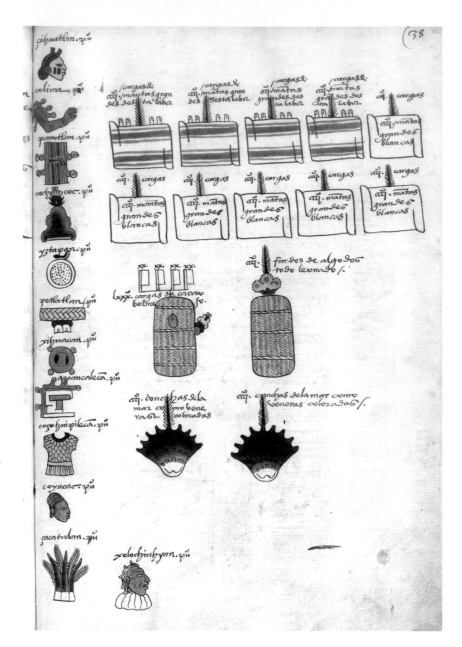

Figure 3. Tribute from the province of Cihuatlan on the west coast includes many bundles of striped and plain blankets, bundles of red cacao and brown cotton, and eight hundred shells of the spondyllus (spiny oyster), used in rituals and for jewelry. The polities in the province are recorded in the column on the left side of the page.

where they learned cosmology, astronomy, and other sciences; the rhetorical arts of oration, song, and poetry; the arts of writing/painting and reading/interpreting that which is written; and history (León-Portilla 1992:71). The Aztecs looked to these sages, these specialists in manuscript painting and exegesis, as the lights and guides whose responsibility it was to provide religious, moral, and intellectual leadership (Boone 2005). As the Aztec lords explained to the newly arrived Franciscan friars just three years after the conquest, the sages were:

> those who guide us; they govern us, they carry us on their back and instruct us how our gods must be worshipped; . . . The experts, the knowers of speeches and orations, . . . Those who observe [read] the codices, those who recite [tell what they read]. Those who noisily turn the pages of the illustrated manuscripts. Those who have possession of the black and red ink [wisdom] and of that which is pictured; they lead us, they guide they tell us the way. (León-Portilla 1963:18-19)

WRITING WITH FIGURES, SIGNS, AND SYMBOLS

Aztec manuscript painters worked with a well-developed graphic system, which I call Mexican pictography. This system employed images as the semantic or basic message-carrying units and organized these units spatially to establish relational meanings. The images usually had an iconic relationship with what they signified; in other words, they pictured what they meant. There was always the potential for other levels of meaning, however, for an image might also refer by analogy to a broader or related entity, or it might symbolize an abstract concept. For example, the picture of a serpent might signify a specific animal, a special kind of offering, an attribute of one or more deities, or the day sign Serpent. Meaning, as the painters and readers of manuscripts knew, always depended on the context in which the images appeared.

The range of things, actions, and concepts that could thus be recorded was vast. In addition to picturing a great variety of objects and items, Aztec painters could depict the major conceptual categories of time, person, place, and action/event, either by naming them or by describing their qualities (Boone 2000:28–63; 2007:33–63).

The painters recorded time by picturing the numbers and signs of the sacred 260-day calendar. This fundamental calendar, which dated all events within the ordered cosmos and was the basis of the divinatory almanacs, employed twenty day signs in combination with thirteen numbers. The day signs mostly appeared as animals (e.g., Crocodile, Lizard, Serpent), but some were plants (Grass, Reed, Flower), a mineral (Flint), a building (House), or natural phenomena (e.g., Wind, Death, Water) (Figure 4). Each sign was sequentially joined with one of the thirteen numbers, to yield 260 unique combinations: 1 Crocodile, 2 Wind, 3 House, 4 Lizard, and so forth (see Figure 2). The civil and agricultural year of 365 days was named according

Figure 4. The twenty day signs.

to the day on which it effectively ended; this was the 360th day, just preceding the five useless and dreaded days before the new year (Caso 1971:346–47). In this way the civil year of 1 Rabbit had the day 1 Rabbit as its 360th day. This complex calendar was so brilliantly structured that these year-bearer days sequentially used all thirteen numbers but only four of the signs to create a repeating cycle of fifty-two years: thus, 1 Rabbit, 2 Reed, 3 Flint, 4 House, 5 Rabbit, and so forth. Aztec painters distinguished the year dates from the day dates by framing the year dates in a square or round cartouche. We see this on the Dedication Stone for the Templo Mayor, where the year date (8 Reed) is framed and the day date (7 Reed) is not (Figure 5).

Aztec painters recorded persons by picturing their general qualities and by naming them. Women and men, for example, were distinguished by their hair and clothing: the woman's long skirt, blouse, and hair braided and bound on top of the head, in contrast to the man's loincloth, cloak, and short cropped hair (Figure 6). Old people were consistently identified by slack toothless jaws, wrinkles, and unkempt hair. Priests, warriors, rulers, and other occupational specialists were distinguished by their different costumes, although rulers commonly participated in ceremonies wearing priestly garb (as they do on the Dedication Stone, Figure 5). Usually, when specific humans are identified, they are named glyphically by a small sign near or attached to their heads. Thus the Aztec ruler Acamapichtli (Handful of Arrows) is identifiable by his name sign of a hand grasping arrows. His occupation as a ruler is indicated by his pointed crown, the speech scroll in front of his mouth (to signal "speaker"), and woven mat on which he sits; his accomplishments as a warrior are announced by the warrior's topknot in his hair. See Figure 7 for the name signs of the Aztec rulers.

Place and location could likewise be described or named, sometimes both together. For example, swampy locations, such as the surroundings of Tenochtitlan, were marked by the presence of blue water canals, reeds, and rushes. The alive and perennially hungry earth might be rendered with an open mouth and the spiny scales of the "earth crocodile." Usually, however, the painters needed to locate things precisely, and in these cases, they employed place signs. These

Figure 5. The Dedication Stone. The event, involving the rulers Tizon (left) and Ahuitzotl (right) offering their blood to the earth, is dated to the day 7 Reed (above the scene) and the year 8 Reed (prominently in a rectangular cartouche below).

Figure 6 (above). People identified by gender, age, status, and their personal names: a) women, b) men, c) old people, d) the ruler Acamapichtli (Handful of Reeds).

Figure 7 (below). The name signs of the Aztec rulers.

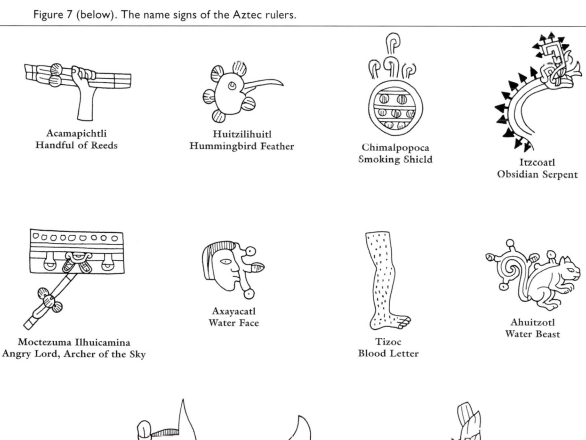

Acamapichtli
Handful of Reeds

Huitzilihuitl
Hummingbird Feather

Chimalpopoca
Smoking Shield

Itzcoatl
Obsidian Serpent

Moctezuma Ilhuicamina
Angry Lord, Archer of the Sky

Axayacatl
Water Face

Tizoc
Blood Letter

Ahuitzotl
Water Beast

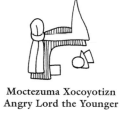

Moctezuma Xocoyotizn
Angry Lord the Younger

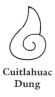

Cuitlahuac
Dung

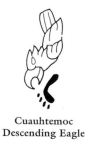

Cuauhtemoc
Descending Eagle

place names are composed of a nominal glyph or two sometimes attached to a topographical feature (Figure 8). The Aztec capital of Tenochtitlan (Place of the Prickly Pear) is represented by a flowering nopal cactus on a conventionalized stone. Neighboring Chapultepec (Grasshopper Hill) is identified by a hill sign topped with a grasshopper; water flowing from its base reminds the viewer that Tenochtitlan's fresh water came from the spring at Chapultepec.

Events and actions were also either presented as pictorial representations or are signaled by signs that reference the event (Figure 9). The painters recorded victory in battle, for example, by picturing the victorious warrior grabbing the hair of his humbled and fallen foe. The conquest of a polity might be signaled by a small temple with its roof askew, from which gush flames and smoke. But warfare could also be indicated more generically by the simple presence of a round shield backed by arrows or an obsidian-edged club. A ruler's accession was signified when the ruler is first pictured, next to a year date, seated on a mat or throne, wearing his pointed turquoise crown, and often with the speech-scroll to signal his title of *tlatoani* (literally "speaker") (Figure 10). His death is indicated by a picture of his wrapped, seated, mummy bundle.

Figure 8. Place signs for a) Tenochtitlan (Place of the Nopal Cactus), b) Chapultepec (Grasshopper Hill), c) Colhuacan (Place of the Colhua), and d) Tlatelolco (Round Earth Mound).

Figure 9. Representations and signs for warfare and conquest.

Figure 10. The death of Moctezuma (Angry Lord) and the succession of Axayacatl (Water Face) in the year 2 Flint.

Time, person, place, and event all come together at the beginning of the *Codex Mendoza* where the events and times surrounding the founding of the Aztec capital of Tenochtitlan are described (Figure 11). As painted by an Aztec master, the codex was commissioned by the first Spanish Viceroy, Antonio de Mendoza, to inform the Spanish king about the history, extent, and customs of the Aztec empire. Here the account begins with the founding of the capital, arranged diagrammatically and centered on the dramatic moment when the great eagle alights on the nopal cactus growing within the marshes of the lake (Berdan and Anawalt 1997:xii, 3–7).

Time, in the form of a segmented but continuous band of year dates, frames all the action on the page. The count begins in the top left corner with 2 House, the date of the founding proper. It then continues sequentially down and around the page (3 Rabbit, 4 Reed, 5 Flint, etc.) to finish at the center of the top with 13 Reed. This duration of fifty-one years defines the period when the Aztecs settled, began to build, and lived in Tenochtitlan before they chose their first noble tlatoani (ruler). Only one year, other than the beginning and ending years, is singled out. In the bottom right of the page, the year 2 Reed is differentiated from other years by the cord tied around the Reed sign and by the fire drill

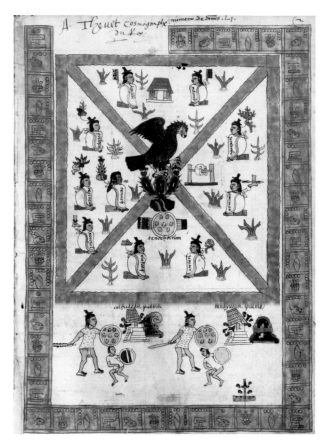

Figure 11. The founding of Tenochtitlan presented in the *Codex Mendoza*.

and smoking board painted above it. These elements remind the reader that 2 Reed is the first year in the fifty-two-year cycle, when the previous fifty-two years were bound and discarded, and the new fire was drilled to usher in the new cycle. The elements characterize the year as having a special quality, but they also function to record the events of this ritual act in this particular year.

Place, which is so fundamental to this story, is glyphically named and pictorially described. Near the center of the page is the place sign of Tenochtitlan, a conventionalized stone (*tetl*) with a flowering nopal or prickly pear cactus (*nochtli*), which together form the sign for *te-noch* or Tenochtitlan (Place of the Prickly Pear). The city's swampy environs and its situation in the middle of a lake are pictorially represented here also. Green reeds and blue canes characterize the low-lying island, which is here conventionally rendered as a rectangle bordered by an undulating band of blue water (the lake) and cut through diagonally by four canals that meet in the center. This rich environment was critical to the Aztec story and to their later success. Its symmetrical, centered presentation here also locates Tenochtitlan conceptually at the center of the world.

The eagle on the nopal cactus is not part of Tenochtitlan's place sign proper. Rather it signals the very event of the founding, when the Aztec tribal leaders, following portents and directives from their principal god, wandered into the marshes of the lake and spied the eagle nesting in the cactus. The ten men who led their people are themselves pictured and named. Seated and covered in plain white cloaks, nine of the men are identified as valiant and successful warriors by their topknot of hair bound in red leather; they sit on reed seats. All have their personal name sign attached. Then tenth man, just to the left of the place sign, is physically distinguished from

the others by his longer hair, his black face and body coloring, and the red patch around his ear. These are all markers of a priest, one who covered his body in ashes, grew his hair, and constantly drew blood from his ears. This priest is identified by his name sign (stone and nopal cactus) as Tenoch, and his elevated status and authority as the principal leader are indicated here by the addition of fringe on his cloak, his seat of woven mat, and the speech-scroll. The painter has thus recorded the facts and explained the relevant qualities of the place, time, participants, and event of the founding.

But time and action are not limited to this one moment. The New Fire ceremony in the year 2 Reed took place twenty-six years after the founding, and other events are recorded in the presentation as well. The small temple at the top of the island rectangle (above the image of the eagle) and the skull rack (to the right) tell of the early construction of the city and its ceremonial heart. The temple and skull rack signify both the things constructed and the act of constructing them. Below Tenochtitlan's place sign, the composite symbol of a round shield backed by spears tells of war, which was to be the vehicle for Aztec advancement.

Warfare, or, more accurately, conquest, is signified in the next two events recorded, pictured in the lower half of the page. Two Aztec warriors, with their torsos covered in quilted cotton armor, brandish weapons and round shields and grasp their defeated enemies by the hair, in a standard convention for conquest. These defeated men pertain to the two towns whose place signs are given—Colhuacan (the curved hill, Place of the Colhua) on the left and Tenayuca (Place of Ramparts) on the right—and whose principal temples are shown burning and collapsing. The Aztec conquests of Colhuacan and Tenayuca are thus recorded very efficiently in conventional and glyphic terms. Rather than picturing scenes of actual battles, the painter has painted statements of victory. The warriors lack names because they function here not as individuals but as actors who manifest the event being recorded. The geographic location, physical size, and population of the two towns are also left unstated, for these factors are incidental to the story. The timing of the two conquests is also vague, because their precise dates are unimportant; what is important is that the Aztecs were militarily victorious over Colhuacan and Tenayuca early in their history, even before they inaugurated their first official ruler.

What the painter has recorded so magnificently on this single page is the confluence of actors (the people and their patron god), places, and events from which the Aztec empire grew. The account focuses on the founding of the Aztec capital in all its significant details, but it also describes that crucial early period when Tenochtitlan developed into a military and political force. By depicting Tenochtitlan at the center of the quadripartite island in the middle of the water, the painter metaphorically located the capital in the center of the world, surrounded by the cosmic sea, and at the point where the four world directions meet.

PICTORIAL HISTORIES

Although the *Codex Mendoza* was painted for the Spanish crown twenty years after the conquest, it is very much a product of the indigenous tradition of history painting. Just as the master painter of the Mendoza recorded the details of Tenochtitlan's founding and early history, Aztec history

painters wrote down the facts and qualities of their past by means of glyphs, symbols, and figural representations. They did so at the behest of rulers who guarded these histories in their palace libraries, along with other documents relevant to the kingdom. After the conquest, Spanish administrators also appreciated and relied on the painted histories as they sought accurate information about the history and nature of Aztec rule (Boone 1998:155–58). Painted histories, as well as the alphabetic accounts that were transcribed from them, are the principal reason we know so much about the Aztecs and their empire.

The Aztecs conceptualized their historical past in two parts and as two separate stories. The first was the story of their migration, when the Aztecs left their mythical island homeland of Aztlan and wandered for many years from place to place, until they reached the marshes of the lake where the portent of the eagle on the cactus revealed the location of their new capital. The foundation of Tenochtitlan is the culmination of this migration story. The foundation has a double role, however, for it is also the basis for the second and subsequent story: Tenochtitlan's rise as an imperial power. These two parts of the Aztec past—these two largely separate stories—are fundamentally different in nature: one describes the movement of people across the land, and the other records the rulers and conquests of a settled population. The Aztec history painters often structured their accounts of these stories differently.

Like all histories, Aztec pictorial histories included four basic kinds of information: time, location, participant, and event. The painters usually relied either on time or on location to structure their account (Boone 2000:64–86). The migration story, because it concerns the movement of people across the land, was often structured graphically as a map-based or cartographic history. The imperial story was structured around time, as a yearly annals.

The history painter of the Mapa Sigüenza (Figure 12) for example, presents the story of the migration as a route of travel from place to place over a conventionalized territory, from Aztlan to Tenochtitlan (Boone 2000:164–73; Castañeda de la Paz 2006). Aztlan, the mythical island homeland, is identified glyphically in the upper right corner as a green hill sign from which grows a plant with feathery foliage, in the middle of a square lake (Figure 13). The large white bird perched on the plant is Huitzilopochtli, who exhorts a cluster of Aztec people to go forth. Fifteen tribal leaders are distinguished and named, and a line of footprints carries them along a winding track past a series of locations, all identified by their place signs. Blue disks indicate the number of years the Aztecs paused in each place. The route proceeds as a counterclockwise circuit around the right half of the sheet, crosses to the far upper left, and doubles back and down to reach Chapultepec (Grasshopper Hill), which dominates the left side of the sheet.

With Chapultepec the painter begins to describe the real geography and environment of the valley of Mexico, with west at the top. Tenochtitlan is located below (east) in the marshes, Tlatelolco is the mound of earth to the right (north), and Culhuacan is the curved hill to the far left (south), all positioned roughly were they are geographically. From Chapultepec, the painter explains how the migrating peoples split off from one another. One footprinted path carries a group to Tlatelolco on the right, another to Culhuacan on the left, and the third along the longer route through the swamps and marshes to Tenochtitlan below, where the small size of its place sign belies the importance of the founding event (Figure 14). Surprisingly, also, the event of the founding is represented upside down in the Mapa Sigüenza and in a manner much reduced from

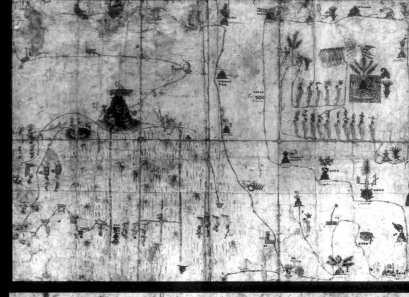

Figure 12. Mapa Sigüenza, a panel of bark paper, preserves the route and significant events of the Aztec migration from Aztlan (upper right) to Tenochtitlan (lower left).

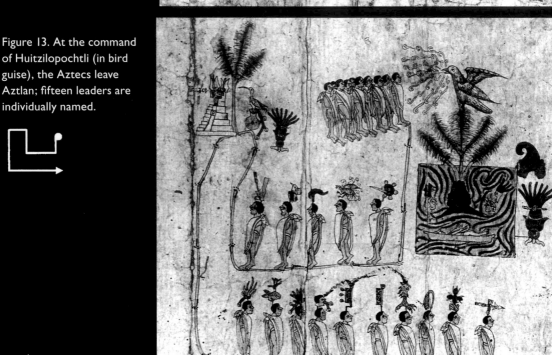

Figure 13. At the command of Huitzilopochtli (in bird guise), the Aztecs leave Aztlan; fifteen leaders are individually named.

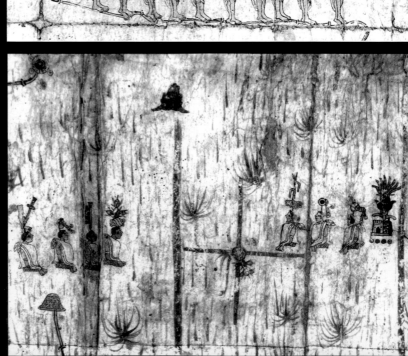

Figure 14. At the end of their migration, the Aztecs found Tenochtitlan, where the canals converge in the marshes of the lake (inverted for clarity).

the grandiose presentation in the Mendoza. The founding in the Mapa Sigüenza is marked only by the appearance of Tenoch and six other leaders who sit on woven mats facing Tenochtitlan's place sign. Whereas the Mendoza account focuses on the founding and requires one to assume a prior migration, the Mapa Sigüenza directs its attention to Aztlan, Chapultepec, and the journey.

The cartographic structure of the Mapa Sigüenza is well-suited to a migration history, which is fundamentally about movement and land. The subsequent imperial story, however, has a different narrative, and therefore a different structure. Imperial histories are largely annals histories, organized around the continuous count of sequential years.

The Aztecs' post-foundation, or imperial, story pertains to the city-state or community kingdom as a corporate body. Therefore, the events included in the account are those that are important to the community as a whole: the succession of rulers, conquests of other polities, major building programs, significant celebrations, and noteworthy natural and climactic phenomena. Along a ribbon of successive years, the painter adds symbolic, glyphic, and figural representations of such events. People are not usually specified, with the exception of rulers, who are always named. The location of the events is not usually given either, because it is understood that everything happens in the place whose history is being presented, unless otherwise indicated by the addition of a place sign.

A section of the *Codex Mexicanus*, which pertains to the rule of Tizoc and Ahuitzotl, shows the features of Aztec annals well (Boone 2000:67–69; Mengin 1952:455–456) (Figure 15). Across two pages the year count reads left to right, beginning with 4 Reed on the far left and running to 9 Reed on the right of the first page, and from 10 House to 2 Rabbit on the next. Above the year date for 4 Reed, the author marks the accession of the ruler Tizoc by painting him wearing the pointed crown of office and seated on the high-backed throne; his name sign is a chalked leg. A small platform just to the right refers to the renovations of the Templo Mayor, begun under Tizoc's rule. Two years later in 6 House, a battle is indicated by one warrior grabbing the hair of his defeated captive, but the sign for the Matlatzinca (hunting net [*matla-*] and rump [*tzin*]) is attached to the winning warrior, which tells us that it was the Matlatzinca who were victorious over the Aztecs. In the year 7 Rabbit, the funerary bundle of Tizoc indicates his death, followed by four disks that probably refer to the short length of his reign; his successor Ahuitzotl (Wa-

Figure 15. The annals history of the *Codex Mexicanus*, pp. 71–72: These two pages record the major events in the reigns of Tizoc and Ahuitzotl.

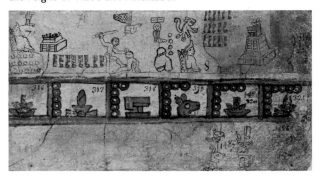
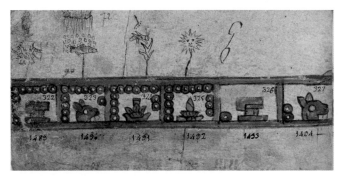

ter Beast) is immediately pictured in an accession statement: crowned, enthroned, and named glyphically. Above the next year, 8 Reed, the tall stepped pyramid marks the completion of the major renovation of the Templo Mayor.

Ahuitzotl's rule is subsequently marred by a series of dire events. The X-like symbol for movement records an earthquake in the year 10 House. The combined image of a rain cloud, hail, and a dead fish vividly describes a particularly destructive hailstorm in 11 Rabbit. We are told that grasshoppers swarmed and devoured the corn in 12 Reed and that a drought (symbolized by the unrelenting sun) came in 13 Flint. In annals such as this, the historian includes the significant events according to their timing; locations and actors are not specified because the reader already knows them to be the place (Tenochtitlan) and people (the Aztecs) of this history.

The differential emphases of these accounts in the *Codex Mendoza*, Mapa Sigüenza, and *Codex Mexicanus* highlights a feature of Aztec pictorial histories that is characteristic of all histories. They exist in multiples. They may tell some of the same stories, but they usually tell them differently or include only part of the material. They may also tell entirely different or conflicting stories. All were commissioned and created to argue particular positions and advance certain assertions about the past, and all are shaped by the specific goals and situations of their production. The pictorial nature of the Aztec histories requires that their authors focus only on those events that are essential to the story being told. The pictorial histories thus give us rich but specialized versions of the Aztec past.

HISTORY IN THE DATED MONUMENTS

The pictorial histories describe a past that has already happened and has largely been completed, but the Aztecs presented other perspectives on historical events by representing them in monumental stone sculpture. Whereas the historical documents describe an ideal past, the dated stone (or wood) monuments highlight an idealized present. This present may involve significant events in the past—usually by including a date that refers to this prior event—but the fundamental message of the monument remains very much concerned with the then-current political and religious situation.

When the major renovations to the Templo Mayor were finished in 1487, for example, the ruler Ahuitzotl commissioned a dedication stone to describe this event. Carved in prestigious greenstone, it pictures Ahuitzotl and his predecessor, Tizoc, standing on either side of a large grass ball (a zacatapayolli, that receives sacrificial bloodletters) (Figure 5). Both rulers are costumed as priests: they wear short tunics, have bulky tobacco gourds on their backs, carry the incense pouches, and have long, tangled hair. Both are drawing blood from their ears with bone awls. This blood flows down, around the grass ball, and into the hungry mouth of the earth creature at their feet. The monument dates the dedication to the year 8 Reed (1487, in the large rectangular cartouche) and the day 7 Reed (above the scene). The monument was carved not to record an episode in the distant past but to celebrate an event of the present. This present, however, embraces facts of the past, for Tizoc was dead at the time of the dedication and could not actually have participated. Ahuitzotl added him to the dedication stone to demonstrate that Tizoc

had, in fact, begun the renovation, which Ahuitzotl saw to completion. The blood offerings of both then became metaphorically joined during the dedication of their great temple.

On many stone monuments, carved dates also link the sculpted figures to specific beings, events, and time. The 1 Reed date on a carved feathered serpent (Figure 16) is the calendrical name for Quetzalcoatl (Feathered Serpent). The dates on the stone Year Bundle, or Xiuhmolpilli (Figure 17), associate the bundle both with the year 2 Reed, the year at the end of a fifty-two-year cycle on which these years were ritually and metaphorically bundled, and with the god Tezcatlipoca, whose calendrical name is the day 1 Death. Moctezuma's inauguration date appears on the so-called Altar of the Warrior with Hearts linking this monument to that event and suggesting that it is the ruler himself who draws blood while floating in a field of hearts. Some dates on other monuments, such as several on the great monolith popularly known as the "Calendar Stone," refer to crucial events that occurred in the distant past but remain powerfully relevant. Their inclusion on later monuments effectively brings these past events again into the present and recontextualizes them as part of the total message.

In the twenty-first century we can read and value these carved monuments as historical records. When they were first carved and displayed, however, they described events and understandings (including understandings of past events) that were then current. In these ways the carved monuments in stone and wood represented ongoing associations and relationships. It was only over time, after the carved monuments weathered and were viewed by later eyes, that they themselves came to represent the past.

Figure 16. Stone feathered serpent, with the date 1 Reed, the calendrical name of Quetzalcoatl.

Figure 17. Xiuhmolpilli, a stone replica of a bundle of reeds, signifying the binding of the fifty-two years at the end of a cycle.

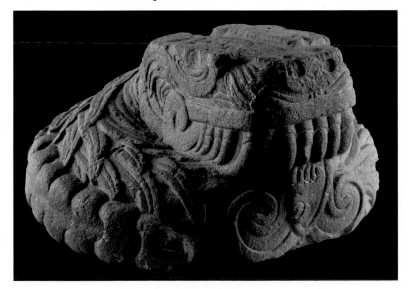

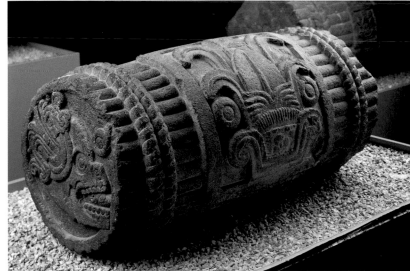

REFERENCES

Berdan, Francis, and Patricia Anawalt. 1997. *The Essential Codex Mendoza.* Berkeley and Los Angeles: University of California Press.

Boone, Elizabeth Hill. 1998. "Pictorial Documents and Visual Thinking and Postconquest Mexico." In *Native Traditions in the Postconquest World,* Elizabeth Hill Boone and Thomas Cummins, eds., pp. 149–99. Washington, D.C.: Dumbarton Oaks.

————. 2000. *Stories in Red and Black: Pictorial Histories of the Aztecs and Mixtecs.* Austin: University of Texas Press.

————. 2005. "In Tlamatinime: The Wise Men and Women of Aztec Mexico." In *Painted Books and Indigenous Knowledge in Mesoamerica: Manuscript Studies in Honor of Mary Elizabeth Smith*, Elizabeth Hill Boone, ed., pp. 9–25. New Orleans: Middle American Research Institute, Tulane University.

————. 2007. *Cycles of Time and Meaning in the Mexican Books of Fate.* Austin: University of Texas Press.

Casteñeda de la Paz, María. 2006. *Pintura de la peregrinación de los Culhuaque-Mexitin (El Mapa Sigüenza).* Mexico City: El Colegio Mexiquense, Instituto Nacional de Antropología e Historia.

Caso, Alfonso. 1971. "Calendrical Systems of Central Mexico." In *Handbook of Middle American Indians*, vol. 10, Robert Wauchope, Gordon F. Ekholm, and Ignacio Bernal, eds., pp. 333–348. Austin: University of Texas Press.

León-Portilla, Miguel. 1963. *Aztec Thought and Culture: A Study of the Ancient Nahuatl Mind.* Civilization of the American Indian Series 67. Norman: University of Oklahoma Press.

————. 1992, *The Aztec Image of Self and Society: An Introduction to Nahua Culture.* Salt Lake City: University of Utah Press.

————. 2003. *Codices : los antiguos libros del nuevo mundo.* Mexico City and Miami: Aguilar, 2003.

Mengin, Ernst. 1952. "Commentaire du Codex Mexicanus Nos. 23–24 de la Bibliothèque Nationale de Paris.' *Journal de la Société des Américanistes* 41, no. 2:387–498. (With facsimile of the Codex Mexicanus published as a supplement to the *Journal.*)

Sahagún, Bernardino de. 1953–82. *Florentine Codex: The General History of the Things of New Spain.* Translated and edited by Charles E. Dibble and Arthur J. O. Anderson. 12 books in 13 vols. Santa Fe: School of American Research and the University of Utah.

ELEVEN

THE AZTECS AFTER THE CONQUEST

ENRIQUE RODRÍGUEZ-ALEGRÍA,
UNIVERSITY OF TEXAS AT AUSTIN

In 1521, after two years of exploration, fierce battles, alliance-building, and epidemics, Spanish conquistadors gained control over the city of Tenochtitlan. The conquest marked the end of the Aztec empire, and Tenochtitlan became Mexico City, the capital of New Spain, a region of the Spanish empire that covered roughly modern-day Mexico and Central America. Spaniards administered their empire from Mexico City, building their main governmental offices literally on top of the ruins of Aztec temples, including the ruins of the Templo Mayor. They built the Metropolitan Cathedral (Figure 1) right in the ceremonial precinct of the Aztecs, symbolically taking over the center of an empire that they had already conquered with violence.

Spanish conquistadors immediately established a political hierarchy to administer their empire. They placed themselves at the very top of the Aztec imperial hierarchy, but they strategically left indigenous rulers in charge of their own towns and provinces. By simply taking over existing indigenous hierarchies, the Spanish managed to gain control over what was once the Aztec empire more easily than if they had tried to reorganize the indigenous government entirely (Gibson 1964; Lockhart 1992). Sometimes conquerors coerced indigenous people and forced them to accept their authority, but other times they obtained what they wanted through negotiation and cooptation (Rodríguez-Alegría 2005). Spanish conquerors also began a process of religious conversion for indigenous people in an attempt to erase ancient religious traditions from Central Mexico and impose Catholicism (Burkhart 1989; Edgerton 2001; Ricard 1966).

In this paper I use several terms to refer to the indigenous people of Central Mexico. Besides general terms such as "Indians" or "indigenous people," I use the term "Aztecs" to refer to Indians within the Aztec Empire of Central Mexico in the pre-Columbian period. "Nahuas" refers to the Nahuatl-speaking Indians of the post-conquest period.

Figure 1. Metropolitan Cathedral with the site of the Templo Mayor in the foreground.

In spite of the strategies of domination of Spaniards, in spite of religious conversion and imperial administration, and in spite of catastrophic depopulation due to epidemics, indigenous traditions continued well after the conquest. This chapter focuses on indigenous life after 1521, and emphasizes the contributions of archaeology to the study of colonial Nahuas, notably, indigenous craft production, technology, religion, and the adoption of Spanish goods.

Both Spaniards and Indians left a rich documentary record of the colonial period, with documents that include indigenous pictorial codices, travelers' accounts, legal documents, and religious writing (Boone 2000). By combining this documentary record with archaeological data we can obtain a clearer picture of indigenous life in the colonial period. We can learn about mundane aspects of life that were left out of the documents, and about Nahuas living in rural areas, isolated from Spaniards. Sometimes archaeology is the richest source of information that we have about the indigenous people that were omitted from the Spanish documents, and archaeological material can help animate the information about cultural life that is mentioned in little detail in historical documents. Archaeology makes the lives of colonial Indians more tangible and accessible to us.

COLONIAL NAHUA CRAFT PRODUCTION AND TECHNOLOGY

The archaeology of colonial Indians in Mexico began with a rather simple, but very important observation. In the 1960s, Thomas Charlton, an archaeologist working in the Teotihuacan Valley, observed that in colonial layers in his excavations there were Aztec-tradition ceramics, including Aztec Black-on-Orange ceramics and Red Ware (Figure 2). Indigenous people continued making these ceramics into the sixteenth and seventeenth centuries, as revealed by radiocarbon dating (Charlton 1968). This evidence showed that craft production among indigenous people continued into the colonial period, and that the Spanish conquest did not immediately change

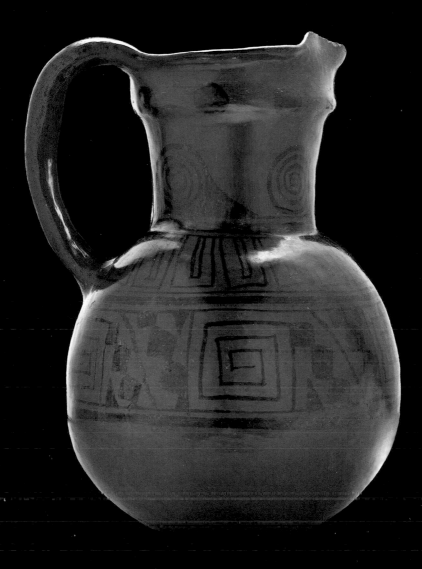

Figure 2. Colonial pottery: (Top) Black-on-Red pitcher;
(bottom) Black-on-Orange molcajete used for grinding.

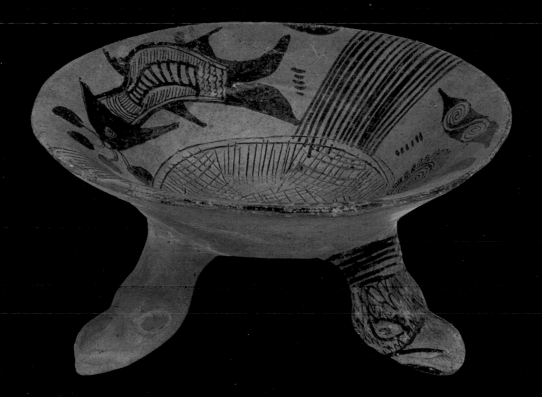

indigenous life in Mexico. In fact, Charlton argued that the effects of Spanish colonization on the daily life of Nahuas were stronger in cities, where Spanish colonizers were in daily contact with Nahuas, and much less marked in rural areas, where daily life continued largely unchanged in isolation (Charlton et al. 2005). This observation made the archaeology of colonial Indians possible, and since then, the archaeology of colonial Mexico has been slowly taking its place alongside history and art history as a vital source of information on Mexico's colonial Indians.

The daily lives of the Aztecs were deeply affected by imperial policies, tribute extraction, and warfare. Also the actions of commoners, rural peasants, and rival states affected the way that the Aztec empire functioned and limited, to a certain extent, the control that the Aztec empire had over people's everyday lives. In the colonial period we can interpret continuity simply as a matter of tradition, but we can also interpret continuity as a way that indigenous people had of seeking political and economic power and controlling their own lives.

The continued use of obsidian (Figure 3), or volcanic glass, as the prime material for cutting tools and arrowheads in the colonial period at the site of Xaltocan is a good example of how what appears to be a simple matter of tradition and continuity was actually a dramatic change and empowerment for colonial Indians. Spanish colonizers brought metal knives, swords, shears, and daggers to Mexico, where the use of metals in the pre-Columbian period was limited mostly to elite luxury goods, such as masks, bells, bangles, and other elements of costume (Hosler 2003). Typically we assume that metals make better cutting tools, and that metal knives must have quickly replaced obsidian blades in the colonial period, leading to a complete abandonment of obsidian tools after the conquest. However, by studying the changes in obsidian tool production before and during the Aztec period, and then during the colonial period, a rather different picture emerges.

Archaeological patterns demonstrate that the use and manufacture of obsidian tools in Xaltocan changed according to the social and political situation in the town. Xaltocan began as a small independent community, and it quickly grew to be a small state and a regional capital by the eleventh century CE. It received tribute from nearby communities (Brumfiel 2005). When Xaltocan was in power, it had access to obsidian from sites such as Otumba and Pachuca and the people of Xaltocan made their own obsidian tools, as can be seen by the presence of both finished tools (obsidian blades, scrapers, and arrowheads), and of production debris (obsidian cores, flakes, and production tools and workshops) (Brumfiel and Hodge 1996; Millhauser 2005). But Xaltocan was conquered by the Aztecs in 1428, and it went from receiving tribute to paying tribute to Tenochtitlan. Life changed in Xaltocan, and craft production declined (Brumfiel 2005). The people of Xaltocan did not have access to obsidian cores (the raw material used for making obsidian blades). Instead, they had to

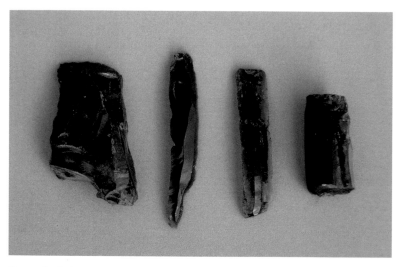

Figure 3. Colonial obsidian from Xaltocan.

purchase finished obsidian tools in the markets. This reduced the overall abundance of obsidian in the site. The evidence consists of a much higher proportion of finished tools to production discards at the site (Millhauser 2005).

After the Spanish conquest, instead of abandoning obsidian use in favor of metal knives, the people of Xaltocan continued using obsidian tools well into the colonial period and probably into the nineteenth or the early twentieth century. More importantly, the people of Xaltocan resumed obsidian tool production in the colonial period; that is, they were making tools from raw materials, rather than having to purchase these tools in markets like they did under Aztec control. Instead of abandoning their traditional tools in favor of European ones, they went back to producing their traditional tools. This dramatic change was probably due to the fall of the Aztec empire, which increased access to obsidian sources that the Aztecs controlled (Pastrana 1988), and to the complete disinterest in obsidian on the part of the Spanish, who were more concerned with metals than stone. The people of Xaltocan could make their own obsidian tools but they could not make metal tools, which made obsidian a much more attractive material for their purposes. In this case, continuity (or the continued use of obsidian) is clearly a matter of empowering the community through ownership of raw materials and the production process, rather than having to be dependent on Spaniards for the supply of finished tools (Rodríguez-Alegría 2008).

It is important to remember, however, that production was not always and everywhere left up to indigenous people. In fact, colonizers coerced indigenous people into providing labor and tribute, often making them work under harsh conditions for long periods of time. One of the ways that colonizers had of organizing forced labor was the *encomienda*, "a grant of Indian tribute and originally labor to a Spaniard" (Lockhart 1992:4). Forced labor and coercion are not always clear in the archaeological record, because the instruments used in physical abuse are often removed from the place where they were used. However, there is plenty of historical documentation about abuses to Indians in the colonial period. These documents can inform archaeological work on production in the colonial period.

For example, Elizabeth Brumfiel (1996) has studied the effects of tribute demands and indigenous resistance on cloth production in the early colonial era. In the colonial period, production of cloth for tribute increased in some indigenous communities in Central Mexico. On top of the increasing demands for tribute cloth by Spaniards, catastrophic epidemics caused dramatic population loss in the colonial period, effectively increasing the amount of cloth each person had to produce to meet tribute demands. The tools used in cloth production, specifically spindle whorls (Figure 4) used to spin plant fibers into thread, are found in many archaeological sites all over Mesoamerica. They are mostly ceramic, and they gave Brumfiel important clues about the cloth production process and the quality of tribute cloth in the colonial period.

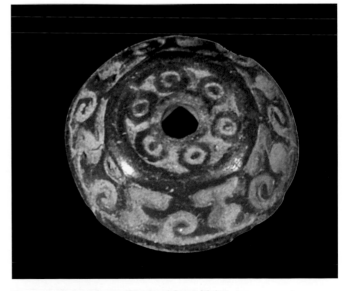

Figure 4. Colonial spindle whorl from Xaltocan.

Brumfiel (1996) explains that historical sources record instances in which Spaniards asked for improved textiles rendered as tribute. The cloth had to be bigger and better, with finer thread and a tighter weave. These sources imply that the quality of cloth rendered as tribute was declining, probably because indigenous people were resisting Spanish tribute demands and expressing their dissatisfaction with exploitation by providing shoddy cloth. Brumfiel reasoned that the lower quality of tribute cloth should be reflected in the spindle whorls. They would be poorer, lower-quality tools that would make poorer, lower-quality thread. Lighter spindle whorls typically make better quality, finer thread, whereas heavier spindle whorls make coarser thread. When Brumfiel weighed colonial spindle whorls, she expected them to increase in size and weight, to produce coarse thread, as the documents implied. But surprisingly, she found the opposite: the spindle whorls were lighter, and they would therefore make better cloth than in earlier periods. In reality, the quality of tribute cloth increased in the colonial period, and indigenous producers did not seem to be resisting tribute demands by making lower-quality products. Rather, they complied with tribute demands by making fine cloth.

The archaeological patterns showed that indigenous people complied with tribute demands. But historical documents capture many instances of indigenous resistance to tribute demands and lawsuits decrying their abuse. By combining archaeological and historical sources, Brumfiel concluded that Indians certainly resisted exploitation, but their efforts at resistance were often crushed by force and coercion. In the case of tribute cloth, indigenous women were closely supervised and forced to make better cloth for tribute. This archaeological case study is a reminder of the importance and power of coercion over indigenous labor in the colonial period, and demonstrates how a combination of archaeology and history can provide a clearer view of the past.

RELIGION

Religion is another aspect of colonial indigenous life that has interested scholars for decades. Colonial images such as the Virgin of Guadalupe have captivated the public's imagination in part as a display of the richness of cultural and religious mixing and creativity in colonial Mexico. Soon after the conquest of 1521, a major project of conversion of indigenous people to Catholicism began. Indigenous people had a polytheistic religion in which many deities inhabited the material world. As the Aztec empire expanded, the Aztecs incorporated the deities of subject communities into their pantheon. Spanish colonizers, instead of adopting the gods of the Aztecs, demanded that indigenous people abandon beliefs and rites related to their own deities and adopt Christianity. They built churches, chapels, and cathedrals, and sent friars to teach Christianity to the Indians. Fully aware of the difficulties of converting Nahuas, friars often changed the way they taught religious concepts to indigenous people to better communicate religious ideas to them. They changed the language of sermons to use concepts that were familiar to Nahuas. They carefully chose the type of imagery they used in churches, they staged plays and musical performances for Indians, and they turned churches and chapels into true theaters for converting indigenous people (Edgerton 2001; Ricard 1966). Colonizers also resorted to violence for dealing with people who retained their pre-Columbian religious practices. They smashed "pagan" idols and physically

punished those who they suspected were not entirely converted to Christianity. In spite of the efforts and cruelty of colonizers, conversion proved to be a difficult task.

There are plenty of examples of indigenous religious imagery that mix Catholic and Mesoamerican religious elements (Figure 5). These images initially give the impression that indigenous people simply did not understand Catholic teachings, or that they reinterpreted Catholic teachings according to their own way of viewing the world, which is certainly correct in many occasions. For example, a baptismal font in Zinacantepec, Central Mexico, contains carved images of different scenes in the life of Christ and of Mary. These scenes are surrounded by decorative motifs related to Tlaloc, the Aztec god of water, including volutes containing droplets of water emerging from flowers. These volutes are similar to motifs seen in pre-Columbian murals at Teotihuacan, and indicate a conflation between the Christian concept of holy water and the indigenous belief in Tlaloc, the god of water (Reyes Valerio 1968). Combinations of Nahua and Christian imagery can be seen in religious objects and murals all over Mexico today (Edgerton

Figure 5. Temple and Cross plaque, San Juan Teotihuacan. Terra cotta disc with a Christian cross in the center on top of a *momoztli* (mound). Beneath the cross is a solar flower, surrounded by feathers and other Aztec-tradition motifs.

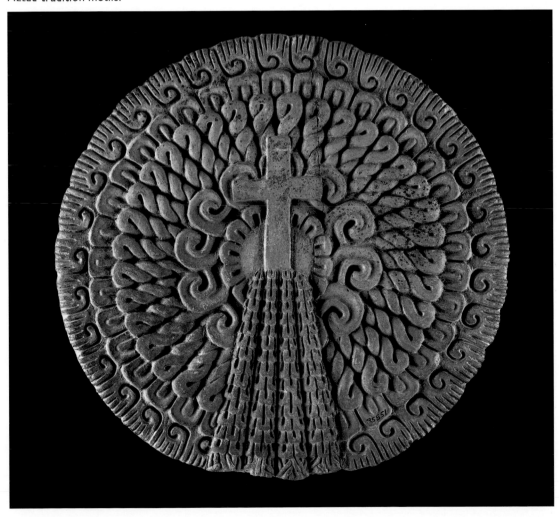

2001). Mendicant friars were aware that such combinations took place, and considered them idolatrous. They repeatedly failed to stop indigenous people from introducing their own material culture, and probably their own beliefs, into Christian ritual, in spite of violent attempts at erasing what they considered idolatry from religious practices in Mexico.

Religious syncretism or mixing was not simply a matter of casual reinterpretation or misunderstanding. Sometimes it was closely linked to indigenous strategies for obtaining power. The murals in the main church at San Miguel Ixmiquilpan, Hidalgo, are among the most dramatic examples of how religious tradition was linked to power in the colonial period (Figures 6, 7) (Edgerton 2001). In 1960, a repair project inside the church at Ixmiquilpan revealed early colonial murals, painted between 1569 and 1572, depicting a rather peculiar battle between good and evil. The murals contained severed heads dramatically flying through the air, warriors dressed with jaguar and coyote costumes using traditional weapons of wood and obsidian, and other warriors using bows and arrows, the preferred weapon of nomadic Chichimecs. The battle is taking place among horses, dragonlike creatures, scrolls, plants, and gore. The presence of jaguar and coyote warriors in these murals is striking. Scholars have argued that mendicant friars in Hidalgo had problems with Chichimec nomads, who attacked the growing numbers of Spaniards in Hidalgo several times. The friars had finally had enough of the Chichimecs, and allowed (or probably encouraged) local indigenous Otomis to wage war against the Chichimecs and effectively get rid of them. The successful Otomi warriors then used these battles to gain prestige from their war

Figure 6. Battle mural in the church of Ixmiquilpan, Hidalgo. An indigenous warrior wearing a loincloth uses a bow and arrow.

Figure 7. Battle mural in the church of Ixmiquilpan, Hidalgo. An indigenous warrior dressed in a jaguar suit wields an obsidian sword.

exploits, as they had in pre-Columbian times. They were honored as jaguar warriors and allowed to paint the church murals in honor of their victory, and perhaps they were even allowed to stage mock battles in celebration of their victory over the Chichimecs (Edgerton 2001; Pierce 1987). By defending the Church, the men of Ixmiquilpan were not just seeking Christian salvation; they were also seeking, and obtaining, social recognition and prestige in their local indigenous community.

The murals at Ixmiquilpan are not the only context that suggests that the prestige of the warrior orders of the Aztecs continued for some time after the conquest. A tripod ceramic plate from Tlatelolco (Figure 8), just north of Mexico-Tenochtitlan, contains an image of a jaguar and an eagle in relief, representing the two major orders of Aztec warriors (Pasztory 1984). The plate was found in an early colonial context, and Pasztory (1983, 1984) suggests that it is evidence of a continued military ideology in the colonial period. In fact, Pasztory (1984) has argued that it is significant that this type of iconography appears in ceramics after the conquest, when the Spanish destroyed much Aztec sculpture, architecture, and painted manuscripts. The conquistadors paid a lot of attention to objects that were overtly religious and that signified the greatness of the Aztec kings, such as monuments and palaces, but they paid little attention to more mundane objects

Figure 8. Ceramic plate with eagle and jaguar motif found in a colonial context in Tlatelolco, Mexico.

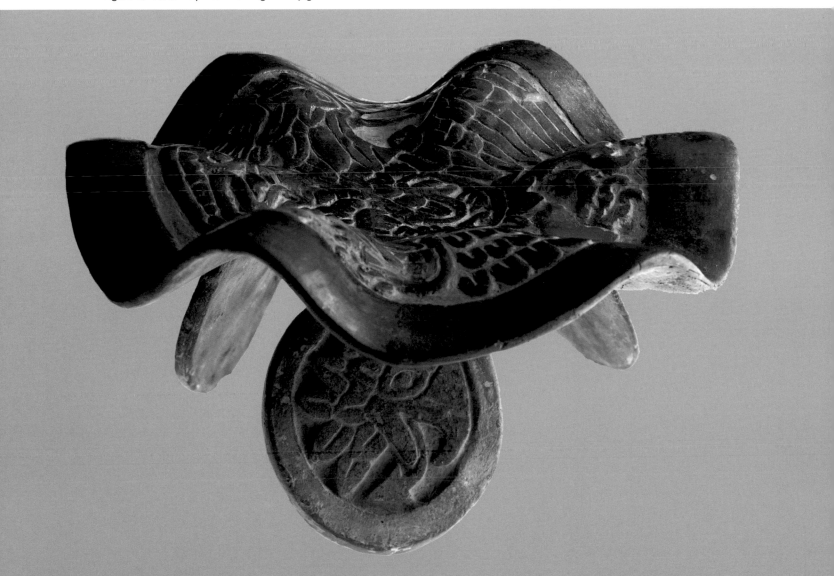

such as ceramics. For that reason, Pasztory believes that early colonial Nahuas transferred their religious and political iconography to ceramics, which the Spanish did not target for destruction. However, the Tlatelolco plate is a very rare example of the transfer of Aztec iconography to ceramics. The transfer of traditional indigenous elite symbolism and imagery to ceramics did not last too long, but it is an important indication of the survival of pre-Columbian ways of obtaining prestige for some time after the conquest.

ADOPTION OF SPANISH MATERIAL CULTURE

Colonial Indians not only held onto their traditions; they also began to incorporate European material culture into their daily lives. Historical documents record instances in which Spaniards tried to prohibit trading European goods with indigenous people (Rodríguez-Alegría 2002). Documents also indicate that some Spaniards wanted to trade European goods with Indians as a strategy for "civilizing" them or making them more European (e.g., Bauer 2001) and also as a way of offering rewards to indigenous allies by giving them gifts of fine European luxuries (e.g., Haskett 1991). By combining information from archaeological artifacts with historical documents, a complex understanding of the adoption of European goods among indigenous people has begun to emerge.

Clothing is a category of material culture that had utmost importance among both Spaniards and Indians in Mexico. It signified many important aspects of a person, including gender, social class, ethnicity, and age (Anawalt 1981). It is no surprise, then, that some Spaniards tried to prohibit the use of European fashions among indigenous people, and that some indigenous people then requested permission to wear Spanish clothes. Documents capture many instances in which indigenous elites, especially men, requested permission to wear Spanish costumes and hairdos, ride horseback, and carry swords and daggers, which were prohibited among Indians. Indigenous testaments sometimes mention European clothing and home furnishings that belonged to indigenous lords in the colonial period (Gibson 1964; Haskett 1991; Lockhart 1992).

Colonial figurines can help build on the data captured in documents, which refer for the most part to men who claimed to be elites (Figure 9). Colonial ceramic figurines sometimes depict women wearing Spanish dresses and indigenous jewelry (Von Winning 1988). Based on the presence of beaded necklaces and earplugs, and on the fact that the women were involved in traditionally indigenous tasks, such as patting tortillas and carrying babies by tying them on their back with a shawl, von Winning (1988) argues that these figurines represent indigenous women. These figurines present important contrasts to the historical documents. First, they show that not only elite men, but also women were adopting Spanish clothing in the colonial period. Second, they show that adopting Spanish fashions did not mean that indigenous clothing was abandoned altogether; rather, Indians combined these fashions, making use of indigenous and European styles at the same time. And third, the Spanish were not in total control over the adoption of European goods among Indians, since women, who were typically left out of legal transactions and proceedings (Kellogg 1995), evidently managed to acquire some elements of European fashion. Future studies on colonial figurines will help create a clearer picture of the adoption of European clothing among indigenous men, women, and children.

Of all the categories of material culture, ceramics preserve the best; therefore, archaeologists have found them very useful in studying colonial interactions. Archaeologists have found that Spanish colonizers partially relied on indigenous ceramics for their own household use (Charlton et al. 1994; Rodríguez-Alegría 2002, 2005). They also imported pottery from Europe and Asia and made their own European-style pottery in factories in Mexico City and elsewhere (Fournier García 1990; Lister and Lister 1982). Serving vessels made by Europeans, known as majolica, are easy to distinguish from Aztec pottery because they have a white surface color covered by a shiny glaze. Archaeologists divide majolica pottery into a variety of wares, depending on the quality of the pottery. These categories largely coincide with degrees of quality that potters themselves purposefully made. For example, "fine-grade" vessels made in Mexico City had a high-quality white glaze and were made into a variety of delicate forms, including compound silhouette

Figure 9. Colonial figurine from Xaltocan.

plates, bowls, porringers with leaf-shaped handles, and jars (Figure 10). "Common-grade" majolica, on the other hand, had a yellowish or off-white glaze and was made into somewhat coarse forms compared with fine-grade majolica (Figure 11) (Lister and Lister 1982).

Archaeologists have studied the distribution of these types of pottery in different sites, and the results have been surprising. First, in spite of prohibitions against trading in European items with indigenous people, in fact, there is plenty of majolica in rural areas, including at sites such as Xaltocan and in the Teotihuacan Valley, and also sites very distant from Mexico City, such as Chihuitán in the Isthmus of Tehuantepec, and in Soconusco. Second, archaeologists have argued that the distribution of majolica in indigenous sites is partially related to wealth. Regions or sites that enjoyed a better economic position in the colonial period obtained more Spanish ceramics and better quality ceramics than economically depressed regions (e.g., Fournier García 1997; Gasco 1992; Seifert 1977; Zeitlin and Thomas 1997). And finally, a recent study shows that indigenous people in Xaltocan showed a preference for ceramics decorated in green. These ceramics may not have been the finest ceramics made by Spaniards, but they certainly matched indigenous religious beliefs in the sacredness of the color green, which was associated with precious jade, exotic quetzal feathers, rich vegetation, and sacredness in general. Spanish ceramics were also shiny, which indigenous people associated with *tonalli,* a life force that all humans contain (in some respects similar to our concept of the soul), which shines and glistens. It comes from the sun and resided also in shiny crafts, gold, water, and anything that glistened (Rodríguez-Alegría in press). Therefore, indigenous people incorporated Spanish pottery into their own cultural categories of value.

Figure 10. Fine-grade majolica pottery made in Mexico City by Spanish potters. Excavated by the Programa de Arqueología Urbana in the Metropolitan Catedral.

Figure 11. Common-grade majolica pottery (Mexico City Green-on-Cream) made in Mexico City by Spanish potters. Excavated by the Programa de Arqueología Urbana in the Metropolitan Cathedral.

CONCLUSION

This very brief glance at the archaeology of colonial Indians in Central Mexico shows that the impact of the Spanish conquest had a variety of effects on indigenous people. Indigenous people as a whole were certainly not wiped out entirely by the arrival of Spaniards, epidemics, and cultural change. Some indigenous people were affected more immediately and more intensely than others. Some continued living their lives as they did before the conquest, while others changed their patterns of consumption of both indigenous and European material culture in an effort to improve their social and economic situations. Some resisted Spanish domination, while others found coercion too strong to make resistance a realistic or effective political strategy. And some indigenous people allied with Spaniards in an attempt to improve their social status and life.

In combination, archaeology and history can provide access to the colonial world, providing crisp, clear ideas about the lives of all sorts of colonial Indians. We have only begun to see the potential that the archaeology of colonial Indians in the Basin of Mexico has to contribute to our knowledge of colonial Mexico. Future studies will build on the contributions of existing scholarship on colonial Indians, giving us greater access to the lives of indigenous people in both rural and urban areas all over Mexico.

REFERENCES

Anawalt, Patricia R. 1981. *Indian Clothing Before Cortés: Mesoamerican Costumes From the Codices*. Norman: University of Oklahoma Press.

Bauer, Arnold J. 2001. *Goods, Power, History: Latin America's Material Culture*. Cambridge: Cambridge University Press.

Boone, Elizabeth. 2000. *Stories in Red and Black: Pictorial Histories of the Aztec and Mixtec*. Austin: University of Texas Press.

Brumfiel, Elizabeth M. 1996. "The Quality of Tribute Cloth: the Place of Evidence in Archaeological Argument" *American Antiquity* 61(3):456–62.

———.(editor) 2005. *Production and Power at Postclassic Xaltocan*, Pittsburgh and Mexico City: University of Pittsburgh and Instituto Nacional de Antropología e Historia.

Brumfiel, Elizabeth M. and Mary D. Hodge. 1996. "Interaction in the Basin of Mexico: the Case of Postclassic Xaltocan." In *Arqueología Mesoamericana: Homenaje a William T. Sanders*. Jeffrey R. Parsons, Ana Guadalupe Mastache, Robert S. Santley, and Mari Carmen Serra Puche, eds. Mexico City: Instituto Nacional de Antropología e Historia.

Burkhart, Louise M. 1989. *The Slippery Earth: Nahua-Christian Moral Dialogue in Sixteenth-Century Mexico*. Tucson: University of Arizona Press.

Charlton, Thomas. 1968. "Post-Conquest Aztec Ceramics: Implications for Archaeological Interpretations." *The Florida Anthropologist* 21:96–101.

Charlton, Thomas H., Patricia Fournier, and J. Cervantes. 1994. "La cerámica del periodo Colonial Temprano en Tlatelolco: el caso de la Loza Roja Bruñida." In *Presencias y Encuentros Investigaciones arqueológicas de salvamento*. Dirección de Salvamento Arqueológico. México, D.F.: Instituto Nacional de Antropología e Historia.

Charlton, Thomas, Cynthia L. Otis Charlton, and Patricia Fournier García. 2005 "The Basin of Mexico A.D. 1450–1620: Archaeological Dimensions." In *The Postclassic to Spanish-Era Transition in Mesoamerica: Archaeological Perspectives*. Susan Kepecs and Rani T. Alexander, eds. Albuquerque: University of New Mexico Press, 49–63.

Edgerton, Samuel Y. 2001. *Theaters of Conversion: Religious Architecture and Indian Artisans in Colonial Mexico*. Albuquerque: University of New Mexico Press.

Fournier García, Patricia. 1990. *Evidencias Arqueológicas de la Importación de Cerámica en México, Con Base en los Materiales del Ex-Convento de San Jerónimo*. Instituto Nacional de Antropología e Historia, México, D.F.

———. 1997. "Tendencias de Consumo en México durante los Periodos Colonial e Independiente." In *Approaches to the Historical Archaeology of Mexico, Central & South America*. Edited by Janine Gasco, Greg Charles Smith, and Patricia Fournier-Garcia. Los Angeles: The Institute of Archaeology, University of California: 49–58.

Gasco, Janine. 1992. "Material Culture and Colonial Indian Society in Southern Mesoamerica: The View from Coastal Chiapas, Mexico." *Historical Archaeology* 26(1):67–74.

Gibson, Charles. 1964. *The Aztecs Under Spanish Rule: A History of the Indians of the Valley of Mexico, 1519–1810*. Stanford, Calif.: Stanford University Press.

Haskett, Robert. 1991. *Indigenous Rulers: An Ethnohistory of Town Government in Colonial Cuernavaca*. Albuquerque: University of New Mexico Press.

Hosler, Dorothy. 2003. "Metal Production." In *The Postclassic Mesoamerican World*. Edited by Michael E. Smith and Frances F. Berdan. Salt Lake City: The University of Utah Press: 159–71.

Kellogg, Susan. 1995. *Law and the Transformation of Aztec Culture, 1500-1700*. Norman: University of Oklahoma Press.

Lister, Florence C., and Robert H. Lister. 1982. *Sixteenth Century Maiolica Pottery in the Valley of Mexico*. University of Arizona Press, Tucson.

Lockhart, James. 1992. *The Nahuas After the Conquest*. Stanford University Press, Stanford, California.

Millhauser, John. 2005. Classic and Postclassic Chipped-stone at Xaltocan. *In* Production and Power at Postclassic Xaltocan. Elizabeth M. Brumfiel, ed. pp. 267–318. Pittsburg: University of Pittsburgh Press.

Pastrana, Alejandro. 1988. "La explotación azteca de la obsidiana en la Sierra de las Navajas." Colección Científica 383. México, D.F.: Instituto Nacional de Antropología e Historia.

Pasztory, Esther. 1983. *Aztec Art*. Harry N. Abrams, New York.

———. 1984. El arte mexica y la conquista española. *Estudios de Cultura Náhuatl* 17.

Pierce, Donna. 1987. "The Sixteenth-Century Nave Frescoes in the Augustinian Misión Church at Ixmiquilpan, Hidalgo, Mexico." Ph.D. dissertation. Albuquerque: University of New Mexico.

Reyes Valerio, Constantino. 1968. "La pila bautismal de Zinacantepec, Estado de México." *Boletín INAH* (31):24–27.

Ricard, Robert. 1966. *The Spiritual Conquest of Mexico*. Berkeley: University of California Press.

Rodríguez-Alegría, Enrique. 2002. "Food, Eating, and Objects of Power: Class Stratification and Ceramic Production and Consumption in Colonial Mexico." Ph.D. dissertation, Department of Anthropology, University of Chicago. Ann Arbor: University Microfilms.

———. 2005. "Eating Like an Indian: Negotiating Social Relations in the Spanish Colonies" *Current Anthropology* 46(4):551–73.

———. 2008. "Narratives of Conquest, Colonialism, and Cutting-edge Technology." *American Anthropologist* 110:1.

———. Forthcoming. "Material Culture, Indigenous Power, and the Spanish Empire." Manuscript in preparation for *American Antiquity*.

Seifert, Donna. 1977. "Archaeological majolicas of the rural Teotihuacan Valley, Mexico." Ph.D. dissertation, University of Iowa. Ann Arbor: University Microfilms.

Von Winning, Hasso. 1988. "Aztec Traits in Early Post-Conquest Ceramic Figurines." In *Smoke and Mist*. Edited by J. Kathryn Josserand and Karen Dakin. BAR International Series, 711–45.

Zeitlin, Judith Francis, and Lillian Thomas. 1997. "Indian Consumers on the Periphery of the Colonial Market System: Tracing Domestic Economic Behavior in a Tehuantepec Hamlet." In *Approaches to the Historical Archaeology of Mexico, Central & South America*. Edited by Janine Gasco, Greg Charles Smith, and Patricia Fournier-Garcia, Los Angeles: The Institute of Archaeology, University of California, 5–16.

TWELVE

THE AZTEC WORLD'S PRESENCE IN COLONIAL AND MODERN MEXICO

EDUARDO MATOS MOCTEZUMA,
INSTITUTO NACIONAL DE ANTROPOLOGÍA E HISTORIA

For a contemporary visitor to Mexico City it might seem odd to find, in front of the Great Temple of the Aztecs, alongside the National Cathedral, in the very center of the city and among the vestiges of the principal Aztec and principal Christian shrines, a group of feathered dancers playing instruments such as conch shell trumpets, and drums, and then asking tourists for money. They are members of traditionalist organizations, the most prominent of which is "Mexicanism," which is associated with the pre-Hispanic world and specifically that of the Mexicas or Aztecs. So they work to "revive" dances even though no one knows the rhythm or movements of the ancient dances and these are, accordingly, modern choreographies. These organizations have other odd beliefs as well, such as denying the human sacrifice even though it is perfectly well documented in pre-Hispanic archaeological remains (see Chapter 9), and specifically not using that term—pre-Hispanic—but rather, talking about a pre-Cuauhtemoc culture. Regarding Cuauhtemoc, the last *tlatoani* or Aztec ruler, they believe his remains lie in the town of Ichcateopan even though this has been indisputably disproved; they regard the ancient pyramids as "centers of energy"; they say the Aztec people were not exploited by a military theocracy but were socialist communities; they are followers of an indigenous science instead of Western science; and for good measure, they are not really indigenous people but mestizos who sometimes make racist arguments such as that there is a single ethnic heritage for all Mexicans. That idea has no objective foundation, but it allows them to conceive of an ideal, imagined community based on very partial and idiosyncratic readings of historical documents and archaeological data. In view of all this, some anthropologists consider their ritual activities and beliefs, as noted by Francisco de la Peña (2002), to be:

a caricature of what they were in the pre-Hispanic era, and their ideals of cultural restoration as absurd and utopian projects. Unlike the real indigenous cultures, whether ancient or current, the activities of these Mexicanists look like a mere simulation of indigenous traditions, a false and more or less aberrant exoticism.

These "plastic Indians" have distorted the past in an attempt to drag it into the present. Their forms of expression falsely represent ancient Mexico. That is why it is important to carefully examine how certain aspects of the Aztec past and many of its symbols have survived the passage of time and come to be viewed as national symbols today. To do so, I will explore the historical background that will help us understand how this came about and its importance today.

A BIT OF HISTORY

On August 13, 1521, after a siege of the Aztec cities of Tenochtitlan and Tlatelolco lasting nearly three months, Cuauhtemoc, the last Aztec emperor, was taken prisoner by Hernán Cortés's men (Díaz del Castillo 1943) (Figure 1). The military conquest was to be followed by a spiritual conquest of the vanquished. The Catholic Church was responsible for this task, carried out through evangelization by three religious orders: The Franciscans, the Dominicans, and the Augustinians. It was clear from the beginning that the monks needed to gain a thorough understanding of the unique characteristics of indigenous religion and daily life so that, as Brother Bernardino de Sahagún put it, the monks would not be deceived by the indigenous people who were in fact worshipping their old gods while appearing to perform Christian ceremonies. That understanding led to the use of various techniques, such as the construction of "open chapels" at the facades

Figure 1. The massacre at the Aztec Great Temple.

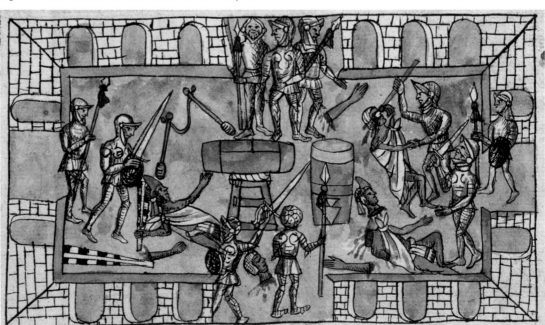

Figure 2. Open chapel at Cuilapan.

Figure 3. Catechism of Friar Pedro de Gante.

of the churches or monasteries/convents facing major patios or squares, where the recently conquered people could attend Mass. The monks realized that the indigenous people were not accustomed to entering the temples of their gods but congregated outside the temple in large plazas in order to take part in ceremonies (Figure 2). Hence, the "open chapels" provided a transitional experience that gradually induced the indigenous people to go into the churches. Another adaptation was to use a kind of codex or scroll with drawings bearing prayers like the Our Father and the Creed, as well as other Christian messages (Figure 3). Still another was to encourage the so-called "Moors and Christians dances," or "conquest dances," performed by two sides, the Christian and the Moorish or pagan, which ended with a Christian victory after several days of dramatizations and dances; the indigenous people would then line up to be baptized.

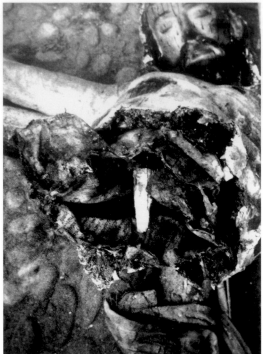

Figure 4. The Christ of Mexicaltzinco.

Figure 5. Detail showing interior of the statue, where the pre-Hispanic document was found.

The monks' efforts met with a rapid response. The indigenous people did their best to counter evangelization, and they devised a variety of ways to do so. One was to make Christ figures of cane stalks in whose interior they hid codices, such as the very well known Christ of Mexicaltzingo (Figures 4 and 5). They also placed figures of their gods within the walls of some churches. Still another tactic consisted of choosing sculptures of the old gods, especially those that represented Tlaltecuhtli, the Lord/Lady of the Earth, which they carved on large blocks of stone, placing the image on the bottom, where it was out of sight (Figure 6). So, the indigenous people chose to place these figures on the bases of pillars in the Christian churches and monasteries with the understanding that the god's figure facing downward would not offend the monks, who would be satisfied if the "devilish" figure was not visible; this allowed the indigenous people to preserve the images of their gods.

The monks soon discovered they were being deceived, however. Franciscan Brother Toribio de Benavente, known as Motolinía, wrote: "Then they saw that they had some images on their altars, together with their demons and idols, and in other parts the image was visible and the idol was hidden, either behind an ornament or behind the wall, or within the altar."

All this led the conquistadors to take further action to ensure the success of their evangelization campaign: the appearance of an image. Many of the conquistadors had come from Extremadura, a province devoted to the Virgin of Guadalupe, where there was an enormous convent at which her image was venerated (Figure 7). This Virgin, with a dark (almost black) complexion and an Arab name, had been very successful in the wars of conquest against the Moors. Cortés was a fervent devotee of the image, and went before her when he returned to Spain in 1528, bearing gifts. Shortly after this military leader from Extremadura returned to New Spain in 1531, the Virgin's image appeared to the Indian Juan Diego in Tepeyac, where the Aztec goddess Tonantzín had previously been worshipped (Figure 8). This sighting fell into a standardized pattern observed elsewhere in Europe and America: 1) The apparition chooses a humble person who will be the go-between with the divinity; 2) The chosen person goes to the church authorities to report the appearance; 3) The church always reacts skeptically to the message be-

Figure 7. The Virgin of
Guadalupe of Extremadura.

Figure 8. The Virgin of
Guadalupe of Tepeyac, Mexico.

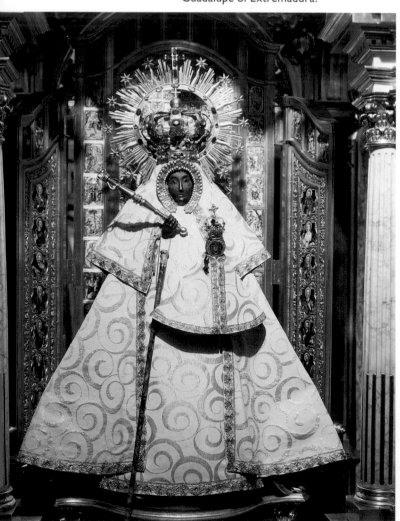

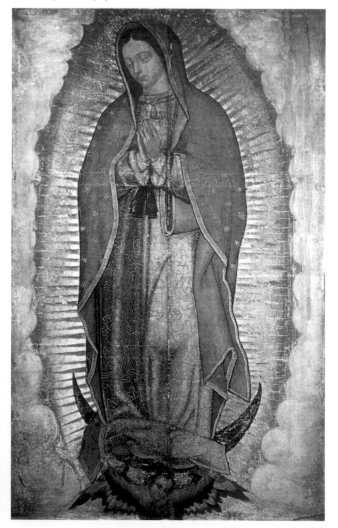

cause it comes from an uneducated common person; 4) A supernatural portent is necessary for the story to be accepted; 5) A shrine is built at the place of the supposed appearance where the faithful can come to pray and ask for favors.

THE EAGLE PERCHED ON THE PRICKLY PEAR CACTUS AND THE NATIONAL SYMBOLS

One image of crucial importance needs to be analyzed. It is the pre-Hispanic symbol of an eagle perched on a prickly pear cactus that grows out of a rock in the middle of a lake. We see this image on Aztec objects such as the "Teocalli of the Sacred War," a stone sculpture that depicts a temple on the back of which we see the eagle perched on the prickly pear cactus, with the symbol of warfare, a stream of fire and water, emerging from the eagle's beak (Figure 9). This was the sign given to the Mexica people by their patron deity, Huitzilopochtli, to mark the end of their long migration. It commemorates the founding of Tenochtitlan, the Aztec capital (see Chapter 1).

In 1523, once the conquest of Tenochtitlan was completed, King Charles V gave Mexico City a coat of arms consisting of a tower with two lions and bridges over a lake, recalling the lake in the midst of which the city was built (Figure 10). A border of prickly pears surrounds this image, but the eagle does not appear in it. However, the pre-Hispanic symbol for the city of Tenochtitlan continues to be used, which raises the question of how this symbol, which represents the triumph of the god Huitzilopochtli (the sun) over his enemies, came to appear on the national seal and flag.

In the early colonial period there were several depictions of this symbol, such as the pages of the *Durán Codex*, in which it appears at least twice: In one such image the eagle devours a serpent and in the other it feeds on birds; both images make refer-

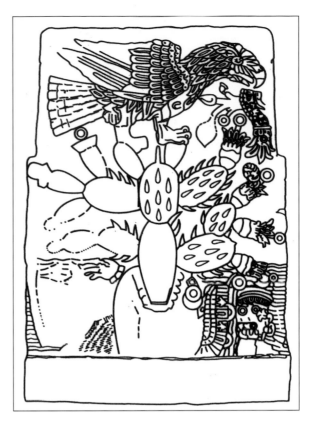

Figure 9. Drawing of the eagle on the Temple of the Sacred War.

Figure 10. The seal of Mexico City.

ence to the foundation of the city of Tenochtitlan (Figure 11). We also see the eagle on page 1 of the *Codex Mendoza*, where it is in the center (Chapter 1, Figure 7). These depictions are easy to explain: the first represents an attempt to illustrate the foundation of Tenochtitlan by Brother Diego Durán, and the second is in response to the first New Spain Viceroy Antonio de Mendoza's request for an illustration of the codex that bears his name. We also see the eagle alone, perched on the prickly pear, in the *Aubin Codex*, and again in the *Map of Tepechpan* (Figure 12). In the *Vatican-Ríos Codex* we see a stone, on which stands a prickly pear cactus with two hearts. The *Codex Osuna* depicts Aztec contingents marching toward Florida to provide support for the Spanish forces seeking to conquer new territories, and the banner that identifies them bears the Aztec symbol.

It is somewhat more difficult to explain the presence of the eagle on the prickly pear cactus in Christian buildings, such as sixteenth-century Augustinian and Franciscan monasteries. It appeared at the first Franciscan monastery in Mexico City, as well as at those of Tecamachalco and Calpan,

Figure 11. The founding of Tenochtitlan, from *Codex Durán*.

Figure 12. The founding of Tenochtitlan, from the *Map of Tepechpan*.

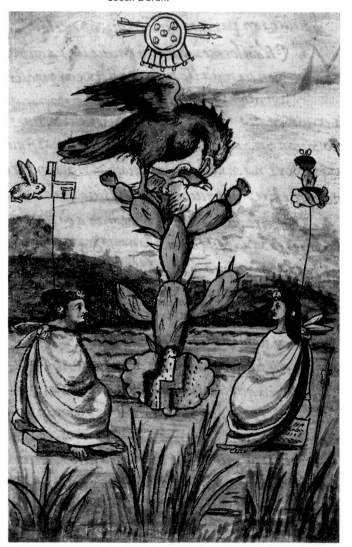

Puebla, at the monastery at Tultitlán and at the temple of Tulpetlac in the State of Mexico. The Augustinians put it in the temple of Yuriria in Michoacán and the Ixmiquilpan fresco in Hidalgo (Figure 13). These depictions of the eagle with the serpent may reflect the monks' interest in attracting the recently conquered indigenous people. It is extremely interesting to note that the image appears on the coat of arms of the second archbishop of Mexico, Alonso de Montúfar, where we see the cactus on a rock. An event of the utmost importance for the adoption of the pre-Hispanic symbol occurred in 1578, when students at Jesuit schools marched through the streets of New Spain's capital carrying placards announcing a literary competition in connection with a gift of relics to Mexico by Pope Gregory XIII. The placard shows an eagle with a serpent in its beak, perched on a prickly pear cactus, as a symbol of Mexico City. From that year onward, the image was used increasingly to represent the city, as we can see in print in the *Ordinances of the Very Noble and Loyal City of Mexico* of 1663, or in the municipal government's seal. In both cases this symbol is superimposed on the castle and lions.

With what we have examined up to this point, we already have two important components: On the one hand, the presence of the Virgin of Guadalupe, and on the other, the ancient symbol of the city of Tenochtitlan in the image of the eagle perched on the prickly pear cactus. The first represents the blending of two female deities in the image of Mary of Guadalupe, who was accepted by the local population and adopted as their own. This later became

Figure 13. Decorative figure of an eagle on a prickly pear cactus, from the walls of the sixteenth-century Christian convent of Yuriria.

a source of unity for the popular uprising against Spanish rule, led by Father Hidalgo in 1810, while the Virgin of Remedies protected the Spaniards. The prickly pear symbol followed a path in which it merged with Spanish elements, and a key moment occurred when the Virgin and the prickly pear came together. This is made clear in Miguel Sánchez's 1648 book on the appearances of the Virgin of Guadalupe, on whose cover the Virgin is shown with the prickly pear cactus and the two-headed Hapsburg eagle behind her. The Virgin and the prickly pear cactus are also joined in eighteenth-century engravings and some paintings. Solange Alberro (1999) has observed: Thanks to this long march, which had begun with Pedro de Gante and culminated with Miguel Sánchez, the prickly pear and eagle of Tenochtitlan had finally merged with the most essential and dynamic symbols of Christianity: the cross and Christ's blood in his Passion in reference to the idolatrous prickly pear, while the Virgin Mary in her manifestation of Guadalupe had drawn the Mexica eagle, the Hapsburg eagle, and the eagle seen by St. John on the Isle of Patmos into her person. Thereafter, the old pre-Hispanic portent was completely and definitively rehabilitated, and hence, it became available for future symbolic needs. Those symbolic needs did not take very long to materialize (Matos Moctezuma 2004).

THE INDEPENDENCE MOVEMENT . . . OR THE WAR OF THE VIRGINS

With Hidalgo's revolt of 1810, the struggle against Spanish power got under way. The Virgin of Remedies was the patroness of the royalist army, "the emblem of the royalist party during the wars of independence," as Jacques Lafaye (2002) observes, while the Virgin of Guadalupe was the patroness of the insurgent army (Figure 14). The victorious insurgent army marched into Mexico City on September 21, 1821, carrying the banner of the Three Safeguards, consisting of three diagonal bands in green, white, and red. Soon it was replaced by the flag that has remained up to the present, on which we have the same colors but arranged in vertical bands with the white in the middle as the symbol of the Catholic religion. On it is the image of the eagle perched on the prickly pear cactus, devouring a serpent (Figure 15). This poses the question: Why was the Virgin

Figure 14.
The standard of
Miguel Hidalgo.

Figure 15. The current flag of Mexico.

of Guadalupe, emblem of the insurgent army, not placed in the white band, which signifies the purity of the Catholic religion? Why did the ancient pre-Hispanic symbol prevail?

During the war of independence it was deemed necessary to appeal to the precedent of pre-Hispanic Mexico, which was a strong, united nation until the Spanish conquest brought tragedy to the peoples of ancient Mesoamerica. We see this concept in the speech Father José María Morelos addressed to the people of Mexico at the Congress of Chilpancingo, where he declared that the Catholic religion would be the only one and the Virgin of Guadalupe was taken as the patroness of Mexican freedom. The speech described the country as having been usurped by the Spaniards, and an interesting passage is the one in which Morelos makes reference to ancient Mexico (Matos Moctezuma 2004):

> Spirits of Moctehuzoma, of Cacamatzin, of Cuauhtimotzin, of Xicoténcatl, and of Catzonzi, celebrate, as you celebrated the *mitote* dance in which you were overcome by the treachery of Alvarado, this happy instant in which your children have come together to avenge the injustices and outrages, and throw off the claws of tyranny and fanaticism they were expected to endure forever! August 12, 1521, has been succeeded by September 14, 1813. Then, the chains of our servitude were brought forth in Mexico-Tenochtitlan; now, they are broken forever in the fortunate town of Chilpancingo.

The war of independence thus attempted to find the umbilical cord tying it to pre-Hispanic Mexico, which had been broken by three hundred years of Spanish colonialism. As David Brading has said in his book *Orbe Indiano*, "Hidalgo and Cuauhtemoc were thus united in the common struggle against the Spanish enemy."

INDEPENDENT MEXICO . . . OR HUITZILOPOCHTLI'S REVENGE

Once independence had been achieved, we see a variety of acts to revitalize the presence of pre-Hispanic Mexico. One of these was the order to disinter the monumental sculpture of Coatlicue and set it up in a corner of the corridors that surrounded the university's patio. Another significant act along these lines was the order for the creation of a museum in which archaeological objects would be kept, pursuant to the decree signed by President Guadalupe Victoria (his real name was Miguel Fernández Félix, but he took the name Guadalupe in honor of the Virgin) in his capacity as Mexico's first president, in 1825:

> His Excellency the President of the Republic has resolved that a National Museum shall be created with the antiquities brought from the Isla de Sacrificios and others existing in this capital city, and one of the University's rooms is assigned to that end, with the supreme Government paying the necessary expenses for showcases, locks, custody of the museum, etc. To this end His Excellency wishes you to designate the room which may be used for this purpose of national use and pride. (Castillo Ledón 1924)

Still another act occurred when the need to reprint Antonio de León y Gama's book about the discovery of the Coatlicue monument and the Aztec Sun Stone was realized. That was done in 1832, on orders from the Secretary of State and Relations, since the book was viewed as "a golden key with which to open up the coffer in which so many secrets, and secrets well worth knowing, have been shut up" (de León y Gama 1990).

Of course, the best example of the relationship with the pre-Hispanic world is the fact that both the country's flag and its national seal bear the ancient Aztec symbol of the eagle and the serpent at their center.

THE MEXICAN REVOLUTION . . . OR MEXICO DISCOVERS ITSELF

The first shots announcing the beginning of the Mexican Revolution were fired on November 20, 1910. The factors that led to the armed uprising, which brought innumerable consequences for the country, are quite well known. The Porfirio Díaz government fell and the aging general sailed from the port of Veracruz for Europe, never to return. But opposing factions fought among themselves for control of the nation, which found itself caught up in a constant succession of uprisings led by other military leaders. Emiliano Zapata in the south, Francisco Villa in the north, Venustiano Carranza, and Alvaro Obregón—to mention only a few—all tried to implant their

ideas, and the armed conflict went on, encompassing every part of the country. It was only in 1917 that the Political Constitution of the United Mexican States was adopted, prescribing the basic principles on which the country would organize itself from that time on. Zapata's struggle on behalf of the peasants demanding land and liberty was not waged in vain, and neither were the workers' struggles, because the new Constitution included two unprecedented sections: That of agrarian rights and that of workers' rights, conceived as collective and not individual. In any case, the armed conflict also focused attention on pre-Hispanic Mexico, and there was a re-discovery of the indigenous peoples and their traditional values. This had a powerful impact on the country's intellectual climate, and its results soon became apparent: Anthropology arose as a way to understand ancient Mexico and the enormous indigenous peasant population, with the aim of improving the latter's living conditions.

Manuel Gamio introduced interdisciplinary studies with his *Population of the Teotihuacán Valley* project, which investigated pre-Hispanic, colonial, and modern Teotihuacán, the entire effort being intended to benefit the modern population. His work was considered a model of dynamic anthropology with practical implications. Among the many opinions that were expressed about his work, we call attention to that of Dr. A. V. Kidder, the director of the Peabody Museum of Andover, Massachusetts:

> Nothing like this notable work has been done before: This work will contribute to disseminating to all and giving a sociological application to a science that has been abstract and impractical. (Matos Moctezuma 2003)

THE MEANING OF AZTEC IN TODAY'S MEXICO

In this way, and under the stimulus of the recently ended revolution, attention turned toward the most underprivileged part of the population. Painters, composers, writers, and many other artists also "discovered" indigenous and peasant cultures and incorporated such cultures into their works. Good examples of this trend are the mural art of Rivera, Orozco, and Siqueiros; the nationalistic music of Juan Pablo Moncayo, Silvestre Revueltas, and Carlos Chávez; the novels of the revolution and those with a rural setting such as *El llano en llamas* [The Burning Plain] by Juan Rulfo, and many more. Many years would have to pass before urban and other themes would appear in the national literature.

Now, then, what remains of the pre-Hispanic Aztec civilization in today's Mexico? I will not talk about rural society in central Mexico, areas where many concepts and modes of living are still present even though blended with Christianity and other elements of European culture that accompanied Spanish conquest. I will instead focus on Mexico City, where millions of people live their daily lives and, without realizing it, carry their cultural heritage, which is an important part of modern Mexicans.

The language that was spoken by the Aztecs, Nahuatl, leaves its impression everywhere. Many places in Mexico City, as well as neighborhoods, streets, etc. still retain the names given them in the pre-Hispanic period. Azcapotzalco, Tlalpan, Coyoacán, Iztapalapa, Tepeyac, Tlatelolco, and

Figure 16. Glyph of Coyoacan.

Figure 17. Glyph of Tepeyac.

Figure 18. Glyph of Tlalpan.

Figure 19. Glyph of Tlatelolco.

Chapultepec are the names of ancient cities, which survived in the same places where those cities once stood (Figures 16–19). Places in the city such as Tacubaya, Tacuba, Tlatelolco, Popotla, and Mexicaltzingo still persist, and what can we say about Churubusco, a word derived from the name of the god Huitzilopochtli? To all these we can also add common words that are heard all the time, such as mecate (*mécatl,* cord or rope); cuate, or friend, which comes from *coátl* (serpent, twin); mole (*molli,* a sauce made of multiple kinds of chilies and chocolate); atole (*atolli,* a corn-based drink); tomate (*tomatl,* tomato); milpa (*milli,* agricultural field); tamal (*tamalli,* a steamed cornmeal dumpling wrapped in corn husks); and hundreds more words of which the preceding are just a few examples. We also have words that have traveled beyond national boundaries to become internationally used, such as chocolate (*chocolatl,* a food made from cacao beans). The Nahuatl language is still heard in some parts of the capital of the republic, and there is a legitimate pride among the people who speak it, such as the residents of the town of Milpa Alta.

We also see other expressions that carry us back to the pre-Hispanic world. One of them is the subject of death, celebrated with skull-shaped breads and skeleton figures on the Day of the Dead, which we regard as reminiscent of the pre-Hispanic past when what we are really seeing is a syncretism between the indigenous and the Spanish. However, all of Mexico identifies so completely with the Aztecs that when reference is made to the president of the republic, he is often described as "the Aztec leader." Our national soccer team is frequently called the "Aztec team."

When we discovered the Aztec Great Temple there were more than a few visitors who said to us: "Why don't you continue digging beneath the cathedral?" I answered that we could not remove it because the cathedral is also a part of our cultural heritage. To this, people replied: "No, professor, this one is ours," referring to the vestiges of the Great Temple.

In 1981 an exhibition of the objects found in our digs was held at the Palacio de Bellas Artes. A stone sculpture of the god Xiuhtecuhtli was shown, and one day a village woman came and knelt before the god and placed a bouquet of flowers at his feet. She crossed herself and said, "you have suffered a great deal, but now you are here." Another day, while visitors were coming in to see the monolith of the goddess Coyolxauhqui, a young man placed a flower on the sculpture.

In connection with the excavation of the Aztec Great Temple, bills and coins were issued with the images of several pieces found in it. Today, there are postage stamps bearing these figures. Cases like these tell us of the impact the ancient world continues to have on today's Mexico. The national indigenous hero is Cuauhtemoc, "the only hero worthy of art," as the poet López Velarde said. But we see one of the best examples of present-day "Aztec-ism" at the National Museum of Anthropology. Its central room is devoted to Aztec culture and the Calendar or Sun Stone occupies the place of honor, on something akin to an altar (Figure 20).

But the most significant thing in all this is the presence of the national symbols on the coat of arms and flag, to which reference has been made repeatedly. They have brought an entire people to identify itself under the symbol of Huitzilopochtli. The Aztecs would be proud to know that the symbol of their city and their patron god would live on centuries later, as the symbol of a nation.

Figure 20. The Aztec Sun Stone in the center of the Hall of the Mexicas, National Museum of Anthropology, Mexico City.

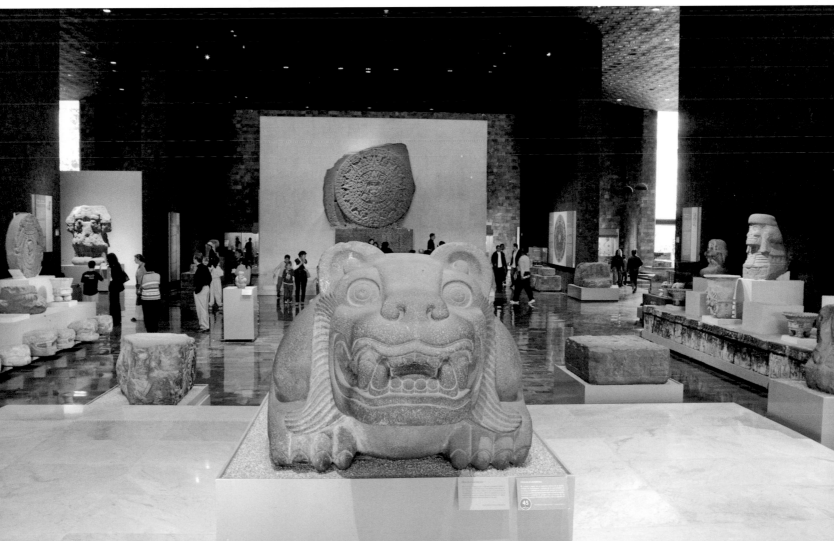

REFERENCES

Alberro, Solange. 1999. *El Aguila y la Cruz* [*The Eagle and the Cross*]. FCE-El. Colegio de México, Mexico City.

Brading, David. 1998. *Orbe Indiano* ["The Realm of the Indigenous"], Mexico City: FCE.

————. 1999. Castillo Ledón, Luis. 1924. *El Museo Nacional de Arqueología, Historia y Etnografía* [The National Archeology, History, and Ethnography Museum], Mexico City.

De la Peña, Francisco. 2002. *Los hijos del Sexto Sol* [*The Children of the Sixth Sun*], Colección Científica No. 444, INAH, Mexico City.

De León y Gama, Anotnio. 1990. *Descripción histórica y cronológica de las dos piedras*. [Historic and Chronological Description of the Two Stones], INAH, Mexico City.

Díaz del Castillo, Bernal. 1943. *Historia verdadera de la conquista de la Nueva España* [The True Story of the Conquest of New Spain], 2 vols. Mexico City: Editorial Nuevo Mundo.

Lafaye, Jacques. 2002. *Quetzalcoátl y Guadalupe* [Quetzalcoátl and Guadalupe], Mexico City: FCE.

Matos Moctezuma, Eduardo. 2003. *Las piedras negadas* [The Negated Stones]. Mexico City: CONACULTA

————. 2004. "Los símbolos prehispánicos y la identidad nacional" [Pre-Hispanic Symbols and National Identity] in *IX Coloquio sobre la Cultura Mexicana, Memoria*. Seminario de Cultura Mexicana, Mexico City.

Motolinia, Fray Toribio de Benavente. 1971. *Memoriales* [Memoir], Universidad Nacional Autónoma de México.

THIRTEEN

IMAGINING A PLACE FOR AZTLAN:

Chicanismo and the Aztecs in Art and Resistance

DAVÍD CARRASCO,
HARVARD DIVINITY SCHOOL

I want to reflect on the ways that Mexican-American artists and intellectuals have imagined a place for Aztlan, the symbolic homeland of the ancient Aztecs, in their constructions of a Chicano identity in the United States. Remembering the deep power that symbols of space and time have had in human culture, I want to illustrate how the indigenous, mythic place of Aztlan has been recalled to life through Chicano arts, politics and imaginations. We will see that Moctezuma's Mexico of the early sixteenth century continues to have a strong hold in the art and imagery of Mexican Americans in the contemporary United States. As Chicano author Rafael Pérez-Torres (1995:5) writes, Aztlan has been "a central image in the intellectual and social thought of Chicano/as."

I will discuss this social thought and artistic expression in three phases. First, I will present an overview of the contested presence of Mexicans in the United States to help readers understand how an exclusionary, xenophobic American mythology that favors an East Coast to West/Frontier worldview sets the stage, in part, for imagining Aztlan as a U.S. story. It creates the perceived need for some Mexicans and Mexican Americans to identify an alternative, indigenous-based narrative of foundations and identity. Second, I will present a summary of "Chicanismo" (Cuellar 2001) and some examples of its origins, its political expression, and its search for Aztlan. As we shall see, Chicanismo uses the place and myth of Aztlan as a means of articulating a political cry for social, educational, and agricultural justice in the United States and to provide a creative

"reversal" of perspective on the religious and political lineages for inhabitants of the southwestern United States. Third, I will show examples of Chicano art that manifest Chicanismo's uses of Aztec imagery in relation to three themes: the sacred plants of foundations and origins, death skulls and skeletons as expressions of Mexican-American suffering, and the sacred mother who protects, nurtures, and inspires Mexican Americans.

THE CONTESTED PRESENCE OF MEXICANS IN THE UNITED STATES

In order to understand why some Mexican Americans turn to Aztec, Maya, Toltec, and other indigenous traditions to shape their aesthetic expressions and identity politics in the United States, it is helpful to consider the following contexts and historical trends. Despite having contributed so much to the culture and economy, Mexican Americans and other Latinos still struggle to find stable and safe economic, political, and spiritual places within U.S. borders. Generations and generations of hard-working Mexican families have assimilated to U.S. culture; learned English; enriched culture; strived in schools; fought in wars; worked as *criadas,* maids and nannies to Anglo children; and produced an effective professional class of physicians, teachers, ministers, and scientists yet still Mexicans and people of Mexican descent are often considered a drain on U.S. health and financial systems and threats to legal order, civil society, and the democratic process. As with many minority histories, mainstream American culture remains largely and somewhat intentionally unaware of the relevant facts, such as in 1848 nearly half of Mexico was ceded to the United States as part of the Treaty of Guadalupe Hidalgo but the majority of Mexican "citizens" remained in the northern territories to work and continue living in a familiar landscape. One in eight Mexican citizens came into the United States during the Mexican Revolution of 1910–1920 and, like my grandfather Miguel Carrasco, worked diligently to learn trades, speak English, and practice Anglo customs while at the same time speaking Spanish and practicing, to various degrees, Mexican cultural activities.

To further understand the use of indigenous and Mexican national symbols in the artistic expressions and politics of Mexican Americans, it is crucial to recognize that over the past twenty years and into the unforeseen future, the United States is undergoing the largest wave of immigration in its history and by far the largest percentage of immigrants are from Latin America, most from Mexico (Paez and Suarez Orozco 2002). In the 2000 census, more than 35.5 million people in the United States were identified as Latinos, and two thirds of those are foreign-born. Many of these Latinos are working, speaking Spanish *and* English (a growing number speak various indigenous languages), struggling to adapt to U.S. political culture, and sending significant percentages of their earnings to their families back in Latin America as remittances (Olmos and Ibarra 1999). Which is to say that there is an expanding borderlands between the United States and Mexico that is defined not primarily by geography but by the places where Latinos live, work, and seek their well-being while at the same time remaining oriented, in part, toward their original homes. As social scientists will attest, migrants from all countries remember, talk, and identify to some degree with the places they come from.

While many citizens and institutions in the United States welcome and cooperate with (and also benefit from) this long-term Latino presence, it is also clear that Mexican immigration in particular is perceived as a threat to the national Anglo-Saxon myth of foundations, purity, and English and Protestant attitudes. In general terms, the Latino presence, what I sometimes call the "Brown Millennium" (Carrasco 2000), challenges the East-West orientation of political mythology in the United States, which finds its most comfortable home in secondary-school curriculums and college courses. According to this curricular orientation, the story of human culture and civilization moves on an East to West axis, starting in Rome or Greece, moving to northern Europe, and then across the Atlantic. This narrative continues with the arrival of Pilgrims at Plymouth Rock, the triumphal story of the 13 colonies and the American Revolution and the Louisiana Purchase of the Jeffersonians. It stops briefly at the Mexican-American War, then elevates and is mesmerized by the Civil War and in some cases the history of slavery. It then dwells on the rise of the great industrialists, especially in the eastern half of the United States and celebrates the emergence of the United States as "the greatest and most powerful nation in the world." However, new scholarly orientations including cultural studies, area studies, and postcolonial studies along with the stunning data about the millions of immigrants moving back and forth from Latin America in the North-South direction reveal a different historical axis, subverting the East-West story. The American story is as much a South to North story as an East to West story.

One of the social movements that enables this new story to take substance in curriculums, politics, and museums was the Chicano movement that began as a combination of field workers, teachers, college students, church people and artists who recognized that they could not find "our story, our identity or our places" in the East-West Anglo-Saxon mythology. In response, many of these activists looked for alternative narratives from within their own families and regional histories. Given the social atmosphere of political and legal discrimination against Mexicans since the seventeenth century, the Chicano movement of the 1960s was drawn to indigenous and national Mexican emblems, stories, places, and heroes. Especially attractive was the story of Aztlan, which told of "Chicomoztoc," The Place of Seven Caves, located in an original homeland north of central Mexico. The story is that the Mexica ancestors were inspired by their patron deity to leave Chicomoztoc and travel south on a long and arduous pilgrimage in search of a new homeland. Led by Huitzilopochtli, the Southern Hummingbird god, they eventually arrived in the Valley of Mexico, where their god appeared to them in the form of a giant eagle landing on a blooming cactus in the middle of the lake of Mexico (see Chapters 1, 10, and 12). One image of the emergence from Aztlan appears in the sixteenth-century document *Historia Tolteca Chichimeca* where a hill is depicted with seven caves in which the original ancestors dwelled before leaving on their sacred journey in search of a new city (see Chapter 1, Figure 1). The Chicano movement recognized a powerful connection between this story of origin in the earth and the tremendous labor efforts Mexican *campesinos* were making in the earth and agricultural fields of the southwestern United States. This profound connection between Aztlan and the sufferings and labors of Mexicans gave birth, in part, to the Chicano movement and Chicanismo. Chicanos began to think of the agricultural fields and social communities where Mexicans resided in the southwestern United States as the site of the original Aztlan.

CHICANISMO AND THE SEARCH FOR AZTLAN

Chicanismo was born as an organized political movement at the National Chicano Youth Liberation Conference organized by Rodolfo "Corky" Gonzalez of the Denver Crusade for Justice in 1969. Its central philosophy was articulated in the "El Plan Espiritual de Aztlán." The opening lines declare:

> We, the Chicano inhabitants and civilizers of the northern land of Aztlan from whence came our forefathers, reclaiming the land of their birth and consecrating the determination of our people' of the sun, *declare* that the call of our blood is our power, our responsibility and our inevitable destiny.

These lines show the reworking of Aztec sacred history in several ways. First, Chicanos are descendents of the ancestors who left Aztlan, which is a northern territory. Subsequently, they became the people of the sun (the title of a book about the Aztecs by Mexico's Alfonso Caso) who, because of a "call" in the blood, have an inevitable destiny. If there is one dimension of the human body associated with the Mexicas it's surely blood, because the Aztecs believed that prodigious supernatural powers resided in human and animal blood. Further, Aztec theology is reflected in the claim of "inevitable destiny," which refers to the cosmic renewal found in the Aztec stories about inevitable patterns of birth-stability-collapse and rebirth of the universe.

Central to this vision is the lineage that Chicanos claim goes back to the "northern land of Aztlan," the place of emergence of the Aztec ancestors. For Chicanos, that northern land is not Guanajuato or Zacatecas but Arizona, New Mexico, California, and Texas. This Aztec place of origins, imagined to be somewhere near San Diego, Phoenix, El Paso, San Antonio, and Los Angeles, was key to the construction and articulation of a common framework for Mexican-American political identity, which depended in part on the adoption of indigenous Mesoamerican imagery.

Since the publication of El Plan Espiritual de Aztlán, many Mexican Americans have embraced the symbol of Aztlan as expressing something integral to being Chicano in the United States. Rafael Pérez Torres (1997:15) writes skillfully about this embrace of Aztlan, saying, "One image central to Chicano/Chicana intellectual and social thought has been the figure of Aztlan." And in a beautifully illustrated book, *The Road to Aztlan: Art from a Mythic Homeland*, editors Fields and Zamudio-Taylor (2001:64) claim that "Aztlan—as symbol, as allegory, and as real and invented tradition—served as a cultural and spiritual framework that gave Chicanos a sense of belonging and a link to a rich and extensive history . . . ethos and foundation." As a historian of religions I am struck by the similarity of this language with the religious category of a "cosmovision," because it communicates aspects of a worldview and shows how the Chicano movement attempted to stimulate a deep cultural renovation of Mexican indigenous mythology and places for its contemporary political struggle.

Fields and Zamudio Taylor (2001) discuss how Aztlan has evolved from a symbol of a single mythic center into multiple symbols of many centers. On the one hand they "deterritorialize": Aztlan is not a specific historical location but a huge geographical area where objects, ideas,

and meanings traveled; were exchanged over enormous distances and punishing terrain, giving meaning and power to diverse communities (see Vélez-Ibáñez 1996) (Figure 1). Shared symbolism of wind, goggle-eyed and feathered serpent gods, copper bells, travel, and *mestizaje* establish that a complex network of communication and exchange linked Central Mexico with the area now known as the American Southwest for centuries before the Spaniards came. Along this network traveled objects of trade and ritual, including animals, art, and religious symbolism, thus providing us with an expansive sense of the territory of Aztlan. But Aztlan is also "re-territorialized" in a series of specific Chicano locations where artworks in various Chicano and other communities show that there are multiple but specific Mexican American homelands. Chon Noriega asserts that Aztlan "refers to all those places where there is a strong Mexican and Chicano/a cultural presence."

Today, Aztlan is used as a name for community centers, parks, and nicknames wherever Mexican Americans live. As a graduate student at the University of Chicago, I was involved in the transformation of a Presbyterian-church-controlled community center called Howell House (in the Mexican-American barrio known as Pilsen) into a service and educational center named Casa Aztlan. Changing the name Howell House to Casa Aztlan meant a commitment to serve the daily needs of the Mexican people for jobs, education, bilingualism, and art. One of the first acts of claiming this space was the commissioning of a Chicano muralist, Raymundo Patlan, to paint large murals around the interior of the main meeting hall. Patlan synthesized the styles of Diego Rivera and Davíd Alfaro Siqueiros with his own evolving art to depict farmworkers in struggle, Aztec warriors in battle, and the landscape of Mexico and the southwest. Today, Casa Aztlan is still functioning, and the murals have spread outside the building to include images of Quetzalcoatl the Feathered Serpent and other Mesoamerican gods and symbols (Pérez-Torres 1997).

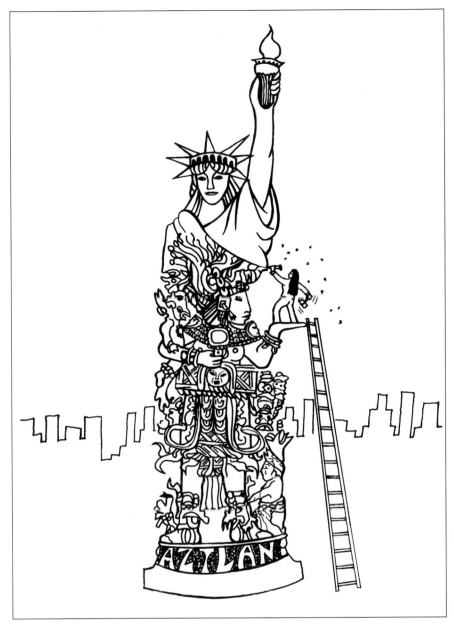

Figure 1. "Libertad", 1976, by Ester Hernandez. The renowned Chicana artist produced this transformed image of the Statue of Liberty while a student at the University of California–Berkeley. It expresses the indigenous roots of the Americas in the form of a Latina recarving Lady Liberty as a Maya *stela*.

Chicano inventions of Aztec traditions are well summarized by Victor Zamudio-Taylor (2001). We are told that Chicanos reinvented the Aztecs in order to formulate their own tradition "to suit contemporary political issues as well as the fashioning of diverse cultural identities that characterize the heterogeneity of the Chicano/a experience" (Zamudio-Taylor 2001:342). The challenge of translating Aztec and Mexican images of Aztec life into Chicano barrios and art workshops was accomplished through the "blurring and defiance of hierarchical boundaries with respect to 'popular,' 'vernacular,' and 'high' culture" (Zamudio-Taylor 2001:343). Concerned about the artistic merit of some Chicano art and its uses of Mesoamerican images, symbols, and gods, the author notes how Chicanismo, the ideology of Chicano/a nationalism, depended heavily on an exaltation of the indigenous past. This exaltation was, in part, an assertion of difference from Anglo values and a critique of Anglo-American erasures of indigenous aspects of Mexican-American life.

CHICANO USES OF AZTEC IMAGERY

In this section I will discuss examples of Chicano art that use Aztec imagery in relation to three themes that have significance in the everyday life of Latinos: the sacred plants of foundations and origins, which relate to the foods, healing practices, and enjoyment of natural beauty in families; death skulls and skeletons relating to expressions of Mexican American suffering; and the sacred mother who protects, nurtures, and inspires Mexican Americans relating to the devotions Latinos express toward family, church, and the various forms that the Virgin Mary takes in their communities.

THE SACRED PLANTS OF ORIGIN

One of the most attractive Aztec motifs for Chicano artists has been the sacred earth and especially the sacred plants of origin. The prototype plant is of course the blooming nopal upon which the eagle, representing the god of the wandering Mexica, lands with its wings outspread marking the site of their new home. The blooming nopal has become an emblem of not only Mexican national identity through its location on the Mexican flag but also a cue for Chicano artists who utilize a number of Mexican plants and fruits as markers of their own sense of origins.

One reason for this attention to plants is the strong farmworker tradition among Mexican Americans. Another is the deep appreciation and knowledge about these plants and their usage in cuisine and healing practices. We see a complex example of the Chicano/a use of the sacred plant of origins in the most powerful essay in *Road to Aztlan*, which is Constance Cortez's "The New Aztlan: *Nepantla* (and Other Sides of Transmogrification)." Utilizing the Aztec term "nepantla," which means middle place or place of passage and reciprocity, Cortez argues for what she calls "nepantla art," which reflects intracultural diversity and personal visions. Nepantla art demonstrates bold new combinations of motifs, colors, places, and time periods, reflecting (though Cortez doesn't say this) the indigenous notion of divine coessences in Aztec cosmology.[1] One of the most attractive nepantla art pieces is Santa C. Barraza's "Nepantla", which highlights the power of sacred origins and is best interpreted by Cortez (Figure 2).

[1] A clear description of indigenous views of "coessences" of gods, humans, and animals is found in Alfredo López Austin's *Tamoanchan/Tlalocan: Places of Mist,* 1997:123–90.

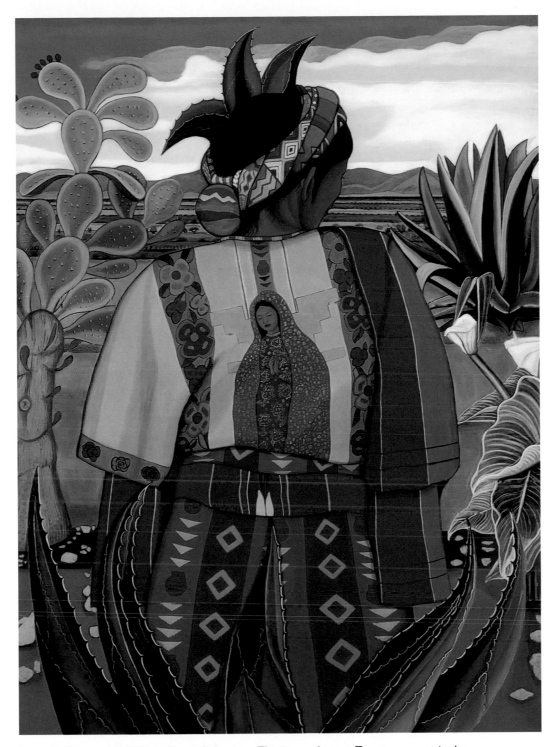

Figure 2. "Nepantla", 1995, by Santa C. Barraza. This image shows a Zapotec woman in the landscape of Oaxaca with a maguey plant emerging from her head. The artist combines indigenous clothing (the huipil), the Catholic Virgin of Guadalupe, and the powerful presence of this ancient plant to illustrate the cultural and social "middle place" that Indians and Chicanos inhabit.

In a color-saturated canvas . . . the artist situates *nepantla* in the river valleys of Oaxaca. The image of the Virgin of Guadalupe is integrated into the weave of a Zapotec woman's *huipil*, or skirt. That the woman is part of the land is indicated by the maguey plant that emerges from her head and by the plant from which she seemingly grows. Here the ancient plant represents

not only geographic affiliation but also life force. The reconciliation of two distinct traditions is the subject of the work. We are invited to join the woman as she gazes at the distant mountains, the place where the ancient ancestors are said to reside. These ancestors intervene in the life of individuals and bring the life-giving rain that nourishes the crops . . . at the same time, the Virgin of Guadalupe, the product of a colonial past, is also part of the woman. The Virgin literally guards her back, an appropriate position given her modern universal association with resistance and the struggle of *campesinos* everywhere. The linkage between the Madonna and politics is indicated by a faint *huelga* eagle just behind the icon. This is the eagle associated with the struggle of the United Farm Workers in the United States. (Cortez 2001:367–68)

Cortez tells us that this image is *not* an invocation of the usual notion of Aztlan but rather a discursive move to invite us to become part of the new Aztlan that is the process of being in

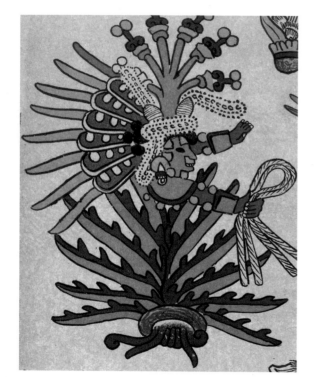

Figure 3. Mayahuel, goddess of the maguey, as depicted in the native manuscript *Codex Borbonicus*.

nepantla. And the entire scene depends on the sacred plant of origins that gives life to the woman in the center of the scene (Figure 3).

Another example of the sacred plant of origins appears in a depiction of the origin of the Mexican Revolution, or at least one part of "Zapata con Maguey, 1991" by Santa C. Barraza (Figure 4). The image shows the Mexican hero-revolutionary Emiliano Zapata emerging from a desert maguey plant indicating the Chicano view that at least the southern Mexican Revolution of 1910 was generated by Mexican agricultural interests expressed in the famous "Plan de Ayala." Below the maguey plant deep in the earth is a huge oval seed containing a back view of a woman huddled into a fetal position, suggesting that the sacred plant of the origin of the Mexican Revolution emerges from the female seed in the earth.

Mexican-American artists, especially those nurtured by Chicanismo, sometimes critique the ways that agricultural work, workers, and the plants themselves have been endangered by pesticides and the profit-oriented agricultural industry. For instance, Ester Hernandez creates a triptych (Figure 5) that transforms the famous, cheerful "Sun-Maid Raisin" beauty into an image of death and poison. We see not a Sun-Maid Raisin but a "Sun Mad Raisins" image of a woman *calavera*, resonating with the Aztec calavera or skulls, surrounded by a solar disk reminiscent of both the religious image of the corona of the Virgin of Guadalupe and the Aztec Sun Stone. In this image, the sacred plants of origin are sources of danger, disease, and death.

THE THEME OF DEATH AND SUFFERING

Mexican Americans have undergone much needless tragedy, suffering, and unprovoked violence in the United States. Some artists show an awareness and lament that elements of the suffering and violence in Mexican-American communities are acted out by Mexican Americans themselves. In

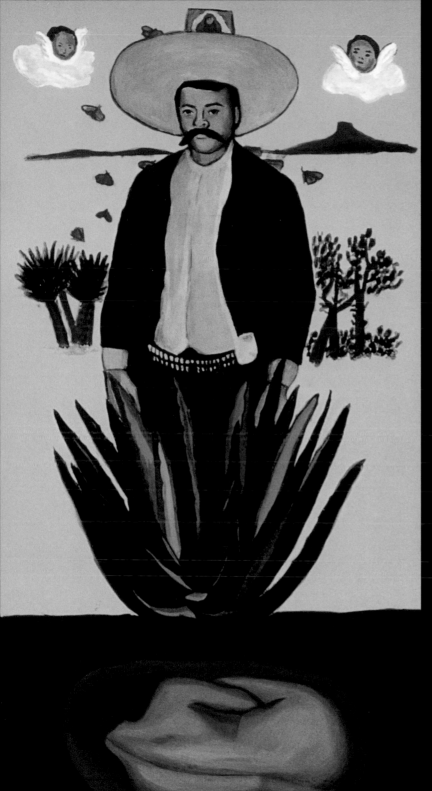

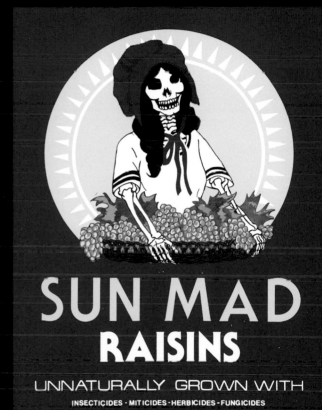

Figure 5. "Sun Mad", 1981, by Ester Hernandez. The artist transforms the cheerful "Sun-Maid Raisin" beauty into an image of death and poison in the agricultural fields of the United States. She uses a solar disk image in the background as a hybrid expression of the corona of the Virgin of Guadalupe and the Aztec Sun Stone.

Figure 4. "Zapata", 1991, by Santa C. Barraza. Emiliano Zapata emerging from a desert plant.

searching for images to reflect the community's suffering, artists and activists have often turned to Aztec and Maya depictions of skulls and skeletons (Figure 6). Nowhere is this clearer than in the luscious art of George Yepes, whose paintings often include Mexican Americans in the forms of skulls with sad, penetrating eyes, skeleton-like features coursing through bodies or deathly white color covering the bodies of otherwise living people. Yepes's most famous calavera piece, "La Pistola y el Corazon," appeared on the jacket of the Los Lobos CD of the same name (Figure 7). It depicts a couple in full body profiles gazing into each other's faces while the male has a huge beating red heart and the female is carrying a large red pistol in her hands. Their elegant clothes, drawing on Mexican fashion, mix with skeletal features that also show traces of marrow and blood. Yepes was able to communicate a combination of death, sensuality, and sexuality in this widely distributed and purchased depiction of Chicano life. Yepes also has a stunning self-portrait in the form of a large skull with his own penetrating and anguished and angry eyes glaring at the viewer. Yepes has said that this image and other calavera-inspired pieces draw in part on Aztec death images and reflect his youthful experiences with gangs and gang warfare that resulted in the murders and wounding of a number of his friends and other gang members in Los Angeles. One of the original twists that Yepes gives to Chicano death imagery appears in a painting he entitled "Adelitas." It is reminiscent of the women who played important supportive roles in the Mexican Revolution of 1910 and who were knows as Adelitas and memorialized in a famous song by the name of "Adelita." Yepes paints an attractive woman in a black, low-cut dress with

BELOW: Figure 6. Cuauhxicalli (stone container for sacrificial offering).

OPPOSITE: Figure 7. "La Pistola", 1988, by George Yepes.

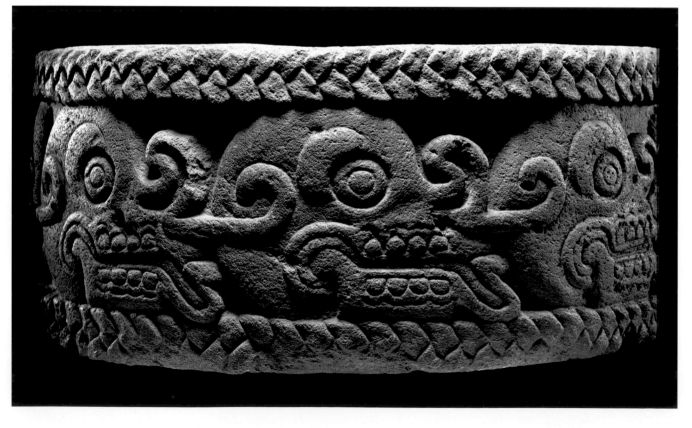

her arms crossed, each hand holding a large red pistol. Her skin is a pasty white color representing the skeletal color of death and the idea that this woman is somehow possessed by a combination of death and beauty and capable of alluring one to a confrontation with her guns. Yepes once remarked, "Copies of this painting have sold well and especially among women lawyers."

Perhaps the most moving and complex example of a Mexican-American artist drawing on the Aztec skull motif appears in Octavio Ocampo's expansive image of the farmworker movement organized and symbolized by Cesar Chavez (Figure 8). Ocampo's painting depicts a huge image of Cesar Chavez's upper body and head surrounded on one side by an outdoor scene of agricultural workers in the forms of rows of skulls with gaping eyes while on the other side of Chavez appears a huge march of protesters representing the United Farm Workers Movement, which used the terms "La Huelga" and "La Causa" to express its commitments. But when the viewer looks more closely at the rows of skulls sitting in the agricultural fields, one gradually notices that each skull is made up not of real skulls but human beings in various tortured postures of labor and suffering, for instance two sisters picking in the fields or a mother embracing her children in gestures of protection, or a man carrying a shot coworker, and so on. Each skull is actually several farmworkers dressed in white and bent over with great weight or in the throes of death. In this picture, Mexican-American farmworker deaths take on deeper power through the artist's use of the traditions of Aztec skulls and Mexican festivals such as El Día de los Muertos.

SEARCH FOR THE SACRED MOTHER

In the early days of the Chicano movement that articulated its plans through the Plan Espiritual de Aztlan, most if not all commentators on the Aztlan traditions ignored one major aspect—namely the central role of the sacred mother. For instance, in Diego Durán's invaluable sixteenth-century account of Moctezuma's sending out his magicians to find Aztlan, the central goal of the search is to find the sacred mother of Huitzilopochtli and communicate with her (Durán 1993). This account was one of the several sources for the use of Aztlan by Chicanos but (perhaps because males dominated the early movement) the role of the sacred mother in the myth was ignored. As more and more women, and especially female artists, have expressed their visions of Chicano history, religion, soul, and existence, the theme of the sacred mother in Aztlan has become a major expression. One outstanding example that links the death theme to the theme of the sacred mother appears in "La Malinche," by Santa C. Barraza. Barraza depicts the indigenous woman translator/mistress of Cortés emerging from a maguey plant with the image of the first mestizo baby emerging from a cut in her breast (Figure 9). The redheaded blue-eyed image of a disheveled Hernán Cortés lurks to one side. In the background we see an Indian hanging in a grotesque shape from a tree in front of a Christian priest. The message seems to be that Malinche is our mother, our generator who came out of the sacred plant and earth of pre-Hispanic Mexico and was torn from her roots and greatly injured by the Spanish conquistador while Indians were murdered by the church. The image shows the sexual and religious violence that she has suffered and out of this suffering has come the Mexican and Chicano people.

As these examples show, Aztec-oriented Chicano art has resulted in hybrids and reinterpretations of the central Aztec themes of sacred plants, death, and now mothers and goddesses. One church.

Figure 8. "Retrato de César Chávez" by Octavio Ocampo. One example of Aztlan's importance to Chicano scholarship can be seen in this cover image of the thirtieth- anniversary publication of the journal *Aztlan*. This is the leading Mexican-American academic journal in the United States and has been publishing significant social scientific and humanistic research since the 1970s.

Figure 9. "La Malinche", 1991, by Santa C. Barraza.

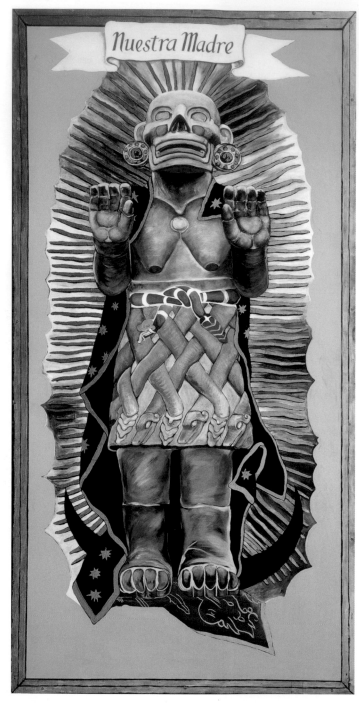

Figure 10. "Nuestra Madre", 1981–1998, by Yolanda Lopez. The central religious Mexican icon, the Virgin of Guadalupe, is replaced with the Mexica deity Coatlicue (the Coatlicue excavated in Coxcatlan, Puebla) on the cloak of Juan Diego. The image says that the social imagery of Chicanos fuses the frightening Coatlicue and the colonial Guadalupe as an expression of a hybrid motherhood.

thought-altering example of this hybridization can be found in Yolanda Lopez's painting "Nuestra Madre" (Figure 10). Lopez has produced a powerful portrait series depicting the Virgin of Guadalupe in different apparitions and guises, representing the diverse powers of the female goddesses in the Mesoamerican world as well as her own powers as an artist to construct divine and human identity. In this image she replaces La Virgen de Guadalupe with the Mexica deity Coatlicue (the Coatlicue excavated in Coxcatlan, Puebla) (Figure 11) on the cloak. There stands the upright, stone image of a bare breasted Lady of the Serpent Skirt, surrounded by the celestial corona and draped with the star-studded cloak of Guadalupe. The words "Nuestra Madre" decorate the corona's peak. Lopez seems to be saying that the sacred mother of the Chicano people is a metaphorical mix of the frightening Coatlicue and the colonial Guadalupe, fusing the two figures and calling attention to their centrality in the Mexica-Mexican–Chicano/a social imaginary.

THE HOPEFUL SKEPTIC OF AZTLAN

The Chicano scholar Rafael Pérez-Torres emphasizes the creative power of a shape-shifting Aztlan now in the hands of a new generation of Chicano/a artists and cultural critics. He claims that Aztlan always names what is absent in Mexican-American existence, and in this openness or emptiness resides a new if not endless potential and capacity to challenge the imagination and language of each generation. In other words, Chicano critical thought has transformed Aztlan from a homeland to a borderland, a shift from a search for origins "toward an engagement with the ever-elusive construction of cultural identity." Since this engagement is so important to Chicanos, Perez-Torres (1997:235) tells us, "We cannot abandon Aztlan, precisely because it serves to name that space of liberation so fondly yearned for. . . . Aztlan is our start and end point of empowerment."

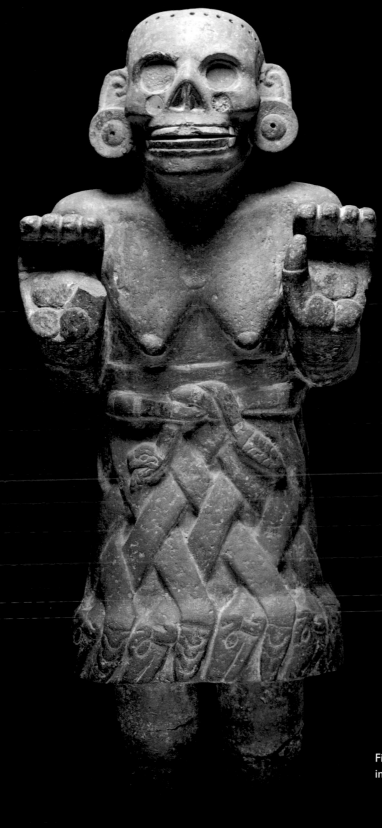

Figure 11. Coatlicue excavated in Coxcatlan, Puebla.

I give the last word to one of the finest scholars of Chicano studies, Luis Leal, whose humanistic insights taught us that the rebirth of the myth of Aztlan among Chicanos was both an affirmation of Aztec ancestry and a political critique against contemporary losses. Leal (1981:22), both kind in heart and wise in mind, respects the searches for the "historical Aztlan" but comes to also recognize the term "spiritual" in the spiritual plan of Aztlan, and writes, "whosoever wants to find Aztlan, let him look for it, not on the maps, but in the most intimate part of his being."

REFERENCES

Carrasco, Davíd. 2000. Introduction to *The Future Is Mestizo* by Virgilio P. Elizondo. Niwot, Colo.: University Press of Colorado.

Cortez, Constance. 2001. The New Aztlan: *Nepantla* (and Other Sides of Transmogrification). In *The Road to Aztlan: Art from a Mythic Homeland*, V. M. Fields and V. Zamudio Taylor, eds. Los Angeles: Los Angeles County Museum of Art, pp. 358–73.

Cuellar, Jose. 2001. Chicanismo. In *Oxford Encyclopedia of Mesoamerican Cultures*, D. Carrasco ed. New York: Oxford University Press, Vol. 1, pp. 180–83.

Durán, Diego. 1993. *History of the Indies of New Spain*, D. Heyden, transl. and ed. Norman: University of Oklahoma Press.

Fields, Virginia M. and Victor Zamudio-Taylor. 2001. Aztlán: Destination and Point of Departure in *The Road to Aztlan: Art from a Mythic Homeland*, V. M. Fields and V. Zamudio-Taylor, eds., Los Angeles: Los Angeles County Museum of Art, pp. 38–77.

Leal, Luis. 1981. In Search of Aztlán, Gladys Leal, transl. *Denver Quarterly* 16 (Fall): 16–22.

Lopez Austin, Alfredo. 1997. *Tamoanchan/Tlalocan: Places of Mist,* Niwot, Colo.: University Press of Colorado.

Olmos, Edward James Lea Ibarra. 1999. *Americanos: Latino Life in the U.S.* New York: Little, Brown.

Paez, Mariela and Marcelo Suarez Orozco, eds. 2002. *Latinos Remaking America*, Cambridge, Mass.: David Rockefeller Center for Latin American Studies, Harvard University.

Pérez-Torres, Rafael. 1995. *Movements in Chicano Poetry.* Cambridge: Cambridge University Press.

———. 1997. Refiguring Aztlán. *Aztlán* 22 (2):13–41.

Vélez-Ibáñez, Carlos G. 1996. *Border Visions: Mexican Cultures of the Southwest United States.* Phoenix: University of Arizona Press.

Zamudio-Taylor, Victor. 2001. "Inventing Tradition, Negotiating Modernism," in *The Road to Aztlan: Art from a Mythic Homeland*, V. M. Fields and V. Zamudio-Taylor, eds., Los Angeles: Los Angeles County Museum of Art, pp. 38–77.

CONTRIBUTORS

Elizabeth Hill Boone
Martha and Donald Robertson Chair in Latin American Art
Tulane University

Elizabeth M. Brumfiel
Professor of Anthropology
Northwestern University

David Carrasco
Neil L. Rudenstine Professor of the Study of Latin America
Harvard Divinity School

Gary M. Feinman
Curator of Mesoamerican Archaeology
The Field Museum

Frederic Hicks
Professor Emeritus of Anthropology
University of Louisville

Alfredo Lopéz Austin
Professor Emeritus
Instituto de Investigaciones Antropológicas,
Universidad Nacional Autónoma de México

Leonardo López Luján
Director, Proyecto Templo Mayor,
Museo del Templo Mayor
Instituto Nacional de Antropología e Historia
Mexico

Eduardo Matos Moctezuma
Emeritus Professor
Instituto Nacional de Antropología e Historia
Mexico

Deborah L. Nichols
Professor of Anthropology
Dartmouth College

Jeffrey R. Parsons
Professor Emeritus of Anthropology
The University of Michigan
Curator Emeritus
The University of Michigan Museum of Anthropology

Enrique Rodríguez-Alegría
Assistant Professor of Anthropology
University of Texas at Austin

Juan Alberto Román Berrelleza
Profesor-Investigador, Museo del Templo Mayor,
Instituto Nacional de Antropología e Historia
Mexico

William T. Sanders
Evan Pugh Professor Emeritus of Archaeological Anthropology
Pennsylvania State University

Michael E. Smith
Professor of Anthropology
Arizona State University

Felipe Solís Olguín
Director, Museo Nacional de Antropología
Mexico

ILLUSTRATION CREDITS

CONACULTA-INAH-MEX: ii, 5, 9, 12, 24, 29, 32, 33, 34, 35 bottom left, bottom right, 37, 38, 39 left, 40 bottom, 41, 42, 43, 44, 45, 46, 48, 49, 50, 54, 56, 62, 63, 64, 74 top, 74 bottom, 75, 76, 77, 78, 80, 89, 90, 95, 96, 99, 101, 103, 107 bottom, 108 second from top, 109, 114 center, 116, 123 top and bottom, 126, 128, 130, 131, 139, 140, 141, 142, 143, 151, 157, 158, 159, 160, 161 right and left, 163, 165 top and bottom, 166, 167, 169, 170, 171, 172, 173, 175, 176, 184, 190 top, center, bottom, 193 left and right, 196, 198, 199, 202 left and right, 203, 205, 206 left and right, 211 top and bottom, 212 left and right, 214 right, 215 top and bottom, 216 right, 217 top, 218, 219, 223, 234, 239.

CONACULTA-INAH-MEX: Authorized Reproduction by the National Institute of Anthropology and History.

Photography courtesy of Lourdes Cué, Seal of Mexico City in the building of the Antiguo Ayuntamiento: 215 bottom, current flag of Mexico: 219.

©1992 The Field Museum, A105154c_241189, Photographer Kathleen Culbert Aguilar, FM_241189: xii.

Photography © 1992 The Field Museum, A105154c_240961, Photographer Kathleen Culbert Aguilar, FM_240961: 110.

©1992 The Field Museum, A105154c_240970, Photographer Kathleen Culbert Aguilar, FM_240970: 72.

©1992 The Field Museum, A105154c_96220, Photographer Kathleen Culbert Aguilar, FM_96220: xx.

Photography © George & Audrey De Lange: 211 top.

©Museum of Ethnography, Stockholm, Sweden. Photo: Gustav Cedergren Collection: 32 top. Photo: Ola Apenes: 44, 45, 46, 49 top left, 49 bottom.

©Foundation for the Advancement of Mesoamerican Studies, Inc., www.famsi.org; images produced by John Pohl; Historia Tolteca-Chicimeca: 4, obsidian edged sword: 125 right.

Field Museum Library, GN563.5.C6 M2n, Codex Magliabechiano, folio 77r: 92. folio 78r: 93. folio 66: 149 top right. folio 70: 149 center right. folio 88: 144.

Field Museum Library, Gn563.5.c6 T3h, Codex Telleriano-Remensis, folio 26r: 7. folio 31r: 14.

Field Museum Library, GN 564 S2h v.1, Florentine Codex, Vol. 1, folio 96: 30 top; folio 97: 30 bottom; Appendix: 100; folio 49r: 147 right; folio 25r: 150 lower left.

Field Museum Library, GN 564 S2h v.2, Florentine Codex, Vol. 2, folio 139: 40 top; folio 16v: 149 center left.

Field Museum Library, GN 564 S2h v.3, Florentine Codex, Vol. 3, folio 854: 31; folio 750: 35 top; folio 187: 47 top; folio 87: 47 center; folio 133: 47 bottom; folio 113: 55; folio 166: 60 left; folio 169: 61; ch.18: 91; folio 68r: 150 lower right.

© Copyright 2002 President and Fellows of Harvard College, 28-40-20/C10108 T 1310: 162.

©1976 "Libertad" Ester Hernandez: 229. ©1981 "Sun Mad" Ester Hernandez: 233 right.

Holmes, W. 1885:71, Texcoco fabric marked vessel found by Holmes in 1884: 50 bottom.

Courtesy Foundacion ICA-Compania Mexicana De Aerofoto: 80.

Azteken, Mexiko-"Federschild" (MVK 43.380), Kunsthistorisches Museum, Wien oder KHM, Wien: 107 top.

Photograph © 2007 Museum Associates/LACMA Los Angeles County Museum of Art Cat.158, p.21, Original in Biblioteca Nacional de Antropologia e Historia. Facsimile in Mr. And Mrs. Allan C. Balch Art Research Library, Los Angeles County Museum of Art, Codex Boturini (Tira de la peregrinacion) facsimile, folios 1 & 2, Originally made in Mexico first half of the 16th century. Facsimile made by Taller de Artes Graficas, Mexico City in 1991: 6.

©National Museums Liverpool, World Museum Liverpool; Codex Fejervary-Mayer, p. 1: 155; p. 28: 97 top left.

© "Nuestra Madre" Yolanda Lopez, 1981-1998, 4'x8': 238.

©Alfred Lopez Austin. Digital illustration: C. Rabiella/Arqueologia Mexicana/Raices: 56.

Courtesy of Eduardo Matos Moctezuma, *Un catecismo náhuatl en imágenes*, de Miguel León-Portilla: 211 bottom. El Cristo de Mexicaltzingo, técnica de las esculturas en caña, de Abelardo Carrillo y Gabriel: 212 left, 212 right; 214 right, 215 top, 216 right, 217; Banderas históricas mexicanas, de Jesús Romero Flores: 218.

Courtesy Museo Nacional de Antropologia, Mexico City, 11.0-02051: 108; 11.0-05384: 109; 11.01546b: 199.

E.W. Nelson/National Geographic Image Collection: 33.

Courtesy of the Newberry Library, Ayer 507.5 B7 H2 1899 (Box) Codex Borbonicus, published by Paris, E Leroux 1899, folio 4: 181; folio 5: 58; folio 7: 57; folio 8: 232.

Photograph courtesy of Deborah Nichols: 113.

INDEX

Page numbers in italics refer to illustrations.